Publishing With
Photoshop®

by David Bergsland

Publishing With
Photoshop®
by David Bergsland

ONWORD PRESS
TM
THOMSON LEARNING

Africa • Australia • Canada • Denmark • Japan • Mexico • New Zealand
Philippines • Puerto Rico • Singapore • United Kingdom • United States

Publishing with Photoshop
by David Bergsland

Business Unit Director:
Alar Elken

Executive Editor:
Sandy Clark

Acquisitions Editor:
James Gish

Editorial Assistant:
Jaimie Wetzel

Executive Marketing Manager:
Maura Theriault

Marketing Coordinator:
Karen Smith

Channel Manager:
Mona Caron

Executive Production Manager:
Mary Ellen Black

Production Manager:
Larry Main

Production Editor:
Tom Stover

Cover Illustration:
Nicole Reamer

Cover Design:
Cummings Advertising

Book Design and layout
Bergsland Design

Library of Congress
Cataloging-in-Publication Data

Bergsland, David.
 Publishing with PhotoShop / by David Bergsland.
 p. cm.
 Includes index.
 ISBN 0-7668-3476-X (alk. Paper)
1. Computer graphics 2. Adobe PhotoShop 3.
Desktop Publishing. I. Title.

T385 .B4655 2001
006.6'869--dc21

 2001028600

NOTICE TO THE READER

*I dedicate this book
to my favorite person in the world,
my one true love,
The Rev. Patricia H. Bergsland.
She is the reason
I keep pushing for excellence.*

Acknowledgments

Over the years, many people have helped me along the way. Personally, I have to thank my friends at Nob Hill Foursquare, my wife's church, for their immense help in bringing me to greater maturity. Their love and support have been essential to my growth as a person, as a teacher, and as a writer. This wouldn't have happened without their prayers and support.

At school, I have to thank my Dean, Lois Carlson; my Associate Dean, Susan Cutler; and my Program Directors, Dan Valles and Marcella Green. They have given me leeway to pursue this new style of teaching and a great deal of support and kindness. We creative types can be very hard to live with, but they have hung in there with me even though I am severely bureaucratically challenged. I am grateful.

Many thanks have to go to my students in my Business Graphics degree and certificate programs at Albuquerque TVI and in my commercial mentoring venture, Pneumatika Online School. It is horribly unfair to name names, so I won't. We've had a great deal of fun. They didn't volunteer as guinea pigs. In fact, most of them think I'm some sort of expert. But I know better...

There is one student who has gone far above the call of duty. She has been a major encouragement to me. Marcia Best has helped, encouraged, proofed, tested, and supplied PC graphics as needed.

At Delmar/Onword, I have had a wonderful crew. Larry Main and I have worked together since 1995. Thomas Stover has been a wonderful help to production – answering my many questions almost instantly. He kept the workflow smooth. My new editor, Jim Gish, has been a joy to work with – as has his assistant, Jaimie Wetzel. Their professionalism is far beyond what I have ever experienced.

My copyeditor and tech editor did a wonderful job. This is the third book I have worked on with Brooke Graves. She just keeps getting better. Melissa Cogswell is my first technical editor at OnWord. Her input was very insightful and helped make this a better book. The crew at Webcom, our printers, have been very responsive and helpful. It is a major task for an author to write, design, and format his own book. All of these people have made it much easier to accomplish.

My major gratitude is reserved for my incredible wife, Pastor Pat as she is known by her sheep. Her ability to put up with my foibles is staggering. Without her love and support, I would have quit a long time ago. In addition to being my wife, she is also my pastor which, as you can imagine, is a fantastic help. Serving as one of her elders has given me a glimpse into true leadership and a teaching ability that has been the core of my inspiration as a teacher and mentor. Her friendship has been my stability. Our love is my reason for going on ...

June 1, 2001
Quail Meadow, New Mexico

This book was written, designed, and formatted on a Mac G4 with 320 MB RAM, MacOS 9.1. I used InDesign 1.5, FreeHand 9 & 10, Illustrator 9, Photoshop 6, Word 98, PageMill, and Mariner Write to create the pieces. My scanner was an Epson 636U. Everything was proofed on my old beatup Laserwriter Select 360. Each chapter was printed to disk from InDesign and distilled using Webcom's settings in Distiller 4. Their RIP doesn't like InDesign PDFs yet. The color chapter was RIPped directly from the InDesign files. I designed all of the fonts used in Fontographer. They are for sale at MyFonts.com

Table of contents

viii: Publishing with Photoshop

x: Publishing with Photoshop

Welcome!

This is the home page for CD included with:

"Publishing With Photoshop",

Part of the **Publishing Pro: Everyday Skills** series from OnWord Press by David Bergsland

NEW READERS CLICK HERE...

Join us for a new type of software training where we focus on learning real world techniques -- as opposed to simply learning software and hoping that someday you'll pick up the necessary real world techniques on your own. Click here to see our unique method of assessment that works whether you are an official student or are learning on yourt own.

The focus of this book is publishing knowledge and practical skills. Here's a link to the Skill Exam Rules.

On this CD-ROM, that comes with the book, you will find the reading assignments, grading policies, miniskill exams, and skill exams. Just click on the links above or below in the button bars.

These materials are published by OnWord Press. Check out the Desktop Cafe, their center for graphic design, desktop publishing, printing, and digital publishing. TO WRITE THE AUTHOR CLICK HERE

The basic instructions for the materials in this book are all found in the next eight pages and on the CD linked to the home page. Simply open CDhome.htm in your browser and get busy...

Working the system

Concepts

1. Skill exams

2. Tutorials

3. Discovery learning

4. Reality orientation

Discovering the basic attitude and skills necessary to survive in the publishing industry

The basics needed for success

One of the largest problems with this style of learning is just getting you to start work. The procedure will probably seem foreign to you – unless you are already working in the digital publishing industry: print or Web (then you will feel reasonably comfortable for it is designed to be realistic).

These materials are what is professionally known to educators as **DISCOVERY LEARNING**. What this means is that you learn to do the exams by discovering what to do. The learning is in the searching and the practice. Try first, then ask for help.

The knowledge you need only comes by experience. The materials in this book offer you experience in a safe environment. You certainly do not want to learn these things while experimenting with your client. (Or should I say former client?)

Personal responsibility

You will have to determine what you need to know and then learn those skills. Your instructor is a resource person who has the skills and the resources to lead you to green pastures where you can graze on feed that will result in professional level skills on your part. Experience cannot be force fed. You must practice on real world projects or the closest thing to it in order to gain the experience you will need in your career.

The learning goals

In reading industry trade magazines, the many books available, and talking to employers in the new industry, it has become apparent that most current study offerings are not meeting the needs of either the employers or the students. Most books still just teach the software assuming that you know the publishing. To quote the chairman of my advisory committee for my Business Graphics degree, which is filled with employers and working graphic designers,

"Software is a moving target."

I have found no titles that teach the image manipulation produced daily in Photoshop from a practical production point of view. This is not graphic design instruction (though that is a part of it). This is not prepress instruction (though this is also a part of it). This is using Photoshop as an integral part of the suite of tools needed for digital publishing and Website construction.

The focus is on student needs

Publishing With Photoshop teaches essential skills needed on a daily basis using the best tool for the task – Photoshop. The concepts and skills taught work equally well with Photoshop 4, 5, 5.5, and 6. The newer versions streamline production with some of the new capabilities (like the Styles palette that allows you to apply multiple layer effects at the click of a button). However, the basic concepts work equally well on any version since 4.0. The concepts and skill sets taught in *Publishing With Photoshop* are essential to professional production without the titillating illustration techniques that have little practical use once the student gets hired. In my experience Photoshop is usually taught as a video game where you can have fun. In fact, Photoshop is an indispensible tool for daily production.

Five learning goals:

- Basic graphic design knowledge without the egocentric techniques taught traditionally in fine art and design schools. These techniques are overly expensive to actually produce in actual projects for real clients who really need to communicate with their customers.
- Practical job skills covering the production requirements of offset lithography, screen printing, electrostatic printing, and inkjet printing – plus the needs of Website creation.

- Strong thinking and problem-solving skills
- Strategies to determine when to use Photoshop and when other types of software are appropriate.
- Basic working knowledge of how to integrate Photoshop with the rest of the software used by the publishing industry for projects in print, multimedia, and on the Web.

The problem with tutorials

Publishing with Photoshop is easy to read, very practical, and a reference for basic techniques that will be used during your entire career as a professional desktop or digital publisher. These techniques cover concepts that are not going to change. However, this book is not enough. A new method of instruction is necessary also. Current courses around the country are usually simply lockstep software tutorials teaching wow-factor techniques. These tutorial entrances to image manipulation are generally helpful, but they teach none of the learning goals listed above. They are boring to you and do not add the skills you really need on a day-to-day basis. They merely show software capabilities — not how to use that software.

This book does assume that you have done some basic tutorial work in Photoshop or that you have some basic experience using the software. If you have not, then some quick tutorial entry is suggested. There are many Websites with simple tutorials. Adobe's Website at www.adobe.com has some, but a simple search will find many more. Adobe's *Photoshop Classroom in a Book* for any version from 3 to 6 also works (even though this is often used as a textbook for the tutorial-style courses).

A new method of instruction is necessary

Lockstep tutorials are little help to you beyond a bare introduction to the software. They teach the location and capabilities of the various dialog boxes and commands. However, tutorials force you to think in the manner and order of the tutorial creator. The problem is that graphic design projects have thousands of different equally competent and professional solutions. It is impossible for a designer to solve design problems by trying to think like someone else. Exams must be open-ended.

Creativity is an extremely subjective process that can be promoted, but never codified.

You will have some need for more directly guided tutorials when you first begin. However, my experience has shown that as soon as you can

 This icon notes a tip to help.

 This icon locates a basic concept.

 This icon warns you that you are about to be assaulted by my opinion.

Have a fun ride!

May 2001

move on, the faster you will learn. We are definitely talking liberty here, not license. This style of teaching gives you freedom within the context of professional production standards. If any solution is not sellable to a real client, you need to redo it until it is.

The procedure and conceptual basis of the skill exam approach

Instead of lockstep tutorials, *Publishing With Photoshop* includes open-ended projects in the form of skill exams. Even the miniskills included in the book give you room for creativity. The skill exams have been tested for many years in order to make sure that they actually help internalize concepts in a production environment. After a tutorial, I could give you an almost identical project and you would not be able to do the work. After a skill exam, the skills are yours – and you can easily transfer those skills to real projects for real clients.

There are ten miniskills and ten skill exams. They are all located in the HTML Website on the CD. This is a copy of the Website I actually use in my classes to teach online. I give my students relative freedom to pick the exams that will help them the most. This means that some will pick the easiest. We always have the lazy ones. However, you are better than that, I know. As you can see on the grading policies page on the Web site, you are required to do five of each type of exam. You can earn the additional points needed for a "B" or an "A" with additional theory, miniskill, or skill exams. Plus, you are strongly encouraged to work on real world projects.

Skill exam rules:

The following are some simple guidelines to make the use of these skill exams and miniskills as fun as possible. The miniskills are easier, with more direct step-by-step instruction. You will find that there is still quite a bit of freedom allowed in them also. The skill exams are real projects for fictitious clients. You can always substitute real work if you have a client with a similar need.

There is no time limit, unless you are substituting real work with the resulting deadlines. Regardless, you can practice as much as you like. Remember, these are genuine skill exams, meaning that you will have to take the time to develop the skills. Please do not assume that you can just toss off the required finished product. (If you can, you are wasting your time talking this coursework.) Pick a skill that challenges you a little.

You can ask as many questions as you need to ask. These exams are designed to teach you needed skills. We are not interested in your methodology (if it's important there will be specific suggestions). The required steps of the

skill exam are all there for a reason. Read the instructions carefully. You can invent your own shortcuts later, on your own time. However, like all projects, skipping part of the project means angry clients and lost work. Treating these exams like job tickets will help you get them done professionally.

If you cannot figure out how to do any part of the skill exam, the instructor or one of the staff will demonstrate it for you. Feel free to ask one of your classmates (but remember they may not know any more than you do). This is discovery learning, so *"figuring it out"* is an important part of the learning process. This learning by discovery is what embeds the skills in your memory.

You will finish with a specific product (usually a JPEG, GIF, or PDF) that you attach to an email, which you then send to your instructor for grading and comments.

If there is a problem with your final product, the instructor will annotate your PDF, or describe problems in the reply email, and send it back for corrections. There is no penalty for the second try (or third or fourth).

If you work in a team with other friends or classmates, you are required to be able to do the skill exam on your own, without help. You need these skills. If the instructor thinks you are trying to get away with avoiding some of the skills, you may be required to demonstrate your skills that have been submitted, at any time.

THERE IΓ NO WAY YOU CAN CHEAT ON THEΓE TEΓTΓ. You have to be able to acquire the skills. At any time, if there is any doubt in the instructor's mind, all he or she has to do is ask you to do the skill while they are watching. Once you have done a skill exam, and acquired the skills, you should be able to redo any of these exams in just a few minutes.

The reason for the theory exams

As you well know, current teaching styles normally use multiple choice testing for theory concepts. This style is used for ease of grading with no thought to its helpfulness in analyzing your actual conceptual understanding. (To rephrase, multiple guess is easy to grade and they don't care what you have really understood.)

Publishing with Photoshop includes a complete set of theory exams using short essay-style questions that enable your teacher to accurately assess your understanding of the basic concepts. These exams are the questions at the end of each chapter. All theory exams are to be typed (with the questions) into an email and sent to your instructor for grading and annotation. My experience is that the teacher's comments help more than anything to increase your knowledge. These concepts are important for you to understand, and they help your teacher know where you need help.

VI: Working the system: Introduction

All of these exams are designed to force you to think

Many of the theory questions are open-ended with no right or wrong answer — just like the skill exams. They are designed to force you to think (although it is certainly more politically correct to refer to the process as strongly encouraging thought). This style of teaching gives you the opportunity to work together with other students on the exams. In fact, you are strongly encouraged to work together.

Robin Williams (in her extremely popular book, *The Non-Designer's Design Book*, Peachpit Press, 1994) calls it "Open Book, Open Mouth" learning. The questions are open-ended, often requiring careful thought and personal opinion to answer. Often there is no right or wrong answer, but a search for thoughtful opinion. The goal is to learn to think, not to regurgitate data. The process of writing the answers into the email and the annotated email responses will give you great reinforcement to help you remember and internalize the concepts. The very process enables long-term retention of the materials.

The importance of real world projects

In my courses, students move on (as soon as possible) to real projects for real clients with real deadlines. This enables them to apply what they have learned, making the new knowledge and techniques a permanent part of their skill set. You always have the built-in option to supply your own "real projects". You will learn so much on these projects (especially if you have trouble), that you really need to push past any fear. These projects will give you a chance to work on *real stuff* in a safe environment with professional help readily available.

When you graduate or finish the coursework, you will have to use it to satisfy real clients' needs. You cannot start this process soon enough. I always give grades to real paid projects, but that will depend on the policies of the school you are attending. If they do not allow it, please write me at graphics@swcp.com and I will try to help. I do online mentoring and consulting for a nominal fee to any student who needs it.

Software versions

Publishing With Photoshop is not version specific, nor are the skill exams. Whenever possible the exams are written to use tools that have not changed in their usage since version 3. The screen captures (where used) are from Photoshop 6, but many of the exams have generic captures that can be used with any version of Photoshop. The biggest difference in this book is that several of the layer styles applied have to be done in separate steps in the earlier versions. Just come as close as you can. The operating principle is simple: **WILL A CLIENT PAY FOR YOUR WORK?**

Often my students have newer versions at home than are available in the lab at school. When hired, many of you will be forced to use older versions to produce the work in their job tickets. I had a student with training in PageMaker 6.5, Quark 3.32, FreeHand 7, Illustrator 7, and Photoshop 4 who was hired by a screen printing firm who used CorelDraw 3 exclusively (in Windows 3.1). I heard quite a bit of complaining about antiquated software and hardware, but the student adapted fast and became a trusted employee generating hundreds of posters, T-shirts, etc.

The basic principle is simple. If you learn these skills, you can use them on almost any software. Photoshop is unusual because it is the only publishing software with no real competition. CorelPaint and Painter have their adherents, but Photoshop is almost universally available. However, you may well be working in Photoshop 3. It cannot do the layer effects, and there are no adjustment layers. (I'm not sure there are layers – period.) However, the procedures and capabilities for creating halftones, multitones, and separations are still the same. That is what you will be doing on a daily basis.

How do you keep up when the meanings change weekly?

Anonymous student

Distance Learning and Online Training:

Publishing With Photoshop includes a complete generic Website on the CD that has been used and tested since 1996. This site is set up for easy inclusion into the distance learning courses taught by any community college, business, or vocational school. If this coursework is not available online at your school or if you are studying alone, on your own, please contact me at http://kumo.swcp.com/graphics or email me at graphics@swcp.com.

The Website on the CD-ROM includes all the reading assignments, miniskills, and skill exams developed for the coursework using *Publishing With Photoshop*. These materials were designed so you can do them online in your home or office on your schedule.

 Learning online or on your own requires much more self-discipline than many realize. You will have to set up a regular schedule to work on these materials. Every online student I have who fails does so because they were not willing or not able to spend the time necessary to learn the skills. It has been known for years that it takes **200 to 400** hours of practice to learn a new piece of software. Many would say that it takes several years to learn the career of digital publishing. In traditional publishing, where I worked, we didn't even interview anyone with less than three years experience. You will have to work at this to be sucessful.

A word on a PDF workflow

Almost all of printing problems are solved or greatly simplified by going to a PDF workflow. I have been using a PDF workflow since early 1998

and it has been an amazing time and effort saver. I include training in Acrobat in all of my classes. PDF is built into Mac OSX on the system level and will become more important to publishing professionals in the coming years. You will still find printers that cannot handle PDFs. Be patient!

Calibration

It is often best not to use too much color calibration while learning. This is simply because you need to learn that hardware and software are not reliable — that WYSIRWYG (What You See Is Rarely What You Get) is far closer to reality than WYSIWYG. You don't want to get hired by an uncalibrated shop and make a fool of yourself. If you do use color management, make sure you can set it up entirely by yourself. Remember, every output supplier will have different procedures, hardware, and software. You will have to set up your machine specifically to work with whichever printer you are using. Color calibration is a senseless joke for working in RGB. There is far too much variance in monitors.

If you are studying on your own at home or in the office

Everything I just wrote applies to you also. Although most people find that working in a group like a class helps a great deal, many of us no longer have the time (or the money) for that luxury. With the self-discipline mentioned in the tip on the previous page, you will find these materials are really fun to use.

Here's the familiar landmark from all my books, now you won't get lost...

Chapter 1

Painting as Opposed to Drawing

Concepts:

1. Lineart

2. Continuous tone

3. PostScript

4. Transparency

Definitions are found in the Glossary.

Placing bitmap illustration into the context of the publishing industry

Chapter Objectives:

By giving students a clear understanding of the position of bitmap illustration in the publishing industry, this chapter will enable students to:

1. define the differences between lineart and continuous tone artwork

2. list the advantages of graphics done in Photoshop

3. list the advantages of PostScript graphics done in Free-Hand or Illustrator

4. discuss why speed and efficiency are such virtues in the publishing industry – both print and Web

5. list unique capabilities of digital painting, in general, and Photoshop, in specific.

Lab Work for Chapter:

1. Install Photoshop and set up aliases or shortcuts to enable it to be accessed easily.

2. Learn the file management procedures for your lab or set up folders for your use on your own computer.

3. Open the Website for this class (or the version found on your CD) and explore the links offered.

If you are taking this class in a classroom setting, this is the time to learn the procedures set up by your school. You will not have time later, and many problems will be avoided by learning these things now.

Painting as Opposed to Drawing

"Normal" drawing

In this book we cover one of the most commonly used tools in our arsenal. *Image manipulation*, more commonly known as *bitmap illustration*, is one of those indispensable tools of digital publishing. Back in those bad old days (before computers), when we **(GASP)** had to do everything by hand, things were clearer. There was camerawork, inkwork, typesetting, and pasteup. These areas have been replaced by image manipulation, digital drawing, word processing, and page layout software.

So, this book is about camerawork instead of inkwork — image manipulation instead of digital drawing. What does that mean? It means that our focus is on specific types of artwork focused on soft transitions and subtle effects. As you see on the opposite page, the drawing is very different from the painting. It's not to say that one is better than the other — they are simply different. The painting is soft, subtle, more realistic. The drawing is clean, crisp, easily resizable, with a much smaller file size. It is also extremely easy to add professional-quality, easily resizable type (with complete typographic control) to the drawing. Any type added to the painting would be limited to large point sizes and fuzzy edges. Photoshop 6 has changed that by allowing vector shapes and font information to be saved with the file. However, even now, painted illustrations simply cannot handle quantities of type.

The attraction of Photoshop certainly has a lot to do with the fact that little or no drawing skill is required.

This enables designers to add graphics in a hurry, under the pressure of horrendous deadlines. Without photography, modern publishing would be impossible without radical changes in process and procedure.

Lineart versus continuous tone

The first distinction you need to understand is the difference between lineart and continuous tone artwork. These distinctions have been blurred a lot recently with the push toward having every software application do a little of everything. However, it is important to understand that, essentially, FreeHand and Illustrator cannot do continuous tone and Photoshop cannot do lineart. This is not to say it cannot be done. More accurately, there are many reasons why it should not be done.

Lineart

For our purposes, *lineart* can be defined as artwork made up of distinct hard-edged shapes assembled into an image. Originally, it was called *camera-ready art* due to the fact that it was purely black and white. Now it is called *vector-based art* or *object-oriented art*. All objects in digital lineart are hard-edged shapes with no resolution or pixels attached to the definition. Even what appear to be smooth gradient fills or soft shadows are really many hard-edged shapes stacked on top of each other — so closely that the transition appears smooth to our eyes.

Reality:

This is not anything that can be reproduced — ever. The best we can do is a rough approximation of it, no matter what media we use. Our goals as publishers should be beauty and clarity. Let reality stand on its own.

Continuous tone

Continuous tone

Continuous tone artwork is very different. There are rarely any sharp edges. The colors are continuously varying. Even in smooth areas, like a blue sky, every pixel will be slightly different in color. In fact, here is the real distinction digitally. Continuous tone artwork is defined by pixels. These pixels are an integral part of the file's definition and description. Therefore, even sharp edges (except for verticals and horizontals) are delimited by jagged blocks of pixilated squares.

The illusion of reality

The main advantage of continuous tone artwork, as we find in Photoshop, is its ability to describe the illusion of reality. In our minds, we all know that photographs are not reality. However, we do assume emotionally that they accurately represent reality. This illusion remains even when we see a man carrying a car on his back. In fact, it still remains when he flips it over on the floor, climbs into the car, and drives off. Our minds may say it is not real, but our emotions still believe.

One of the problems with Photoshop is that this illusion of reality is completely under the control of the artist. This gives us a brand new responsibility. How many really know, for example, that we have not seen an undoctored photo in print for years? Zits, stray hairs, cuts, wrinkles, and so on all are eliminated routinely. However, it goes much farther than that.

About a decade ago, when I was still a full-time art director, the printing plant where I worked commonly printed huge bar posters for a national brand of beer. When their art directors flew in from out of state to press-proof the posters, they entertained us with stories of the bubbas who visited their plant looking for the girls. What they found so funny was that the head was from one girl, the nose from another, the hair from another, the eye color was invented, the breasts were from yet another girl, the legs and rear from another — all carefully merged into that delectable form the bubbas were lusting after. Even if they had wanted to put the girls on display, it would have been impossible. Those women did not exist except in the eye of the designer. This is true of every woman in every ad. Why do you think there is so much trouble with teenage girls and anorexia? They're striving to attain something that does not exist in reality.

Ethical considerations

This manipulation first became obvious to the public during the OJ trial, when the same photo was used on two national magazine covers with two totally different constructed images. One looked like a thug and the other looked like a beneficent hero. In Photoshop, where we have pixel-by-pixel control, we can do anything we like with an image. Photos are no longer

good evidence. The only reason the photo of OJ's shoes could be used was that it was printed six months before the alleged deed.

Are we responsible for telling the public that we have played with reality? In most cases today, we are not. Even photojournalism is full of doctored photos that go far beyond the editing done in the photographer's mind as he or she decides what to shoot and what to ignore. It is fascinating, for example, to watch the coverage of the same event through the eyes of FoxNews and CNN. Often, you would think they were covering different events. I have no answers to this problem. I do know that you need to be aware that messing with reality carries some responsibility with it. What you do with that is up to you.

Fine art graphics

A discussion of continuous tone artwork would not be complete without mentioning fine art. Paintings, pastels, pencil drawings, and the like are all continuous tone. In fact, they are commonly a serious problem. The little gouache on the right, for example, was a real pain to reproduce because of the texture of the paper it was painted on. But my purpose here is to remind you that the illusion of traditional fine art is not really possible in Photoshop. Photoshop simply does not have the tools necessary.

Digital fine art is the realm of Painter, now owned by Microsoft and Corel. What will happen to it in the future is not known now. However, that is the program for those of you looking to illustrate with the appearance of traditional fine art tools. Painter can mimic any of the tool marks of any of the traditional tools in the artist's box: sable brushes, bristle brushes, palette knives, camel-hair mops, gum erasers, kneaded rubber erasers, bleach, hard pencils, soft pencils, carpenters' pencils, and so on. Each brush, in the newest versions, has individual trails for each hair of the brush.

Many of you will probably do as I do — create your illustrations traditionally. Then I scan the artwork and manipulate it in Photoshop. Whatever procedure you use, the artwork you create will often be scanned into Photoshop. You may use pieces or the entire piece of artwork. You may use photos of the artwork. The thing to be remembered here is simple: *traditional fine art pieces cannot be reproduced accurately*. It is not even theoretically possible.

Photography

Here we enter the most common use of Photoshop. The name says it all. Photoshop is a complete digital photography lab, primarily designed to fix, modify, and prepare photographs for reproduction. I've spent years, as a photographer, fine artist, and art director, trying to understand why the

HIGH ON THE MESA

© Patrician Stock:
http://kumo.swcp.com/graphics

> **It is a shameful thing to be weary of inquiry when what we search for is excellent.**
>
> Cicero

vast majority goes ga-ga over photographic techniques and technologies. It was a major epiphany to realize that the main attraction seemed to be for people who couldn't draw very well.

NOW, NOW – PLEASE DON'T GET YOUR KNICKERS IN A KNOT! This is not meant as an attack, but as a commentary on current graphic styles and fashion. Photography completely took over printing in the later half of the twentieth century. Roger Black called it the "age of the X-acto knife," and it is true that one of the major drawing tools of the 1950s–1980s was that sharp blade. I think he missed it a little, though. The pervading technology underlying graphic design for the past five decades has been photography: graphic production as we know it would have been impossible without photography.

Photoshop has merely accelerated that trend. Most of the new fashionable styles in digital artwork are based on photographic collage – the assembly of various images into a supposedly coherent whole. Most of our so-called drawing ability has been reduced to making accurate selections of scanned objects to add to that collage of photographic images. Even here there are amazingly powerful software tools to help those who can't draw very well to make those selections semi-automatically.

Even people who could never draw a leaf can find one and scan it. This is primarily what Photoshop does. We call it image manipulation, and so it is. We rarely create those images any more. We combine them. The images we create are usually done in a camera: traditional film or a digital record of pixels. This is neither good nor bad. The best work is still done by people who can draw – usually by those with fine art training. It is astonishing to find out how many of the really good graphic designers began with a BFA or MFA degree in painting or drawing.

Why do I mention this? Because I am convinced that this is the reason why Photoshop classes are always filled to overflowing and the FreeHand/Illustrator classes are filled by people who discovered the need for digital drawing while trying to do what they wanted to do in Photoshop.

Photoshop's appeal

I constantly hear students proclaiming that *"Photoshop is much easier to understand"* or *"Wow, I love Photoshop!"* It does seem simple to understand. The complexities of typography and PostScript production fade away under the assault of those countless and dazzling abilities to manipulate scans. What these students usually fail to realize is that all those amazing distortion filters do exactly that – distort. This is why most Photoshop output tends to look like those practice exercises we used to do in art school as we learned to draw and paint. The problem, of course, is that most new Photoshop users have never learned to draw or paint.

However, Photoshop genuinely does enable almost anyone to generate images that look wonderful, without their needing to know how to draw. That has to be the most common question from new graphic designers. "I don't know how to draw. Can I still do this?" The answer has to be, "Yes!"

Scanning and general usage of Photoshop

It should be obvious, at this point, that you will be doing a lot of scanning. We will make some scanner recommendations in a little bit. For now, let's just talk a little about how you will be using Photoshop day-to-day. Basically, you will be scanning photos. Unlike what you were led to believe in your "Look at that! Isn't that incredible?" Photoshop class, most of the fancier techniques are merely methods of losing money.

I suspect that this is the time to add a little reality orientation. Many teachers and most books will not mention reality because it might lower the amount of book sales. I just want you to know the truth. In the day-to-day work of graphic design, you will not be allowed to waste time with the fancier Photoshop abilities. One of the real advantages of Photoshop 6 is that you can add many of these things more quickly — some of them even fast enough to be truly useful. However, the bottom line is that Photoshop is most commonly used as a production tool.

I know that prices vary, but the following statements are very close to the facts you will have to deal with on a daily basis:

- Dropping a grayscale photo into a layout is worth about ten minutes of your time. This includes scanning, cropping, cleaning up, correcting, sharpening, and saving the file to a useful place in a useful format.

- Dropping a full color photo into a layout is worth about fifteen to twenty-five minutes of your time. This includes scanning, cropping, cleaning up, correcting, sharpening, and saving the file to a useful place in a useful format. The only reason you get the extra ten to fifteen minutes is to get the color balanced more accurately.

- The majority of graphics used in day-to-day document production are freebies added without charge. They are one of the ways you make your artwork more valuable than your competition's work.

- Most of the incredibly fancy effects are only appealing to other Photoshop users. Most readers consider them confusing and ugly.

- The biggest problem for Photoshop users is not the short amount of time available and the tight deadlines. The worst problem is making graphics that are too complicated to print. This is almost entirely due to a lack of print and/or Web production knowledge.

The news isn't all bad

Before you go getting all depressed on me, let me say that the purpose of this book is to get you past these obstacles. It is possible to learn how to produce on a professional level and still have design time fun. However, sticking your head in the sand will not work. You will be required to get your mind off the fun and games long enough to learn production necessities.

Talking to the choir

I imagine that many of you are already saying, "I know all that stuff." My response is, "*I doubt it.*" The most recent statistics I have seen suggest that nearly two-thirds of all documents received by service bureaus and printing companies are unprintable as received. The problem is even worse with Web jobs. Most Websites are more flash (pun intended) than substance. Even if we disregard the incredibly long download times, the majority of Websites are designed more for personal designer gratification than client and customer function.

The purpose of your designs

This is obvious, but let me continue – please. You will be fixing photos to make them printable or to make them small enough to be used online. Obviously, I am not talking to those of you who make your living in illustration. But then, most of you don't. Full-time illustrators are a rare breed in our post modern digital culture. Many of you probably have that aspiration. Good for you. However, you will still need to know the practical matters we will be covering in this book. You have no idea how much it will help you to get a reputation of always making your deadlines with artwork that is usable without a lot of correction and manipulation.

If you think about it, most documents have little need of the fancier capabilities. In fact, in most cases, the fancier effects are counterproductive. You need to remember that your client's customer did not pick up your brochure to see the gorgeous graphics. They picked it up to have easy access to important facts about the client's products or services. They were looking for knowledge, data, and technical specs.

The same thing is true online. Your client's customers did not type in the URL to that incredibly impressive Website you designed to sit back and murmur, "*This site is amazing. The artist who designed this is fantastic.*" They are going to the Website for information. The graphics should be there to help surfers find their way through the site with ease, comfort, and

speed. The graphics are there to set the tone and make the journey more aesthetically enjoyable. If your amazing graphics do not serve that pupose — **DELETE THEM!**

So, where are you using Photoshop?

If you think about it, most printed documents have a few photos and a logo or two. Increasingly, we see a lot of fancy backgrounds. Usually, however, these backgrounds only make the documents less accessible and harder to read. The same statements apply to Websites. Remember, as a practical matter, the first thing most cyber travelers do when they find the data they have been looking for is print the page.

As I hope you realize, the problem with most digital photos is that they print too dark and/or they are too large to download. These are easy problems to solve. All it takes is a little knowledge. This is what I hope to impart to you over the next 350 pages or so.

The good news

If you learn these simple production techniques and acquire the conceptual background necessary, you will free up enough time to allow your creativity to flow. Once production techniques are mastered, creativity is completely unhindered by them. I realize that as you start the process, all you see is things you cannot do. After you have mastered the process, you will simply have no ideas that you cannot produce.

The creative process is understood a lot better when you realize that, in essence, it is problem solving. What I propose to do is give you solutions to most of your production problems. Eventually, these problems will no longer be a part of your design and production process. The solutions will flow habitually, without conscious thought. Only then will you be free to create graphic designs you can be proud of.

What you need before you read this book

As we get into the use of Photoshop, we need to talk about the entry-level hardware and software requirements. Please bear with me. Some of this will seem very basic. However, like all prerequisites, these are based upon experiences that I will share as appropriate. If you have been around for a while, some of these things will seem like no-brainers. However, I have ample evidence to suggest that many who have been working in the industry for years do not understand why they are having some of the troubles they are having, or how many are hardware-related. Photoshop is a heavy user. Most of these following recommendations are truly minimums.

> **Natural abilities are like natural plants — they need pruning by study.**
>
> Francis Bacon

If you are serious...

You need to think in terms of a dual processor (PC or Mac), a gigabyte of RAM or more, a very fast hard drive or a RAID array, an accurately calibrated 21-inch monitor, and a $2,000 scanner or better.

The basic problem is space

Photoshop's basic need is for lots of room. It needs lot of RAM. It needs a lot of storage space. It also needs a lot of empty disk space in which to work. The basic formula is this: Photoshop needs three to five times the file size for both RAM and empty hard disk space (called a *scratch disk* by Adobe). In reality, the empty hard drive space is the more important. If you run out of scratch disk room, Photoshop simply locks up with no chance to save.

RAM, in contrast, is a production speed necessity. If you do not have enough RAM, Photoshop will continuously be working in virtual memory. As I'm sure you remember, *virtual memory* is hard disk space used as RAM for those occasions when there is not enough physical RAM.

To restate, if you are working on a 30 MB file (which is relatively small in print production) you need about 110 MB of RAM for the simple operations and 170 MB for the filters that are more complicated mathematically. You notice I put an extra 20 MB in both of those figures. This is because it takes nearly 20 MB just to open and hold Photoshop in RAM as you work.

If you run out of RAM, Photoshop does not stop (although it will seem like it). The software simply continues working in millionths of seconds instead of billionths. In other words, your production speed slows down by a factor of a thousand. Instead of less than a minute to save, it can take ten to fifteen minutes. Filter applications can take hours, literally.

What I want to do is give all of us a base to start from. From here on I will be assuming that you have this setup or better. If you don't, you are going to be very frustrated (in fact, you are already, if you are working in the field).

So, let me give you a list:

• Basic computer literacy.

Duh! This is much more important if you have a Wintel machine — although Windows 98 was nearly functional and Windows 2000 is solving most of the remaining problems. Windows machines require you to have a lot more computer hardware knowledge because they are much more complicated to set up. It is true that you can add whatever capabilities you like. It is also true that when you do so there will be multitudinous configuration problems. The only useful advice is to save often and keep a list of your tech support numbers next to your computer. There will be nothing you can do about the infancy of color calibration, the plethora of inadequate hardware sold to the unsuspecting, or the ugly interface. The main thing is to be very careful about upgrades once you are running well. An upgrade can take a couple of months or more to integrate into your setup.

If you have a Mac, you made the wise choice for graphic designers. You will have far fewer configuration and operating problems. However, if you have hardware problems you are in deep doo-doo (repairs are more difficult). Regardless, you still need to know how to run your computer. You still need to save often. You need to rebuild your desktop regularly, clean up your filing messes, and name your files with real names that can be remembered (in other words, names that can be figured out by your replacement when you call in sick). If you haven't done it yet, you need to buy and read the appropriate version of Robin William's *Little Mac Book* series. Most of your operating systems will be covered. She is a marvelous writer — very clear and very easy to understand.

For both platforms you need to be able to load system software, install programs, and set up a functional filing system. Beyond that, you need to have developed a basic troubleshooting methodology so you can figure out what went wrong. To say that computers are sensitive and complicated is understating the obvious. Remember, it is not **if** your hard drive crashes, but **when** it does. The same is true of corrupted files, failed floppies (including ZIP floppies), and all of the host of things that can and do go wrong with your files as you work on them. It may happen a little less often on a Mac, but it still happens on a regular basis. You task is to learn to deal with it quickly, without getting upset over the unavoidable.

• The hardware minimum — the real minimum.

This minimum is debatable, but I will give you some general guidelines. You obviously need a Pentium or PowerMac. Anything older will greatly add to your frustration — plus many of the newer software applications will not run on the older machines. More than that, you need a relatively current CPU. Photoshop 6, as well as the rest of the latest versions of Adobe's software, almost demand a G4 or a Pentium III or IV. A dual-processor setup really helps with Photoshop.

The CPU speed in megahertz is not nearly as important as the amount of RAM you have available. In fact, when you purchase your new machine, back off on the MHz a little to add more RAM (if you have to). This is also one of the main reasons why Windows 95 is not sufficient — it only supports a maximum of 64 MB of RAM per program, which is only enough to learn and practice on Photoshop. You really need 128 MB and more just for Photoshop in addition to your other minimal needs (24+ MB for PageMaker, 32+ MB for Quark, 48+ MB for InDesign, 48+ MB for FreeHand, 48+ MB for Illustrator, 24+ MB for your system software, etc.). Basically, you need a minimum of 256 MB of RAM in your computer (anything less will be frustrating and necessitate work with small files only). Even on my machines with 256 MB RAM, I run 512 MB of virtual memory or more.

Versions:

I am serious when I say that all versions from 3 to 6 are sufficient. Many in the field are still using those older, "outdated" versions. I tried to be flip about it in the body copy. However, if you have an older version of Photoshop, it will work fine. The only problem you may have is that your production speed might suffer a little. However, I find that those with the newer versions waste an inordinate amount of time playing with effects, so, don't worry about the age of yours. Also, the older versions take far less RAM and run much faster while doing the slightly more limited things they do.

You will need at least a 2 GB hard drive (the norm is at least 20 GB). Photoshop requires five times the file size in empty hard drive space to use a scratch disk. Many keep an empty gigabyte external hard drive hooked to their SCSI or FireWire port simply as a scratch disk. By the way, you will probably need to get a SCSI or FireWire card if you have a PC (I think they call FireWire IEEE 1394 or some similar user-friendly nomenclature).

You will need some sort of large removable storage. SyQuest was always the best, until its bankruptcy. Iomega's products are very frustrating, but they are the best available at this point (although good things are being said of Castlewood's Orb). Just remember that the ZIP is just a souped-up floppy and as such is subject to regular cartridge failure (plus it is SSLL-LOOOOWWWWW). You need to keep in mind that many of your desktop publishing projects will total nearly a gigabyte or more. A JAZ drive can solve some of the problems. Most of us are using CD-R or CD-RW for storage. Increasingly the solution is found in one of the writable DVD versions.

A copy of Photoshop — Hey, hey, hey!

No, I am not kidding or being funny. I cannot tell you how many students and new designers I have fought with for months because they really believe that their shareware paint program or Paintshop Pro can cut it. The professional production of printable photos and usable Web graphics requires Photoshop — sorry. PhotoDeluxe can't do it. CorelPaint can't do it. Photopaint can't do it. Photoshop is an essential program. That being hammered home — no, you do not need 6.0, 5.5, 5.0, or even 4.0. Photoshop has been functional since version 3.0. The only problem you will have is with the LE versions, which cannot do process color (CMYK) and have a limited number of layers. I do strongly recommend 6.0; it's one of the best upgrades in years. However, if you still have that old Quadra or 486 you will have to find a used version of 3.0 or 4.0. The techniques discussed in this book work fine on those versions. In fact, one of the darkest secrets of the digital age is the simple fact that the older versions still work (and many people still use them).

A PostScript printer

Again, this is a no-brainer, but often disputed by persons new to the industry who are trying to avoid the expense. Simply put, there is a reason why the publishing industry uses (what have come to be called) the Big Six: PageMaker, Quark, InDesign, FreeHand, Illustrator, and Photoshop. Now we can add Acrobat, Streamline, and a host of others, but they all have one thing in common — they write clean, printable PostScript. PostScript is not an option. It is the standard for professional quality output of printed materials and has been since the late 1980s.

You cannot even generate a PDF without a PostScript printer driver. Linescreen, dot shapes, knockouts, traps, printer's marks, and many other things require PostScript. It is highly recommended that you have a tabloid color laser printer. These now start around $5,000. A tabloid B&W laser printer is now less than $2,000. Those are phenomenally cheap prices. A PostScript printer is one of the major reasons why professional printing looks so much better than secretarial or office output.

TIP: For years, the only way to get decent PostScript output was to spend the big bucks for a PostScript printer, or pay the service bureaus outrageous prices for contract proofs. The good news is that you can now do that with many of your cheap inkjet printers — using yet another piece of Adobe software called PressReady. It is a PostScript Level 3 RIP that supports many of the small Epson printers, some of the HP inkjets, and one Canon inkjet. The bad news is that Adobe stopped development of PressReady in the spring of 2000. It costs $250 at the Adobe site, and it is supposed to remain available. You can also find out which printers are supported there. Hopefully, by the time this comes to print they will have come up with a replacement. At this point my advice is get it while you can.

• A good scanner.

"Good" basically eliminates anything under $500. Actually, it nearly eliminates anything under $1,000 (with the exception of Agfa's Duoscan). The best consumer brands are: Heidelberg, Agfa, Umax, Epson, Microtek, in that order (IMHO). The main thing needed is a good Photoshop plug-in. These five brands have good plug-ins. The rest don't. HP is an excellent scanner, but its scanning software has always been clumsy, inadequate, and slow. Some of my students claim this has gotten better in recent years. Scanner brands like Relisys, Tamarack, Mustek, and the others of that ilk can take up to an hour to do a poor-quality scan. (However, even Heidelberg and Agfa have very slow, cheap consumer scanners.)

It is important that you check out the optical resolution. That is the first number listed when they say a 600 x 1200 dpi scanner, for example. The 600 in this case is the actual count of sensing devices per inch in the scanning array. The 1200 simply means that the scanning bar is calibrated to cover 1/1200 of an inch at a time down the length of the scanning bed.

For now, let's just say that the minimum is 600 dpi optical with 30-bit color depth for reflective art. You will understand those terms better before we finish, if you don't now. If you have the money and the business, it should be obvious that a *professional scanner* is greatly preferred. However, these are expensive (from $3,000 to $300,000) and are really necessary only if you have a lot of business or a lot of high-end process color business — CMYK or hi-fi color. The better scanners are not only much better in the

IMHO

This is email and list short-hand for In MY Humble Opinion. I will add this acronym when I am offering more pointed opinions.

Where should you be by this time?

This is the introduction to your studies around Photoshop. If you are in a class, your instructor will be showing you what is expected with file management, which software and hardware are available, and so forth. It is time to get yourself settled in. This would also be a good time to quickly go through the tutorials in the Photoshop manual.

DISCUSSION

You should be meeting your classmates and finding out their history and goals. You will become increasingly convinced during your career in publishing that lone wolves make lousy graphic designers. Publishing is a team sport, and you might as well get started now.

Talk among yourselves...

shadows, with much more accurate color, they are also much faster. Many can claim an average of a scan a minute. The more you get into Photoshop production, especially print, the more you will want and eventually need a professional scanner.

So, the prep work is done. Now we can get to the chapters that teach you what you need to know — answers that led you to buy this book.

HAVE FUN!

Knowledge Retention:

1. What function does image manipulation fulfill in our industry — print and Web?

2. What are the advantages of digital lineart?

3. Why do you need so much RAM?

4. Why do you think Photoshop is so popular?

5. Why is continuous tone artwork needed to give the illusion of reality?

6. Why is use of complicated filter and plug-ins not advisable in most production situations?

7. What ethical considerations are involved with Photoshop use and image manuipulation?

Chapter 2

Dealing with Bitmaps

Concepts:

1. Bitmap

2. Pixel

3. Dot

4. Sample

5. Dither

6. Halftone

7. Aliased

8. Anti-aliased

Definitions are found in the Glossary.

Working with images broken up into little squares

Chapter Objectives:

By giving students a clear understanding of the position of bitmap illustration in the publishing industry, this chapter will enable students to:

1. define the difference between a pixel and a dot

2. explain the need for a halftone

3. decide whether aliasing or anti-aliasing is preferable

4. describe the relationship between color depth and the amount of colors available to an image.

Lab Work for Chapter:

1. If you are new to Photoshop, work the tutorials.

DEALING WITH BITMAPS

Making it usable

This is the core of the matter: printed continuous tone is made of dots. Online images are all made up of dots. As we take a look at this, we need to be constantly sure of the type of art we are dealing with. You need to understand the difference between lineart and continuous tone. Traditionally, lineart was inkwork. It is artwork that is black and white. It is what was formerly commonly called camera-ready.

As we mentioned in chapter 1, lineart has become PostScript illustration, Flash, and SVG. Digital software does muddy the waters a lot. The main thing to remember is that *all* images are converted to a dot structure before they can be viewed. Monitor (Web) images are made of dots. Printed images are made of dots. All digital images are made of dots once they are output.

The problem is that continuous tone cannot be printed without contortions.

Printers and presses require dots. Monitors use dots. Most of the reproductive processes are unable to print areas that vary in color. More than that, even digital presses that print dots of variable size, cannot print dots that are different colors. This is the key concept you must remember. Presses and printers use dots that are a constant color. They might be all black or all red or all cyan — but for any given printhead, toner cartridge, or plate cylinder, only one color of ink is possible. Every different color of ink or toner requires a different print head, toner drum, master, or plate.

The varying colors and the appearance of continuous tone on a printed product (or a monitor) are an optical illusion. This illusion is created by using dots that are so small the human eye blends them into tints, shades, and continuous tone. This is the basic concept we deal with in publishing. This is where Photoshop lives.

There are two basic types of dots

The basic difference is simple. Can the dots vary in color or not? Those that cannot are better called *dots*. Those that can vary in color should properly be called *pixels*. This invented bit of computerese is a contraction of the two words *picture element*. Basically, most dots that are not printed are pixels. We will discuss printed dots in a little bit.

Pattern dither

Diffusion dither

Pixels have color depth

The amount of different colors that a pixel can express is determined by its color depth. The term *color depth* is an expression of how many bits of data are assigned to each pixel. If one bit is assigned, there are only two possibilities: on or off. If 2 bits are assigned to a pixel, there are 4 possible colors; 3 bits = 8; 4 bits = 16; 5 bits = 32; 6 bits = 64; 7 bits = 128; 8 bits = 256; and so on. These numbers represent possible colors. For example, a four-bit monitor would have sixteen colors available.

A two-bit screen would have four colors — maybe white, green, red, and blue. These colors would be it. Each pixel would be one of those colors and nothing else. There would be no grays, no yellows, no browns; nothing else. The norm for publishers like us is a 24-bit monitor; 24-bit color depth has 16.7 million colors available by using three 8-bit channels (256 x 256 x 256 equals millions). The norm for viewers of our Websites is still 16-bit color (thousands), closely followed by 8-bit (256). We need to remember that. What looks gorgeous in 24-bit is definitely compromised by the color limitations of lower color depth.

Dithering

But what would happen if the screen were drawn in a checkerboard pattern of red and blue alternating pixels? Some sort of purple, depending on the hues involved. This technique of generating the illusion of additional colors by using patterns of pixels is called *dithering*. Dithering can be in defined patterns — think uglier than sin — or in a random arrangement called *diffusion dithering*.

As you can see, any type of dithering is a compromise at best. In fact, dithering can easily destroy an image (as you can see in the patterned dither sample). However, you need to understand that dithering is often the best solution to problems of limited color depth and/or low resolution. Diffusion dithering has to be matched to your printer. Every printer will have a dot size that works best with its resolution. The use of a diffusion dither can solve many problems in this area, as we will discuss in chapter 12. There is no help for a pattern dither. This is one of those things that clearly identifies inadequate software, hardware, or wetware.

It is very important to keep the different types of dots clear in your mind as you use them. For clarity's sake, I will do my best to remember to use the following codes to help you separate dots from pixels. Basically, scanners and monitors use pixels. Printers and presses normally use dots. The problem is that most people refer to any type of dot or pixel as dpi (which obviously stands for dots per inch). It will help you a lot to keep these things separated in your mind, at least.

Here are the codes we will be using (assuming an accurate proofing process):

- spi = samples per inch for scanner pixels
- ppi = pixels per inch for monitor pixels
- dpi = dots per inch for printers and imagesetters
- lpi = lines per inch for halftone screens on plates, masters, and toner drums

You can certainly continue to call everything a dot, and all resolutions dpi, but this artificial differentiation into the four types of dots will be helpful as we get a handle on dots in the workplace.

The halftone revolution

As we begin to learn to be comfortable with dots and pixels, a brief look

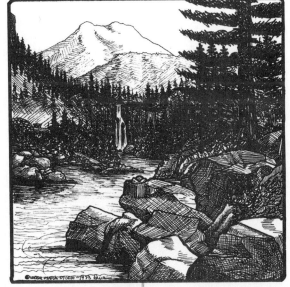

at history is in order. Photography triggered the search for the ability to print shades of gray. All reproducible artwork before that time was lineart — primarily engravings and etchings. These were made up of tiny, overlapping, and crosshatched black lines cut or etched into copper plates. It took until the latter part of the nineteenth century to develop a technique to solve the problem of printing photographs. This methodology produced what came to be called *halftones*. A halftone broke a continuous tone image into tiny little dots that vary in size. Evidently someone, while trying to explain the concept, said the dots covered half the area (or something like that). We really don't know where the term came from.

The concept of tints

One of the basic concepts in the area of halftones is the tint. We are not talking about the fine art version, where a *tint* is a color plus white and a *shade* is a color plus black. For clarity's sake, we would do better to call artists' tints *pastel color*. Printing does not have white ink available, on a practical level. Yes, it is true that there is something called Opaque White ink. However, coatings of printed ink are so thin that, in actual use, all ink is transparent (with the exception of screen-printed inks). I can remember several projects, designed by the inexperienced, where project costs went through the roof because we had to print the white ink three to seven times to get it opaque enough to satisfy the *artist*.

Tints smoothly blending from 100% on the left to 0% on the right:

So, in printing, a tint is named by the percentage of area covered by the dots. The white used to make the tint is actually the bare paper showing through between the dots. In other words, a 50% tint using square dots would look like a checkerboard of solid ink squares alternating with blank paper squares. For a 30% tint, the dots would cover 30 percent of the area. For a 90% dot, the paper is almost entirely covered except for tiny little areas of blank paper.

For now, what you need to know is that printers require dots. There are only a few digital process color laser printers and presses that use pixels. More than that, presses need what are called *hard dots*. These dots are a specific size and a uniform density. It is very important that they be predictable in size and location, so they can be calibrated to produce tints that are accurate to plus or minus half a percent or less in color. Needless to say, cheap printers cannot be this accurate.

THE DIGITAL EQUIVALENT OF PHOTOGRAPHIC DOTS

Computers require pixels

Pixels are very different from dots. First of all, they do not vary in size, they vary in color. Pixel size is determined by the software and hardware. The color variance is determined by the color depth (or number of bits assigned to each pixel). Pixels do not vary in frequency – they are always part of a rectilinear grid of specified dimensions. Increasingly, the grids use square pixels.

Pixels are used by scanners, monitors, and digital files in general. Paint programs, like Photoshop, define images by their pixel dimensions. An image that is 300 pixels square would be two inches square at 150 ppi, one inch square at 300 ppi, and half an inch square at 600 ppi. As you can see, pixel count is very different from resolution, which is expressed in pixels or dots per inch or millimeter.

Usually you can't see pixels, so here is a demonstration. The pixels are on a regular grid, and they are each a specific color. Each picture element is assigned a position

on that grid or map. This grid is commonly called a *bitmap*. This may be because the first bitmaps used one-bit pixels on their grids. However, a bitmap is simply a description of the color of the individual pixels with each pixel having a specific location defined by the grid. This location is usually measured from the top left pixel. So the third pixel from the left on the second row would be mapped as 2,3 (or 3,2 – but who really cares except programmers?).

This arrangement is much like needlepoint canvas, which is also a tight, rectilinear grid. The only difference is that needlework places its picture elements on the intersections instead of the holes. However, like a pixel, each stitch can only be one color of yarn.

All of these pixels are fixed elements. They cannot be moved. All you can do is change their color. If you change the color of the shape to the background color and redraw the shape ten pixels to the right, it appears to have moved. It has not. It's much like movie marquees with moving lights. The light bulbs do not move, even though the eye reports the illusion of movement.

DEALING WITH THE JAGGIES

How do we handle those stair-stepped edges?

If you look at the two images to the right, one is so jagged as to be unusable. The other appears relatively smooth, as if it were made with vector outlines. In fact, both of them are equally jagged. In the better looking image, the jaggies are simply too small to see. We are now entering the reality of digital imaging. All digital images, when reproduced on a monitor or printed, are jagged. In fact, both of these images are the same except one is at 600 dpi and the other at 25 dpi.

The most common method of dealing with these jaggies is to make the blocks (pixels or dots) too small to be seen. As we will discuss in detail in chapter 8, this really isn't very hard. At normal reading distance, about eighteen inches, dots one point square are about as small as we can see in a continuous tone pattern. A point has now become exactly a one-seventy-second ($1/72$) of an inch. We can see very thin lines down to .15 of a point (.00021 of an inch) because the connected lines are so wide or long. In a

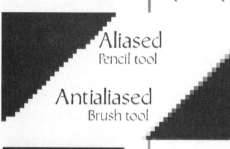

Aliasing:

The top triangle is aliased. The bottom one is antialiased. Notice that there is no difference in the vertical or horizontal edges. The only place you see this problem is with angled edges.

rectilinear grid, we can barely make out one-point dots. In fact, if they are one-point pixels with color depth we would call it the Web (72 ppi).

So you can see why our little digital printers with resolution from 360 dpi to 1440 dpi look very good. The normal PostScript laser printer in the office or your studio at 600 dpi or 1200 dpi looks great. The dots are simply too small to be seen without a magnifying glass or loupe. However, most of you have seen what happens online if you aren't careful. The edges of shapes look pretty rough at 72 ppi.

Our programming heroes have come up with another solution to the jaggies. Here again is one of those computerese things. Plain jagged edges are called *aliased*. I know it sounds nonsensical – just memorize the term. As we mentioned, the only solution for aliased edges is higher resolution to make the jagged steps too small to see.

The other solution is called *anti-aliasing* (go figure). This solves the jaggedness of aliased edges by adding pixels of partial color to the jagged edge to visually smooth it. As you can see above, the anti-aliased edge has a lot of little gray pixels added. Looks horrible, doesn't it?

However, look at the same lines at higher resolution. Now the anti-aliased line looks noticeably smoother. Yes, it is an illusion necessitated by the jaggies. Yes, it looks horrible enlarged. Yes, it adds a huge amount of horrible clutter at the edges of an anti-aliased image. But, yes, it does look a lot better at the final viewing resolution. The effect is especially noticeable online at 72 ppi, as we mentioned. In a continuous tone image, anti-aliasing is always present. It is what makes accurate selection for image editing so difficult.

How pixel colors are determined on a grid

We are going to take some simplistic examples to show how anti-aliasing works. It doesn't matter if Photoshop does it differently. I am just trying to show you how it works conceptually. The basic problem is that a pixel can only be one color. So, if a red line crosses a blue background at an angle, the individual colors are calculated by percentage. That is, if a pixel has half of its square area covered with red and half covered with blue, the resulting pixel will be colored with a equal mix of red and blue, or purple. If only 25% is covered with red, the pixel will be blue-violet. If the pixel is covered 75%, it will be red-violet.

The sample image at the top of the next page shows pixel calculations expressed in percentages of black. Mathematically, Photoshop's

method is surely more elegant and much more complicated, but I am sure you can see the basic concept. This is how anti-aliasing works, reduced to its simplest view.

This is something you will have to keep track of while you are using Photoshop (or any other program dealing with bitmaps). In essence, the only difference between the Pencil tool and the Brush tool is that the pencil is aliased and the brush is anti-aliased. This is why I mentioned that in my samples for the top illustration on the previous page.

Maintaining the illusion of reality

When you are working with photos, you will almost always want anti-aliased edges for your selections and tools. Bitmapped photos are surprisingly fragile. If the reader or viewer can see any place where the hand of the designer has touched, it's obviously not a record of reality. There are no aliased edges in reality. However, anti-aliased edges have no part in vector drawings. If you need artificially smoothed edges, those vector drawings from FreeHand or Illustrator must be anti-aliased. As an example, this is one of the benefits of Flash. It can smooth the edges of its vector images for the Web.

Rough approximation of pixel colors on a slanted edge.

There are no aliased edges in reality.

Anti-aliasing can really save a lot in file size, though. For printing aliased shapes accurately, like PostScript type in a page layout program, a minimum of 1200 dpi is needed in the printer – and 2400 dpi is preferred. For viewing anti-aliased shapes, like Web graphics on your monitor, 72 ppi can do a reasonably good job. The problem, of course, is that 72 ppi images cannot be upgraded to printable images. But we are getting ahead of ourselves.

Dealing with file size

As I mentioned briefly in the first chapter, major consideration must be given to the file size of Photoshop graphics. RAM needs are extreme – three to five times the file size, minimum. The need for adequate scratch disk room

is even more critical, with the same five times the file size requirement. By now you should understand that the problem is the need to account for every single pixel. Each one must be described, in most cases individually.

For an 8"x10" image at 300 ppi, Photoshop must deal with 7,200,000 pixels. At 1-bit, this is 900K. At 8-bit, this is 7.2 MB. For 24-bit RGB, it is 21.6 MB. For 32-bit CMYK, it is 28.8 MB. The actual file size is usually a little larger to cover file name, type, and storage path plus all the other descriptive necessities. Regardless, it is a lot of information.

The need for triple the file size (or more) is a result of the one to three intermediate steps done as Photoshop calculates how each individual pixel is going to change according to the mathematical procedure set up by the filter. However, on a practical level, we can assume that Photoshop requires around 16 MB just to open the application into RAM with no file open. Then we can begin to see the basis for those seemingly *ridiculous* hardware requirements.

That 28.8 MB 8"x10" image would need about 165 MB of RAM to work on it at production speed in CMYK. Otherwise, instead of taking the allotted twenty to twenty-five minutes to prepare that color photo for printing, it could take up to two hours. Please remember that letter-sized full-bleed images are 8.75"x11.25". We won't even get into the increasingly common full-bleed tabloid images. Just opening a brand-new, blank tabloid image of 11"x17" at 300 ppi, CMYK produces a file size of 64.3 MB — with no layers, extra channels, history states, or snapshots.

Many of us create these huge images by compositing and blending several multi-megabyte files into the final image. Multi-layered Photoshop files with many masks and extra channels can easily be hundreds of megabytes in size. The printable image requirements on Photoshop are truly extreme.

What can you do about it?

Not much — beyond the exercise of care and common sense. If you only have 128 MB RAM in your computer, developing full-bleed tabloid images in Photoshop will necessarily be a rare event. To rephrase, you'll find yourself working for a couple dollars per hour (or less) if you try. Obviously, you can work in RGB as long as possible, which helps a little. However, the color in RGB is often radically transformed by the conversion to CMYK.

Now you are beginning to understand why many color documents are filled with relatively small images set on colored background stages created as vector images in PageMaker, InDesign, Quark, or FreeHand. File size is a constant concern in Photoshop. You need to learn to keep track of it and to develop strategies to accommodate this issue. We will discuss a lot of these things as we continue through this book. It is not a small problem.

Just a week ago, in a poster design competition we had in my classes at the community college, one of the entries was disqualified because the student could not get his design to print fast enough to make the deadline. Even on my Phaser 780 Plus (CMYK laser printer) with 192 MB RAM, it took nearly an hour and a half to print from the G3 with 96 MB RAM that he was using. Of course, he was making some basic errors of ignorance.

First of all, he was printing a multi-layered PSD file from Photoshop (which is much slower than printing the same file saved as a TIFF and placed into PageMaker, InDesign, or Quark). Secondly, he produced all his type in Photoshop 5 which added a lot of complexity to the PSD and also compromised the quality of the type by lowering it to 200 ppi (another error). Thirdly, the full-bleed tabloid image was a composite of nearly a dozen smaller images. The file size was 162+ MB. As I mentioned, the print time was well over an hour.

These file size complications will not disappear because a genie appears from your mouse to grant your wish. The solution is conscious planning and a developed strategy. You will find that I am not a huge fan of filters (especially the distortion variety). I find that the file size issues with the resulting production slowdown are not worth the effect achieved — in most cases. This is not to say that I don't use filters. I do, a lot. However, I only use them when I know that the effect I need can be done no other way **AND** when the time and money in the budget are sufficient.

I will talk about these things at length in relation to many different areas of design and production as we go through this book. The result will be that you will free up a lot of design time by eliminating much of the production time. Most of us *are* in this because we *like to draw*. There is nothing wrong with that. Our difficulty almost always comes because we let the day-to-day production needs overwhelm us. My goal is to greatly reduce those demands, thereby freeing time for you to design better.

Let's get into the actual program!

Where should you be by this time?

This would be an excellent place to open some blank documents with white backgrounds just to experience the file size complications. Open a **17"x22"** RGB image at **300** dpi with a blank white background. Try to draw in the image with your brush tool (or anything else you might like). Then try several other sizes to see how the file size changes.

DISCUSSION

Talk about strategies to deal with file size issues. Make sure you understand aliasing and anti-aliasing. What are alternatives to these huge bitmap files?

Talk among yourselves...

Knowledge Retention:

1. Why is aliased type such a problem?
2. Why is anti-aliasing normally required for photo retouching?
3. How do pixels enable the Web?
4. Why is white ink not really available to printers?
5. How are printers' tints produced, conceptually?
6. Why are production considerations so important to us?
7. What size is a pixel?

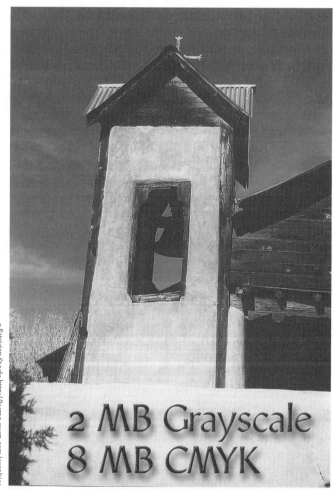

© Patrician Stock: http://kumo.swcp.com/graphics

2 MB Grayscale
8 MB CMYK

Chapter 3

Photoshop's Interface

Concepts:

1. Toolbox

2. Palettes

3. Docking

4. Preferences

5. Scratch disk

 Definitions are found in the Glossary.

Basic interactions with the software and its setup

Chapter Objectives:

By giving students a clear understanding of advantages and disadvantages of Photoshop's interface, this chapter will enable students to:

1. explain the different tool groups
2. set up their palettes
3. locate and use the tool shortcuts
4. list and describe the palettes available.

Lab Work for Chapter:

1. If you are new to Photoshop, work the tutorials
2. If you have some skill, do Miniskills #1–3.

All miniskills and skill exams are found on the CD.

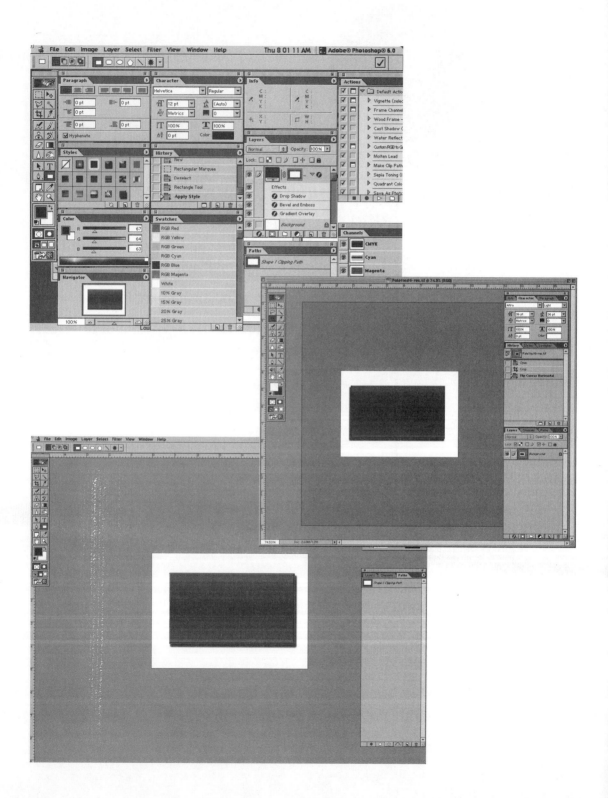

HOW PHOTOSHOP PRESENTS ITSELF

Dealing with the interface

As we get into Photoshop, this first thing we must come to grips with is the interface. Saying that the monitor is overwhelmed with parts is a major understatement. As you can see on the opposite page top left, at 800 x 600 pixels the monitor can become so filled with parts that you cannot even see the image underneath all those palettes.

Needless to say, the illustration is very extreme. You all know that palettes can be docked into tabbed groups. In fact, many of these palettes come in groups. The Layers, Channels, Paths group comes to mind immediately. I use three basic groups myself.

In addition, very few of us work at 800 x 600 pixels on the monitor. I normally have my 17" monitor set at 1280 x 1024 pixels, for example. As you can see, that same image at lower left (that you could not see under the plethora of palettes in the 800 x 600 capture) now has plenty of room to work. In fact, it could be argued, in this case, that the monitor is too big.

For those of you still in version 5 or 5.5, you can see that PS6's new Palette Well really helps reduce clutter. When I was still in 5.5, I kept many of those palettes now in the Well closed, unless I needed them. I rarely use the Navigator, for reasons we'll cover in a bit. So these captures are the first time I have had it open since I first saw it (in version 4, if I remember).

The toolbox

I can't think of a better place to start dealing with Photoshop's interface than the tools it uses. As we go through, I will mention the keyboard shortcuts used. Unfortunately Photoshop, unlike more contemporary software, has hardly any ability to customize shortcuts. It is a serious lack — probably due to the arrogance that comes with developing *essential* software: "We'll tell you how the interface will work." They've got us over a barrel. We are really required to have Photoshop to do any form of digital publishing.

However, one of the nice things about Photoshop is the fact that all of the tools can be selected by typing a single letter. This should give you some idea how little Photoshop was designed with type in mind. It is true that PS6 now has a real type tool that does a remarkable job for a bitmap manipulation program, but it is peripheral to the original vision.

The Palette Well

In version 6, Photoshop has added a space at the end of the Option palette to store seldom-used palettes. It is only visible if your monitor is set to at least 1024 pixels wide in resolution.

Keyboard shortcuts

For Photoshop, memorizing the shortcuts is really not an option — it's a necessity. As we have already seen, finding enough working room is a real problem here. The normal solution is a large, high-resolution monitor. This means that mousing times are the most critical part of your production speed. You do not want to be wasting time mousing across 17 inches.

If you have read any of my other books, you know that I spend a lot of time helping you streamline your production. You also know that one of the best ways to save time is the use of keyboard shortcuts. The standard times are something like this (at least proportionally):

- **Menu commands:** **a couple of seconds**
- **Toolbars:** **a second**
- **Keyboard shortcuts:** **a tenth of a second**

In Photoshop's case, as with InDesign and Illustrator, there are no toolbars as such. However, the toolbox is so incredibly complicated, with all of the multipart fly-out submenus, that the access times for tools can be more than two seconds. In fact, until you learn the interface, you will find that it can take you several seconds merely to find the tool you need.. Even after you know where it is, it takes almost a second for the fly-out submenu to appear after the tool icon holding it is clicked on.

Shortcuts are not an option in Photoshop

In other words, to repeat myself, shortcuts are not an option in Photoshop. (If you haven't been paying attention, that kind of repetition means that this is really important!) Thankfully, the Photoshop team at Adobe is well aware of this need. They have set up the toolbox to help you a lot, once you learn their paradigm.

Toolbox structure

The first thing to notice about the toolbox is the tiny little triangle or arrow at the bottom right of many of the tools. If you are familiar with Illustrator and InDesign, this is a familiar element. Many of you already have some Photoshop experience and you know about these things. However, I have to talk about things like this a little bit. I have found that many people who have been using Photoshop for quite a while (even years) are remarkably ignorant about the basics.

The little arrow indicates that there are more tools hidden off that tool button. The first tool we will talk about, the Marquee tool, has four variants: rectangular, elliptical, single pixel row, single pixel

column. In my humble opinion, this is a real problem with the interface. Adobe would do a whole lot better with more toolbars rather than a large group of hidden tools that have to be memorized (which is difficult for tools that you use only a couple of times a year).

I don't have any idea of how many hours I have spent looking for hidden tools over the past several years. Yes, I mean hours. I am fairly proficient with Photoshop, as you can imagine. I still spend an inordinate amount of time looking for tools because I cannot remember where they moved them for this version. (Of course, this is complicated by the fact that I have old machines at school that cannot be upgraded to run the latest versions; thus, I have to keep track of versions 4, 5, 5.5, and 6.)

Regardless, you will have to go through this frustration. My main comfort is that this is a normal, if irritating, part of using Photoshop. The majority of us are not full-time Photoshop users. In fact, you had better not be. Photoshop is not a self-sufficient application. It cannot do page layout or draw. It cannot do Website construction. It produces graphics to be used in all of those applications. You will be using Photoshop constantly — from 20% to 60% of the time. You will have many other interfaces and shortcuts to remember. The arrogance of Photoshop is unkind, at the very least.

Shift cycling

Once you have a general idea where the tools are that you use, Photoshop does have a very easy way to use them. You can add the Shift key to the shortcut to cycle through the fly-out menu.

Tool groups

In this chapter, we will not talk about specific tools. Let's leave that for the next few chapters. What we need to do is understand the basic structure of the toolbox. As you can see in the illustration, I have used Photoshop's seemingly arbitrary groupings of tools. They seem to make some sort of sense, but then you will find random tools in very strange places. For example, the Line tool is now part of the PostScript tools with the rest of the drawing tools. I know it makes some sort of sense, but I looked for it for a long time one day until I finally found it.

LET'S TAKE THE GROUPS IN ORDER

Selection tools

These are the tools used to select pixels. There are several other methods not found in these tools, but these are the "normal" ones. You need to learn these shortcuts very fast. When you are working with pixels you have to have a

way to decide which pixels to change. You will use these tools a lot. They are important enough to spend an entire chapter on them (chapter 4).

Painting tools

These are the tools you will use for painting — duh. You will discover that Photoshop is very limited in this area. Basically you have one very powerful brush. It is almost always round. If it is aliased, it is called a pencil. If it is anti-aliased, it is called a brush. If it is feathered, it is called an airbrush. If it is using a snapshot as the pixel source, it is called the History brush. If it is painting with the background color, it is called an eraser.

There is nothing like what you find in Painter, where a brush can mimic any fine art tool with an individual pixel trail for every hair in the brush; sable rounds, sumi-e, bristle, camel-hair mops, and on and on. Photoshop does not have any of these things — nor will it ever.

The painting tools also include the two fill tools: paint bucket and gradient fill. It contains tools to lighten, darken, saturate, sharpen, blur, and smudge.

PostScript tools

These are the very limited portions of FreeHand and Illustrator used for simple shapes in Photoshop. Photoshop does have the infamous Pen tool, with all of the Illustrator variants. It uses Illustrator's Select and Direct Select model — a little clumsy, but effective. It has a type tool that works a lot like InDesign's tool — with a few limitations. And it has all the normal PostScript shape creation tools.

It occurs to me that Photoshop's clumsy versions might be the source of many of the PostScript illustration phobias I run across. In Photoshop, these tools feel very clumsy. However, version 6 has made major strides toward usefulness.

Miscellaneous tools

Here is a weird melange: annotation tools, eyedroppers, a measurement tool, the Grabber hand, and the Zoom tool. The usages are all pretty normal. We'll cover them in chapter 4. The main thing to remember here are two shortcuts you will use all the time.

TIP: Double-clicking the Hand tool causes the image to fit to window (be as large as possible in the monitor without distortion). Double-clicking the Zoom tool causes the image to go to **100%.** In Photoshop's case this is often confusing, because **100%** means that each pixel in the image matches a pixel on the monitor. This is why a 1" square at **300** ppi looks about **4.25"** square at **100** percent. **300** pixels cover nearly four and a quarter inches on a **72** dpi monitor. For Web images, this shortcut is often the quickest way

to see what the image will look like on the Web. Another major benefit is that 100% makes the image look as it will when printed. At different enlargements, a lot of strange things can show up on the screen. Using 100% will show you what is really there.

Color tools

My first reaction is to be snide and say, "What color tools?" Basically, Photoshop has only two colors available: Foreground and Background. You will have to learn which tools paint with which of the two colors.

Secondly, Photoshop basically only works in process color. There are some new spot color options, but they are very limited and complicated to access. Most people give up trying to use them.

As you can see, there are two swatches here, the foreground color swatch and the background color swatch. There is a little double-sided arrow for switching the colors. There is a little black-and-white icon, which when clicked resets the swatches to the default: black foreground and white background.

Quick mask tools

These allow you to use the painting tools to make a selection.

Viewing format tools

These allow you to decide if you want to be able to see the desktop behind (like normal on a Mac), if you want the desktop covered with a neutral gray with the image centered, or if you want full-screen graphics without the visual encumbrance of the menu bar.

Jump to ImageReady

What needs to be said here? As I mentioned, we will cover these in depth in chapter 4. For now, let's just say there are a lot of them and their operation is often not very intuitive.

The palettes

Now we come to the infamous Adobe interface in all its glory. This is where it all started. Everything in Adobe is built off the success of Photoshop. The problem, of course, is that the interface reflects Adobe's image of how you are going to work. You really have very few options. There is a strong right-handed bias. The palettes are constantly covering each other up. What can you do?

Actually, there are several things you can do. First of all, learn how to dock your palettes. By dragging the tab of a palette to the bottom edge of another palette, you can make the first palette a permanent part of the palette

A docked setup

above. You can then add other tabs to that subgroup of palettes. It is a little tricky, until you learn to see the visual indicators of docking. But you can do it and it will help a lot. It eliminates the overlapping problem.

The main way to deal with palettes is to get rid of those you never use, drop those used occasionally into the Palette Well (if you have version 6), and dock all of the others into a relationship that makes sense to you. The problem, of course, is that you have no idea how to do this until you use Photoshop for a while. If you are already a *user*, it will help you a lot to start thinking about your setup.

As you can see from my setup to the left, I have nine palettes in a default docking layout. As mentioned, this keeps the palettes from overlapping as they change size. These nine are the palettes I, personally, use all the time. This leaves three palettes in the Palette well. Actually, I would normally have those palettes in the Well closed – if I wasn't writing this book. Let's cover those first.

Actions palette

This is the closest that Photoshop comes to interface control. Though you cannot change keyboard shortcuts in Photoshop, you do have the ability to record macros and assign them a keyboard shortcut using the function keys. It seems powerful, although I have heard a lot of complaining from the geeks among us about lack of power and so forth. Something about some actions are not actionable (that word in itself should give you a handle on the geek quotient attached to this palette).

As one who does not waste my time with programmable actions (it's my choice, remember), Actions goes much farther than I have ever needed. I think I have used this palette about three times since it was added to the program. Those of you who do a lot of repetitive work, where you can duplicate your actions, have my sympathy. This palette might well become one of your best friends.

 You should know right now that I will almost always pick the hand-done course of action. I almost never use auto anything. In my world, average is never good enough and does not really exist. I never have seen that .7 child they are always talking about in the average family. I realize that many of you will use these auto functions. My job is to show you how to control the process. Then, when auto does not work, you can fix it.

I realize that I may be more fortunate than many of you, in that I do not do much repetitive stuff. However, even when I try, an auto function

just slows me down because I am constantly having to go back and tweak things that didn't "auto" to my satisfaction. Your projects will look much better if you can develop a workflow that eliminates most automatic and repetitive adjustments.

Color palette

This is a poor, difficult-to-use version of the Color Picker that comes up when you double-click on the foreground or background swatch in the toolbox. It just takes up space. The only real advantage is that it gives you colorized sliders for RGB. But then, it always gives you RGB sliders, no matter what color space you are actually using. As you will discover, there are many good reasons to leave the RGB color space as soon as possible.

Navigator palette

Here is yet another highly touted ability of Photoshop that has spread like a disease to the rest of the line. It lets you navigate your document in a little thumbnail in a palette. It is far slower to use than the normal shortcuts used all the time in every publishing application.

 CONCEPT: Here we come to the first of my diatribes on production speed. You will find a lot of them in this book. The bottom line in publishing is the deadline and the very high speed assumed in professional production. The Navigator palette gives us a clear example of how not to work. The palette sounds wonderfully cool — easy access to hidden portions of the image. The problem is the slowness of the process.

My open palettes

I realize that you will probably have a different set. However, we can use the capture on the opposite page to provide an order: top to bottom.

Character and Paragraph palettes

These are borrowed, almost without change, from InDesign. They are active only when the Type tool is being used. They are very powerful and work the way you wish they would – a nice set of palettes.

Info palette

An essential palette when making color adjustments, decisions about dot gain adjustments, and so on. It gives colors by the numbers.

Navigation shortcuts

 TIP: Basic navigation procedure is constant in all publishing software (except Quark, of course). Command/Control Zero to fit the image into the window. The Command/Control spacebar to access the magnification tool that Adobe calls the Zoom tool. Marquee the area you need to work in and the area surrounded will enlarge to as large as possible in the center of the window. To zoom out a little, add the Option/Alt key. To scroll around release everything except the spacebar and you will have the Grabber hand to pull the place you need to work into view. This procedure is so common that just a little practice makes this a habit that is used as needed without conscious awareness or decision. **It's much faster.**

Miniskill #3

CLEANING UP A FILTHY PHOTO

Using the History brush to clean up a ridiculously dirty photo. (The complete instructions are on the CD.)

History palette

This is one of Photoshop's nicest features. It keeps track of the last few things you have done. The default is the last 20 things you have done, but it is limited only by the amount of memory, storage, and CPU speed you have available. On my iMac or G4, it is instantaneous.

The nice thing is that it is not linear. Multiple undos are really good, but they are completely linear. The History palette allows you to go back 7 steps and then come forward 3, or whatever you need.

This palette also gives you the controls you need to take historical snapshots, which can then become the source for the History brush. You will be using this procedure a lot. There are several skill exams that cover its use in specific tasks. Check out the one to the left.

Swatches palette

This has the same problem as the Color palette. You cannot use it to apply color other than changing the foreground and background colors. Therefore, the built-in Color Picker, accessed by double-clicking on the foreground or background swatch in the toolbox, works better in most situations. I use this palette to hold the Web-safe color swatches. I personally find this a handy use. If you find another use for it, it's already in the setup.

Styles palette

New to version 6, this one holds a huge bunch of those layer-effect groupings that have been around for several versions, but were just too hard to access. Now you can make them into a graphic style that can be applied with a click of the mouse. These styles are applied to every nontransparent pixel in a layer. In a single-layer document, nothing happens.

The problem is that Photoshop comes with 47 gazillion of them, most of them hideous. The default set is pretty limited, but just click on the Load command in the Option menu popup at the upper right corner of the palette. You can have so many styles that you can spend dozens of minutes or more just finding that style you liked yesterday.

You can use EDIT>> PRESET MANAGER... to set up a custom set of styles to load in your palette, but it is not much faster than simply loading the styles and then deleting the ones you do not want. Simply Option/Alt click on the style to delete it (or drag the style to the little trash can at the bottom of the palette). It is a hassle that you cannot multiple-select and delete many at a time. However, once you have a set you want, the hassle is gone. I will probably experiment with several small style sets that can be used and managed more easily – when I have a few free hours to spend (right!). I use this palette a lot in PS6.

Layers palette

This palette has become the center of Photoshop. It enables incredible things to be done. It also enables vast amounts of RAM and disk space to be used. In recent versions, everything you do adds another layer. I heard people on the PS6 beta team talking about using thousands of layers in a single document (I really did). Using hundreds of layers seemed to be commonplace. Personally, I rarely use more than about six or so.

This area is so important that we are going to spend an entire chapter talking about the power and the options of layers for production use. In production terms, the main concern is the huge amount of time you can spend on effects that the client does not care about and will not pay for. It is certainly an area where you have to practice self-control.

Channels palette

This palette gives you access to the individual primary colors of RGB or CMYK. It gives you access to the three parts of Lab color. You can add channels with masks – especially partially transparent masks. You can add spot color channels. (The spot color options in Photoshop are very limited. We will discuss this more in chapter 10.) It is one of the more powerful sources of pixel control. Everything done in the Channels palette affects the entire composited image.

Paths palette

This palette controls paths created, allowing you to open the path as a selection, add the path area to a selection, subtract a path area from a selection, make a clipping path, and so on. Because of my solid background as a PostScript illustrator using FreeHand, I tend to use this palette more than the Channels palette. Paths can be used to make selections in individual layers, but in general, they are global like channels.

Now that we have briefly covered the palettes, we need to go on to preferences. Most of you have probably noticed that Photoshop really does not have too many palettes. It has twelve, compared to InDesign's and Illustrator's eighteen or more (depending upon how many libraries are showing). But you certainly need to control them.

Preferences

Adobe, in general, does not use Preferences much. However, there are several things you need to decide. That is what preferences should be used for – long-term interface decisions. We really need to go through them page by page. They will help you understand the interface quite a bit better. However, I will crop the pages tightly so we don't waste too much space.

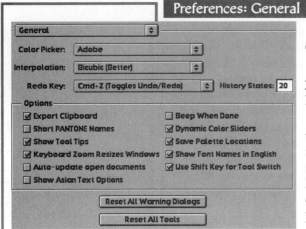

Preferences: General

Here are several obvious choices.

Color Picker:

I think Adobe's works best, but that is your choice.

Interpolation:

This can be set in the Image size dialog, where it is needed. "Bicubic" is normally the best for regular continuous tone artwork. "Nearest neighbor" works best for lineart and art with large solids. The default is bicubic and is the best choice for most purposes.

Redo Key:

Command/Control Z is what it has always been. I'm not sure why you would want to change, but PS6 gives you two more options.

History States:

The default is twenty and this seems to work well. If you have limited RAM, you may need to lower this number. If you are being very experimental, I can easily see where fifty or more would be nice.

Export Clipboard

This can be a real problem. The memory requirements are very steep. I leave this unchecked except for special needs.

Short PANTONE Names

This will make the use of spot colors easier in document assembly. However, as you will discover, Photoshop's support of spot color is so limited that it really makes little practical difference.

Show Tool Tips

You will really need this one as you learn the keyboard shortcuts. I wish they had the Show Fast option from InDesign. You really have to wait for them to pop up (one to three seconds).

Keyboard Zoom Resizes Windows.

This sounds good, and I leave it checked. However, I wish it only resized windows larger. Making them smaller is rarely helpful.

Auto-update open documents

This refers to synchronizing documents when you jump back and forth into ImageReady. I usually wish to make the decision about updating, so I leave it unchecked.

Show Asian Text Options

If you use Asian text, this is obvious.

Beep When Done

I like this option, but some find it irritating.

Dynamic Color Sliders

This sounds excellent, if you are accustomed to the sliders in InDesign. Because Adobe offers sliders only for RGB, it doesn't help much. Sliders for Lab color would be marvelous. I know that many of my students (who cannot think in CMYK yet) really wish for CMYK sliders.

Save Palette Locations

This is a necessity for setting up your interface.

Show Font Names in English

I never noticed that this was a problem, but then what do I know?

Use Shift Key for Tool Switch

VERY IMPORTANT! This is often the only keyboard access to hidden tools. It adds the Shift key to the shortcut to toggle through the tools hidden in the popup stashes on the toolbox.

Preferences: Saving Files

Image Previews:

The default is always save an icon, a Mac thumbnail, and a Windows thumbnail. In general, this is a good thing. The only problem I have ever had here is that those options bulk up the file size a little for graphics sent online. The Save For Web option strips them out.

Append File Extension:

HERE IS SOMETHING IMPORTANT. The default is Always and you need to leave it there. DOS will never die! Even though most Wintel users have become sloppy because Windows 95, 98, and ME do not seem to require extensions anymore, they are still necessary as long as DOS is the base code. I have heard again that DOS is gone. I've heard this every year since 1995. It hasn't happened yet.

At this point I can hear the Mac users squealing, "We don't need them!" Yes, you do and here is why. First of all, none of us can avoid the cross-platform issue. We all work cross-platform to some degree. If we get a file from a PC, we need the extension to know what kind of file it is.

 This is especially important on the Web. Files attached to emails will often become unreadable without the proper extension. (You need to remember that most servers are UNIX or NT.) Without the proper

DOS extension files become unreadable. Just as bad are spaces and unusual characters in a name. Yes, the Mac can use anything other than a colon. Everyone else has very strict restrictions. In fact, it will save you a lot of trouble if you go beyond the file extension and continue on to that old nemesis: the 8.3 naming conventions. It's a slight pain to solve a lot of cross-platform trouble before it starts.

File Compatibility

You need to leave this at the defaults until the rest of the publishing world catches up. Photoshop 6 has really pushed the envelope by adding vector information, font information, layers in TIFFs, and more. No one else supports it yet (as of New Year 2001).

Recent file list contains:

Whatever makes you happy.

Preferences: Display & Cursors

Color Channels in Color

I find that having individual color channels in color helps me to adjust the images. However, these channels are actually grayscale, and this is the norm. I would check this one.

Use Diffusion Dither

If you have an old, low-bit monitor, this might be necessary. As long as you have a 24-bit monitor, it is not necessary.

Use Pixel Doubling

If you have a slow machine, pixel doubling will halve the resolution of the previews. Seems like a silly thing to me. But then, using Photoshop on a 486 does too, and I have students still doing that.

Cursor display

Here we come to something that PS6 has realized, but you still need to decide. In PS6, you can see that Brush Size is checked for painting cursors. In almost all cases you want this. Otherwise, you have little idea of how many pixels are being battered by your tool. If you want the precise crosshair cursor at any time, all you have to do is click on the Caps Lock key. However, those crosshairs are often invisible over an image.

For the other tools, you may well want the precise option. However, in many cases, the precise cursor is almost invisible, especially on large, high-resolution monitors like most of us are using. You will need to learn where the hot spot is for the various tools. For example, the hot spot for the paint bucket is the tip pixel of the paint being poured from the bucket.

Preferences: Transparency & Gamut

No comments necessary here. The Gamut warning is supposed to warn you of RGB colors that will not print properly. It does this by covering those colors with the color chosen here. But Photoshop does not do this automatically. You must select GAMUT WARNING from the VIEW menu to actually see the warning. I don't use this because I go to CMYK mode so soon.

Preferences: Units & Rulers

These are obvious choices except for the fact that you might get the impression that Photoshop can do page layout. Do not be fooled.

Preferences:

Grids & Guides

I don't use them. If you do, the choices are obvious.

Preferences: Plug-Ins & Scratch Disks

Additional Plug-ins Folder

This gives you access to a second folder where you can store plug-ins.

Scratch Disks

This has become less of a problem recently because the normal hard drive size has reached multiple gigabytes. As I mentioned, Photoshop needs three to five times the file size in empty hard drive space. This can easily be a gigabyte. Here you get to choose where you will have Photoshop grab that scratch disk partition. For most of us, the startup disk works well until it starts to fill up (defragging helps).

It was formerly a big problem when hard drives were a couple hundred megabytes and usually slow. However, even now I would recommend an extremely fast external FireWire hard drive that is used only for the scratch disk space needed. It will still increase production speed.

Preferences: Image Cache

Cache Settings

This setting determines how many pixels Photoshop uses to produce histograms and the like. A level of 1 uses all the pixels. The default setting of four uses a quarter of the pixels. Again, this speeds previews. I have always just left it at the default.

Where should you be by this time?

You should be feeling your way around Photoshop. You need to get your preferences set up. If you have not found your personal palette setup yet, you need at least to set things up as I have shown you I do. It may not work for you in the long run, but it is a starting place.

DISCUSSION

You should be discussing default setups with each other. A frank discussion will help you a lot to get your software set up so it works well for you. Don't forget that left-handed people often need to move palettes to the other side of the screen.

Talk among yourselves...

Preference usage

As you can see, preferences settings are important but not used very often. This is the way it should be. You do need to be aware of them, however. If you go to a new machine and it doesn't work, the problem is almost always a preference. Also, as you are learning to set up for your personal usage, preferences play a larger part than they do as you get into comfortable production mode.

The basic setup

I have given you some of the settings I use. The important thing to remember is that there is no right way to do this. *The wrong way is to not do it.* It is critically important that you learn the program so you can set it up to work as an extension of your creative process. This will not happen by accident. You will have to work at it. All I can do is give you the options, and tell you what I do.

The biggest mistake made by digital publishers is to take what the software developers throw at them without thought. You will be amazed at how much you can speed up production by carefully setting up your default layout and preferences.

Knowledge Retention:

1. Why is docking palettes almost necessary?

2. What is the major problem with Photoshop's toolbox?

3. Why are selection tools so crucial?

4. Why does the author think the Navigator palette is redundant?

5. What is a scratch disk?

6. Why do you need to control the interface?

7. How do you find a setup that works for you?

Chapter 4

Accessing Pieces
Concepts:

1. Marquee

2. Lasso

3. Magic wand

4. Quick mask

5. Path

6. Feather

7. Clipping path

8. Mask

Definitions are found in the Glossary.

Learning to use the selection tools and simple masks

Chapter Objectives:

By giving students a clear understanding of how to select specific areas in Photoshop images, this chapter will enable students to:

1. produce accurate masks
2. produce clipping paths
3. isolate parts of an image
4. assemble parts to produce composited images.

Lab Work for Chapter:

1. Finish some of the theory exams and email for grading.
2. Finish Miniskills 1 and 2.
3. More advanced: Skill #6.

Pixel picking...

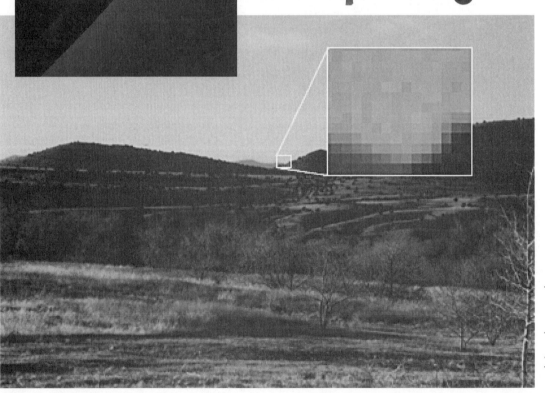

CONTROLLING WHAT YOU CONTROL

Accessing pieces of the image

Selection Tools

As I have mentioned several times already, you really cannot do much with a Photoshop image until you learn how to select the specific pixels you need to modify. This chapter will focus entirely on that issue.

Those of you accustomed to PostScript editing, either illustration or page layout, will be frustrated by the fact that there are no shapes or objects that can be selected and moved or transformed by simply clicking on the object. However, Photoshop has a plethora of tools that allow you to save areas of pixels as ongoing selections. This allows you to treat these selected areas as individual shapes – sort of.

I see no point in wasting your time with conceptual matters here. Let's get into the tools and see where we end up. I'll type the shortcuts after the tool names. Remember that to cycle through the various tools in a given fly-out submenu, you add the Shift key to the single-letter shortcut. So, in the first example, you would use M to access the marquee tools, and Shift>>M to cycle back and forth from Rectangular to Elliptical.

Moving selections

Once you have areas selected, you will often need to move the selection or move the pixels selected. This is one of those things that has changed over the years. In current use, if you move the cursor inside the selection, it turns into an arrow. If you click-drag, you move the selection outlined by the *marching ants*. The image will not change. Only the selection outline will move.

To actually move the pixels selected, you need to change to the Move tool (V) or hold down the Command/Control key. Then when you click-drag, the selected pixels move, revealing the background color. This unveiling of the background color is something that you will need to become accustomed to, as you begin to learn Photoshop.

Only on a layer with a transparent background will moving the selection do what newcomers expect – reveal what is underneath. What you need to fix firmly in your wetware is that, as far as Photoshop is concerned, there is always a built-in background layer. It helps me to think that all the new colors painted or pasted on an image are just covering a solid block of the background color.

Adding to and subtracting from a selection

One of the major concepts you need to understand is that you will almost never make the selection you need on the first try. Adobe recognized this early on and gave us very handy ways to deal with this issue.

Simply stated, you add to a selection by holding down the Shift key while selecting another group of pixels. You subtract from a selection by holding down the Option/Alt key while selecting another group of pixels. This procedure takes a lot more time to explain in writing than it does to actually implement. A quite common procedure is to make a basic, approximate selection using any method and then nibble at the edges with the various selection tools to perfect the selection.

Marquee tools (M)

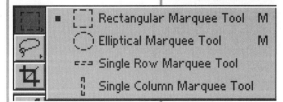

These tools work pretty much as you would expect a normal drawing rectangle or ellipse tool to work. However, rather than drawing shapes, they select all the pixels within that shape.

If you have an older version than PS6, these are the only rectangle and ellipse tools you have available. Photoshop 6 now has vector PostScript drawing tools, but they are not our concern here. In versions prior to version 6, this is the only method you will have to draw a box or ellipse. You marquee a selection, and apply a stroke or fill to it. PS6 now has vector tools, so there is an option of separate tools to draw rectangles, ellipses, polygons, stars, and so on. However, it is still often much quicker to do this with the marquee tool of your choice.

As you can see, only two of the four tools are available with the M shortcut. Photoshop has always had the single row and single column options. I think I've used them two or three times in the past ten years. It would be a major hassle to have to cycle through those two also.

The Rectangle and Ellipse Marquee tools work the way you would expect. If you hold down the Shift key as you marquee, you produce a square or circular selection. If you hold down the Option/Alt key, you marquee from the center out. If you hold them both down, you marquee a circle or square from the center out.

The marquee tool of your choice is often the fastest way to begin a selection from which you can then add or subtract. A marquee tool is also the fastest way to clean up areas selected with other, less precise tools, such as

the magic wand. We'll talk about that more when we get there, but Miniskill #1, for example, is much quicker if you Wand-select the background, cleaning it up by adding missing areas with the Rectangular Marquee tool.

Constrain and fixed size

If you look in the Option palette, you will see that you have the option to set up a fixed size for the marquee tools. You also have the option to constrain the selection proportionally.

The Lasso tools (L)

These are the freehand drawing selection options. As you see, there are three of them: freehand, polygon, and magnetic. Shift+L will cycle you through the group. The normal Lasso tool is very clumsy without a good mouse or a graphic tablet. Even then it *feels* a little jerky. This is the perfect tool for adding or subtracting a little bit as you clean up the edges of a selection.

Because these tools are hand-drawn, they are difficult to use well. When dealing with a photograph, any hint of the human hand breaks the illusion of the image. For that reason, you will often need to soften the selection edges. You have two options.

Aliasing

Selections are one of the major places where you need to keep track of whether you are aliasing or anti-aliasing the edges. All of the selection tools have a checkbox for anti-aliasing. The only exceptions are the rectangular selections, because vertical and horizontal edges do not need anti-aliasing. Even here, however, if you rotate or free-transform the rectangle, the edges will automatically be anti-aliased.

Feathering

In addition, in most selection instances, you have a feathering option. Feathering allows you to fade the edges of a selection a specified number of pixels. In other words, if you move that selection, or manipulate it, you will have a very soft edge fading into the area outside the selection.

Feathering is also the method used to produce those old-fashioned vignettes. This is where you have an oval photo fading into the background. They can be simply produced by making an elliptical selection with a large feather. Then you can either invert the selection (SELECT>> INVERT) and clear, or you can delete the background to the appropriate background color. You can also simply cut or copy the selection to the Clipboard and then paste it into a document large enough to hold the feather. Be really careful that you do not crop the edges of a feather. It ruins the illusion.

Option Palette

In versions prior to 6, you must double-click on the tool to bring up the Options palette. In version 6, it is always across the top of the window and changes contextually with the tool.

Polygonal Lasso tool

I find this to be one of the handiest selection tools. Basically, you select areas by clicking around the image. As you click, straight-line selection segments connect the dots, as it were. This tool seems to be very quick and surprisingly accurate for tight selections.

Magnetic Lasso tool

This is a much ballyhooed tool that I find merely irritating. The basic concept sounds really good. You just drag the mouse around the edge of a clearly defined shape in the image. The tool will look for the contrast changes and automatically draw your selection. You can set the width, frequency, and edge contrast.

- **Width** – how wide an area over which the tool will check for contrast changes.
- **Frequency** – how often the tool creates anchor points.
- **Edge contrast** – how much contrast the tool should look for.

Hitting the Delete/Backspace key will eliminate the last point placed. You can also click to place points you think are needed that the tool didn't pick up on. It all sounds wonderful. In practice, it has never given me a selection that I didn't have to work and rework. I find that the Pen tool works better for me — but then, I am pretty good with that tool from all of my PostScript illustration experience.

Many people love this tool, and that brings up a very important point. My job in this book is to give you a point to start from. Please do not assume that my methods are the only methods. I can tell you that they work — for me. You need to keep an open mind and explore new ways to do things. Your personal tool set and work procedures could end up very different than mine.

Magic Wand tool (W)

This is an extremely handy tool that is almost unique to Photoshop. FreeHand does now have wand capabilities in its Autotrace tool, but this is just because so many people have discovered the obvious benefits of a tool like this. It is fairly crude, but it is also fast and intuitive.

The basic concept is simple. When you click with the tool, it selects every pixel that touches the original pixel that is the same color. Of course, the actual practice is not nearly this simple. "Same color," of course, means something very different in Photoshop. It is the same color within the tolerance typed into the tolerance field in the Options palette.

The first slightly frustrating part is that this tolerance is expressed in PostScript levels. The second, more complicated issue, is that normal color

differences exist between adjoining pixels in almost every continuous tone image. As you can see in the enlargement, even though the sky in the image looks like a smooth gradation from top to bottom, in reality, every pixel is a different color.

This is why the magic wand is such a sloppy tool. Usually as you use it, you are constantly adjusting the tolerance to try and get what you need to select. You will find that you can rarely select exactly what you need with the magic wand.

 However, the magic wand is commonly the fastest way to begin a selection. It can select broad areas of similar color that can be cleaned up relatively quickly by adding and subtracting with the Marquee and Lasso tools.

Anti-aliasing

You will also notice, as you look at the Options palette, two checkboxes that are very important. The first one to mention is the normal anti-aliasing option. This is sometimes helpful, but sometimes a major complication. In Miniskill #2, for example, you will have a heck of a time if you have anti-aliasing on. Selecting with the magic wand with anti-aliasing will select the edges of the black surrounding shapes also. If you turn off anti-aliasing, you will find that the white areas can be selected with simple clicks and shift-clicks with the magic wand. In this simple selection in a gradient, for example, you can see the strange edge selections caused by anti-aliasing the tool.

Contiguous

You will probably find that you change this one back and forth also. Normally, I would leave it at Contiguous. If you uncheck this option, the magic wand will select every pixel in the image — within the tolerance set for the tool. There are times when this really helps. Selecting the background around some type, for example, usually requires that Contiguous be unchecked so you can also catch the areas inside the counters (on letters like BOP or any letter with contained space).

Use all layers

I don't find that this one affects me much, but that is probably just my specific working style. I usually am just trying to make selections in individual layers. If you need to select all of the pixels of a given color in all of the layers, this could solve your problem.

Miniskill #2

COLORIZING

Adding color to a black and white tiff using the Magic Wand and Gradient tools.

Color range selection

Under the Select menu is the command for Color Range.

This dialog box gives you the option of making a selection by sampling colors with an eyedropper. You can also select all the reds, greens, and so forth.

This is another option that some people love. It is far too slow. I have never successfully used this option without being forced to waste many expensive minutes.

Move tool (V)

The Move tool moves selected pixels. Although this tool is not really a selection tool, it is integrally involved with selections. I suspect that is why Adobe put it here with the rest of the selection tools. What the Move tool does is give you the choice of moving the selection or moving the pixels selected.

The tool itself is not accessed that often, simply because holding down the Command/Control key while using a selection tool accesses the move tool. The thing to remember, always, is that moving pixels reveals the background color. Moving them on a layer with transparency reveals transparency (for transparent is actually the background color of that layer).

Cropping tool (C)

You will use this tool a lot. If you don't now, you need to understand why this is so important. First of all, the tool has become much more powerful in the recent versions. We'll discuss this in a bit. However, the most important reason to use it has to do with file size management.

As you become accustomed to Photoshop, and bitmaps in general, you will be surprised at how much you can save in file size with a relatively minor crop. Cropping off a quarter inch around all four sides of a 4" x 5.5" image will save you 405,000 pixels on a 300 dpi image. That is nearly a megabyte and a half if the image is RGB.

Adobe has added several new wrinkles to the tool in PS6, as they did in 5.5. If you move the cursor outside the marquee, you can rotate the marquee. When you crop it (by double-clicking within the marquee), the image is automatically straightened (the marqueed and rotated area snaps back to horizontal/vertical).

There is now a Perspective crop that allows you to adjust the cropping marquee to a rectangle in perspective. When you apply the crop, it distorts the rectangle back to flat perspective. Also, now when you drag the cropping marquee outside the image area, you add image area in the background color (just like the Canvas Size option under the Image menu, but you have much more control).

Fixed image size

One of the useful abilities of the cropping tool is the ability to specify size and resolution. When you marquee with this option set up, and crop the image, it is automatically cropped, resized, and the resolution set in one step. It is an amazing help when making a group of pictures the same size. You can also change just the width, the height, the resolution, or any two of the three options. It is very handy.

Slice tool (K)

To me, this seems to be a strange location for slicing. Slicing is breaking up a large Web image into pieces with separate links possible to each piece. It is actually a misplaced ImageReady tool, and yet another sign that the Adobe programmers were infected with the "we have to be able to do everything" virus while engineering Photoshop 6.

If you want to do slicing, there are some factors you need to consider. Web design has been absolutely overrun with inappropriate design and nonfunctional setups. These things have been said by hundreds of teachers, columnists, and designers, but **NO ONE SEEMS TO BE LISTENING**.

Slicing is one of those things that new designers assume will be used because "they are so cool!" Image maps are not cool – they are normally a very poor choice. This is true for a number of reasons:

- They are too large. Any image over 15K to 25K is too large. Even that is pushing it.
- There is no visual clue to where the links are located – there are no underlines.
- There is no clue telling the surfer which links have already been visited.
- They are too large. I know. I've already said that. Then why weren't you listening? The average modem is still 28.8, with 56K coming in a close second. At those speeds, a 20K graphic will take 20 seconds **MINIMUM** to download. All the stats say that your customer left after waiting 5 seconds – maybe 10. And all of this assumes a good connection and path at both ends and around the world. In reality, even small image maps often take more than two minutes to download (if anyone ever bothers to wait long enough to find out).

Quick mask (Q)

This tool, option, or ability is in the same category as the eraser tools mentioned in the sidebar. In reality, they are part of the painting process. It is true that the process is used for selection. However, it has all of the benefits and problems of painting – because it **is** painting.

The concept is simple. You paint with black and white. The black areas become the selection. The major advantage to this technique is that you can easily produce soft-edged selections. Gray areas painted in become transparent or partial selections. The difficulty lies in the fact that you cannot really see where the edges will be until you proof the results.

Magic and background eraser tools

These tools are often used as part of the selection process, but we will get to them in the next chapter when we talk about painting tools.

Where should you be by this time?

You should be feeling your way around Photoshop. Mini-skills 1 and 2 will give you a good start at selection techniques. Or you can just practice selecting objects out of a scan. Mainly you want to get as good as you can as fast as you can. Selection techniques are usually the limiting factor as far as production in Photoshop illustration is concerned.

DISCUSSION

You should be discussing selection techniques with each other. A frank discussion will help you a lot to learn your tools.

Talk among yourselves...

Paths

These are shapes drawn with PostScript illustration tools. They can be converted to selections or masks, added to existing selections, or subtracted from those selections. You should use them a lot, but they are much more appropriate in the context of the discussion of those tools.

Selection summary

What it comes down to is that almost anything in Photoshop can be used for selection purposes. This is a necessity when dealing with a map of pixels. You need to get used to this.

Knowledge Retention:

1. How do you add to a selection?

2. What are the major problems with slicing?

3. Why are selection tools so crucial?

4. What is the major advantage with Quick mask?

5. Why would you want to use a fixed-size crop?

6. What is the major advantage of the Polygonal Lasso?

7. What is the problem with the Color Range selection process? (You won't be able to answer this one without trying the procedure — yes, practice!)

Chapter 5

Coloring pixels with painting tools

Chapter Five

Painting with Pixels

Concepts:

1. Brush

2. Airbrush

3. Pencil

4. Eraser

5. Paint bucket

6. Gradient

Definitions are found in the Glossary.

Chapter Objectives:

By giving students a clear understanding of how to paint by coloring pixels, this chapter will enable students to:

1. produce custom brushes
2. control aliasing and feathering
3. produce usable fills and strokes
4. control brush size with shortcuts
5. control brush opacity with shortcuts.

Lab Work for Chapter:

1. Finish some of the theory exams and email for grading.
2. Finish Miniskills 2, 3, and 4.
3. More advanced: Skills #2, 4, and 8.

COLORING WITH PIXELS

Bitmap painting

Now we come to that area that most people think Photoshop is all about. I've already mentioned that Photoshop is really not a very good drawing or painting program. However, over the years and the versions, things have gotten better. Although very few actually paint in Photoshop, the painting tools are used all the time to clean up scans and captures.

This gets back to my main premise: most graphic designers are not illustrators. People who are truly making a living as full-time illustrators are actually rare. What most of us do is use some basic illustration skills in the process of assembling documents. What eliminates a lot of our illustration is still the time pressures of deadlines and client need. The result of this is that I will not spend any time here on drawing techniques. I will only briefly cover the new painterly options to the tools in Photoshop 6.

Painting Tools

The truth about illustration

Those of you who draw and paint, do not despair. I am one of you. However, most of you would not be reading this book unless you were in a position similar to the one in which I find myself. I can wow my friends, co-workers, and supervisors. On the national scene, I am nothing. There are many full-time illustrators who make my efforts look virtually nonprofessional.

However, my lack of superstar capabilities is not the real issue here. The truth is that the world of top-end illustration feels a lot like the feeding frenzy that occurs when a fresh-cut slab of beef is tossed overboard in the harbor. Some love that intense competition and adrenaline. Let them have it. The rest of us fondly dream of that type of client and that type of recognition. The truth is we don't want it enough to put up with the other sharks.

This is not important. All of us *like to draw.* In other words, we are in this industry because we like to make beautiful things. In fact, most of us are compulsive about it. I can't tell you how many jobs I lost in my youth because I was constantly drawing when I was supposed to be working.

Artistic skill is not required

However, the truth of the matter is that some of the best graphic designers can hardly draw at all. The sad thing is that this has encouraged a fashion for illustrators who cannot draw. A quick look at the recent fashionable illustrations and award-winners shows that drawing and painting skill is certainly not one of the major requirements any more. Elegance is certainly missing — as is taste, in most cases.

Many of you are probably excellent artists. I am pleased for you. However, most of you who are good artists are lousy designers. In other words, you can draw pretty pictures, but you have a heck of a time communicating clearly. Remember that this is truly our task. We have to clearly communicate the message from our clients to their customers about a specific product or service. Truly beautiful illustrations are too often self-focused. The result of seeing the illustration is, "*That* is gorgeous!" The reaction should be, "I could really use that product."

With all of that in mind, let's get into Photoshop's painting tools. As I mentioned earlier, it really doesn't have much. You need Painter for that. However, the one brush available in Photoshop has gotten much more powerful over the years.

The brush

Probably the best place to start is the Brush palette. Here you see a limited version with some of the basic brushes that come with Photoshop 6. I have appended some Natural Brushes to the list. As you can see, I missed the Assorted, Calligraphic, Drop Shadow, Faux Finish, Natural Brushes 2, and Square brushes. Here's a very limited sample of the variety of strokes available.

You can probably find what you need within the assortment. If not, you can make your own. As you can see on the top of the next page, there is a New Brush dialog box that allows you to make any size or hardness brush – as long as you like elliptical brushes. If you adjust the spacing, you can even produce automatic dotted lines of any size.

Custom brushes

However, the newest versions of Photoshop allow you to go far beyond that. Basically, you can make a brush out of anything you can draw. All you have to do is paint the pattern you want to use for your brush shape and choose EDIT>> DEFINE BRUSH, assign a name that makes

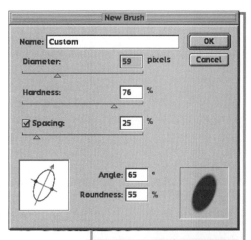

sense to you and start to use the new brush. Here is a very quickly defined 810 pixel "burst" brush. The new brush is the white star pattern clicked over the radial fill. Actually, this new custom brush shows yet another ability that brushes have – the ability to fade.

More than that, they can fade in size, opacity, and/or color. Beyond that, they can be completely con-

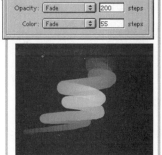

trolled by the abilities of your graphic tablet. Photoshop 6 has added a Brush Dynamics palette to the end of the Options palette to control these abilities. To give you an idea, here is a dark gray brushstroke over a black background using the settings you see just above it. Hopefully, that will titillate the grey matter. I really like the decreasing opacity, but who knows what rings your chime?

Using the brushes with a graphic tablet

So we have all these brush shapes. How do you use them? Basically you need to determine what type of use you will be making of the tools. In other words, will you be drawing enough to require a graphic tablet?

A graphic tablet might well be a necessity if you use Photoshop for fine art or full-time illustration. Other than that I am not so sure. Personally, I have used a tablet sparingly over the years. What I have discovered is that the extreme sensitivity of the tablets I have used requires quite a bit of practice to use well.

For those of you with fine art backgrounds, I would rate the sensitivity at least equal to a Windsor Newton Series 7 sable round, size #8. If you can draw a 000 line with that #8 brush, then you have some idea of the skill involved with the graphic tablet. Yes, you can "dumb it down" a little. But basically, it is an entirely different way of working.

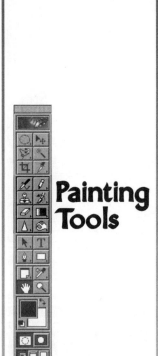

Painting Tools

That being said, a good tablet is essential for actually painting with a computer. Virtually everyone agrees that anything less than a Wacom is too much less. By all reports, the USB Graphire is a super buy. It's sold as an iMac toy. It's been around $100 plus it includes a copy of Painter Classic. However, that might well change now that Corel and Microsoft have taken over Painter. Those two have always been a concern for publishing pros.

Whatever deals are available when you come to make the decision, the only decision is which type of Wacom tablet do you want? Basically, you have to determine whether you work with finger movements, wrist movements, or arm movements. There are tablets several feet square for those of you who paint with large arm movements. For most of us, a small 4" x 5" tablet works very well because it works with finger and small wrist movements. Whatever size the tablet is, it covers the entire screen. The only problem I have ever had is that the tablet never seems to know what to do with a second monitor (if you have one of those).

LET'S MOVE BACK

Photoshop's painting tools

The largest problem with the brush tools is that, at first glance, they all appear the same. As you begin to use them, you will discover that each tool has slightly different options. However, you can produce the same marks with several of the tools.

Specifically I am talking about the Airbrush, Paintbrush, and Eraser tools. They can all use any brush in the Brushes palette. Adobe tells us that the airbrush paints soft strokes. Balderdash! If you pick a hard, aliased brush shape, the airbrush will make a mark identical to a pencil.

However, the focus of each brush does change. Depending upon the options picked, it can be a radical change. More than that, you can set up each brush differently so you really do get four separate brushes to use while painting. We'll discuss this option after we define the capabilities of each brush.

Beyond all of this, there is a huge variety of painting tools in the latest versions. Photoshop 6 also has some fairly good drawing tools to add simple PostScript illustration to the mix. I plan to cover them all in the next few dozen pages.

Pencil (B) — it's with the paintbrush, use Shift+B to access

 This tool can also use any of the brush shapes in the Brushes palette. However, the anti-aliasing is turned off on all of them. It only paints aliased shapes. It's the **ONLY** tool that paints aliased. Yes, there

are times when you really want that hard, aliased edge. The only way you can produce that type of edge is with selection edges or the Pencil tool. The painting tools do not have the option of turning aliasing on or off.

Auto Erase

The Pencil tool does have a really nice option. It is called Auto Erase. The term comes from working with images in the bitmap mode (which is Photoshop's name for 1-bit images). Here Auto Erase is easy to understand. With Auto Erase turned on, if you click first on a black pixel it will draw in white. If you click first on a white pixel, it will draw in black.

In color or grayscale, the Auto Erase tool can do some nice things to build up texture. Here, if you click first on the foreground color, the tool will draw with the background color. If you click first on anything else, the tool will paint with the foreground color. As you can see in the little example to the right, this can produce nice painterly results.

Cleanup

One of the most common uses of the Pencil tool is to clean scans before you bring them into FreeHand, Illustrator, or Streamline for tracing. You will discover that autotracing in those programs works best with high resolution black-and-white images. The Pencil tool is about the only tool that works in that environment.

 One of the handiest features of Photoshop's brush tools is the ability to click and then click again with the Shift key held down. A straight line segment will be drawn between the two clicks. You can save a remarkable amount of time when cleaning up edges and squaring pieces by using this technique.

Brush (B)

This is the *normal* painting tool — whatever that means. I mean that this is the tool thought of by most people when you mention pixel painting. It is always anti-aliased. As mentioned before, the only aliased option is the Pencil tool. When you want to draw or paint in Photoshop, the Brush tool will probably be the tool of choice.

Wet Edges

To help that a bit, the Wet Edges option does to the edge of a stroke what a programmer thinks a fine art watercolor stroke would do. It does not give you a wet edge that dries with that little hard, crystalline outline. It does make the color more intense at the edges of the stroke while leaving the center of the brushstroke a little transparent.

There are some shortcuts that will really help you when choosing your brush size. However, they only work when you are using the regular, preset

The Pencil tool

A quick demo of the auto erase option in grayscale. I used black for the foreground color and a medium gray for the background color with a 44 pixel natural brush shape called Chalk. The tool was set to fade in opacity and size over 100 steps. It looks like a nice quick method of adding a pine tree graphic or something similar. Regardless, it is a nice effect.

round brushes. The basic shortcut is to press the right bracket] to make the brush larger and the left bracket [to make the brush smaller. This is a set of shortcuts you really need to memorize immediately.

 MAJOR DIFFERENCE BETWEEN PHOTOSHOP 6 AND THE EARLIER VERSIONS: Before PS6, when you used the brackets, you just went to the next largest preset. This meant that you were very limited in brush size choices. More importantly, you only had six preset, hard brushes and then quite few soft brushes. With PS6, if you start with a hard brush, you will stay with it, getting larger and larger. The same is true of the soft brushes.

Above the presets, the sizes change as follows:

Preset to 100 pixels	10 pixel increments
100–200 pixels	25 pixel increments
200–300	50 pixel increments
400–900	100 pixel increments
999 pixels	maximum brush size

The nonround presets do not work with the bracket shortcuts in Photoshop 6. This new change is slightly irritating, but it makes sense when you think of it from a programmers' perspective.

Brush opacity

You can change the opacity of any brush simply by typing a number. 1=10%; 2=20%; 3=30%; and so on. Zero sets the brush to 100%. This works for all the brushes, including ones you make yourself.

New Brush dialog review

As you can see, your choices are Diameter, Hardness, Spacing, Angle, and Roundness. The Diameter can vary from 1 to 999 pixels. The Hardness can go from simple anti-aliased to a rather large feather (0% to 100% with 100% being anti-aliased and 0% being a very soft feather).

Spacing can go from 1% to 999%. This sets how far the brush shape overlaps. Any percentage larger than 100% will give you a dotted line as you draw: 50% will cause the brush shapes to overlap by 50%, and so on. If you have spacing turned off, the Shift/straight line shortcut will not work. You should be able to see how spacing works by looking to the left.

Angle and Roundness should be self-explanatory. I realize that for some this is never the case, but that is all the time or space we have for this relatively easy and simple dialog box.

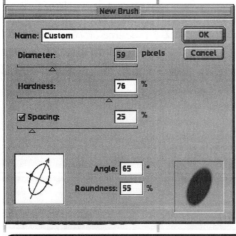

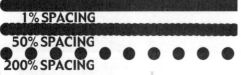

1% SPACING

50% SPACING

200% SPACING

Airbrush (J) — A is taken by the Selection tool

This seems to be a simple feathered brush, at first glance, and basically it is exactly that. There are several differences, but they really do not show up until you get to lighter pressures or to the natural bristle shapes available in the presets.

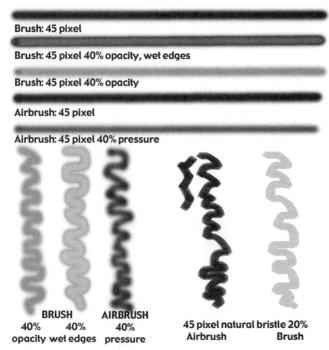

Brush: 45 pixel

Brush: 45 pixel 40% opacity, wet edges

Brush: 45 pixel 40% opacity

Airbrush: 45 pixel

Airbrush: 45 pixel 40% pressure

BRUSH		**AIRBRUSH**	**45 pixel natural bristle 20%**	
40%	40%	40%	**Airbrush**	**Brush**
opacity	wet edges	pressure		

> ### Opacity vs. Pressure
>
> The differences between the brush and the airbrush rapidly become apparent when you use them. They will not become apparent until you practice with them.

Basically, the airbrush fades to the edges of the stroke. As you can see, the 40% airbrush looks very different from the 40% brush even when they are using the same brush. The first major difference you will see is when you simply hold down the mouse button with the brush stationary. The paint will continue to build just like it does with an airbrush.

When you get to natural shapes, you can clearly see in the preceding samples that the airbrush acts much more like a brush. Obviously, with a graphic tablet, you have a very natural-looking result. You can set the size to vary with pressure and end up with brush strokes that look remarkably like they were done with traditional tools (if you need that effect).

Pressure

Pressure differs from opacity in that it refers to the amount of paint applied, as opposed to the transparency of that paint. As you can see, even very light pressures still give relatively dark, opaque color.

Eraser (E)

Basically, all the other brushes are available as erasers. In Photoshop's paradigm, this means that the brushes now paint with the background color. As you can see, the popup menu gives you the choice of any of the three tools we have discussed so far. Even the grayed out Wet Edges option is available if you choose the Paintbrush option. The entire Brushes palette of shapes is available, plus transparency, pressure, and the things we have discussed already. The block is the original tool for nostalgia-challenged folk. There are no size or opacity options with that original square block that simply paints with the background color.

Eraser variants (Shift E)

Beyond the brush mode selection, there are now three Eraser variants. We have been talking about the *standard* eraser. The others get very complicated. Basically, the Background Eraser erases to transparency, even in the background layer. The Magic Eraser erases with the selection ability of the magic wand.

Background Eraser (E)

As you can see, the Background Eraser has so many variants that the tool is hard to use. If you choose a sampling of Once, Discontiguous erases all pixels you pass the cursor over which are within the tolerance of the first sampled color. With Contiguous, they have to be connected with the original pixel. Find Edges is used to erase the background fringe often included with a selection that is moved. It sounds much better than it works, but then I have heard several people who love it.

Magic Wand Eraser (E)

This one works the way you would expect it to work. The controls are basically the same as the magic wand. The difference, of course, is that it erases to transparent (or the background color on locked or the background layer).

Gradient and Paint Bucket tools (G)

These two tools are clumsy in the same popup. You will need to remember that they are now combined. The only reason I can imagine to combine them under one shortcut is that they both fill a selection (or the entire image with no selection). Then again, our first discussion item is not named very well in the first place. With the paint bucket, we are again dealing with nostalgia.

Paint Bucket (G)

This tool should really be called the Magic Paintbrush. Then I would not have to bother to explain it. It works like the magic wand except that it fills the selection with the foreground color or a pattern. Like most brushes, it can paint with any of the blending modes. You will find it very frustrating when filling areas that are not a smooth color. In most cases it will be quicker to select the area to be filled and then use the EDIT>> FILL command.

Gradient tool (G)

This is Adobe's Gradient tool. It works basically the same as it does in Illustrator or InDesign. It is a wonderful tool that fills the entire selected area with the gradient of your choice. As you can see, there are a few choices. Of course, in this new day of software that always goes above and beyond, you have so many choices that you can waste a lot of time.

 Let's add a little pitch for sanity here. I have to do that on a regular basis. This has become an increasing problem over the past decade. Now that software companies are almost entirely dependent upon

Overheard in an artist interview on the tube recently:

"Complicated designs are really relatively easy. The difficult thing is to do the simple..." Simple elegance and your ability to produce it needs to become one of your major goals as a designer. It will take you years of hard work and effort to achieve it.

upgrades for their continued existence, discretion seems to have been thrown to the wind. When we couple that with the fact that many new designers have no inclination to learn their craft, we have what I call **PROFEƧƧIONALLY UGLY DEƧIGN**. We can see that trend clearly here in the sheer amount of gradient options available. You really need to be careful to keep control of yourself. Good taste requires restraint.

There are a few things to remember when using the gradient tool:

- Gradients rarely look real. With the exception of a New Mexico sky, they almost never appear in reality.

- Gradients fill the entire selected area. They can wipe out your entire image if you are not careful.

- Gradients must be added carefully. This usually means transparently and in small doses.

- Unless you are careful, gradients will really bulk up file size with Web graphics.

Custom gradients

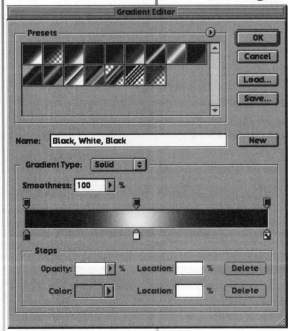

Of course, even the dozens of presets are never quite what you need, so you have complete control when creating new ones. In fact, some day soon, you need to set up your default gradient choices. By holding down the Option/Alt key, you can simply click to delete any of the presets that are too ugly to be believed. You can load any of the sets you see in the Options popup menu on the previous page. You can make new ones by simply clicking on the New button (duh). When you get the collection you desire, simply click the Save button and give a name to your collection. Then you will be able to load it any time you like.

On the gradient ramp at the bottom of the dialog box, the little box-arrows under the ramp allow you to add or change colors at will. The only limit is how many you can squeeze into position. The box-arrows above the ramp allow you to add or change opacity at will. They are normally lined up, as you can see in the sample. However the Opacity Stops and the Color Stops are completely independent of each other. The only real control is your taste – and we have already covered that problem.

Stamp tools (S)

As usual, there is more than one. As usual, they are poorly named. Here the term **stamp** seems to have been chosen because C (for cloning tool) is already in use by C (for Cropping tool). S for Stamp is easy to remember – and you need to, for you will use this tool a lot.

Clone Stamp tool

Cloning is one of those skills you will need constantly. This is often the only way to repair an image. As you can see to the right, Miniskill #4 is entirely about the tool. However, almost all of the miniskills and skills use this tools, as will virtually every project you produce.

 One of the concepts you need to clearly understand as you build your skills in Photoshop is that evidence of the touch of the human hand is usually undesirable. The Clone Stamp is often the only way to edit, correct, or add to an image while maintaining the illusion of reality.

The basic concept of cloning is simple. You set a source point by holding down the Option/Alt key and clicking. Then when you click with the stamp, it will copy or clone the pixels from the source. If you choose aligned, the source will move with the tool. If you choose nonaligned, the source will always remain the same and every time you paint with the tool you will paint starting from the same source. You can paint with any of the blending modes at any opacity.

As you can see in the samples to the right, you need to develop a stitching technique. Your cloning source should be as close as possible to where you paint the clone. However, you cannot make it so close that the brush shape overlaps with the source or you will get repetitive pattern artifacts.

You need to make multiple sources and clone back and forth across the damage or item being removed. This is to cover the fact that color is constantly varying and it will usually be different on the different sides of the area being removed or covered.

You also need to be careful of areas, like the sky, where you are dealing with a gradient. In general, a sky gradient is parallel to the horizon going from dark to light, top to bottom. If the edge of the photo is near the sun, you may find a little radial gradient action around the sun. In many objects, like a pipe, the color graduates smoothly from dark to light.

 The main thing to remember when cloning repairs and so forth is that you need to use the largest brush you can. This is because the pixels in a continuous tone image are continuously different. Even if

Miniskill #4 --

ELIMINATING A BAD SCRATCH

Using the Rubber Stamp to remove scratches.

Cloning Technique

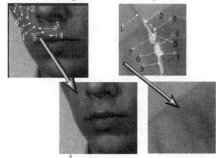

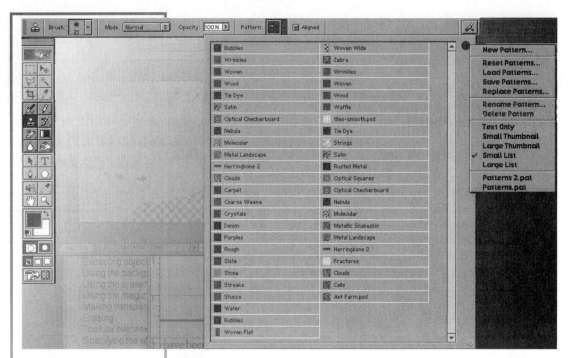

you look at a smooth sky area, you will see that the color constantly varies. Enlarge the magnification to **800%** or so if you doubt.

Pattern Stamp tool

This is actually a paint brush that gives you the chance to paint with a pattern. You can make a new pattern any time you need it by simply selecting an area and choosing EDIT>> DEFINE PATTERN. Of course, randomly chosen image areas will probably not tile very well.

As you can see above, forty-seven patterns come with Photoshop 6. If you have the Aligned button checked, the pattern will always tile seamlessly. If it is not checked, each time you click the tool to apply the pattern it will start a new tiling alignment. As usual, you can paint with any blending mode and with any opacity.

Blur, Sharpen, and Smudge (R)

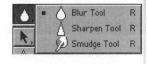

These tools are very useful. The Smudge tool is the most dangerous. What they do should be fairly obvious. They allow you to blur, sharpen, or smear with your collection of brush shapes in your Brushes palette. Believe me, if they are not already, they will become some of your favorite tools.

For example, photos often should not be sharpened too much. This is especially true of portraits. Here oversharpening normally messes up the

skin texture, changing it to orange peel. What you need is a small brush that will sharpen just the eyes and maybe the lips. The sharpen brush works very well for this.

The Blur tool works to clean up unwanted textures in places like the cheeks of a model's face, for example. It is also a super solution when you sharpen a photo and that linen tablecloth suddenly looks like burlap.

We'll discuss blurring and sharpening in depth in chapter 9 as we cover halftone production. For now, let's leave it at indispensable. These are some of the major things to control in the reproduction of photos.

Smudge tool

Here we have trouble, right here in River City. This tool will work fine in fine art, painterly illustrations. Here, everything is done by human hand and it is obvious. A little smudging can be used to great effect.

However, as I have implied several times and will now state directly, you will normally be working with photos or scans of reality. This is not because these are better or prettier. They are just more common – and they are usually much cheaper (and often worth every penny – IMHO).

If you touch reality with a smudge, it will look like a mistake. You may be able to get away with using this tool in very blurry areas of your images. Normally, however, a smudge on the side of a model's nose looks like dirt – at best. For Miniskill #4, the most common mistake is using the smudge tool. It is always instantly recognizable, and it always looks very bad.

Burn, Dodge, and Sponge tools (O)

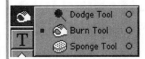

These tools are supposed to mimic old photo developing tools. We used to have a little paddle (or a sheet of torn paper or whatever) that we would hold over the paper being exposed to hold back the light in certain areas to make them lighter. This was called *dodging*.

We also used sheets of paper with holes cut in them to let extra light hit certain areas of the image. Often we just made a circle of our thumb and forefinger to let that extra light darken just those areas that needed it. This was called *burning*.

Of course, Photoshop adds new twists. First, you can control the exposure or strength of the effect. This seems obvious, and works that way. Second comes a little confusion. You have control of whether these tools affect the highlights, midtones, or shadows. It can take some experimentation to get the effect you want. When you figure that out, it is often hard to get a brush that will work, so you might have to make a custom brush shape.

Sponging has two choices: Saturate and Desaturate. It works the way you would expect, with the same brush shape problem.

Miniskill #3 --
CLEANING UP A FILTHY PHOTO

Using the History brush to clean up a ridiculously dirty photo with a blurred snapshot of the dirt.

The History and Art History Brushes (Y)

Here are some tools that I have to admit (with shame) I never learned until recently. The History Brush tool has become one of my most commonly used tools in the past few months.

The Art History brush, in contrast, remains an object of my contempt. It seems to be an excellent way to ruin an image with random soft, uncontrollable squiggles. I think I saw somewhere that it is a sop for those without artistic skill to make something look painterly. Gag!

The basic concept is simple. At any time while you are working on your image, you can take a snapshot of the current state of affairs. Big deal! Well, actually it is once you add a dollop of creativity to the mix.

As you can see in the sidebar, you can blur an image enough to eliminate all the dirt and take a snapshot. Then you can use the History Brush in darken mode, where it will change nothing except areas that are darker than the image, and simply paint out the light dirt with a large brush. By switching to the lighten mode, you can paint out the dark dirt.

 There is something you need to remember about dirt. Dark dirt can be embedded in the emulsion of the photo. Usually you can do little about that except cloning it out. However, a lot of dark dirt is on the glass of your scanner. Light dirt is the curse of the twenty-first century as far as film processing is concerned. Its most common source is dirt in the processor that gets between the light source and the emulsion of the print. It is there because photo processing has gotten so expensive, and therefore so competitive, that most companies save money by rarely cleaning their processors. You can find better processing companies. They will be a lot more expensive. Your clients will never use them for the snapshots included in your newsletter job ticket.

Being able to paint with a historical snapshot will be the solution to many of your problems. The Eraser tool also has an Erase To History option that uses the same snapshot. You may find that you have several snapshots saved for different purposes. I have been known to paste in an image, take a snapshot of it, delete it, and then paint portions of it into my composite image with the History brush.

Basic brush use

Remember that painting in Photoshop often has very little to do with artistic skill. It is true that coordination and drawing skills will be extremely helpful. However, in a bitmapped environment, brushes are often your best editing tool. Painting with a mouse is still closer to drawing with a brick. Graphic tablets do better, but they are very different tools.

Right or wrong

The bad news for some of you is that there is no right or wrong. There is no way to blame your poor results on bad technique. There is no right or wrong technique. You must experiment all the time. As you have seen so far (and you have seen little yet), Photoshop is an amazingly complex piece of software. There are probably a dozen ways to do almost anything you need to do. You will have to develop your own working method that fits your style and your needs.

This is why I was so frank about tools I do not use. You will have ones that you never use also. Your set will probably be different from mine. It doesn't matter, and there is no right or wrong.

Most importantly — keep experimenting!

Here's one of the practice images done while I was developing this chapter. Great art? Nope! Did I learn a lot? You wouldn't believe how much — and, I have been using Photoshop as one of my primary tools since the early 1990s. Even if you are an old-timer like me, you need to practice regularly.

A RADICAL SHIFT

Moving on to PostScript

In FreeHand and Illustrator, even in InDesign, Pagemaker, and Quark, drawing is a specific type of vector drawing called *PostScript illustration*. PostScript illustration must be approached as a combination of objects belonging to two simple categories: lines and shapes.

When discussing PostScript illustration, it is helpful to consider the fine art technique of collage. You need to contrast collage in your mind with montage. This is where you glue separate pieces on top of each other to produce the final image. It is not like a montage, where you assemble photos into a larger photo. In a collage you can use any type of object and arrange it anyway you wish, piling pieces on top of pieces. In a montage, photos are added together through multiple exposures onto the same negative. You can blend one image with another in a montage. You cannot do that in a

collage. The layer blending we will be talking about in the next chapter is not possible in PostScript illustrations. In PostScript, everything remains separate – a pile of shapes and lines.

Here is a task for your imagination: Purely PostScript collage has an inexhaustible supply of lines and shapes. Each line and shape can be stretched, bent, and otherwise reshaped however you choose. You can then paste these manipulated lines and shapes on your collage in the locations and order that you decide are best. Because it exists only in digital code, this collage is infinitely flexible; you can pick up any line or shape and put it down in a new position, slip it between two other objects, or discard it altogether. Any element can be exactly duplicated, manipulated in a new way, or left as is. It is almost as if each shape is on a separate sheet of perfectly transparent, infinitely thin Mylar and you can shuffle these sheets at will.

This scenario is actually a reasonably accurate description of the PostScript illustration process. We have been given a totally fluid, incredibly malleable drawing medium. It has taken "inkwork," or lineart, to new heights, adding color, type, patterns, shading, and much more. It is a wonderful tool. However, it has little to do with the bitmap layering we will talk about next in Photoshop.

The nature of PostScript

Originally, the basic idea of PostScript drawing was to produce graphics that are very small, very portable, and extremely flexible, and that can be resized at will. In purely PostScript illustration (like FreeHand and Illustrator), all the pieces are described through the use of mathematical equations. These equations are used to generate outlines (curved and straight) that are called Bézier curves (named after the Frenchman who defined the equations). It is extremely important that you understand this concept of mathematically generated outlines of shapes. Because all these shapes are mathematical, they are much smaller than bitmaps.

To understand the difference, let us talk about a simple drawing: a white page with a black circle in the middle of it. As you can see in the drawing to the left, this image could not be much simpler. Let's make it 10 inches wide, 8 inches tall with a 3-inch circle centered in the image. (The rectangle outline is just to show you the edges.)

Let us assume that we have drawn it in Photoshop using the marquee tools and simple fills with a black stroke around the outside white shape, at a resolution high enough to avoid the jaggies around the edges (let's say 300 dpi). If this Photoshop drawing is 10 inches wide by 8 inches tall, at 300 dpi it contains

millions of pixels: (10 x 300) (8 x 300) = 7,200,000 pixels. So if this is a black-and-white image (1-bit color), this file has to be at least 900K in size. If it is in grayscale mode (8-bit color), it would be 7.2 MB of data. If it is in RGB mode (24-bit color), it would be 21.6 MB. If it is in CMYK mode (32-bit color), it would be 28.8 MB.

These figures are accurate no matter what type of image is in that 10-inch by 8-inch area. Bitmaps do not care what the pixels are. All they do is describe them individually. Yes, we know there are compression schemes that ameliorate this problem. However, the concept is accurate. Every pixel has to be described. This is why many are surprised when they place a TIFF from Photoshop into page layout and the background is opaque white. How can you get rid of that opaque background? Only by using PostScript.

How would PostScript describe this same simple illustration?

I will not even attempt an accurate rendition of the PostScript language. This is what we are dealing with: a programming language – actually a specialized form of that type of torture device for creatives known as a page description language. PostScript has its own dictionary of terms used to express itself. You do not need to know it. In fact, if you are an artist, you will probably not be able to stand dealing with it. The good news is that you don't have to.

The invisible square box that contains the circle starts 350 pixels from the left and 250 pixels from the top.

The invisible square box that contains the circle ends 650 pixels from the left and 550 pixels from the top.

However, you have to understand conceptually what is going on. So, this is basically what PostScript does. It describes shapes by their starting and ending points, locating them on a bitmap grid that is included in the page size description. So, for this example, we have something like this: Page size: 3000 wide, 2400 tall; draw circle, start 350,250; end 650,550, fill 100 black. As you can see, the start and end locations are measured in pixels from the upper left corner.

The arrows on the drawing above right point to the corners of the bounding box of the circle. A bounding box is defined by the horizontal and vertical lines that touch the far left, far right, top, and bottom extremes of a shape. The shape locations are described by using the upper left corner to start and the lower right corner to end.

The important thing to understand is the simplicity of this approach. Assuming that each character in that description just written is a byte of data, we used 86 bytes of data to accurately and completely describe this simple drawing. That is 86 bytes – not 86K (or 86,000 bytes), or 86 MB (86 million bytes of data) – but 86 bytes. This is not even close to being a 1K file, which has 1024 bytes of data.

All shapes and lines in PostScript are described in this manner. All of these shapes are simply described and piled on top of each other, the last one on top of the first ones. Because each of these shapes is independently described as a specific object, it is very easy to reshape by rewriting the description.

How does this fit into Photoshop?

Very clumsily! PostScript illustration does not fit into Photoshop any better than Photoshop and bitmap manipulation fits into FreeHand or Illustrator. This doesn't mean that it is not done. It means, in my humble opinion, that you are asking for trouble when you start combining the two types of image creation into the same illustration.

My opinion aside, is it done? It is done constantly. Does it cause printing problems? Yes, many digital documents do not print because of conflicts in this area. Can it be done smoothly? Certainly, if you keep the individual capabilities clear in your own mind. The problem arises when you try to blur the distinction.

The peculiar nature of PostScript lines and shapes

The line

A line connects points. If you remember your geometry, a straight line is the shortest distance between two points. Any line starts at one point and ends at another. Lines may be any length. Lines can be very short (millionths of an inch) or stretch for light years. They can be straight, curved, or any combination of straight and curved sections.

In PostScript, lines are called paths and are defined by points.

The sections of a line between two points are called *segments*. A segment can be straight or curved. Segments can connect two points by the shortest distance or indirectly in a curve, bending along the way. PostScript segments are linked together so that neighboring segments share a common point. In this way, you can think of a PostScript line as a connect-the-dot puzzle. Each point is a dot. You draw one segment from dot A to dot B, a second segment from dot B to dot C, a third segment from dot C to dot D, and so on. The completed image is called a *path*. A path may consist of only one segment, a thousand, or many more.

Obviously, the form of each straight and curved segment in a path determines the overall appearance of an image. The appearance of a path is equally affected by the manner in which one segment meets another segment

at a point. Segments can meet at a point in two ways. First, the two segments can curve on either side of a point, meeting on the common tangent to the curves passing through the point. This kind of point is called a *smooth point* or a *curve point*. Second, two segments (straight or curved) may meet to form a corner. If two curves meet at a corner, each of those curves will have a different tangent. The point where they meet is called a *corner point*. FreeHand has a third choice, called a *connector point*, where a straight segment is the tangent of the other curving segment. This is not available in Adobe programs.

KEY DEFINITION: *Tangent* — a straight line touching a curve at a single point. There can be only one tangent to any curve at any given point.

In PostScript, assembling segments is much like drawing curving lines using French curves in drafting. If you match the tangents, you get a smooth curve. If the tangents do not match, there is a bump or corner in the resulting curve. PostScript curve points have a single tangent for both curved segments meeting at that point. As a result, the curve flows smoothly through the point with no bump. Corner points have separate tangents for each curve, or one of the segments is a straight line that is at a different angle than the tangent of the curved segment on the other side of the point.

Handles

As you can see in this illustration, one of the apparent differences between point types is those thin lines with the crude cross at the end that appear when you select a point. These are called *handles*. Illustrator's points look a little more elegant, but there are no visual distinctions between points. FreeHand gives us a little square for a corner point and a circle for a curve point (FH10 does either).

All points have two handles: an incoming handle describ-

FreeHand points

As you will notice, I am using FreeHand points and descriptions here. This is because Freehand's version of displaying PostScript on the screen is easier to understand. We'll get to Adobe's version soon enough.

Bézier Curves

☐ **Corner Point:** Independent handles.

◯ **Curve Point:** Two handles locked together as a tangent to the curve.

△ **Connector Point:** One tangent handle that remains aligned with incoming segment.

Connector points are rarely used.

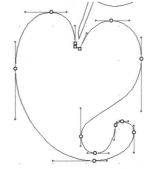

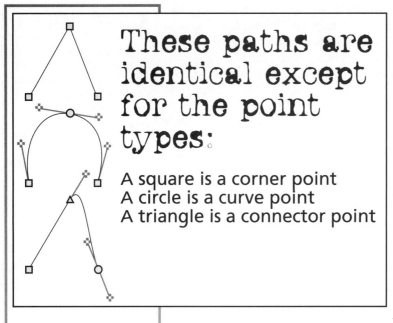

These paths are identical except for the point types:

A square is a corner point
A circle is a curve point
A triangle is a connector point

ing the tangent of the segment attached to the previous point; and an outgoing handle which will determine the curve of the next segment generated when you click to produce the following point. Point handles are a unique and necessary part of PostScript illustration.

Handles are the WYSIWYG tools we use to manipulate the curves of segments. They have two basic attributes. First of all, they indicate the tangent of the curve of the segment they are attached to. Every segment has a handle at each end. When you click on a point, four handles appear — the outgoing and incoming handles for each segment attached to the point. Secondly, the length of the handle determines the amount of curve of the segment.

To rephrase, let's consider simple corner points. Often you cannot see one or both handles. If you simply click to produce corner points, you get straight lines connecting the dots. A corner point with straight segments coming into and out from the point will appear to have no handles. In fact, both handles have zero length in this case. In other words, when the handles have zero length the segment is as short as possible. Remember from high school geometry, the shortest distance between two points is a straight line.

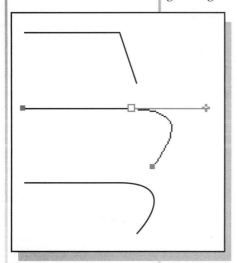

When the handles have length, that length is added to the segment. As a result, the segment has to bend, and the shape of those bends is determined by the tangent shown by the angle of the handles. The easiest way to show you is to draw a little two-segment path with corner points, and then draw out the handle of the middle point. You can draw out the handles by clicking on the point with the Convert Point tool, then drag out the handle. That is all I did in the little illustration here. As you can see, the length of the handle is added to the segment. This is obviously not a one-to-one relationship, but conceptually this is what happens.

All of this sounds very complex. However, once you start practicing with the point creation tools, it becomes second nature. You do not even think about it any longer. You find yourself simply creating and manipulating infinitely malleable lines into shape. It is very elegant and free. This is one of the reasons why designers use FreeHand and Illustrator more and more as they increase in skill digitally.

The PostScript shape

If you recall, a line is called a *path* in PostScript. Like a geometric line, a path is a purely one-dimensional shape. It has length but no width or height. More appropriately stated, in PostScript, a path can have any width at your whim (including none). It is merely a description of a line, no matter what form it takes.

When a path goes back to the originating point and connects the last point with the first point, it becomes a closed path – a *shape*. The area enclosed by the closed path is the shape. In PostScript the attributes of the area are called the *fill*. The attributes of the path are called the *stroke*. All shapes have stroke and fill. However, in Photoshop, you can only stroke a selection outline. Other than that, you will have to go to FreeHand or Illustrator to manipulate stroke.

You can manipulate the area inside a path separately from the outline itself. This inner area is called the fill. Just like a line, the fill of a shape may be black or white, none or colored. It can even combine many colors fading into one another in linear or radial gradients.

Postscript drawing tools

The Selection tools (A)

The Path Component Selection and Direct Selection tools are very similar to InDesign's and Illustrator's in appearance. They are also much like Quark's Item and Content tools in function, although there are major limitations. The complicated name is simply to avoid confusion with the Move tool (I guess). The Path Component Selection tool is very limited. All it can do is select paths and move them.

The white-filled arrow at the bottom does path editing like the Direct Selection tool in Illustrator. The major difference is that Photoshop's version will not even touch type. Type is kept totally separate in Photoshop.

These tools not only work on drawn paths, they also work on any path created and saved into the Paths palette from a selection. However, those of you with FreeHand or Illustrator experience will be frustrated.

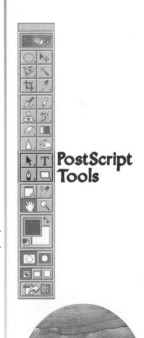

PostScript Tools

Corner point handles

One of the most disconcerting aspects of Adobe's solution is that there is no way to drag out handles on a corner point. Of course, Freehand's version is clumsy also. Most Adobe corner points have handles of zero length. What you must do is hold down the Option/Alt key to drag out the handles with the CHANGE POINT tool and then move the tool over the handles that result while keeping the Option/Alt held down. Now the CHANGE POINT tool allows you to drag and rearrange the handles individually as needed.

The Pen Tool (P)

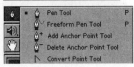

Photoshop's Pen tool is very definitely InDesign's and Illustrator's four-part PEN tool plus the Free-Hand Pen tool. Most people seem to believe that Adobe's Pen tool is the standard by which others are defined. This is only true if you have used Illustrator's Pen tool for any substantial period of time. For those coming from FreeHand's single tool, it will be a shock. I still find that InDesign's version works the way I wish Illustrator's or Photoshop's did.

Again, for those of you who are not familiar with Adobe's version, you have to closely watch the tool when working with a path to find out what is happening. If you see a little plus next to the tool, you will add a point. If you see a little minus, you will subtract one. If you see the little open pointer, you will change point type from smooth to corner or vice versa. There are shortcuts to access any of the tools individually, which are the same as Illustrator's shortcuts. Only the Pen and the FreeHand Pen are available with the Shift+P. However, the new tools give you the other Pen tool portions effortlessly.

The basic advice is to remember that holding down the Command/Control key changes you back to the last selection tool you used. Holding down the Option/Alt key switches you to the Convert Point tool.

 One of the things you quickly learn in Photoshop (as in all Adobe programs) is to carefully watch the graphic signals on the screen. There are constant visual reminders telling you what the tool will do when you click. These are shown in little subicons to the lower right of the cursor. In the Pen tool, for example, a plus means add point, a minus means delete point, the open arrow or V pointing toward the upper left is the convert point tool, and the little circle means you will close the path.

This is disconcerting to FreeHand users only (although the subicons are available as a preference called Smart Cursors in FreeHand). After a while Photoshop's implementation seems very elegant and obvious. However, I am still firmly convinced that, for almost all graphic creation work, Illustrator users will go back to Illustrator and FreeHand users will go back to FreeHand.

Even for Illustrator users, there are just too many things missing in Photoshop (like blending, composite paths, and the Pathfinder filters). As far as FreeHand users are concerned, there are even more things missing, such as live envelopes, a perspective tool, and many more.

 Command/Control T (Free Transform) works beautifully on paths. This is probably why Adobe did not litter the interface even more with transformation tools. Just remember to hold down the Command/

Control key to shear with a side handle or nonproportionally transform with a corner handle. It is not enveloping, but it is very good.

Vector Shape tools (U)

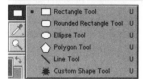

Photoshop had added several PostScript shape drawing tools. Thankfully, this set of tools has been added to the Options palette so you have a more direct method of choosing between the tools. Mainly, you can see them all at the same time. (What a concept!)

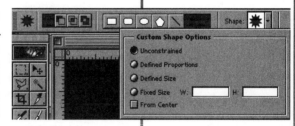

As you can see to the right, all of the tools have Options popups which vary for each tool. We'll cover those options as we go through the list. The main thing to remember, of course, is that these are PostScript paths, not bitmapped shapes. They can all be moved and edited with the two selection tools. They can all be modified with the pen tools.

At the left side of the Options palette is a simplified set of Pathfinder filters from Illustrator and FreeHand. This limited set allows you to add to the shape, subtract from it, and produce the intersect or the exclusion. As with Illustrator, the path shapes do not change visibly on the screen, so you have no idea what you are doing. You have to add a fill to tell. In this instance, FreeHand's implementation is far superior.

The Ellipse Tool

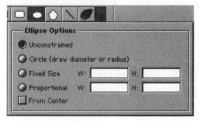

This tool is a normal ellipse tool. If you hold down the Shift key; the shape is constrained to a circle. If you hold down the Option/Alt key, it draws from the center out. It's just another reason to create graphics in a graphic program. It also draws from handle to handle, as usual. Here we see, yet another time, Adobe's interface mania. The Ellipse Options box seems to be there just because *every shape tool has one*.

The first option, for example, gives you an option you always wanted in your heart of hearts. If it is checked, holding down the Option/Alt key just changes whether you are dragging out the radius or the diameter. You always get a circle. I can't remember requesting that one.

The Fixed Size and Proportional fields should be available for all tools, like we see for the Marquee tool and every other tool in Photoshop's

arsenal. We can't have that, though, because the Polygon and Custom Shape tools need the Options popup. Having to open yet another popup really makes these tools slow and clumsy.

The From Center option is stupid. All of these tools in every PostScript program have drawn ellipses from the center out by simply holding down the Option/Alt key (since time began). The only benefit I can see here is that the tool will always draw from the center out if you have this checked. It is sort of a mislocated preference.

The Rectangle tool

This tool works like the Ellipse tool in all respects except for the square substitution for circle. The only interesting option is the Snap to Pixels checkbox. This would seem to prevent anti-aliased (think blurry gray) edges on your new crisp rectangles.

The Round Cornered Rectangle tool

Come on, Adobe, give us a break! A separate tool for this? Set the radius of the round corners in the Radius: field.

The Polygon Tool

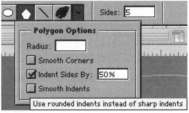

This tool is a severely limited version of the Polygon tool. As you can see from the dialog capture to the left, the shape of the points of the star must be guessed. There is no preview and no adjustment for obtuse/acute points. With an infinite variety of stars possible with every number of points, this makes this tool functionally useless except for regular polygons (hence the name, I guess).

Radius is their version of fixed size. It's the radius of the circle containing all the points of the polygon or star.

Smooth corners rounds the tips of the star or polygon. No controls here either.

Indent Sides By: ???%. Yes, this is the only control you get to produce a star — no preview, no obtuse/acute slider.

Smooth Indents replaces the sides of the star with arcs from point to point on the polygon — no editing, no preview. As you can see, the popup tool tip is not very helpful.

 I'm sort of sorry, but I find these tools really offensive. If you are going to add PostScript illustration to a program, you at least need to add good tools. Of course, the whole idea is questionable in my mind. Lest you think this attitude is an anomaly, Adobe has ruined Illustrator by adding most of Photoshop to it — let's go baroque.

The Line tool

What can we say? The tool draws lines. Hold down the Shift key and it draws horizontal, vertical, and 45° lines. It can draw in virtually any pixel width (1,000 pixels is the limit). The real use of this tool comes with the Options popup. As we have discussed, you can draw a straight line at any time, with any brush, by simply Shift-clicking.

However, if you need arrowheads to create callouts, this is the only place you can do that. Again, there is no preview and no real controls. Nevertheless, the arrowheads produced are good looking and work fine. The percentage measurements are based on the pixel width of the line.

The Custom Shapes tool

This one is fun, if not very commonly used. I imagine that we will start seeing these shapes a lot. They make excellent masks.

Painting summary

The major thing I need to impress on you is that Photoshop 6 is finally becoming an illustration program, in addition to its already famous image manipulation abilities. We can argue whether PostScript illustration tools belong in a bitmap program. But the fact of the matter is that they are there, they work well, and they will quickly become part of our publishing vernacular.

The biggest benefit I can see is that more people will probably become aware of the power of PostScript illustration. Photoshop 6 has also taken a large bite out of Painter's turf. Those of you who have been using Photoshop for a while now will probably be spitting and sputtering, "Photoshop could always do these things." That is true, but they are much more accessible and easier now. Photoshop has become fun to illustrate with and much of the intimidation is gone. The upgrade to version 6 is the best in years.

I realize that the previous paragraph may seem like a reversal of opinion. Truly it is not. Photoshop's tools are not editable. The freedom of PostScript illustration is missing. However, version 6 has become much more usable. It's a good thing.

Where should you be by this time?

You should be submitting theory exams, finishing Mini-skills and skill exams, and producing finished illustrations. You need to be practicing with all of the painting and drawing tools.

DISCUSSION

You should be discussing drawing and painting techniques with each other. A frank discussion will help you a lot to learn your tools. You really need to know the difference between drawing and painting, and know which is advantageous where.

Talk among yourselves...

Knowledge Retention:

1. Why is the author so opposed to the addition of mediocre PostScript drawing tools to Photoshop?

2. What are the differences between the airbrush and the brush, opacity, and pressure?

3. What are the only aliased brushes?

4. How does Auto Erase work?

5. Why would you want to use brush dynamics?

6. What is the Cloning tool and why is it important?

7. What is the problem with the Smudge tool?

Chapter 6

Layers
Concepts:

Definitions are found in the Glossary.

Compositing images

Keeping pieces separate through the use of layers

Chapter Objectives:

By giving students a clear understanding of how to combine and separate the pieces of an image, this chapter will enable students to:

1. add and use an adjustment layer
2. produce and edit a layer mask
3. blend layers using various modes
4. add a portion of one image to another seamlessly.

Lab Work for Chapter:

1. Finish more of the theory exams and email for grading.
2. Finish Miniskills #6 and 7.
3. More advanced: Skills #4 and 7.

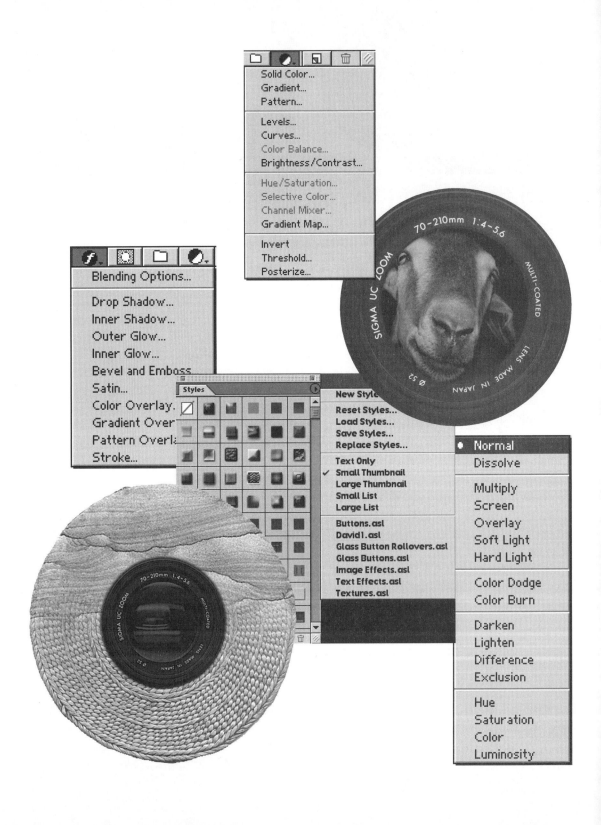

COMBINING IMAGES

Putting together the pieces

Now that we can select areas of pixels, and paint them in new colors, we can begin to talk about putting finished images together. One of the primary tools for that is layers. A *layer* is basically an additional document made part of an existing document. It is limited to the same color space and resolution, but other than that it is just another picture on top of (or underneath) an existing image in a Photoshop document.

Another way of looking at the concept is to think of layers as a stack of images on transparent sheets of plastic that can be shuffled at will and edited individually. Each layer or image can be edited separately.

However, layers go far beyond that. Shortly, we will talk about the different blending methods whereby you can apply mathematical formulas to combine pixels in one layer with the pixels of any other layer in a large variety of complex operations. You have complete control of the opacity. You can edit, copy and paste, or move the layer independently. You can also move any layer above or below any other layer.

In addition, there are now extremely powerful text layers (which we will cover in chapter 7). Finally, there are adjustment layers that enable you to apply color adjustments that remain editable. These adjustment layers can also apply very complicated filter effects that also remain editable.

One of the things you need to remember is that all of the layer controls are only available in the PSD (Photoshop) format. Although it is possible for you to save layer information in the new TIFFs produced by Photoshop 6, it is certainly not advised, for reasons we will talk about in the printing problems section. Even if other software starts supporting layers in TIFFs, it will not be a good idea — probably until the second decade of the new millennium, at least.

Quick summary of layer abilities

1. A layer can be edited and/or slid around separately — completely independent of the rest of the document. The pixels on a layer can be transformed, scaled, rotated, flipped, inverted, whatever you can imagine.
2. Each layer has its own opacity. One of the main features of a layer is its transparency.

I know this might sound stupid to several of you with prior experience, *but* transparent areas of an image can be recognized by the checkerboard pattern used to display them. You can change the color and size of the checkerboard if you have trouble seeing the transparency.

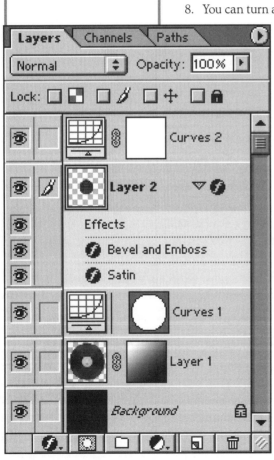

3. Each layer can be blended with the layers below it by using one of many blending modes. As you will see soon, these blending modes are extremely powerful.

4. Any layer can be made visible or invisible to allow working on layers. You can simply click the visibility of each layer off and on independently.

5. Layers can be linked together to work as a unit so that portions of an image can be transformed together.

6. A layer can contain its own layer mask to hide portions of the pixels on the layer. This layer mask can have partial transparency to fade the edges of the layer in and out.

7. You can free transform individual layers. This allows you to scale, shear, flip, rotate, and add perspective to a selection or layer.

8. You can turn any layer into a mask for the layers above it by making it the bottom layer of a clipping group. For example, type on the bottom of a clipping group will be filled with the contents of the layers above it in the group.

9. You can stylize the entire layer with styles or anything available in the Layer Effects dialog box. You can add bevels, extrusions, shadows, special fills, and dozens more (all at the same time if you are taste-challenged).

10. You can combine any layer with any or all of the other layers by merging or flattening.

11. You can drag'n'drop any layer or linked layers into any other open Photoshop document. You can also copy and paste. Anything drag'n'dropped or pasted into a document forms a new layer.

The Layers palette

All the layer controls are contained in the Layers palette. There is a visibility column, the eyes on the left, that allows you to control whether you see the pixels in the layer. There is a links column next to it that enables you to make layer groups with a simple click. The links column also shows which layers you are writing in, by the little brush icon. This is also where the Layer Mask icon shows up when a mask is present.

Layer styles

 This icon at the bottom of the palette gives you a pop-up menu to add effects and styles to a layer. Double-clicking on this icon in a layer opens the Layer Effects dialog box, which gives you complete control over the effects applied to the layer. As you may have noticed, version 6 gives you a little triangle to fold open the effects you have active in a layer. This gives you easy access to all the parts of a style, for example. You can see a sample of this in Layer 2 on the previous page.

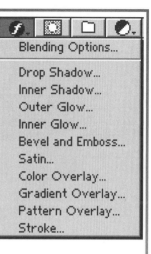

Photoshop 6 has brought a major new usability feature to us. Photoshop now has a Styles palette that allows you to apply styles, which are easily editable, with the click of the mouse. What you see to the left is just a small portion of the presets that I have saved as my group of styles. It is the one called David1.asl on the Option menu to the right of the palette.

The wonderful thing about the Styles palette is the ability to apply completely editable multiple effects.

By double-clicking on the little white *f* in the black circle in a layer you can, at any time, open the Layer Style dialog box for that layer and edit the style you are using. You can then save that new style, if you think it will be useful.

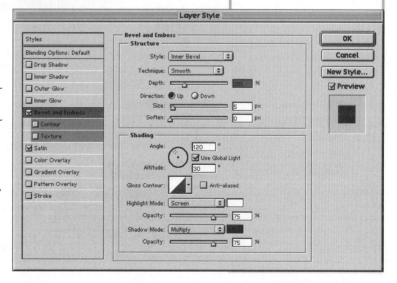

Layer masks

Clicking this little icon creates a new layer mask on the active layer that allows you to control which areas of the layer will be seen. We'll talk about the power of layer masks in a little bit. The main thing to remember for now is that layer masks allow you to mask off pixels without destroying, deleting, or making them transparent. Also, a layer mask remains editable. When you have a layer mask active in a layer, a little mask icon shows up in the column next to the eye icon that shows the visibility. When the mask icon is there, any changes to the layer will be changes made to the mask. Black areas block the pixels. White areas reveal them. Gray areas are partially transparent.

New Layer Set

Clicking on this icon gives you a new layer set. I personally dislike it when software adds new terminology for something that was adequately named before. However, because these sets do not exist outside Photoshop, I guess it makes sense. You are making a new folder to hold a group of layers that you can fold open and closed just like a normal folder in a window. Consider it layer storage, if that helps you.

Add fill or adjustment layer

This button enables you to add an adjustment layer or a fill that has its own layer and layer mask. As you can see to the left, there are a lot of possibilities here. We will cover these things throughout the book.

New layer

Clicking on this icon gives you a new blank layer. Dragging an existing layer onto this icon produces a copy of that layer. You will be surprised how often you will use this little function.

Delete layer

Clicking the little trash can deletes the active layer. Dragging an existing layer onto this icon also deletes the layer.

Opacity control

This gives you a slider to adjust the opacity of a layer. It is usually easier to just type a number to change the opacity — 1=10%; 2=20%; 6=60%; and so on. Of course, you cannot do that on the new type layers in version 6 because you would type

the number into the text block. However, the opacity controls are still there to be adjusted with the mouse. This is one of the major tools in the current fashion of Photoshop illustration.

Blending modes

As I have mentioned already, blending modes are extremely important. You really need to memorize what each mode does. You can use them to lighten and show the detail in underexposed photos, darken overexposed or high-key images, and many other things. You use these modes a great deal when working with the History brush to eliminate dirt and so on, as we mentioned last chapter. These are the methods of combining layers.

A list of blending modes

Normal

What do you think? Everything remains normal and the layer does not interact with the layers below it. I think of it in terms of overprinting, but then that is probably just my experience.

Dissolve

This works just like Normal until you change the opacity. Then transparency is added with a transparent diffusion dither. In other words, transparent pixels begin appearing within the image, revealing the layers underneath or the background color of the background layer. It is well named. It does make the layer look like it is dissolving.

Multiply

This basically adds the color of each pixel of the layer to the colors of the pixels under that pixel. In other words, it makes the image darker. This is the way to darken and add detail to a very light image. Simply copy the image into a duplicate layer (drag the layer to the New Layer icon) and apply the Multiply mode. For severely light images, you might have to do this several times with varying opacities in the various layers. For some reason, several light transparent layers often work better than trying to do it all in one layer. By adding a layer mask you can just darken the areas that are too light. You can also use the History brush in Multiply mode to darken certain areas. It is an extremely handy mode.

Screen

This mode is the opposite of Multiply. You can use this to lighten areas. I have seen scans that looked totally black on the screen reveal astonishing detail through the application of Screened duplicate layers and/or the History brush. This is also a good way to add highlights.

Miniskill #6 --

BALANCING A PHOTO WITH TOO MUCH CONTRAST

Fixing a photo with very dark shadows and blown out highlights.

The original is very dark.

Here's a screened version.

Overlay, Soft Light, and Hard Light

These three modes apply different combinations of Multiply and Screen using 50% gray as neutral. In other words, they apply effects to the highlights and shadows. Overlay, for example, uses the dark tones to darken the dark areas while the light tones lighten the light areas. Hard Light really exaggerates the highlights, often causing a "plastic" look. These modes can be used very well with filters like Emboss where the flat area is 50% gray.

Color Dodge or Burn

These two modes increase contrast by intensifying the hues or increasing the saturation (same thing). Color Dodge lightens as it brightens. Color Burn mainly deepens and intensifies the shadows.

Lighten and Darken

These modes work by comparing the pixels in the upper layer with those in the lower one. They do this channel by channel for all the channels. Lighten only makes changes when it finds a pixel in the upper layer that is lighter than the ones in the lower layer. Darken works oppositely by changing only pixels that are darker.

You will discover that these two modes are often the easiest and best way to get rid of dirt in a photo or scan. Simply make a very blurred shapshot to use with your History brush and then use lighten and darken modes to paint out the dirt. This technique is used in several of the skill exams: Miniskill#3, Skill #2, and Skill #5 come to mind.

Difference

Here's one of those mathematical wonders. It compares the upper layer and the image below it using black as a neutral. If there is no difference in color between the two, those pixels are changed to black. It usually results in more saturated color, often psychedelic. It's great for professionally ugly stuff. As you can imagine I have never used the filter.

Exclusion

This is a more subdued version of Difference that creates much less saturated colors (that is, they are grayed out).

Hue, Saturation, and Luminosity

Here we have computer geek speak. For those of you with fine art training, these would be hue, saturation, and value. In each case, the mode takes that particular information from the overlying layer and applies it to the

| Normal |
| Dissolve |
| Multiply |
| Screen |
| Overlay |
| Soft Light |
| Hard Light |
| Color Dodge |
| Color Burn |
| Darken |
| Lighten |
| Difference |
| Exclusion |
| Hue |
| Saturation |
| Color |
| Luminosity |

image beneath. Hue changes the colors only. Saturation changes the intensity only. Luminosity changes the value (or grayscale info) only.

Color

This mode applies both the hue and saturation — everything except the value. I imagine it uses Lab color where the luminosity (or light and dark information) is completely separated from the color data.

Using the modes

I suspect that most of this seems rather esoteric to many of you. Believe me, you will be using many of these modes a lot. You will see in many of the Skill Exams and Miniskills that the uses of Multiply, Screen, Lighten, Darken are extremely varied and powerful.

I find I use these modes more and more as I understand them better. As usual, writing this book has been a great help — experimentation is essential. I know I mentioned this at the end of the last chapter, but this concept is very important. I realize that this is often difficult to schedule. If you have a wise boss, you will be required to experiment and learn new software and techniques. The rest of you will have to assign the priority in your own minds.

 When I was a full-time art director, I looked for projects that would allow me to push the limits. Many projects do not have this option. However, you will find that they are treasures. Surprisingly, they are often the tiny throw-away projects, like that little windshield flyer for the local car wash. Coupled with this search was a concerted push toward streamlining production. I learned to streamline production on an extreme level to free up more time for experimentation on the projects that allowed for it. It was the only way to consistently grow creatively.

Transparency masks

One of the things you need to understand is that every layer has a built-in, invisible mask attached to it. A *mask* is just a saved selection. You can always add a custom layer mask (which we will talk about in a bit). However, the transparency mask is always there. In older versions, the only layer that doesn't have one is the background layer. In Photoshop 6, even the background can have a layer mask. Anything rasterized from FreeHand or Illustrator has an automatic transparency mask.

In other words, *all the transparent areas function as a mask that can be converted to a selection simply by Command/Control-clicking on the layer*. This is a shortcut to memorize, **RIGHT NOW!** Being able to select all of the opaque pixels in a layer, with a click, is extremely handy. It is one of the real benefits of the layered structure of Photoshop documents.

Masks

A mask is just a saved selection. It can have hard or soft edges. It is also one of the areas where most Photoshop users simply shut off. I confess that I was that way for years. The good news is that the recent versions of Photoshop (especially 6) have made mask usage relatively easy — sometimes even simple.

Making realistic montages

As you build your images, you will find that it is very easy to add pieces that stick out because of their hard edges or because of a fringe of background color from a prior image. Photoshop has added more power to control these things with every version. Photoshop 6 actually makes the process relatively easy.

Practical steps for realistic blending of pieces

1. Anything that has to be moved around in the image should be put on a separate layer. This enables moving with ease. In addition, portions of the layers that are moved off the layer remain available as long as you are in PSD format. If you move the layer back, those pixels currently outside the image will reappear.

2. Blending modes are critical for smoothly combining many of the effects you will need.

3. Just as traditional painting requires extremely careful control of value, photo montages in Photoshop require delicate opacity adjustments. Often, new elements that appear too strong can be delicately knocked back with the addition of slight opacity.

4. To make a new element fade into the existing image, graduated layer masks are often a real help. They can now be added with a simple selection of a command on the Layer Mask pop-up menu at the bottom of the Layers palette.

5. Although you can blend a new pasted piece by copying the original with a feathered mask, you will often find that a blurred mask works better. It also offers more control. The easiest way to do this is probably to Command/Control-click on the layer to load the transparency mask. Then click on the Add Layer Mask button at the bottom of the palette. Deselect the image and then add a healthy dose of the Gaussian Blur filter to the new layer mask.

There is no reason why you cannot add a gradient mask to the blurred mask or any other layer mask. Just select the mask and draw over it with the Gradient tool set to Foreground to transparent in the Multiply mode. A foreground of black will block out the edge of the mask. A foreground of white will gradually move back the edge of the mask, revealing more of the image on the layer.

6. You can also edit your mask with any paint brush. Paint with black to block out areas. Paint with white to reveal them.

7. Clipping groups are also very handy. All you have to do is Option/Alt-click on the boundary between the two layers and the bottom layer will use its transparency mask to mask the upper layer(s).

Mask of the goat

Mask edges fixed

PRODUCING EDITABLE EDITS

Adjustment layers

One of the problems faced in earlier versions of Photoshop was eliminated with the addition of adjustment layers. The basic idea here is to make edits with a layer that remains editable and only affects the layers underneath it. The entire concept of adjustment layers is very important to modern Photoshop illustration. Just remember that you can greatly add to the RAM requirements if you are not careful.

 The way to add an adjustment layer is to use the Add Adjustment Layer pop-up under the icon at the left bottom of the Layers palette. They were formerly quite a bit more hidden. If you haven't been using them up to now, it will take some retraining of your habits. However, the ability to retain editorial control of your adjustments is certainly worth the effort. Actually, the problem quickly becomes overuse.

Changes made with an adjustment layer do not degrade the image

It is really important to remember that not only are adjustment layers editable, they also never degrade the image. This is extremely important for those of us who have applied Curves or Levels several times as we watch our image fall apart.

At this point, most of the options you see to the left are not part of our discussion now. However, (trust me) we will be talking about them a lot as we go through the rest of the book.

Targeting adjustments

One of the nicest things about adjustment layers is that they come with their own built-in layer mask. This makes it easy to target your adjustments to specific portions of the image. This is one of the things that really blows the minds of people with a photographic background.

I remember a photo we had to deal with several years ago that brought this home to me. I wish I had it to show you now. The problem was not as severe as you find in Skill Exam #6, but it was much clearer — so clear that I think a verbal description will do the job.

We were producing a historical book for the YWCA about their camp in the Sandia mountains, East of Albuquerque. It had been used for years by thousands of girls and women — 100 years to be exact. One of the photographs they really wanted to use was from the 1930s. It showed five girls at camp, three of whom later became leaders in the national organization.

The photo was shot by a nonprofessional (probably one of the other girls). It was a nice black-and-white photo; clean, sharp, good contrast. The only problem was that the photographer had not noticed a tall pole of some kind behind her that had dropped its shadow directly across the girl's face in the center of the back row.

 One of the major things you will be doing in Photoshop is cleaning up things like this. One of the most common is that infamous phone pole growing out of the new hire's head. One of our jobs as design professionals is the elimination of these photographic mistakes. Most of us rarely have the luxury of professionally shot photos. Most of the ones you deal with will have to be closely examined for phone wires, zits, bad shadows, unbelievable color contrasts, and so forth.

Back to the tale: When we first saw this shot we just thought the girl in the center was black. It looked perfectly natural at first glance. However, we were working with the woman in question and she was an extremely elegant, very light-skinned, Spanish woman.

Obviously, we had to fix this. At that point, we were using version 2.5, so adjustment layers did not exist. Basically, we selected the girl's face and adjusted it until it was in the proper grayscale range when compared to the rest of the girls. It took us well over an hour. Boy, I wish we had had what

we have now. We applied Curves, many times. We had to rescan several times. With adjustment layers we could have made a mask and edited and re-edited until we had what we needed in a few minutes.

Controlling the effect

In general, adjustment layers affect all nontransparent pixels found below them in the Layers palette. Obviously, you can control that to some degree by moving the layer up and down in the stacking order. This is accomplished by clicking on the layer on the palette and dragging it into the position you require.

Often though, you wish the adjustment to apply to only one layer or two. This is also a simple task. All you do is place the adjustment layer directly above the layer or layers you wish to adjust. Then you Option/Alt-click on the boundary between the layers to convert them to a clipping group. The little broken arrow angled down that you see to the right will appear in the layer so you know that (in this case) the Hue/Saturation adjustment is only affecting the type in the Welcome to the Wedding layer.

Clipping groups

Clipping groups are layers that are grouped together so the transparency mask of the bottom layer clips all the pixels in the layers in the group that are above it. To rephrase, the bottom shapes contain the upper layers by masking out everything outside the shapes in the bottom layer of the group. It's actually harder to explain in words than it is in pictures.

These groups are easy to make. All you have to do is Option/Alt-click on the border between two layers and they become a clipping group. The little broken arrow pointing down that you see highlighted above right appears in the upper layer. The name of the bottom letter becomes underlined, as you can also see.

The limit to the number of layers in a clipping group is your common sense. Clipping groups require much more work by the application than most things do in Photoshop. You should not use them unless you need to and cannot figure out any other way to accomplish what you need to do.

As mentioned before, layers in general gobble up RAM rather quickly. As you can see, above right, simply duplicating a layer triples the working space needed, from 1.42 MB to 4.26 MB. The calculations needed to compute a clipping group are in addition to that. On older machines, this can quickly become a real problem. I have seen students go outside to have a cigarette

while a filter is being applied to a tabloid image that had bulked up to more than 200 MB with all the layers added at whim. Delete layers no longer needed. Keep backup copies of your documents. I have seen people who always work on duplicated layers so they won't "damage" the original. While they are doing so, they are often complaining about the slowness of Photoshop.

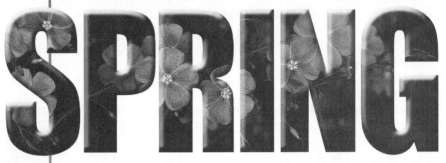

Nevertheless, clipping paths are often a nice solution. What you have to bear in mind is that products like the example above always compromise readability, and often legibility. I like to tell myself that it is more legible in color (as you can see in Miniskill #10). However, if the reader of your document has to stop and figure out the word or words, you have made a major mistake and wasted a lot of your client's money.

 Because you can see an accurate preview on the screen, take your time and adjust the clipping shapes until you are certain that the image is as readable as possible. Then place it into your final document as large as possible to help the reader with your gorgeous artwork. Remember, the purpose of your fancy illustration is not ego gratification but customer reaction. You are helping your client communicate with his or her customers.

Layer masks

We've mentioned these casually throughout this chapter. A little repetitious clarification will not hurt. A *layer mask* is like an alpha channel, in that it is a grayscale (or 8-bit) addition to the layer. An *alpha channel* is an 8-bit, grayscale additional channel to the entire document. You should be able to see why they add to file size.

Where a layer mask or an alpha channel is white, it is transparent. Where it is black, it is opaque. Grays produce partial transparency. Lighter areas are more transparent, darker areas less.

The main thing to remember is that layer masks only affect the layer they are attached to — neither the layers above nor the layers below. The

only exceptions to this occur when the layer mask is on the bottom layer of a clipping group. Then both it and the transparency mask of the layer mask (or clip) all the layers above it in that group.

 Layer masks can be moved around, from layer to layer, by Command/Control-clicking on the mask to load it as a selection. Then click on the layer you want to move the mask to and click on the New Layer icon at the bottom of the Layers palette. To move them from document to document, you load the layer mask as a selection, save it as a channel, and copy/paste the channel to the new document. This of course assumes that they are the same pixel dimensions.

Merging

When you click on the little triangle at the top right of the Layers palette to open the Option menu, you see the options to the right. Most of the options are better done with the buttons at the bottom of the palette. Layer Properties allows you to rename the layer. Blending Options allows you to combine layers with far more power than the normal blending modes. If you think it important, you need to check Help, your user manual, or a reference book like *The Photoshop Wow! Book* (Peachpit Press). However, there are three commands here that we need to mention.

Merge Layers, Merge Visible, and Flatten Image allow you to combine layers when needed. These options change, depending upon what you have in the file. The most common reason is to save RAM. Obviously, you do not want to do this until you have completely finished with those separate layers. When layers are merged they take on the blending mode and opacity of the bottom layer of the merging group.

There are two things to remember when merging multiple layers. One, keep track of hidden layers in a group that is being merged. Hidden layers (those with the eye clicked off) are discarded when the visible layers in a group are merged. Two, all layer effects, styles, and layer masks are applied and discarded by the merge.

 At various times, depending on what you select in the layers you have created, you may find Merge down, Merge Layer Set, Merge Group, Merge Linked, or others. They are usually obvious. One little-known option is to hold down the Option/Alt key and choose Merge Visible. This merges all the visible layers (with the eye) into a new layer while leaving all the original layers intact.

Flattening

Flattening is similar to merging, with two very important differences. First of all, flattening discards all hidden layers. Secondly, flattening removes

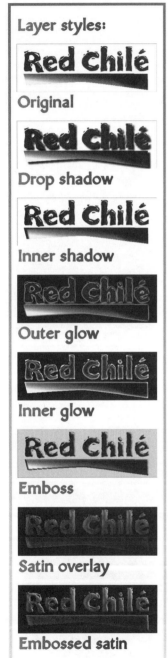

Layer styles:

Original

Drop shadow

Inner shadow

Outer glow

Inner glow

Emboss

Satin overlay

Embossed satin

any transparency and makes the entire document one background layer. In addition, just as in merging, all layer masks, layer effects, and styles are applied and discarded.

This is why all TIFFs, JPEGs, EPSs, and so forth are saved as copies of the PSD. None of them support transparency. Only the new TIFFs support layers. Only PDF supports the vectors. Files almost always have to be flattened – either by hand or automatically – before you can save in anything but Photoshop format.

Layer styles

One of the curses and blessings of Photoshop is its ability to easily apply dozens of special effects. The curse is that these effects in the hands of the taste-challenged produce what I call professionally ugly artwork. The blessings are all the beautiful things you can do to embellish a simple design when you are in a hurry. And we are all in a hurry. If you aren't yet, it is because you are a student. Brace yourself!

Layer effects normally work only on transparent layers. They cannot be applied to the background layer, a locked layer, or a layer set. As mentioned earlier, many of these effects are stored in sets on the Styles palette. The important thing to remember is that they are always editable by double-clicking the little *f* icon to open the Layer Style dialog box.

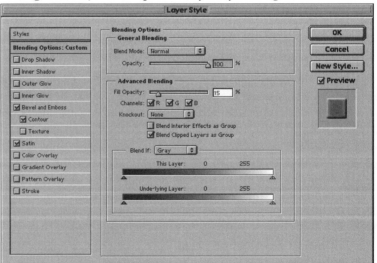

I'm not even going to touch the Advanced Blending options, as I mentioned already. However, the rest of the styles are very easy to edit and manipulate. The samples in the sidebar are just a few quick options.

One of the best ways to learn to use the styles is to apply some of the presets and then open the Layer Style dialog box to see what Adobe did to create the style. The problem is not being able to do amazing things. If you are creatively innocent, try the *Wow!* book. The main thing, of course, is to remember that the purpose of all of this is communication.

Just as important as taste is production capabilities. For those few samples in the sidebar on the opposite page, I spent an hour and a half. I have seen many students waste entire *days* playing with effects for a project. You better have a darned good reason to spend that much time on the illustration. I freely admit that sometimes this is exactly appropriate. I expect you to admit that most of the time it is a colossal waste of time and money.

Basic position

I fully realize that this is a very basic introduction to the entire areas of layers, effects, styles, masks, and so on. There are literally dozens of books to allow you to turn Photoshop into a video game. It is great fun. It makes entertaining reading. You'll find techniques that you can add to your repertoire. It is not what we are about.

What I care about is that you can get around the document and do all the basic techniques you need, while maintaining a cost-effective production speed. Being forced to wait tables severely compromises your ability to play in Photoshop.

Where should you be by this time?

You should be feeling fairly comfortable with Photoshop. You should have done several Miniskills and skill exams. The tools and palettes should no longer be an issue.

DISCUSSION

You should be discussing illustration techniques of all kinds with each other. One of the best ways to improve your skills is to expand your horizons by brainstorming with other designers.

Talk among yourselves...

Knowledge Retention:

1. What is a layer mask?

2. What is the curse of styles?

3. Why are adjustment layers so helpful?

4. What is the production problem with clipping groups?

5. Why would you want to merge a group of layers?

6. What is a layer style?

7. How do you move a layer mask from one layer or one document to another?

Chapter 7

Photoshop's typographic tools

Concepts:

1. Serif

2. Sans serif

3. Typesetting

4. Em and en

5. Orphan

6. Widow

Definitions are found in the Glossary.

Deal ing with type in a bitm apped im age m anipul ation pro gram

Chapter Objectives:

By giving students a clear understanding of how Photoshop sets type, this chapter will enable students to:

1. add professional type to a document
2. transform type as needed
3. kern, track, and adjust type
4. add styles to type while retaining legibility.

Lab Work for Chapter:

1. Finish more of the theory exams and email for grading.
2. Finish Miniskills #5, #8, and #10.
3. More advanced: Skills #1, #3, #7, and #9.

All righty then, what the heck is goin´ on here? It was working yesterday evening, wa

Serifs

Type

No Serifs

Type

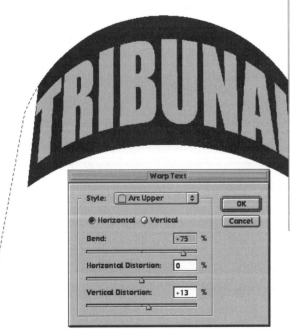

Warp Text

Style: ⬚ Arc Upper ▮

OK

Cancel

● Horizontal ○ Vertical

Bend: +75 %

Horizontal Distortion: 0 %

Vertical Distortion: +13 %

Photoshop's typographic tools

Until very recently, using *typography* and *Photoshop* in the same sentence never made for a positive statement. There is a real problem with bitmapped type. Basically, this revolves around the need for type to be printed at 1200 dpi or higher to realize professional quality.

I really am not kidding. There are many who think I am being too loose and that 2400 dpi is the true minimum. The problem comes with the serifs and the thin portions of humanistic or calligraphic type. The serifs on some Bodonis, for example, can be less than a tenth of a point thick. The thin portions of Americana are certainly that thin, even at 24-point type. Many of the more elegant serif typefaces have very thin thins and serifs. Good type, in general, is very subtle. Even Helvetica has many subtle thicks and thins.

The resolution problem

Photoshop images are almost never more than 300 dpi, for reasons we will discuss in chapter 9; 150 dpi and 200 dpi images are common. At resolutions this coarse, type is fattened to ugliness. Many of the subtleties of excellent type are lost completely, You cannot even do good kerning when each pixel is a half point in size.

For these reasons, until Photoshop 6, I told my students never to use Photoshop for type unless they were doing Web work. Even now, type is better done in FreeHand or Illustrator. Now things are more complex, though. PS6 does much better with type than its predecessors.

Photoshop 6 can contain vectors

Now Photoshop can contain most of the same PostScript information that has been part of PageMaker, InDesign, Quark, FreeHand, and Illustrator. To translate, Photoshop now has many more and better PostScript illustration tools. These vectors cannot be imported into the other publishing programs except as EPSs and PDFs. I have been continually surprised (and often disgusted, to tell the truth) at the statistics that show how many people use Photoshop for page layout. I know that merely shows that those people have

no idea about page layout, but it does not change the fact that it is done – and done often. Now at least they can do simple things with typography and PostScript, that will print out at high resolution.

I talked two chapters ago about how limited Photoshop's new vector tools really are. You can do some simple things with them. However, they are mainly a starting point for mask creation. As we saw last chapter, the tools can be very handy when adding masks and stylized shapes.

At least Photoshop's vectors are PostScript. There have been many, over the years, that could not claim that. We cannot escape the fact that printing's standard is PostScript.

Professional type is also PostScript

As I have mentioned several times already, when you are producing documents for print publication, PostScript is not optional. That especially applies to type. Sooner or later, if you make your living from publishing, you will toss all of your TrueType fonts. You will either start buying PostScript fonts or switch to OpenType (which is cross-platform).

Even if you do not do that, TrueType is still a vector font format. All type is vector information. So what do we do with all this vector information? The good news is that PS6 can now handle it.

Everything is rasterized for publishing

Vector EPS **Bitmap TIFF**

The illustration on the left was originally a combination FreeHand and Illustrator file with pieces done in each program. It is much better looking in color, but there is no need to go there for our purposes here. On the right is a TIFF rasterized from the EPS. I'll have no way to see what it is going to look like until the book is shipped. However, the one on the left should be printed at 2400 dpi and the one on the right is 300 dpi. It is also printed at 2400 dpi, but its resolution in Photoshop is 300 dpi.

Is it really true? Yes. Even vector artwork is rasterized by the PostScript printer, imagesetter, or press in order to actually put the image on the substrate. Above that, until Photoshop 6 almost all TIFFs and Photoshop EPSs were pure bitmaps (unless they had a clipping path). It is true that Photoshop EPSs and PDFs can now contain vector data. The problem is that Photoshop's tools are so limited that most of these vectors are going to end up rasterized anyway. Beyond that, TIFFs are still the most reliable format for imported bitmap graphics. It will be a while before Photoshop's vector data becomes mainstream.

On other words, almost all of those gorgeous vector effects end up at 72 to 300 dpi. Web graphics (except for Flash and SVG) are 72 dpi. Bitmap print graphics are twice the linescreen, or 150 dpi to 300 dpi. Images for billboards are commonly 20 dpi or less. We'll cover all of this in chapter 8 on pixels, resolution, and linescreen.

It is true that when you keep the vectors in Photoshop files they would print at the resolution of the printer or imagesetter. At 600 dpi for desktop printing to 2400 dpi or more for professional output, the vector data would look much better. In reality, FreeHand and Illustrator are still so much better at it that they will remain the PostScript tools of choice for a long time.

THAT BEING SAID...

Photoshop's new Type tool is very good

The major reason for this seems to be the typographic advances made with InDesign. Having adopted InDesign as my major page layout software, I really feel comfortable with the new type features. The type palettes, shortcuts, and features are InDesign right down the line. It doesn't have all of them, of course: no spell checker, no style or character palettes, and so on. But then, what the heck would you need them for in Photoshop?

Using the new tool gives you a separate type layer that remains editable. It also gives you a text box that has most of the capabilities of a professional page layout program.

The old type dialog box is gone!

Those of you familiar with Photoshop's former type interface will be (or are) amazed that you can now simply click on a document and start typing. You can click-drag to marquee out the specified size for a text block,

just like the frames you use in InDesign and Quark. You now have the same Character and Paragraph palettes used in InDesign – with very little missing. Above and beyond that, most of the same shortcuts you use with the Free Transform bounding box work here on the text frame also.

NORMAL TYPE EDITING HAS ARRIVED IN PHOTOSHOP!
Kerning is the normal Option/Alt plus left/right arrow routine most of us are familiar with. Adding the Command/Control key kerns ten times as far. Changing one word to another font or size is no problem. Individual colors for each letter are no problem. It is not as automated as professional page layout. Most of the incremental buttons are missing (in many cases there are keyboard shortcuts, though). However, it is professional typography.

Professional typography?

We have gotten ahead of ourselves a little. My experience has proven to me over and over that most of you do not have much typographic knowledge. More than that, a majority of you do not know the differences between typewriting (word processors) and typesetting.

Many graphic designers would probably be surprised to discover how many readers and viewers of their work simply dismiss it and move on – turning the page or clicking the link without reading it. As far as I have been able to determine, the number one reason why the ultimate consumer of your work ignores what you have done is poor type. Bad or clumsy typography really offends your readership.

Many of you do not believe me. *"I've never done that,"* you say. I would suggest that you have never really observed your own reading habits. In our modern marketing age, excellent type is a subconscious assumption. If you do not meet the standard, you will be classed with the bureaucrats and the rest of those who do not bother with good type.

This is not the place for a course on typography. If you do not have this knowledge you **must** learn it. However, we cannot avoid a quick review. Without the simplified basics, you will simply not understand what I am talking about.

WE ARE NOT TALKING ABOUT TYPING 101!

Typewriting versus typesetting

One of the major concepts of graphic design (often lost in the shuffle) is the centrality of the copy. Even your amazingly fancy Photoshop illustrations are usually meant to attract the reader to the copy. Many Photoshop illustrations merely showcase type. Our entire idea is to communicate the client's product as the solution to the reader's need. More than 95% of this

communication will take place through the words you place on the document. (If you don't understand this, you need to read books on advertising and design, as we are not going to cover this at all. Those written by David Olgilvy, among many others, are highly recommended.) Even in a Photoshop book like this one, PS6 has opened the Pandora's box. It doesn't just do pretty pictures any more.

The standard proverb is that a picture is worth a thousand words. This is true, but it takes an exceptional picture to express exactly the thousand words necessary to produce the desired action on the part of the reader. These pictures can be created. However, they will take you lots of time and money; even an excellent illustrator or photographer needs consummate skill to communicate clearly. Even exceptional designers can rarely pull it off without needing additional explanatory verbiage.

Typography in general

It would be nice if I could assume that you have already had six credits in typography or six years doing type. However, students usually have never had any formal instruction in the basics, as I just mentioned. Worse yet, they have keyboarding training. Although we do not have the time or the space to teach typography here, we will review the essentials. This is yet another place where you need to study until you have a good, solid, basic knowledge of type. Probably the most fun to read is *Stop Stealing Sheep* by Erik Spiekermann and E. M. Ginger (Adobe Press, 1993). The most comprehensive (yet still accessible) is probably *The Elements of Typographic Style*, by Robert Bringhurst (Heartily and Marks, 1999).

 You will probably find that the longer you work in graphic design, the more you will fall in love with type. As mentioned earlier, it is our major avenue of communication. Often, it comprises all of the graphic design of a piece. Yes, Toto, there are many printed projects that have no graphics. For the next few pages, we are simply going to review some basic differences between typewriting and typesetting — if nothing else, to pique your interest. This is by no means intended to be comprehensive, but it covers what you will need for this book.

What is bureaucratic type?

You have probably guessed that this is a category of mine that is not in common parlance. What I am talking about is type produced by nonprofessionals, using word processors with factory defaults. They were formerly called typists. Typewriter work was instantly recognizable for many reasons. Some of these reasons were dictated by the equipment: the typewriter. Some were a standard business writing style resulting from adaptations to typewritten copy.

Whatever the cause, this typewritten copy is extremely dangerous to your financial health as a graphic designer. So I need to give you a short list of things that typesetters cannot do that are usually taught as proper keyboarding technique. To rephrase, many of the reasons your type looks unprofessional were taught to you in your typing classes.

This is not Typing 101!

I hope that by this time you have realized that *type* has nothing to do with typing. It is obvious that the terminology is different. We are talking leading instead of linespace. Point sizes indicate the different measurement system needed. The lists go on and on. However, we have hardly begun. Much more significant than the new language are the actual mechanics of typesetting. The rules have changed! In fact, one of the difficulties in publishing classes today involves a paradox: (1) To get a job, desktop publishers have to be able to type well. (2) Learning to type in a typing class teaches students so many bad habits that you wonder if it is worth it. In fact, the standardized keyboarding classes *require* the use of many of these typographic errors to receive a passing grade.

At this point, we're going to talk about a group of major differences. By then, we hope, you will be into the new paradigm enough to learn the rest as you proceed in your career. It is very important to realize that these differences are not minor quibbles. They are absolutely necessary for professional document construction and career advancement.

If this is all brand new to you,

read *The Mac (or PC) Is Not a Typewriter*
by Robin Williams (PeachPit Press, many editions)

1. No double spacing

Typing classes teach that one should always double-space after punctuation. This was required by typewriter character design. All characters on a typewriter are the same width, or monospaced. The result is that sentence construction becomes hard to see. A double space emphasizes punctuation and makes it visible.

Typesetting, in contrast, is done with proportional type. This means that every character has its own width that is designed to fit with the other characters. Typeset words form units characterized by even spacing between every letter. In fact, professional typesetting is judged by this characteristic. What is called the *color* of the type is created by the even fit, which is called *letterspacing*. Professional type should have an even color (no blotchiness) when seen from far enough away that the paragraphs become gray rectangles. Double spacing after punctuation puts little white holes in the type color.

Double spacing is no longer needed because the better-fitting words make punctuation a major break. In addition, extra white space is built into the typeset punctuation characters themselves.

I have never found an excuse for double-spacing in professional type

2. Fixed spaces

One of the real lacks of the new type tools is no fixed spaces. Professional type needs the use of em, en, and thin spaces at the least. The lack of them shows some of the Photoshop team's attitude toward type. But then, there is no tab either. You cannot do tables, tabular matter, or anything like that. It really is no great lack when you do type as you should in Photoshop. In other words, if you are producing headlines, subheads, and limited, large display type, the lack of some of the typographic characters is not too much of a problem.

3. En and em dashes

The next major change we need to discuss is dashes. Typewriters only have one: the hyphen. Type has three: the hyphen, the en dash, and the em dash. All three have very specific usage rules. They are a part of all professional fonts. In a Mac they are Option-Hyphen for the en dash, and Option-Shift-Hyphen for the em dash.

Hyphen:

This is the character used to hyphenate words at the end of a line and to create compound words. A hyphen is used in no other places.

Em dash:

This dash is an em long. It is a punctuation mark. Grammatically it is stronger than a comma but weaker than a period. Other than that, there is no standard any more. American English is a living language in constant flux. These changes have accelerated in recent years. In many cases, there are no rules any more. Em dashes are used more every year. In many ways they are very helpful, but traditionalists tend to hate them. In general, all you can do is flag any doubtful use and go with your customer's opinion, right or wrong.

Typewriters use a double hyphen for the em dash. This is an embarrassing error to professionals. In fact, it is one of the sure signs of amateurism.

Ems and ens

These fixed spaces are what type is built upon. The em space is now a square of the point size. In other words, an 18 point em in 18 point type is a blank space that is 18 points wide and 18 points tall. All fonts are built with em units — usually a thousandth of an em. An en space is the same height but half as wide.

En dash:

This dash is an en long. It is used with numbers, spans, or ranges. For example, pages 24–39 or 6:00–9:00 or May 7–12. It is a typo to use a hyphen in these cases.

Hyphen - En Dash – Em Dash —

Finally, do not think you will not be caught. Hyphens are about half as wide as an en dash. They are often higher above the baseline than en or em dashes. Also, they are often slanted with little swashes on the ends, whereas en and em dashes are normally rectangles.

4. No underlines

The next difference has to do with the physical nature of typewriters. Because they only have one size of type, there is no way to emphasize words except for all caps and underlining. Underlining is necessary in that case. In typesetting, underlining ruins the carefully crafted descenders. In addition, the underlines that come with the type are usually too heavy and poorly placed. They make the type harder to read.

When copy to be formatted is received from nonprofessionals, underlined type is normally set in a bold face – unless it is the name of a book or periodical, in which case it is set in an italic font. If you decide that an underline is an appropriate solution, please use a narrow box or a hand-placed line, as in the following example:

<u>Typing</u> not <u>Typing</u>

The goal of typesetting is to make clean, elegant type that can be read without distraction. Underlining is almost as bad as outlines and shadows as far as professionals are concerned. They ruin the unique characteristics of the font. At times they serve a useful design function, but this kind of modification should be used very discreetly – and always intentionally.

5. No ALL CAPS

As just mentioned, all caps is the other way to emphasize words on a typewriter. Typesetting has many more options. There is *italic*, **bold**, SMALL CAPS; larger size, extended, **NEW FONT**, and so on.

There is something else, however. Studies have shown that type in all caps is about 40% less legible than caps and lowercase or just lowercase. All caps is also much longer than the same word set in caps and lowercase. Because our major purpose is to get the reader to read our piece and act on the message, you should never use all caps (unless you have a good reason).

For example, caps can be used very effectively to de-emphasize a line of copy. All caps in six-point type was a standard method used to keep people from reading the small print on unscrupulous contracts.

 There are those who are certain that the preceding statement is wrong. However, they have obviously never done much comparative reading. There are some studies that suggest that all caps work fine for one to eight words, like on a billboard. However, here the length of the capitalized words is usually the issue. You're the designer. Just be careful.

By the way, all caps reversed is even less legible. In fact, text set that way will not be read unless you force the reader graphically with size, color, or some other such ploy. Sometimes this can be used to the client's advantage. For example, you will regularly see the antismoking warning on cigarette ads set small, all caps, reversed out of a gray box.

The only place this is not true is on projected or backlit images. Presentation slides do read easier with dark backgrounds and light type. The Web is another issue, though. Here the reversed type usually reads well, but usually it will not print (the backgrounds usually do not print).

6. Real quotes and apostrophes

Here is another place where typewriters are limited by the lack of characters. All typewriters have is inch and foot marks (technically they do not even have that, but use prime and double prime marks). Quotation marks and apostrophes look very different. This is another typographical embarrassment when used wrongly.

Inch/foot' " Open/close quotes' ' " "

An apostrophe is a single close quote.

7. Kerning and tracking

Here is another typesetting capability that cannot even be considered by typists. Letterspacing has a peculiar meaning in digital typesetting, much like leading. This is caused by the fact that with hot type you could only space the slugs apart by inserting slivers of metal. Digitally, anything can be done — and often is.

Tracking is the official term used to replace letterspacing now that we can move letters either closer together or farther apart. In reality, either term can be used and understood. The actual procedure simply inserts or removes space around every letter selected or affected.

Although Range Kerning (changing the tracking for certain words) is used all the time by typographic novices, it is despicable to traditional professionals. The letterspacing in quality typefaces is carefully designed

into the font. Changing the tracking for stylistic reasons or fashion changes the color of the type at the very least. At worst, it can make the color splotchy. It always reduces the readability, which is certainly a mortal sin.

Kerning is a different thing altogether. Here the problem is with letter pairs. There is no way to set up the spacing around letters to cover all situations: AR is a very different situation from AV; To from Tl; AT from AW. Literally thousands of different kerned pairs are needed to make a perfectly kerned font. Most of them can only be seen at the larger point sizes. Some pairs kern together and some kern apart.

Normal: Edges of character slugs touch

Awkwardly

Tracking: All letters are moved equally

Awkwardly

Kerning: All pairs are adjusted

Awkwardly

Quality fonts have kerning designed into about a thousand letter pairs. In addition, all professional publishing programs allow you to adjust kerning for individual pairs. Photoshop gives you the normal keyboard shortcuts. Option/Alt–left arrow brings letters together, and Option/Alt–right arrow moves letters apart. Adding the Command/Control key moves the letters ten times as much. The best way to show the basic difference is with the illustration above left.

As a graphic professional, you are expected to kern everything over 14 point or so — certainly all headlines and subheads. It is entirely normal to spend fifteen minutes to a half hour getting the letterspacing perfect for that logostyle or headline. In fact, in FreeHand or Illustrator, it is not at all uncommon to kern the best you can and then convert to paths and modify some of the lettershapes so they fit even better.

8. Eliminate widows

As Roger Black said, in *Desktop Design Power*, *"Widows are the surest sign of sloppy typesetting."* A *widow* is a short line at the end of a paragraph that is too short. What is too short? The best answer is that the last line must have at least two complete words and those two words must be at least eight characters total.

Bad widows mess up the type color. They allow a blank white area to appear between paragraphs that stands out like a sore thumb. There is no way to eliminate them except by hand. The best way is editorially. In other words, rewrite the paragraph! However, graphic designers do not often have such editorial authority.

You must be gentle or your corrections will stand out worse than the widow. Always make your changes to the entire paragraph. Extremely short paragraphs cannot be fixed, except to "break for sense." This means placing soft returns so that each short line makes sense by itself (as much as possible). This is especially true with headlines and subheads. Widows can make headlines look like they are balancing on a point — which causes visual tension, makes the reader uncomfortable, and may cause the reader to go elsewhere for a more friendly, relaxing read.

Do not confuse widows with orphans. An *orphan* is a short paragraph or paragraph fragment left by itself at the top or bottom of a column. Orphans are normally a two-line minimum, either top or bottom of a column. They should never be a problem in Photoshop because you should not be setting columns of type in Photoshop.

9. Use real small caps

Small caps are a specialized letter form. Correctly speaking, they are little capital letters, a bit larger than the x-height, that are designed so they have the same color as the rest of the font. Here you have to be careful, again. Photoshop creates small caps by proportionally shrinking capital letters. This makes them appear to be too light. The best method is to use fonts that have custom-designed small caps (they usually have lowercase numbers also).

There is one place where small caps are not an option. This is with times. The appropriate usage is not 9:00 A.M. or 9:30 AM or 9:45 a.m., but 9:53 AM. AM and PM are the only two words where small caps are required, except for B.C. and A.D. (which are politically incorrect).

This has been a very limited review of common type usage problems. I did not even begin to cover what you really need to know. Just do not delude yourself into thinking that you really do not need to know this stuff.

The Chinese showed their wisdom again by considering calligraphy to be the highest form of art. Once you understand type, you will increasingly see its beauty. Well-drawn type is absolutely gorgeous. After a while, you begin to understand why some of the best graphic designs are simply type. Many of the best Photoshop graphics are a pretty background with gorgeous type apparently carved, embossed, or stamped onto the surface. Excellence in typography is invisible to most readers, but it adds grace, elegance, and trustworthiness to your designs.

Three categories of people produce words on paper: typists, typesetters, and typographers. We have been discussing the first two. Typographers make typesetting an art. You should now have an inkling of how difficult that is. They are some of the finest artists in existence.

100,000 type styles

Now that we have briefly discussed typesetting, we need to quickly review the typefaces themselves. There are many classification systems for type. Bringhurst seems to use dozens. For the purposes of this book, there are five classes: serif, sans serif, script, text, and decorative. It would probably be acceptable to combine script and text or even script, text, and decorative, but these five categories have served well over the years.

Bringing it into perspective

Out of the 100,000 faces mentioned earlier, only a thousand or so are used all the time by many people. Out of those, there are about a hundred or so serif fonts that a majority use for body copy and another hundred for heads and subheads.

There are a huge number of decorative faces. Most of these are unsuitable for anything other than illustrations. Many are totally illegible at normal reading sizes. Probably 30,000 are multiple-derivative, differently named copies of the 200 popular fonts. So it isn't as scary as it sounds — quite. However, you will have to learn to recognize several hundred fonts by sight. You will probably develop a font library of several thousand different fonts faster than you think you will.

First, we must define a serif

A *serif* is a flare, bump, line, or foot added to the beginning or end of a stroke in a letter. I'm sure you already know this, but do you know their importance? They seem totally insignificant, but they certainly are not. They strongly influence how we react to type. In fact, on a subconscious level, serifs can be one of the most powerful influences on the reader's perception of the product. Most people are totally unaware of the effect type styles have on their lives.

Reading has many habitual associations. The type read during an event or occasion takes on the flavor of those memories. To be functional in modern American society, we must read — and we do it constantly. Each of us reads thousands of pieces every day. In our homogeneous, franchised society, most of us see the same things every day. We have a surprisingly uniform typographic experience

The result of all of this is that virtually every person in the United States has similar reactions to various type styles. This has greatly accelerated as we enter the twenty-first century.

Serifs

Type

No Serifs

Type

For example, Century Schoolbook is a very commonly used serif typeface. In fact, many (if not most) reading primers are set in Century (hence the name). As a result, people who read well and like to read have very positive reactions to this face. An additional effect is that most people find Century Schoolbook very easy to read.

Almost every good book you have ever read was set in serif type. Virtually every textbook was also. All body copy from before the 1950s was serif. Because of these things, serif typefaces are perceived as warm, friendly, nostalgic, and easy to read. Designers began to use these connections consciously during the 1940s and 1950s.

As a result, serif faces are used almost exclusively in ads promoting quality, stability, good value, integrity, and warmth. They are also used to reinforce family values, patriotism, and the emotional content of character traits considered positive by our culture. Serif faces produce these types of reactions in the reader (at least subconsciously). Remember this as you pick the font for that word you want to carve into the limestone background you carefully scanned for your magazine cover. You will be amazed at how you can change the reaction of the readership of the magazine.

Regular use of sans serif is relatively new

Even though sans serif faces have been around since at least the nineteenth century, they were never popular until the 1950s. Bringhurst likes to show ancient Greek sans serif faces, but that is stretching things a lot. Until after WWII, they were used extensively only by the modernist, Bauhaus movement in Germany during the 1930s, where geometric type was promoted as modern. Futura is a classic example of this style. Most people perceived these faces as plain and unadorned or aggressively modern. Ties to Germany during the time of Hitler's ascent are not friendly.

Helvetica

ABCDEFGHIJKLMNO
PQRSTUVWXYZ
abcdefghijklmnopqrstu
vwxyz 0123456789

The first widely
fashionable
sans serif typeface.

In the late 1950s, Helvetica became extremely popular. It was designed by Max Miedinger in 1957 and was quickly accepted as a new standard type style by many in the business, scientific, and advertising communities. Most logos from that period (like CBS, Exxon, Texaco, and many others) were created with Helvetica Black. Sans serif faces, in general, became de rigeur for scientific publishing. It is likely that many of you have bad memories from physics and math books set in sans serif. Please keep that in mind as you use these faces.

The Times/Helvetica problem

One of the more interesting phenomena of digital publishing is the use of Times and Helvetica. Although these are very well-designed typefaces, their excessive usage resulting from their specification as the default fonts in so many applications and operating systems has completely changed their perception in the mind of the "typical reader." This could even be considered a Word, PowerPoint, and Office problem, specifically.

At this point, most serious graphic designers avoid these two fonts like the plague. As a result, the only place people see them is in output by people who are untrained in publishing and simply use the software defaults — think schools, bureaucracies, the IRS, collection agencies, and the like. Because of this uncaring usage, Times, Times New Roman, Helvetica, Geneva (Apple's system font), and Ariel (a Microsoft version of Helvetica) have been virtually ruined for serious use by designers.

Businesses of the time saw sans serif faces as modern, clean, cool, unemotional, and businesslike. Recently, there has been a fad among the avant garde computer byteheads of setting body copy in sans serif. They use distorted, condensed versions, but they fit the stereotypical usage pattern. Their usage is more a rebellion from convention, which fits nicely into the gestalt of sans serif usage.

Again, graphic designers have consciously reinforced these reactions. At this time, sans serif faces can be used effectively to produce these feelings and responses. The usage was almost unanimous — until desktop publishing brought in designers with no design education — the reactions are still predictable enough to be very useful. Sans serif faces are clean and mechanical. Serif faces, in general, are more elegant and "beautiful." These concepts have to be modified a little with some of the gorgeous decorative faces available today in both serif and sans serif.

And all the rest?

What about all the type that is neither serif nor sans serif? First of all, proportionally there isn't that much of it. However, as mentioned, its major use is in graphics and illustrations. *Decorative* or *display* is the term for the miscellaneous grab bag, but most of it is either serif or sans serif anyway. *Decorative type* is defined as a typeface that is so highly stylized that it cannot be read in body copy sizes. Of course, you better not be doin' body copy in Photoshop. For that reason some people call this category *display*. *Display* is the term used for the large, splashy ads in newspapers, as opposed to the classified ads.

You need to be very careful in the use of these fonts. Legibility is the obvious problem, but that can usually be solved by size and location. It goes beyond that, though. Circus type and western or Victorian type are commonly so fancy that they defy classification. Decorative faces can have shadows, fills, outlines, inlines, or any combination of these attributes. Sometimes they are three-dimensional. And this is before you beat it up with a layer style.

The good thing about decorative fonts is that they have very specific connotations. Fonts are available in art deco, art nouveau, Victorian, and almost any other artistic or decorative style of the past several centuries. They are the best (and usually the easiest) method of promoting an instant, emotional, stylistic reaction from the readers to your design.

Handwriting

There are two other general classifications that must be considered. *Script* and *text* fit nowhere and must be dealt with separately. Basically they are both handwriting. *Script* is modern handwriting. *Text* is medieval

handwriting. Text is also known as *Blackletter*. Blackletter was used in Germany until the Second World War. How they could read it fast is beyond me — but then I have never had to.

The 1950s saw an explosion of script styles. This was primarily due to the fad for hand-drawn headlines brought about by photographic pasteup. The problem with scripts is making the letters match up. This is one place where you have to watch the tracking very closely. The letter forms are designed to overlap precisely. If the tracking is too loose or too tight, they miss each other. This can be a real pain in Photoshop. You may need to go to PostScript illustration to get the word spacing and lettershapes you need.

type type type
Too tight Too loose Correct

Because script and text are so difficult to read, both of these categories have very restricted usage. In fact, they are limited to products where people are extremely highly motivated to read them, like invitations, greeting cards, and the like. Occasionally you may find a use for them as headlines, graphics, banners, or other such items, but you must always be aware of reading difficulty. Use all the tricks you can muster to enhance readability, such as emphasizing with white space, large sizes, extra line spacing, and so on.

Italics and obliques

One original standard for type is the carved type in Roman columns honoring emperors' great deeds. They are still the classic standard, and the reason why many old-time pros still call vertical faces "Roman." You should check out fonts like Trajan, Augustinian, and their ilk. The problem with these carved letters was that they were all caps. Lowercase letters crept in as people wrote the words. As they wrote faster and faster, what we now call lowercase letters developed out of the handwriting of the day. The second time this happened was in Italy in the early Renaissance. In Venice, a man named Aldus Manutius developed a font based on the handwriting of his day, which he called "Italic." It became very popular, but because of the slant and styling of the letters, it was often not as legible — and still isn't.

In this day and age, every normal vertical style (sometimes called roman) has a matching italic: Diaconia Roman foxy, *Diaconia Italic foxy*. As you can clearly see in these six words, italic is a very different font. The as, fs, xs, and ys show the most obvious differences. One of the aberrations of the digital age is a new phenomenon of fake italics called *oblique*. These are not true italics, but merely slanted roman characters. Obliques drive type purists nuts!

Remember, legalism kills

Some italic faces:

Dastardly
Dastardly
Dastardly
Dastardly
Dastardly
Dastardly
Dastardly
Dastardly
Dastardly
Dastardly

The factors discussed so far in this chapter have to be considered, but they cannot become rigid rules. If you have a good reason, ignore the rules. Make sure you do it on purpose, though. The relationships described here are real and they work on a practical, predictable level. You ignore them at your own risk. Some fields, like snowboarding, try to require that you break all rules (but that's just another rule). Many have strict requirements – often unwritten. The main thing is to be conscious of what you are doing and why. As the designer, you are responsible for every mark on the sheet. If you cannot think of a good reason to use it, delete it!

Much of this is obvious stuff, once you become aware of it. Common sense plays an extremely important part in design. If you look at the piece and you have to concentrate to read it, readers certainly will not bother. Examine what you are doing, carefully. You will find that you can solve many problems without having to call in "expert" advice.

Good type is subconscious

The first thing you must remember is that all of us have been constantly immersed in excellent type since we learned to read in all areas except bureaucratic output. Most of our textbooks were poor type. Bureaucratic output is poor type. Other than that, everything is and has been typeset by professionals until the very recent desktop publishing revolution. There is more bad type out there now than ever before in history. However, readers are still turned off by it.

The basic problem is that all of us have far too many things we **must** read. For most of us, this is our daily routine. We come home after work and check the mail. Many of you do what I do and stand near a wastebasket to save even more time. But the basic procedure is almost always the same. We quickly shuffle through the mail and divide it into three piles: bills and legal; junk mail; and stuff we want to read. Many of you are like me and have a fourth pile of stuff you **must** read, like trade magazines and so on.

The bills are usually poor typographically – which further reinforces our prejudice about printed matter that doesn't meet professional standards. The stuff we want to read is usually excellent, professionally set type: magazines, books, catalogs, and so on.

What I want to talk about a little is junk mail. I am defining this word differently, so pay attention. *Junk mail* is mail that you can decide not to read without opening the envelope – safely reject without reading.

How do you make that determination? Some are unsolicited sales pitches (what we normally call junk mail). Others are bureaucratic output that bureaucrats are required to produce to keep their jobs. It is always instantly recognizable by its bad typography, and can be rejected out of hand. Most

of us have learned that bureaucratic output almost never contains anything really important. Even bureaucrats know that if it is important they need to get a graphic designer to typeset the materials.

One of the worst, and most irritating things, is that letter of legalese that comes from your local utility. The type on the envelope is typeset so you take it seriously. Then you open it, and find a bureaucratic letter. The result is usually anger, at best. With all the competition for your client's customer's time, you need to be careful.

However, it's time to get to Photoshop's tools and abilities. It's your responsibility to set excellent type. If not, I'll find you and do something unspeakable. (Later, when you're not expecting it.)

Photoshop's type abilities

T The basic starting point is the Type tool itself, of course. It looks the same as earlier versions, but it is certainly not. You will see that immediately upon click-dragging in a new document. As you can see, it looks like a word in a Free Transform bounding box. In fact, it is — with a few minor variations.

It pretty much works like Free-Hand's text block, except that you cannot change tracking, leading, spacing and so forth. I find I really miss the little overflow box that you can double-click to shrink the block down to fit the type. However, those are minor quibbles. Photoshop will never and should never be a PostScript illustration program.

What it can do is amazing for those of us who have used Photoshop since version 2.5 or earlier. Dragging on any of the handles resizes the text block. Move the cursor outside the block and you can freely rotate the type. That's pretty good for starters.

Holding down the Command/Control key changes the bounding box to a free transformation tool. Now dragging a handle resizes the type inside the block! Dragging the sides of the box sideways skews the type. Dragging a corner handle resizes. Dragging a side in or out, up or down, scales the type nonproportionally. If you add the Option/Alt key, the block becomes a reflection tool that allows you to flip and rotate the type through three-dimensional space. The Adobe engineers really did a job. The only thing missing is the ability to drag a corner out independently to scale into perspective. To do that you'll have to rasterize the type.

 One disconcerting thing about the text block is that it feels like you cannot get out of it. This is true until you learn that you need to bash the enter key on the numeric keyboard to execute the type. However, this is a common enough technique so you'll remember it almost immediately as you set type.

The type remains editable until rasterized

Throughout all these transformations, the type remains editable. What a nice treat! You can add layer styles and the type remains editable. You can save the file and the next time you open it, the type is editable. This, of course, is because it remains vector.

Warping text

One of the new additions that is nice, if limited, is the text warping capability. As you can see, the Text Warp button is just to the right of the color swatch on the new Options palette. When you click on it, the dialog box to the left appears. The popup gives you sixteen different warping options, if you include None.

Once you pick one, there are several sliders that become activated to adjust the amount of warping. As you can see at the top of the next page, the warping is very clean. You do have quite a few options.

Beyond that, you can change your mind at any time — as long as you do not rasterize the layer. Switching to the Flag warp was as simple as picking a new option in the popup in the Warping dialog box.

This is a great tool for those custom headlines often needed in product logos and so forth. It is not nearly as powerful as Freehand's Enveloping palette and tools. There are no editing capabilities at all. What you can get out of the Warping dialog box is the limit of the transformation. Nevertheless, it is a nice feature that is sure to be used a lot. The potential for professional ugly is extremely high.

Warped isn't a nice word either.

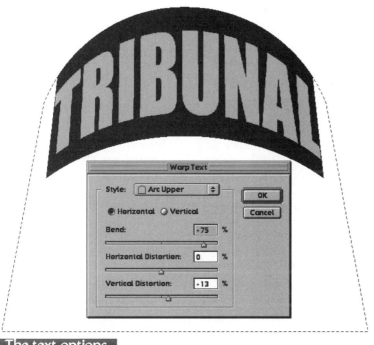

The text options

Here is the entire Options palette for type. It is pretty typical of the

current capabilities in most illustration program. One of the nice things is that Photoshop 6 uses the same type popups as InDesign. In practical terms, this means that there are no more Bold or Italic styling buttons. This is a good thing, because styling options have always been a problem in Postscript output. Right next to the Font popup, there is a Style popup. As in InDesign, it only shows the actual font styles installed on your machine. This eliminates the dreaded Courier font substitution almost entirely.

The next popup, Type Size, gives you several starting points for point size. However, that is all that is needed since you can so freely resize your type by Command/Control-dragging the corner handles. Just remember to add the Shift key to keep the type proportional – if that is what you want. Distorted type is very obvious to a reader.

The next popup gives you control of aliasing types. You will find that it makes some difference to the look of the type. It will cause the type to jump around a little in the smaller sizes. However, it is innocuous enough. It is not a biggie, just nice.

Text alignment

Here we see what appears to be a real limitation. All we have here is Flush left, Flush right, and Centered. I was distressed about that until I saw the Paragraph palette, which we will talk about next.

THE TEXT PALETTES

The Character palette

Here we find most of InDesign character palette. On the first row we have the Font and Style pop-ups already discussed. On the next row we have Point Size and Leading. Pretty normal stuff. The incremental up/down buttons are really missed though. The shortcuts are Command/Control +Shift +< or > for point size, and Option/Alt plus the up or down arrows for leading.

The next row has the kerning and tracking controls. A serious lack is the absence of Optical kerning. That powerful feature of InDesign would have been very handy in Photoshop because almost everything needs kerning in the points sizes normally used in Photoshop. You will almost always use the Option/Alt left/right arrow kerning and tracking shortcuts here. They give you a lot more control.

The next row contains Horizontal and Vertical Scaling. Why you would ever use these field is beyond me. The Command/Control +drag options to transform the text block are so easy that these seem redundant. However, if you need to get one piece of type exactly the same width and height as another, this would be very handy.

The bottom row gives you Baseline Shift and the Color Swatch fields. They are what you would expect. The Baseline shift is not needed much, But when it is, it is essential. The color swatch is easier found on the Options palette so most will probably use it there.

The Paragraph palette

Here we see why I so quickly passed over the alignment options on the Options palette. In the Paragraph palette we find all of the options from InDesign: flush left, flush right, centered, justified quad left, justified quad center, justified quad right, and full justified. It may be overkill in Photoshop, but it's nice.

The first row has the Left Indent and the Right Indent. The second row has First Line Indent. The next row has Space Before Paragraph and

Space After Paragraph. Just the simple controls needed. Drop caps is missing. This is too bad because this option is so powerful for fitting graphics into text. However, it goes quite a bit beyond the necessities of bitmapped illustration. You can turn Hyphenation on and off here, as well.

The Options menu really should be the source of these capabilities. The justification is InDesign's. It contains minimums, maximums, and desired for word spacing, letterspacing, glyph scaling, plus the setting for autoleading. The Hyphenation dialog box is also InDesign's. The real key is that you have InDesign's multiline composer for justification. This is an extremely powerful capability that produces far better justified copy.

Hanging punctuation

One of the things we typographers have been asking for for years is the ability to hang punctuation. What this means is the ability to optically align the side edges of our paragraphs by putting part of the punctuation outside the edge of the text block. It's an optical illusion thing, but very important. Photoshop 6 has borrowed part of this from InDesign also. As you can see from the sample, the capital A does not hang to the left, and it should (like it does in InDesign). The lines from *goin'* through *evening*, are horribly set. But at least it is a step in the right direction. It is not a page layout program. You need to remember that.

All righty then, what the heck is goin' on here? It was working yesterday evening, wasn't it?

Summing it up

As we have seen, Photoshop has leapt into the twenty-first century with vigor. The new typographic capabilities are a major improvement. The bad news for many is that there is now no excuse for horrible type in Photoshop graphics. You are going to be forced to learn your craft if you want to maintain the illusion that you are a professional graphic designer.

Where should you be by this time?

You should be creating Photoshop graphics with flair and style. You should have done several Miniskills and Skill Exams. The tools and palettes should no longer be an issue.

DISCUSSION

You should be discussing illustration techniques of all kinds with each other. Especially important is the idea of type content in illustrations. How important is it to your style? How important is it to control customer reaction to your clients' products and services? One of the best ways to improve your skills is to expand your horizons by brainstorming with other designers.

Talk among yourselves...

Well, actually not. I could only hope you would be forced into decent type. However, you now at least have the option to do so. Being able to retain the vectors in an EPS or PDF will probably become extremely important to many of us. Photoshop can do a lot better than ever before. It remains to be seen how the average Photoshop user exercises his or her options.

Knowledge Retention:

1. What are your warping options?

2. How do you transform type?

3. Why are the new type capabilities so important?

4. How do you skew or shear type?

5. What is the problem with Times New Roman?

6. What is an en dash?

7. Why are word processing skills often a problem?

Chapter 8

Dots, Pixels, and Linescreen

Concepts:

1. Halftone

2. Stochastic

3. Linescreen

4. Halftone cell

5. Gray level

6. Banding

Definitions are found in the Glossary.

Coming to grips with the reality of linescreen, halftones, and resolution

Chapter Objectives:

By giving students a clear understanding of how Photoshop produces halftones, this chapter will enable students to:

1. choose appropriate linescreens
2. calculate levels of gray
3. describe a halftone cell
4. explain the advantages of stochastic screening.

Lab Work for Chapter:

1. Finish more of the theory exams and email for grading.
2. Finish more Miniskills.
3. Finish more Skill Exams.

256 levels of gray

7 levels of gray

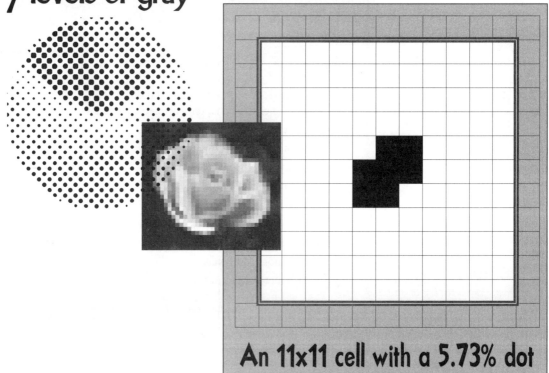

An 11x11 cell with a 5.73% dot

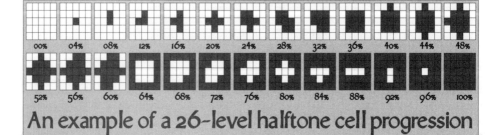

| 00% | 04% | 08% | 12% | 16% | 20% | 24% | 28% | 32% | 36% | 40% | 44% | 48% |
| 52% | 56% | 60% | 64% | 68% | 72% | 76% | 80% | 84% | 88% | 92% | 96% | 100% |

An example of a 26-level halftone cell progression

Making it printable

This is the core of the matter. For this chapter, we are talking about printability. This is where the rubber meets the road, so to speak. This is why you need so much RAM and PostScript output. Printed photos are made of dots. Here we have to talk about some semi-complicated theory that causes many people conceptual problems. The basic question is, "Why do I need 1200 dpi or more to print photos?" Or secondly, "Why are my photos so dark and ugly?"

Printers and presses require dots — both dpi and lpi. We have not talked at all about linescreen and halftone dots yet. Most of the reproductive processes are unable to print areas that vary in color. More than that, even digital presses that print variable dots cannot print dots that are different colors with the same toner cartridge or ink. This is the key concept you must remember. Presses and printers use dots that are a constant color. They might be all black or all red or all blue — but for any given print head, toner cartridge, or plate cylinder, only one color of ink is possible. To rephrase, every different color of ink or toner requires a different print head.

The varying colors and the appearance of continuous tone on a printed product (or a monitor) are an optical illusion. This illusion is created by using dots that are so small the human eye blends them into tints, shades, and continuous tone. This is the basic concept we deal with in publishing.

There are two basic types of dots

Before we can go on, we need to discuss the two basic types of dots. We've already covered the difference between dots and pixels. Now we need to cover the difference between dots and linescreen.

As a reminder, the following codes are being used to help you separate the different types and purposes of spots and dots. Basically, scanners and monitors use pixels. Printers and presses normally use dots. The problem is that everyone calls any type of dot or pixel *dpi* (which obviously stands for dots per inch).

Here are the codes we will be using (assuming an accurate proofing process):

- spi = samples per inch for scanner pixels
- ppi = pixels per inch for monitor pixels
- dpi = dots per inch for printers and imagesetters
- lpi = lines per inch for halftone screens on plates, masters, toner drums, and traditional printing presses

You can certainly continue to call everything a dot, and all resolutions dpi, but this artificial differentiation into the four types of dots will be helpful as we get a handle on dots in the workplace.

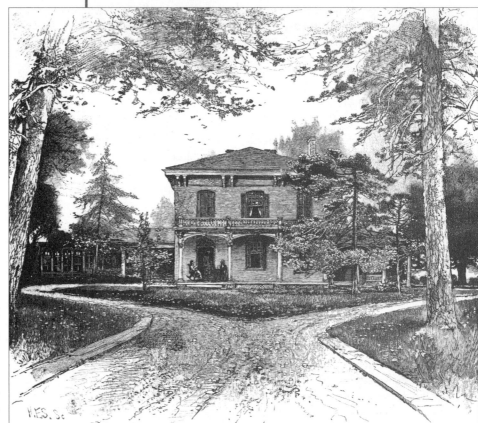

© Patrician Stock: http://kumo.swcp.com/graphics

This etching is about the best we could do for printed graphics in the 1800s. This is a 300 dpi grayscale halftone (which has broken up the fine lines). You really should see it as lineart.

The halftone revolution

To briefly review, in the nineteenth century photography triggered the search for the ability to print shades of gray, as mentioned in chapter 2. Drawing and painting reality in a convincing manner was (and is) too difficult for most people. All printable artwork before that time was lineart — primarily engravings and etchings. Even this is too difficult for most modern artists. These were made up of tiny, overlapping and crosshatched black lines cut or etched into copper plates. Those etchings and engravings are still amazing pieces of artwork. In many ways they are still far superior to photos. However, the skill levels are unknown in the modern age.

In the latter part of the nineteenth century, a technique to solve the problem of printing photographs was developed. They were first commercially printed in *Century* magazine (which was anticipating the new century with as much anticipation as we faced the new millennium). This methodology produced what came to be called *halftones*. A halftone broke a continuous tone image into tiny little dots that vary in size.

Two types of halftones

There are two basic ways to vary the tints that are apparently created by the dots. (Remember that a *tint* is a percentage of area covered – in a 15% tint, 15% of the paper is covered with ink or toner dots.) The most common method, at present, is the original technique that varies the dot size, with dots in a rectilinear grid. This is the halftone technique. It has been used with increasing frequency since the late 1880s. Only since the 1990s has there been a digital alternative.

This second, alternative method varies the dot location and frequency. Here the dot size remains constant. This is commonly called the *stochastic technique*. In appearance, it resembles the technical pen technique of stippling or the old intaglio method called mezzotint (but the stochastic dots are often much smaller). This is a brand new capability made possible by the extremely fast computers that are now readily available, and it can only be produced digitally. You could consider halftones as AM and stochastic as FM.

Most commonly, what we tend to see as stochastic is really diffusion dithering. True stochastic requires great computer processing power to precisely place extremely tiny dots. Cheap inkjet printers all use diffusion dithering. In the miscellaneous bitmap techniques in chapter 13, we will talk briefly about using Photoshop's diffusion dithering capabilities to solve problems with low-resolution printers. A third method, used in a couple of digital printers (which may never see common usage because of its complexity), varies both size and location of the dot.

For now, what you need to know is that printers require dots. Most of the new digital color laser printers and presses use pixels that vary in color for their printer dots (which is driving traditional printers nuts). More than that, all of these printers and presses need what are called *hard dots*. These dots are a specific size and a uniform density. It is very important that they be predictable in size and location, so they can be calibrated to produce tints that are accurate to plus or minus half a percent or less in color. Needless to say, the cheap printers (under $2,000 for letter-sized or $5,000 for tabloid) cannot be this accurate.

The example on the top of the next page should give you a much better feel for how these dot structures appear when magnified. As you can

An old engraving

This illustration of Lincoln's home is from *Century* magazine, sometime in 1887. I can't figure out the exact date the way it is bound in my book containing 1886-1887. The fluidity of the line suggests that it is probably an etching — but not necessarily. Regardless, it is a gorgeous piece of printing in the original.

One interesting thing about the illustration on the opposite page is the quality improvement in consumer scanners. When I originally wrote *"Printing in a Digital World"* I could not reproduce any of these old engravings. This time it went a little easier, but it still took a lot of care and more than a half hour to get what we got.

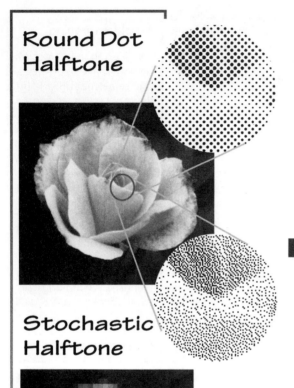

Round Dot Halftone

Stochastic Halftone

see, the dots for both types have very hard edges and destroy all fine detail. Notice that halftone or stochastic makes no difference. If you look at this illustration from ten feet away, both of the enlarged circles will look the same. At the dot sizes used, all we see in our minds is smooth gray gradations. Once the dots are formed, the image cannot be enlarged without making the dots visible to the naked eye. If they are reduced in size, the dots can easily get so small that they will not reproduce, and the image will get muddy, blotchy, and ugly. That was the problem with the etching of Lincoln's home. I finally had to go to a 300 dpi grayscale halftone, which lost almost all of the detail.

Computers require pixels

As you remember, pixels are very different from dots. First of all, they do not vary in size, they vary in color. Pixel size is determined by the scanner, monitor, software, or printer. The color variance is determined by the color depth (or number of bits assigned to each pixel). More importantly, pixels are not able to vary in frequency — they are always part of a rectilinear grid of specified dimensions.

Pixels are used by scanners, monitors, and digital files in general. Photoshop defines its images by their pixel dimensions. An image that is 300 pixels square would be two inches square at 150 ppi, one inch square at 300 ppi, and half an inch square at 600 ppi. The image to the left gives you some idea about how pixels look. The one right below it is exactly the same image reduced until the pixels are invisible. Remember, that is the key — dots or pixels that are too small to be seen with the naked eye.

PRINTED HALFTONES

Linescreen usage

To review, printers require dots, and the vast majority of those dots (except for the cheapest inkjets and some of the most expensive image-setters) come in regular patterns. These regular patterns are normally called *linescreen*. The name comes from the original screens, which were made of plate glass with tiny parallel lines scribed into the front and back surfaces at right angles to each other. Linescreens were measured by the number of lines

per inch. This is a physical measurement; for instance, a 133-line screen has 133 horizontal lines and 133 vertical lines. The term is in such strong usage that no one even questions the fact that lines haven't been used for many decades. Linescreen now refers to the grid size that holds the dots.

First of all, notice that the dots produced by the halftone screens are very close together. The number of lines per inch is commonly 150 for the normal "slick" magazines you read. For ultra-premium art reproduction printing, 300, 500, and even finer linescreens are used. Second, notice that linescreen is much coarser than the dpi ratings of digital printers. Printer dpi start at 300 and continue up to 4,000 to 6,000 dots per inch. So, the question becomes, "Why does traditional linescreen need so few dots per inch while digital dots need many times more?" The answers are coming.

Lines per inch

There are two reasons why we use the dot sizes commonly available. The first (and most powerful) factor is the capability of the human eye. At normal reading distance (around 18 inches), dots that are a seventy-fifth of an inch (75 lpi) or smaller are blended into smooth colors. We might notice a grainy texture at 75 lpi. Even this disappears at 133 line or higher. With anything coarser than 75 lpi, almost everyone can see the dots with the naked eye. There are always one or two students in my classes who can see 85-line dots fairly easily, and always a couple of others who cannot see even 65-line dots.

The second factor controlling dot size is the technology of the printer or press. For example, for years newspapers were limited to 65-line screen. They were printing on unsized newsprint paper with relatively liquid ink. If the dots were any smaller than 65 lpi, they soaked into each other, plugged up in the shadows, and disappeared in the highlights.

What we need to do is consider all the linescreen ranges in common use. It is important that you understand which printers use which linescreen and why. You need to know what linescreens are used where and why. This knowledge will greatly help the production of your printed designs. In fact, if you do not know the intended linescreen before you begin, you will not be able to compete in production. The time you can waste is phenomenal.

Every publishing technology
has a linescreen
that fits its technology best

Various linescreens

133 lpi

100 lpi

65 lpi

A test:

You really need to stand these two pages open and walk about twelve feet away. You will see that all the half-tones look the same from that distance (which may vary according to how well you can see).

Zero to 25 lpi: Billboards (grand format inkjets)

Sometimes these very coarse screens (0 to 25 lpi) are used for purely graphic reasons by designers, but in standard production, only billboards use them. They are also used for the building-sized posters (100 foot by 300 foot) on the sides of city buildings. Remember, the use of 75 lpi is based on the 18-inch reading distance. Let's compare billboard quality to commercial printing quality (150 lpi): 150 lpi @ 18" is the same visual quality as 75 lpi @ 3', or 37.5 lpi @ 6', or 19 lpi at 12', or 10 lpi at 24', etc.

Billboards are normally read at 100 feet or more. On top of that, they are usually read by someone flying by at highway speed. Billboards are commonly 4-line to 12-line. But their apparent resolution capabilities are superior to those of glossy photos in National Geographic or Smithsonian magazines. To help visualize, 8-line at 100 feet is roughly equivalent to 512-line screen at 18 inches or reading distance. (By the way, traditionally printed billboards make wonderful wallpaper — if you can still find them. All you normally have to do is call the local outdoor advertising company. Ask them for outdated printed signs that they are tossing. A twenty-foot Clydesdale makes a wonderful mural.)

25–50 lpi: Screen graphics and foil stamping

Linescreens of 25 to 50 lpi are rarely used except when required by technologies like foil stamping or screen printing on coarsely woven fabric. They could be used very effectively for posters and flyers when forced to use 300–600 dpi printers. They rarely are, but this just seems to be the result of design school training. These screens can work very well. In addition, they are very easy to deal with. They usually produce very small file sizes. They print beautifully and even the low-res printers mentioned can render them clearly. The photos look great from a distance of five or six feet, and up close you want your readers to read the words anyway.

 If you are designing a foil stamp and want to use tints, I wouldn't recommend anything finer than 25 lpi. If you can figure out a way to make it look good, a 10-line screen would be better. If the dots

get any smaller than this, the unused foil cannot be stripped from between the dots. In other words, the foil stamping is ruined.

For screen printing, the coarseness of the fabric weave and other substrates like wood dictate linescreens of 50 lpi or coarser. You can easily tell the dot size because it is readily seen with the naked eye at eighteen inches away, or so.

50–75 lpi: Cheap copiers and 300 dpi printers

This is the area inhabited by cheap copiers and the defaults of 300–400 dpi printers. As you will see in the discussion of halftone cells, low-resolution printers are only capable of photo reproduction in this range (50 to 75 lpi). These dots are still easily visible to the naked eye — disturbingly so. Only the most uneducated eye can ignore the low quality of continuous tone art rendered with these large dots. In fact, they cannot even print these screens well, so you should consider the graphic option mentioned above.

 These dot sizes are neither fish nor fowl. All they are good for is to convince readers of a lack of professionalism. Their quality is obviously not intentional. It is merely irritating. If you have to use lpi dots of this size, you really need to consider all your other options.

Process color digital printers

Surprisingly, this is also the listed linescreen in print dialog boxes of digital color printers. My Phaser 780, for example, says that it prints at 60 lpi. Because those lpi dots are really 8-bit pixels though, an apparent 150 linescreen is realized. However, the dot patterns used are far outside what would be considered normal halftone linescreens. In fact, they are not reproducible at all. For proofing, however, they are gorgeous prints.

75–100 lpi: Newspaper and screen printing

In the days of letterpress, newspapers were limited to 65-line. Now newspapers printed with offset lithography normally use 100-line. Some older papers with outdated equipment still cannot handle anything finer than 65- to 85-line (but they are disappearing rapidly). This is due to the poor quality of paper and the relatively liquid ink used. When designing newspaper ads, be sure to call

and ask what your newspaper requires. You may be pleasantly surprised. You may be disappointed. Some of the special color sections are printed on better paper with even finer screens.

Screen printers are limited to this range partially by the size of the holes in the screens they use. There are rumors of 120- and even 133-line screen printing, but don't believe it until you see it. Screen printers are also limited by the surfaces on which they print. Clothing causes trouble with dots that are finer than 50 lpi. The fabric weave is much coarser than that. Even here you will occasionally see 100-line artwork on relatively smooth materials like T-shirts, sweatshirts, and soda cans.

85–120 lpi: Quickprinters (using duplicators)

Most quickprinters are proud of the fact that they can print 100-, 120-, or even 133-line images. Most should stick to 85-line. Again, this is due to the equipment used. Quickprinters are built around the duplicator and/or copier. A *duplicator* is a cheap, mass-marketed press and its resolution capabilities are fairly crude.

Technology limitations of the duplicator

- A big problem, as far as linescreen is concerned, is the size and number of ink rollers. Duplicators do not have anywhere near as many as presses do. As a result, the ink is not ground as fine. Ink particle size limits the dot size.

- A larger problem is the integrated duplicator, which carries the water on top of the ink on the same roller. It makes the duplicator easy to run, but the inevitable emulsification limits the size of the dot. Plus it is much harder to run *dry*, so there is a lot more dot gain (which we will talk about in chapter 9).

- Plates contribute to the situation. Most quickprint plates are exposed on platemakers. These specialized cameras are designed to save money, not to increase quality. The quality of the lens optics is relatively poor. Many of the lenses do not even focus well. Their sharpest focus is still *soft*.

- The plate materials are yet another factor. The paper and plastic used cannot normally hold dots smaller than 100 lpi (if that).

- A newer problem involves digital plates. Many of these plates are output on plain-paper laser printers. These 1200 and 1800 dpi printers claim 133 lpi. In fact, due to the nature of toner melted onto paper or plastic, these printers often give very mottled screens

at anything finer than 85 lpi. (However, much of this is because many so-called 1200 dpi printers are truly 300 or 600 dpi printers interpolated to 1200 dpi just like scanners [beware if you see 300 x 1200 dpi listed as the resolution, for example].)

In most cases, 85-line screen will give better results. The equipment used by quickprinters can handle 85-line screen very well, with no effort. Trying to print fine linescreens on quickprint equipment is analogous to trying to road race the family sedan. It can be done — with extreme care, a lot of work, and many special parts. However, neither the printing nor the racing can match the real thing.

133 lpi and up: Commercial and process printing

This is where the printing professionals live: 133 lpi and up. Many are quite snobbish about it. You need to remember that there is nothing wrong with coarser screens. They have their place. In some situations, these large dots are a real advantage. However, for reading, 133 and up is best.

For many years, 133 lpi was the commercial printing standard. Recently, with technological advances in presses and platemakers, 150-line screens have become the norm. Much of the improvement is determined by two main factors: equipment and paper. Equipment has gotten good enough that 150-, 175-, and 200-line screens are no big deal. If the shop is set up to handle them, these fine screens give superlative results. All it takes are good materials, a relatively dust-free environment, and excellent personnel.

Magazine publishing has made a similar turn. The large heat-set web presses used to print full color magazines have developed to the point where 150-line images are now the norm. The change from 133- to 150-line has been gradual, but most of what you buy at the newsstand these days is 150 lpi.

The finer linescreens have been encouraged by the fashionable trend toward using coated papers. These sheets hold the ink on the surface of the paper, making it much easier to control the dot size. The negative side is the slick look. You only have to think *slick Willie* or shyster salesman to realize that problem. More and more people dislike the look as *slick* becomes synonymous with *cheap*.

Some artists have been relieved by the recent turn toward uncoated, fiber-added stock. As long as the paper is calendered (smooth and compacted), the fine linescreens will do very well on these new sheets. In all cases, the

look of the final product is controlled more by the quality of the artwork than by the size of the dots that render that artwork. Excellent designers produce beautiful printed work—even on 300 dpi black-and-white laser printers.

The upper limits of linescreen and practical considerations

The upper limit is primarily a function of the technology. Offset lithography is normally limited to around 200-line screen. At this point, even presses have enough emulsification of ink and water to limit dot size. However, many printers brag about being able to print 300-line screens. At least one printing firm, in Phoenix, has developed proprietary processes that allow 500 lpi.

Gravure uses no water, so emulsification is no problem. These presses function comfortably in the 150 to 300 lpi range. Their limitation is primarily the grain structure of the plate and the ability of the resist to prevent the acid from breaking down the dot edges. Also, the plate can deform if the dots are too small.

Waterless printing is limited only by the grain of the plate. Some waterless jobs actually use the granular structure of the aluminum in the plate for the dot. These measure around 600 to 700 lpi.

Quite often, it is undesirable to print with too small a dot. When you push the limits of the available technology, there is a tendency for the larger (shadow) dots to plug up. As a result, 300 lpi can have much less shadow detail than 200 lpi, even though the midtones are sharper. In addition, the finer the dot, the higher the cost. Ultrafine screens require better equipment, better facilities, better personnel, and more time — not to mention more money.

In most cases, screens finer than 175-line are not cost-effective. In fact, unless you are printing on super-smooth, cast-coated stock, the ultrafine screens might easily muddy the image. This is the same problem mentioned in the quickprint section. A printer using a duplicator might be able to print 133-line screen — but can the duplicator handle the paper necessary to benefit from the tiny dots? With 200- to 300-line screen, you get the same muddy images unless you pay the piper: cast-coated paper, well-maintained top-quality press, experienced and highly skilled press operator, and so on. You will not be happy with less.

As a desktop publisher, you need to understand the client's needs and the printer's capabilities. You need a stable of suppliers who can produce what is needed, in the most cost-effective manner, at the highest practical quality. There are certainly times when you need very high resolution. Maps, for example, have extremely fine, colored detail to print. Look at those from *National Geographic*. Fine art reproductions also require the detail

allowed by the higher resolutions (although you will often have a hard time convincing the artists of the costs involved).

The first decision in design is: "Who is going to print this?"

Technical variations: The shape of the dots

Dot shape is one of the variations to be considered when producing a job. Here we are not talking about the wild variations formerly used by traditional photographic halftone screens. These more appropriately fall into the realm I call nouveau riche design or what John McWade calls "grunge collage." In our digital world, this maximum baroque is the use (normally overuse) of Photoshop filters.

However, within the usable realm, a variety of dot shapes have definite utility. The normal dots are round or square. These work the way you expect, except for one problem. A visual jump in tone is caused when ink spots touch; the ink spots actually wick together (as you see to the right). This is called *bridging*.

The elliptical dot solves this problem. It is really a very minor problem except for one important consideration. The facial skin tones of Caucasians commonly fall in the 45% to 55% range. The bridging causes posterization of facial skin tones. An entire cheek, for example, might be rendered in dots from 49% to 52%. This can become a flat shape of color. The tonal jump at 50% in the square-dot halftone is virtually eliminated by the elliptical dot.

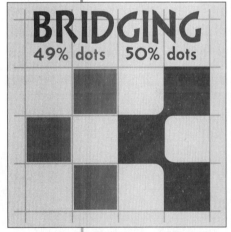

However, elliptical dots exhibit the same bridging in the low 60% tints. This tonal jump is right in the middle of Hispanic and Native American skin tones. In most parts of the country this bridging is also a problem. Round dots bridge a little higher than elliptical dots – around 75%. This commonly is the skin tone range of people with very dark skin, like some from Jamaica. However, Photoshop's curves controls can solve this problem easily, as we'll see in halftone production.

The main point to remember is this: when the older, traditional halftone producers say that elliptical dots are needed for portraits, remember that they are talking about a world of publishing that was all European (and mostly northern European) until the 1980s or later. Things are different now. America is much more diverse than that.

Another underused dot is the line dot at 0 degrees. This dot produces a halftone made up of horizontal lines that vary in thickness. It is a very pretty graphic effect. Halftones made with these dots can appear very sharp and crisp, even at 50 to 65 lpi. In fact, this dot shape works best when it is large enough to be seen. They have to be lightened a lot, also.

The rest of the dot shapes are merely interesting. The problem is that they usually identify someone fresh out of school. Students tend to be the only ones who use the unusual screens. Customers are normally very difficult to convince. In fact, most of the special effects in printing (that fall outside the norm) have little utility in helping the client communicate with the reader — and that is what we are about, remember?

THE PROBLEMS WITH DIGITAL DOTS

Producing the illusion of variability

As you now know, digital dots fit a tight grid called a *bitmap*. In addition, these dots do not vary in either size or location. Some of the digital color printers and presses use pixels instead dots (i.e., they vary in color), but this is not the normal situation. As a result, digital printers have had to come up with what are called *halftone cells* to produce the illusion of variability.

These cells are made up of groups of dots. Each cell corresponds to a single linescreen dot. There are several problems with these cells. To start, they use the bitmap we keep referring to. This means that our formerly well-shaped linescreen dots become jagged assemblies of squares. This is more of a surprise to traditional printing professionals than anything else. They still cover the required percentage of area to make a tint. The dots that constitute the cell are so small that the irregular dot shapes are invisible without magnification.

A larger problem is the way the dots vary in size. Traditional dots gradually changed with virtually infinite variability. Halftone cells are limited by the number of dots available within the given cell. If the halftone cell is three pixels square, there are only ten levels of gray (3 x 3=9 plus one for

45-line screen with line dots at 0°

all white) or ten different tint percentages. This means that, with a 10-level halftone, I only have 0%, 11.1%, 22.2%, 33.3%, 44.4%, 55.6%, 66.7%, 77.8%, 88.9%, and 100% tints to work with. This ruins the halftone by posterizing it. Subtle shading is converted to one tint.

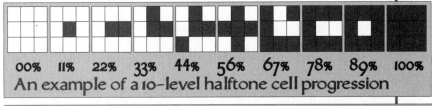

00% 11% 22% 33% 44% 56% 67% 78% 89% 100%

An example of a 10-level halftone cell progression

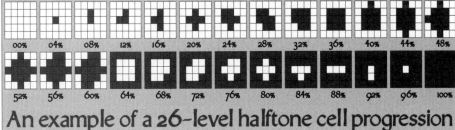

00% 04% 08% 12% 16% 20% 24% 28% 32% 36% 40% 44% 48%

52% 56% 60% 64% 68% 72% 76% 80% 84% 88% 92% 96% 100%

An example of a 26-level halftone cell progression

The only way you can achieve more levels of gray is to use more dots per cell. For example, the following cell sizes produce these gray levels: 3 x 3=10; 4 x 4=17; 5 x 5=26; 6 x 6=37; 7 x 7=50; and so on. In fact, over 100 levels of gray are essential — 200 levels or more are very good. This requires cell sizes of 10 x 10 to 16 x 16 — or 101 to 256 levels of gray.

This is why digital printers require so many more dpi than linescreens need lpi. If you have an 85 lpi screen with 101 levels of gray, you need 850 dpi, because each dot of the linescreen requires 10 digital dots. A 150 lpi screen with 256 levels of gray needs 150 x 16 = 2400 dpi.

PostScript limits

The problem is that the human eye requires at least 100 levels of gray to see smooth gradations — to rephrase, 100 levels of gray are necessary for a photo to look like a photo when it is printed. If you are doing gradients longer than two inches, many more levels of gray are necessary.

With enough dpi in the printer, PostScript Levels 1 and 2 allow for up to 256 levels of gray. PostScript 3 allows 4096 levels of gray. With 256 levels of gray, each level is four-tenths of a percent (.4%) from its neighbor. With that small a difference, even the subtlest details can be rendered. Of course, this assumes that the dot size of the linescreen is smaller than the detail. A half-point dot has obvious difficulty rendering quarter-point detail. This is why exceptional detail is so rare in printing.

The PostScript 3 solution

In the late 1990s, Adobe solved many of our problems in this area. The release of PostScript 3 and implementation in recent Raster Image Processors (RIPs) has made some of our gray-level concerns less important. PostScript 3 can theoretically produce up to 4,096 levels of gray. Beyond that, PostScript 3 offers automatic dithering at the boundaries of the tonal bands.

Printer resolution requirements.

However, none of this matters if you do not have enough resolution in the printer to make the halftone cells smaller than the normal ability of the human eye to see individual dots. Now you know why digital printers require such seemingly ridiculous resolutions. When you divide it out, it quickly becomes apparent why 300 dpi printers are limited to the standard 53- or 60-line screens; 600 dpi printers can barely handle 85-line screen (with 50 levels of gray); 1200 dpi plain-paper printers work best at 85-line, though 1200 dpi imagesetters that output film can output 100-line or even 120-line. However, as you can see if you think it through, 120 lpi at 1200 dpi only gives 101 levels of gray.

The formulas are simple:

- dpi ÷ lpi= the horizontal dimension of the halftone cell
- dpi ÷ the horizontal dimension of the halftone cell = lpi
- lpi x the horizontal dimension of the halftone cell = dpi requirements of the printer

Professional output is normally 2400 or 2540 dpi. This allows 256 levels of gray at 150-line screen This is one of the reasons why many industries are switching to 150-line from 133-line. The 2400+ dpi imagesetters and platesetters allow easy production of 150-line composite negs. Increasingly, the plates are output directly.

Gray level guidelines

Most of us have found that, for most photographs, 100 to 150 levels of gray are enough to produce good photos. This means that 1200 dpi output is often good enough (and it is usually less expensive to output). There are two situations in which this will not be enough: photos with fine detail and those with large areas of subtle gradation.

Detail issues

The detail situation is most easily explained by talking about low-resolution printers for a moment. As you can easily see, a 300 dpi laser printer is not going to get you very far; 300 dpi halftones are less than acceptable for any reading situation. They are defaulted to 50- or 60-line screen. Simple

division shows us that 300 ÷ 50 = 6 and 300 ÷ 60 = 5; 5 x 5 = 26 levels of gray and 6 x 6 = 37 levels. Even with 37 levels of gray, all the detail is gone. This happens because at 37 levels, each level has to cover almost 3%.

Much of the subtle detail in a photo is the result of gray levels that vary by half a percent or less. Dark hair, for example, might fall entirely between 73% and 79%. This means that all of the detail will have to be rendered by the dots in this range. If you only have 60-line screen (26 levels), the levels would be 72%, 76%, and 80%. This would mean that the hair just mentioned would all be rendered by these three dot sizes. They could all be 76%. No matter what, neighboring hairs that were 75% and 76% would be the same color, and the detail would be gone. With inadequate gray levels, it is easy to produce portraits of people with dark hair who end up looking like they are wearing dark gray felt skull caps.

The final problem with detail, of course, is the simple physical size of the halftone dot. No matter how many levels of gray you have at your disposal, an lpi dot that is a hundredth of an inch is going to have a hard time rendering the detail in a photo of hairs that measure .003 inches each.

Gradation and banding issues

The most common problem caused by inadequate levels of gray is banding or poster-ization. This occurs when bands or areas of the different grays become visible to the naked eye. To explain this, we are going to have to do a little math — I hope it won't be too traumatic. Let's take a head shot, printed large, of a woman with a beautiful complexion. By using the Eyedropper tool and the Info palette, we discover that the

256 levels of gray

7 levels of gray

tonal range in her cheek goes from 47% to 49%. Moreover, the area covered by these tonal values is three inches square, roughly.

If we have a 1200 dpi laser printer and we are using 120-line screen, then there are 101 levels of gray possible from black to white, 0% to 100%. So, for all practical purposes, each level of gray is 1% different from the next. So, on the cheek above, the entire cheek area will be rendered by three levels of gray. It is very likely that several of those tonal areas will be a half inch across or more. They will be seen, in other words. It will not look good.

There are a couple of solutions to this. Increasing the printer resolution to 2400 dpi would give me five levels of gray in the same cheek. This might work. However, the best method is to take your Curves adjustment under IMAGE>> ADJUST and increase the contrast in that area — but we are far ahead of ourselves.

Where should you be by this time?

Working, working, working. You should be practicing, and doing Miniskills and Skill Exams. You should be feeling comfortable with Photoshop by now.

DISCUSSION

You should be discussing illustration techniques of all kinds with each other. One of the best ways to improve your skills is to expand your horizons by brainstorming with other designers.

Talk among yourselves...

The file size problem

The higher resolutions cause more problems due to the size of the files necessary. Let's simply state, at this point, that 200-line plates require huge amounts of memory and very high imagesetter and platesetter resolutions: 200 x 16 = 3200, so 3200 dpi is required. A 10" x 10", 3200 dpi, 24-bit file would be (10 x 3200 x 24)2 or 589.824 billion bits of data, or over 73 gigabytes (if my quick math is accurate). Not many of us have hard drives large enough to hold this. We aren't even counting Photoshop's working requirements (like at least three times the file size for RAM and up to twelve times the file size in empty hard drive space).

Practical considerations

So, the final question for this chapter becomes, "When do I use what?" The answer is obvious. The linescreen used is determined by the capability of the hardware that will be used to print your project — not the printer you use for proofing at your desk.

Pick your printer before you design

The first choice you should make when beginning to design a project is the printer, service bureau, or printing firm you are going to use to output the project. Everything in your project must be designed within the capabilities of your printer, imagesetter, or press. We will talk later about the adjustments you need to make to enable printability. For now, be happy that you know what linescreen is appropriate and when.

Knowledge Retention

1. Why does the printer's technology matter?

2. How does a stochastic halftone differ from a traditional one?

3. How does higher resolution solve posterization?

4. What determines the quantity of levels of gray?

5. How does bridging affect portraiture?

6. What does linescreen describe?

7. What is a printer's tint?

Chapter 9

Chapter Nine

Printing It Well

Concepts:

1. Curves

2. Histogram

3. Levels

4. Unsharp Mask

5. Dot gain

6. Dot range

7. Specular highlights

Definitions are found in the Glossary.

Learning the skills and knowledge necessary to print grayscale well

Chapter Objectives:

By giving students a clear understanding of how Photoshop produces halftones, this chapter will enable students to:

1. choose appropriate linescreen
2. calculate levels of gray
3. describe a halftone cell
4. explain the advantages of stochastic screening.

Lab Work for Chapter:

1. Finish more of the theory exams and email for grading.
2. Finish more Miniskills.
3. Finish more Skill Exams.

Reproductive capabilities

RANGES: APPROXIMATIONS AND AVERAGES

CAPABILITY LIMITS:	DIGITAL	QUICKPRINT	COMMERCIAL
Linescreen	8–150	65–120	133–200
Minimum stroke (points)	.15–.5	.5–1.5	.15–.3
Area solid (square inches)	100+ s.i.	3–16 s.i.	200+ s.i.
Sheet size (commonly available)	12"x18"	12"x18"	26"x40"
Dot ranges (best)	3–97	7–90	5–95
Registration	1/64"–perfect	1/8"–1/64"	half a dot
Color printing	process	spot	spot+process
Maximum # of colors	4	3	16
Turnaround	hours	1–2 days	4–5 days
Letterpress (die cuts, foil, embossing)	N/A	rare	common

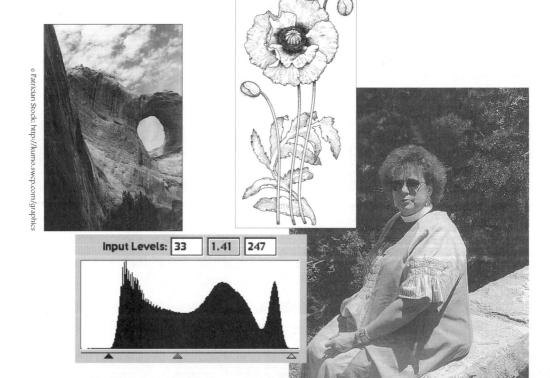

© Patrician Stock: http://kumo.swcp.com/graphics

Input Levels: 33 1.41 247

EXCITING BLACK-AND-WHITE COLOR?

Check out a Rembrandt etching

Often, one of the more difficult concepts to grasp is color. In printing, every color costs almost the same as any other color. That is the positive side of it. The negative side is that every color costs almost the same as any other color.

Enough cuteness. What I am trying to say is that there are an almost unlimited number of colors available to print. But each additional color costs nearly as much to print as the first one did. This demonstrates what I am talking about (if we ignore art and design charges, setup charges, and the cost of paper): if a black-and-white document costs $100 to print 1,000 copies, then red and black will cost around $200; red, blue, and black will cost $300, and so on. It is very easy to reach twelve or more colors and extravagant expenses unless the designer uses skill instead of ego. The most common solution is process color which we will cover in chapter 11. However, even with process color, there are four colors of ink or toner plus four negatives and/or plates to pay for — not to mention the expense of an accurate color proof.

Most jobs are limited

The theme of this book is practical production for realistic design— for the real world and the majority of your potential clients. In the real world, most jobs are one- or two-color. Process color is becoming increasingly common, but it is still expensive. Most jobs do not require the expense. Current stats are hard to find, but the best estimate I have is that the year 2000 brought us about 50% grayscale, 30% spot color, and less than 20% process color (most think less than 10%). The reason I am guessing is that all of the statistics I have seen ignore in-house printing in the office. Most ignore flexography and package printing. I think my figures are close, however, and my process color percentage is higher than most think it is.

Regardless, you'll normally have one or two colors to work with. As far as Photoshop is concerned, these are almost all one-color jobs. Even the spot color jobs normally use grayscale halftones. So, for my coursework, I want you to learn how to make a single-color job pop off the page, grab customers by the throat, sell them the desired message, and produce an appropriate response. In the course of this pursuit, for this book, you will learn how to produce excellence in grayscale reproduction.

Needless to say, you want to do all of this tastefully and tactfully, with a sense of style and grace. Common marketing research has revealed that everyone sees thousands of messages per day. Your work has to pierce the

clutter and the consciousness of the reader you are pursuing. Fortunately, it is much easier to do that in a single-color than you might think.

If you can't design persuasively in grayscale, your color work will be unbearably weak.

Grayscale brings clarity

Especially while you are learning, it is usually better to design in black-and-white, adding color conservatively to an already strong structure. You can clearly see the structure of a design in black-and-white. Color can be marvelously subtle; but it can also be muddy in concept and incoherent structurally. Any color is weaker than black or stronger than white. Creating entirely in mixed colors always weakens contrast, at the very least. It also tends to lessen the focus. And I haven't even mentioned the huge numbers of people who are either partially or completely colorblind.

Traditionally, all artwork for printing was done in black-and-white to make it *camera ready*. Camera ready meant that everything was either black or white so it could be accurately reproduced with high-contrast litho film. The poppy to the left is a good example of stippled technical pen work that was common in the 1950s through the 1990s. Even now, most of your proofing will be done in black-and-white on a laser printer. Working powerfully and competently in black-and-white is a saleable skill that will help you throughout your career. Yes, this is one of those fundamentals you hear so much about in all fields — something to build upon.

Black-and-white design helps keep the structure of a project strong. Computer screens cause many problems because it is so easy to add strong, complicated, and often unprintable color at the click of a mouse. Even if you get the chance to design a high-budget, multicolor piece, always proof it in black-and-white. Look at it carefully. Hang it on the wall and walk off twenty feet. Squint at it (to blur it) so that you are looking at the layout without being seduced by details that the reader may or may not notice. Many designers look at the work upside down or in a mirror, for the same reason.

The single-color majority...

Back to our portion of reality. Because many of your jobs will be single-color and many more will be two-color, let us figure out how to do them well. It only takes a good copy of a Chinese monochrome landscape to realize that black-and-white (and a few grays) can move your emotions more strongly than most color photos ever could. In fact, unless carefully controlled, color merely reduces contrast and lessens impact, as I have mentioned. Blue and white is much weaker than black and white.

Black-and-white pieces can be extremely "colorful." Of course, there is a problem with starkness, but the human brain has a phenomenal capability to blend multiple objects into apparent grays. If you draw several dozen parallel lines close together, your mind will tend to blend them into some sort of gray — a darker gray for thicker lines and lighter for thinner lines. A darker area if they are closer together and lighter if they are farther apart. This phenomenon works with any type of shapes, if they are small enough.

Linescreens

To sum up what we learned in the previous chapter, the object size that blends invisibly starts around 65 to 85 objects per inch. You can use squares, circles, dots, lines, whatever. As long as there are 85 or more objects per inch at a viewing distance of around 18 inches, you will see grays. The printing term for this phenomenon is *screening*. You can have line screens, circle screens, mezzotint screens, or any kind of screen you can conceive of and purchase. Plus, you can produce your own.

Every photograph you see printed is screened, as we covered thoroughly in chapter 8. Almost all the tints (pastels and shades) are printed as screen tints. Usually the screen is so fine that you cannot see it except with a magnifying glass. Coarse commercial printers use 133-line screens. Top-quality ones use 150-line to 200-line or more. Waterless offset can print 600-line screens or finer. With normal offset lithography the upper limit is around 200-line screens. Normal screen printing limits are around 100 dots per inch. Quickprinters are often limited to 85-line screens (or should be). Old-fashioned newspapers use 65-line screens (which can be seen with the naked eye). Copiers are often limited to the same coarse 65 dots per inch; 300 dpi laser printers can only effectively output 53 lines per inch (which is unacceptably coarse for almost everyone). *[I know we just covered this, but it is important that you remember it!]*

So who cares!

The situation is this: a printing press and most digital printers can only print solid color or no color (i.e. black-and-white). So, if your heart is set on shades, tints, grays, pastels, or the like, you have to use screens.

Sorry to reuse this, but drawings with coarse enough crosshatching to see clearly (and reproduce easily) are hard to find.

What Rembrandt did with fine-line crosshatching, you can do with simple screen effects. I agree that this little landscape is a bit crude, but at least you can get the idea of hand-produced, crosshatched grays. Every photo that you see printed – color or grayscale – is screened. It is the only tool a printer has to produce the illusion of continuous tone artwork.

Continuous tone

Any art that has graduated tones – pencil, charcoal, pastels, watercolor, airbrush, photograph, so on – has to be screened to be made printable. Pencil drawings are the most difficult to reproduce because of the subtle light grays. You scan art like this and produce the screens you desire on the computer in bitmap, image editing, and manipulation programs (Photoshop). Your printshop can shoot a camera halftone in five minutes for around $10 to $20. You have to be able to do the same on your computer. *"Ah ha,"* you say, *"now I know why I need a G3 with 128 MB RAM – minimum."*

You do get much more control with the computer. Digital control of individual gray levels is impossible with a traditional camera. However, digital halftones require much knowledge and experience. It does help if you know how to control a traditional camera. You also need to know what the press needs. Even flat tints can have great impact. A screened box in back of your type can separate it from the rest of the text. It makes a natural setting for sidebars (those additional, peripheral pieces of information placed on the edges of your article to entertain the more serious readers).

Screened boxes do not produce impact!

Screens in back of type do lower the contrast and do make type harder to read. However, they make excellent devices to separate different sections. My advice is to use the screens to set apart the areas of lesser importance so the primary content areas pop off the page more easily.

Beware of looking like a novice!

One of the digital jokes in the industry is the piece done by a desktop novice with screens and boxes and lines and... Screens should be used like color in general – for specific purposes, with restraint. Color can have great impact when used tastefully and carefully. A grayscale page with one red

spot is extremely dramatic. A little color has impact. A lot of color often merely lowers contrast and confuses the reader by interrupting the flow of the copy. Colored headlines and subheads often have less impact than black ones unless care is taken and adjustments made in font, size, location, and spacing. Novice and bureaucratic work consistently uses erratically styled headings and subheads, all of them colored.

Yes, color is important, but learn to work in black-and-white first. Then you can add color carefully. Forget color entirely if you lack taste or style. The world needs less garishness, not more – please.

PRACTICAL ADVICE

Tips on halftone production

Producing screened photos or scanned artwork that prints well involves several factors that are not immediately apparent. First and most important is that a halftone laser proof is going to print very differently when it gets on the press (unless you have direct digital output). In fact, if the laser proof looks good in your hand, it will normally look terrible when printed traditionally. This is true for a number of reasons.

Dots everywhere

For a halftone print to look good, every area of the picture has to have dots. If the highlights go blank (paper color), the picture will look like it has a hole in it. In addition, all the highlight detail will disappear. If the shadows print solid, they won't look like part of the picture. They will appear to lie on a different plane than the surface of the photo. In addition, all the shadow detail will be lost. As you can see, the top half of the carving photo looks pretty grim. There is no dot in the highlights and no dot in the shadows.

The goal is to have a 3–5% black dot in the high-lights and a 3–5% white dot in the shadows – after it is printed! This is usually spoken of as a 3–97 or a 5–95 dot range. In other words, you want your lightest area to be 5% (with a tiny black dot) and your darkest shadow to be 95% (with a tiny white dot).

Dot gain

I know that my view of dot gain is at variance with Photoshop's internal dot gain adjustments and uses different techniques than the views expressed so well in Blatner, Fleishman, and Roth's *Real World Scanning and Halftones* (Peachpit Press, 1998). However, their procedure doesn't match the reality I have experienced for thirty years. Plus, it does nothing to solve the problem of plugged shadows or blown-out highlights. **Bear with me, I'll explain as I go.**

When you scan your photo, you need to find the brightest highlight and put a dot in it and the darkest shadow and put a dot in it. **Be careful not to put a dot in the specular highlights.** These are the places where the sun is reflecting off chrome or something similar. Specular highlights have to go to pure white to look natural. However, specular highlights are almost always very small. The actual highlights must have that dot. It's easy to provide – just be patient.

Dot gain

The next problem is that offset presses, inkjets, screen presses, flexographic presses, electrostatic presses, and so on do not work very well. Printing is a very difficult process. We expect 9,000 to 13,000 perfect images an hour – with the color consistent, everything square ... at 3 to 4 sheets a second! Web presses (those that print from a roll) can produce more than 50,000 sheets per hour or 400,000 to 800,000 pages per hour after trimming. Most printing recently has been lithography. However, even the digital processes have problems in this area.

Let's just talk offset lithography for a while. As you should know, the plate is coated with water, then a greasy ink. The ink cannot stick to the water, only the image. That whole mess is offset on a rubber blanket which in turn rolls it onto the paper at 3 to 4 sheets a second. It goes even faster if the paper is in rolls instead of sheets – up to 100 copies a second.

Printing is a craft – not a science!

The ink has to be wet enough to transfer easily. As a result, it soaks into the paper. It spreads a little. In fact, with a cheap press or duplicator on uncoated paper, it spreads a lot! Even with the best presses on extra glossy coated paper, the size of the dot gains 5 to 10% or more. For example, at a 10% dot gain, a 10% dot becomes 11%, a 50% dot becomes 60% and a 90% dot becomes 99%.

The problem is greatly multiplied with uncoated stock and/or old presses and duplicators. Uncoated stock has a dot gain ranging from 15% to 40% depending on the condition of the press and the absorbency of the paper. With the lower figure, the dot range on the plate has to be 5–85. With 40%, the range often has to be 10–60.

We haven't even mentioned factors like ineffective sizing on the cheaper sheets (of paper). This causes the ink to bleed into the surrounding areas. Simple, physical pressure from the large steel rollers carrying the image can squeeze the dots, spreading them out over a larger-than-specified area. Toner scatter (around the edges of the dots and shapes) makes even

electrostatic dots hard to control. The thing to remember is that all printing has dot gain, all the time. The only exception is constantly calibrated, regularly adjusted electrostatic presses. They can even produce dot loss.

Reproductive capabilities

One of the big things you must learn early is to allow for the capabilities of the reproduction technology you will be using. As we have already mentioned, this is the major factor involved in choosing the linescreen to use. You will discover in a few pages that this linescreen is one of the first things to be taken into account as you begin scanning. It is a factor you need to account for *before* you start.

The entire problem of dot gain makes this even more important. As we will cover in the next couple of pages, dot gain is determined not only by the basic technology, but also by the individual press and press operator. A quickprinter with new, well-maintained presses and experienced operators can hold a 15% dot gain or even less. A "down and dirty" operation using the same equipment but older and without scheduled maintenance, plus inexperienced press operators, and a "fast and cheap is better than quality" attitude could have a dot gain as high as 40% or more. I have worked for several printers like that. Their policy was – "Don't worry, I'll give them a discount if they complain."

However, the basic differences in dot gain are determined by a simple distinction that has been around printing for about forty years. That is the difference between quickprinters and commercial printers. Recently we have had to add digital printers, while realizing that these digital capabilities can be found in both quickprinters and commercial printers. Understanding these differences will enable you to quickly get a basic guess about the dot gain and other limitations you will be experiencing.

Commercial printers usually use presses

Commercial printers normally represent the higher end of the printers' quality spectrum. These are the printing companies that can handle anything you need (in most cases). On a normal basis, they handle hairline registration, large solids (areas of flat, even, 100% color), process color (often process plus spot in the same sheet), long runs, complicated binding, large signatures and page counts, foil stamping, die cutting, embossing, and so on.

To do this requires excellent equipment and experienced personnel. In the commercial printing plants I have worked for, we usually didn't even interview anyone with less than three years' experience. The last place I worked, before I started teaching at the beginning of the 1990s, bought a new press for a million dollars or more every three to four years. All the

Disclaimer

This table by no means encompasses everything available. It is simply meant to give you a quick conceptual comparison. It does represent what is commonly available outside the megalopoli. It does give you a place to start your plans.

people working there (except for a few bindery workers and a couple of entry-level trainees on the cutter and platemaker) had ten to twenty years of experience. This is still true today. They just bought a new six-color 40" press that cost $1.4 million (they purchased one of the cheaper brands). This is not an expensive press. We're talking a Buick as compared to a Mercedes or Lexus. Even a basic two-color press will cost a few hundred thousand dollars. This is excellently engineered equipment.

Presses like this are designed to control image location within a couple of thousandths of an inch. They use densitometers on test strips printed at the lead edge of the sheet to control exact ink densities. Many modern presses have a computer console that can automatically scan a test strip and adjust the ink flow every quarter-inch or so across the entire width of the ink train. They can then store the ink densities from that job and reproduce it, at a push of a button, the next time the job is reprinted.

The press operators have trained eyes (from years of experience) that can detect the slightest color variations, as well as the skill to adjust the color printed by the press until it exactly matches the contract proof. It is a matter of intense pride that they can produce excellence in printing that is astounding to those of us remembering the capabilities of presses just thirty years ago.

Reproductive capabilities

RANGES: APPROXIMATIONS AND AVERAGES

CAPABILITY LIMITS:	DIGITAL	QUICKPRINT	COMMERCIAL
Linescreen	8–150	65–120	133–200
Minimum stroke (points)	.15–.5	.5–1.5	.15–.3
Area solid (square inches)	100+ s.i.	3–16 s.i.	200+ s.i.
Sheet size (commonly available)	12"x18"	12"x18"	26"x40"
Dot ranges (best)	3-97	7-90	5-95
Registration	1/64"–perfect	1/8"–1/64"	half a dot
Color printing	process	spot	spot+process
Maximum # of colors	4	3	16
Turnaround	hours	1-2 days	4-5 days
Letterpress (die cuts, foil, embossing)	N/A	rare	common

More than that, these presses have dozens of rollers in their ink trains that are designed to mill the ink and spread it out to exceedingly smooth, exactly controlled layers of ink. In addition, these presses have adjustments that allow (nay, require) the press operator to set the printing cylinder pressure so the gap between the cylinders exactly matches the thickness of the paper. The thickness of the paper is actually measured with a micrometer to a tolerance of thousandths of an inch as the operator sets up the press to run that particular paper through for a given job. It goes without saying that a press can run the best printing papers available to produce this high-quality — extremely smooth, exactly coated sheets or rolls. These presses can feed paper consistently within a tolerance of a few thousandths of an inch.

As a result, an excellent press can hold a 3% dot at either end with a premium cast-coated sheet. A good press can hold a 5% dot. However, as we will explain in a bit, most of them still have dot gains that run from 5% to 15% or more.

Quickprinters usually use duplicators

The classification of quickprinter came from a brand-new type of printing that arose in the 1960s with the development of duplicators and paper plates. Although it is true that the modern quickprinter has much better equipment, and the paper plates are now a tough plastic, the technology limits are still there. To give you an idea, a good-quality one-color duplicator costs less than $15,000.

Many duplicators carry the water to the plate on the surface of the ink. This means that they have to use a stiffer ink (with varnish in it). It also results in emulsification where the water and the ink turn to a sludge. (Emulsification is usually connected with soap, but here we are talking the physical blending of oil and water.) This sludge bleeds into the nonimage areas around black solids and is repelled off the tiny dots. As a result, duplicators do well if they hold 10% dots at either end. In fact, it usually takes a very good duplicator, with separate water and ink trains, and a very experienced press operator, to enable a duplicator to hold a 10% white dot in the shadows and a 7% dot in the highlights.

Even the duplicators that have separate ink and water roller groups have far fewer rollers than a press does. Where a press might have several dozen ink rollers and a dozen water rollers, duplicators usually have less than ten. This means that the ink is not milled nearly as much and the ink layers are quite a bit thicker.

Duplicators cannot adjust paper pressure, in most cases. The printing cylinders are held together by stiff springs that allow the cylinders to stretch apart enough to allow the paper to roll through. Duplicator paper control is very crude. In the industry it is usually called "bump it a skosh" registration. In other words, the paper feed adjustments are just able to control a hundredth of an inch. In the simpler, integrated duplicators (those that carry the water on the surface of the ink), paper feed controls are very limited, barely enabling paper control in the range of plus or minus a sixteenth of an inch or more.

Duplicators are also not designed to handle coated paper. With the registration problems and the lack of coated paper, most quick printers are not able to produce process color, at all. You do need to know that many quickprinters do have what are called two-color T-head duplicators. By having two plate cylinders offset their ink onto one blanket cylinder,

they can indeed produce excellent hairline registration for two-color spot work. However, the other limitations still apply. Take a close look at the chart on page 150.

Duplicator dot gain normally runs around 25% or more (though many shops will not admit it). In many shops, speed means more than quality and the dot gain suffers. The faster the duplicators are run the more the ink fountains must be opened to keep up with the ink flow. Inexperienced duplicator operators also have a hard time controlling ink and water balance. If they cannot control and limit the water, they are forced to increase the ink flow even further. The result can easily be dot gains of 40%.

Quality quickprinters produce excellent work (though they are forced to use coarser screens). They normally run 85- to 100-line screen. Be leery of claims of 120 linescreen by quickprinters. It is theoretically possible, but practically unattainable. A 120-line screen on a duplicator almost always means muddy screens and large dot gain. With relatively new, well-maintained T-heads, souped-up ink and water trains, and metal plates, quality quickprinters can comfortably handle 100-line screens with hairline registration and impressive quality. Many even try to do process color — and they do surprisingly well considering their equipment. However, the paper they have to run and the equipment they are using still makes 15% dot gain a minimum.

Always check the printer out and ask for samples

As you make these decisions about who is going to print your designs, always get samples from the printers you are getting bids from. Remember that the samples you see are the best and most perfect that shop can produce. Average or normal quality will be a little less. However, by seeing the shop you can get a pretty good idea of their capabilities. A dirty shop normally means poor maintenance and higher dot gain. Commonly, it also means personnel that care only about their paycheck.

In my experience, the better printing companies have operations where you can almost eat off the floor. Some actually do for bragging rights. They will have well-lit pressrooms with enough space to work comfortably. Often, out of pride, the press operator will be wearing a white shirt or blouse. Beware of press operators covered with ink. If they can't keep themselves clean, they will have trouble keeping the paper clean also.

Generational shifts

Most of you have seen what happens when you make a copy of a copy of a copy of a copy, and so on. The edges are destroyed on the image, all the grays disappear, and the entire image gets much more contrasty. This contrast increase also messes up our halftones. Every generation causes a loss of around 3% at both ends of the dot range.

To demonstrate, if I shoot a film negative of a laser print I lose 3%. When I make a plate from that negative, I lose another 3%. When I print off that plate, the paper image loses another 3%. So, a composite negative out of an imagesetter saves 3%. Outputting plates directly with a platesetter saves 6%. Printing directly with a digital press saves 9%. All of this is approximate, depending on the press, the operator, the weather, and so on.

I wish it were all this tidy. The figures I have given you work theoretically. In reality, they can vary quite a bit. For one thing, they do not add up so tidily — 3+3+3+3=12. But those numbers do give you a solid feel for what you have to do when producing screened halftone scans. The main thing to remember is that every generation increases the contrast and causes dot loss at both ends of the grayscale. Every shop is different. Usually, all you have to do is ask, "What is your dot gain?" **IF THEY CANNOT TELL YOU, FIND ANOTHER PRINTER.**

Miscellaneous problems

The first problem has to do with the abilities of printing personnel. Many quick print operators are taught to run their ink very heavy to compensate for the fact that duplicators cannot run very dense solids. Even large bold type gets washed out unless they pump up the ink flow. Of course, running the ink heavier means you need more water to keep the background clean — more ink, more water, more sludge. This gives the huge dot gains in the 30% to 50% range. Often, screens are almost impossible.

A newer, more common problem is plain-paper laser prints. Here the problem is the toner. Toner particles are attracted into clumps and then ironed on to produce the halftone dots. In addition, computer output deals with square pixels. They may be very small squares, but square they are — not round. There is also random toner "noise" from scattered particles, as mentioned earlier.

To put it nicely, plain paper laser halftones are a blotchy mess under a magnifying lens. The dots are not smooth circles but ragged approximations of circles. The generational changes smooth things out, but greatly increase the dot gain. The only solution is to overexpose the negative or paper plate to burn out some of the ragged edges. This also distorts the dots. However, it is better than plugged shadows. If possible, find a quickprinter who can output plates directly on a laser printer. This greatly increases the quality of the results.

The electrostatic solution

However, electrostatic presses (think printing-quality copiers and laser printers) can work with no dot gain at all, if properly calibrated. **This is the only technology that can work with no dot gain.** However,

this rarely happens. In addition, those copier operators at the corner copy shop usually won't have a clue what you are talking about. However, by carefully running your own tests, you can quickly find out what that DocuTech at Kinko's is capable of. You will find that different shops have different standards. We have about a half dozen Kinko's where I live. Only one regularly calibrates their printers. That shop really does a lot better quality work — for the same price.

Some observations

I would suggest that you examine the coarseness of your screen. Printing establishments are usually compulsive about printing at the finest screen they think they can handle. Often they can't print as fine as they think without quality compromises. It is true that fine linescreens produce halftones that look much clearer and sharper than coarse screens. They also plug easier in the shadows and drop the highlights. Many cheap books would look a lot better if printed at 100 line instead of 133 line.

At school, I was having a horrible time with my 1200 dpi laser halftones on plain paper. We were printing on student-ravaged duplicators that were 20 years old. The shadows were plugging terribly and everything looked mottled. The solution turned out to be reducing the line screen to 85 line and overexposing the negs by 2 seconds. I also adjusted for a dot gain of 35% to 40%. They looked much better. (Now, of course, the traditional printing program has been shut down because of a lack of students. I teach an entirely digital workflow and have since 1995.)

The 85-line screens are obviously more coarse. However, the midtones are clean, the highlights are crisp, and the shadows have good detail. The clients are much happier. This is where it pays to work with one printer. That way you can develop a solution that produces excellent halftones quickly and easily. Permanent relationships with your print suppliers will help you improve quality a great deal. As we'll cover later, we have to do similar things to work well with our Risograph press.

These techniques are important. Much of your design work will require mastery of these single-color problems. If that single-color is not black, you have to work more. Everything has to be hit a little harder. This is also true if you are using colored paper. All of these things cut contrast and reduce impact. It is no real problem. You simply have to be aware and compensate. Designers love to solve problems, you know. Often the biggest problem is simply being aware that there is one.

Single-color jobs are just as much fun to design as the four-color monsters. In fact, you often have much more freedom because the budget doesn't hit the client so hard in the pocketbook. Only pride requires huge

budgets and unlimited options and forgets about simple. Buy (or look at) an Ansel Adams photo and realize the impact of well-done black-and-white.

Target dot ranges

I will give you some rough approximations based on my experience with a wide variety of printing equipment in many different shops. The only thing I am sure of is that these are merely ballpark starting points. You will have to keep track of the output from the presses you use in the printshop you have chosen. The numbers will also vary with the stock used. A number one premium uncoated offset sheet comes close to cheap, thinly coated matte. Some uncoated stock is so absorbent that screens are almost entirely unprintable unless you cut the lpi to the minimum.

Talk with the people who will actually be printing your project — but don't believe everything they say. Many press personnel honestly believe that everything they get on a plate is 5–95. Be careful not to burst their bubble. Dot gain normally runs from 15% to 35% (it will usually be close to 10% even at top-quality process shops with well-maintained presses). This is not a character flaw, it is part of printing.

In general, this means that every dot grows by that dot gain percentage. This is not strictly true, but it works well enough conceptually. The following table should give you a rough idea:

Starting dot	10%	20%	30%	40%	50%	60%	70%	80%	90%
10% dot gain	11	22	33	44	55	66	77	88	99
20% dot gain	12	24	36	48	60	72	84	96	100
30% dot gain	13	26	39	52	65	78	91	100	100
40% dot gain	14	28	42	56	70	84	98	100	100

This theory has to be modified by reality, of course. The midtones gain the most. The physical nature of a press produces pressure of the plate on paper that actually squeezes the dots so they spread out. This effect is most noticeable in the midtones. Actually, these figures are not off by much. However, the midtones (from 30 to 60%) should be lightened a little more to compensate for the larger gain there. It is certainly true that every shop and every job in that shop runs a little differently. You can usually assume that the midtones will gain more than the shadows. With some printers, even the 60% dots go solid. Some cannot hold a 10% highlight.

Reality check

If you have a duplicator that generates a 40% dot gain, everything that is 65% or darker goes to solid black — no detail. This is one reason

Dot gain

Obviously the figures on this page do not correspond with Adobe's figures. Adobe's numbers are twice as high. Mine say that 10% will make 50% change to 55%. Adobe says 10% will make 50% change to 60%. The system I use gives you a much better handle on the endpoints of the dot range. With a 30% dot gain, using duplicators that can barely hold a 90% dot, you can easily see that you better think seriously about making your darkest shadows 85%. That is the real point of all of these numbers in the first place — will the shadow details print?

Raw scan

A simple correction

and I'm still a little worried about the darkness of this.

why cheap printers often produce photos of black people that show eyes and teeth as white spots in a solid black shape that used to be a face. If you do not compensate for dot gain, the printed photo will look horrible – dark with no detail. **MORE AND MORE, HALFTONE PRODUCTION IS YOUR RESPONSIBILITY.**

Dot gain is usually expressed in a dot range from the highlight to the shadow. In an ideal world, the plate would be 5–95 so that the press could produce 3-97. This is rarely the case. The good news is that competent printers know precisely what the dot gain is. More than that, they know what the dot gain is for each press. Each press is different. The printer for my printing textbook (*Printing in a Digital World* by Delmar, 1997) asked for the halftones to be adjusted to 5–85. I did what they asked, and it worked as predicted. The point is that dot gain is important and you need to keep on top of it. To a large degree, it is controlled by the skill of the press operator and the quality of the press or printer.

No matter what is said here, someone will get upset. The only consistent thing about dot gain is that everyone deals with it differently. The important thing is to know that it exists. When you bid out a job, ask your suppliers for their procedures and ask how they want you to handle it.

Photoshop's version of dot gain

One of the difficulties, of course, is always what the software engineers do to the simplest things. In earlier versions of Photoshop (especially prior to 5), dot gain was not done at all to grayscale unless you converted from CMYK. Then the dot gain for the black plate was applied to the grayscale image. Recently, things have gotten more complicated. Version 6 has added grayscale profiles.

The real problem for me is that Photoshop does not include everything in one dialog box. In addition, they force us to deal with dot gain in a manner that I had never seen before Photoshop. I'm not saying that what I learned was right or the only way, I am saying we need to be clear about what we are doing. Let's take a look at Photoshop's dot gain dialog box. It is at the top of the next page.

If you look closely, you will see that the dot gain for every tint level is different. Photoshop is saying that if the 50% dot prints at 70% it is a 20% dot gain. It doesn't matter to them that the 20% figure only applies to the 50% mark. As you can see, the dot gain at 10% is extreme. Looking at the curve, it appears to be about 80% according to the method shown on the previous page. Even according to Photoshop's method it is about 8%.

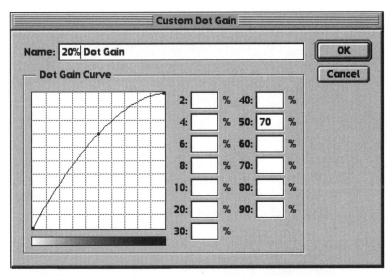

The 20% level bumps up to about 32%; the 30% up to about 48%; and so on. The worst part, though, is that the dot gains shown in the curve are much lower than reality in the shadows. My experience has proven time and again that a 20% dot gain makes the 80% tints go solid. In other words, all shadow detail from 80% to 100% is gone, with no dot at all.

Is Photoshop's dot gain necessary?

Yes, it seems to be. I just spent nearly six months using a custom dot gain of 0% while making all of my adjustments manually. I found that the image on screen was so far off that I had to go back to Photoshop's standard, default method.

However, their way of setting dot gain also causes several problems. Setting the dot gain the way suggested results in plugged shadows and lost highlights. Something else is needed and I am going to provide you with that. Before we can do that, we need to cover two of the main tools for tonal correction: LEVELS and CURVES. I think it will help a lot if we go over the tools before we discuss how to use those tools on a practical level.

EASY BUT INADEQUATE
The Levels adjustments

Here's the darling of all the other books. It is easy. It is very limited. Worse than that, doing what we need to do, Levels is very complicated. The main reason for all of this is probably a PostScript thing. Many of you have probably noticed that RGB colors are all listed in a weird numerical code.

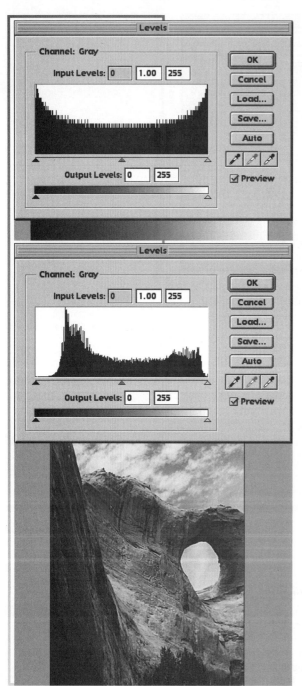

I'm assuming that it is a PostScript thing, but that is not necessarily true. However, PostScript did come before Photoshop. Regardless, the numbers used for non-printable color are strange to the normal person. They run from 0 to 255. That's not too bad.

The problem is, they are backwards from the normal way we think about color. It would make sense if zero were no color or white. However, these 256 levels are the colors of light, so zero equals no light or black. None of us ever learned to think about color like that. As you'll see when we start talking about color theory, RGB uses these levels because it is the color space of light. However, not many of us will soon become accustomed to red plus green equals yellow (even though that is the truth for that color space). I suggest that we should not become too focused on this method of describing color. But, Levels gives us no choice in the matter.

What Levels uses to describe the color in a document or selection is the histogram. A *histogram* is a bar chart that shows us how many pixels are at each of the 255 PostScript levels of gray. The histogram to the top left shows a nice smooth curve because this is a blank document with a horizontal black-to-white gradient applied. Each of the ends has a little more black and white, than the grays in the middle. Also, it is not nearly as smooth as you would think it would be, but you should get the idea.

The histogram right below the gradient shows the colors in the photo of Window Rock. This is a much more normal-looking histogram. This particular image has more shadows than highlights, and fewer midtones than anything. Still, the graph is a relatively clear indication of how the colors are distributed in the image.

As you can see, there are no real blacks and no pure whites. The first, and most common, thing we can do with Levels is click the Auto

button. This moves the Zero Input Point to the darkest gray in the image and moves the 255 Input Point to the lightest area in the image. You can see the results in the histogram to the right. The darkest level has been moved to 29 and the lightest level has been moved to 247. The result, as you can see just below the histogram, is a much better-looking image with more contrast.

The histogram at the bottom right is what Levels looks like after the Auto adjustment has been applied. As you can see, everything has been stretched out: 29 to 247 becomes 0 to 255.

Gamma

The third slider in the center of the histogram (the gray one) adjusts the midtones — what the geeks call gamma. I've read and heard many definitions of this term. The best one, believe it or not, is the slope of the curve of the contrast. I imagine that was a real help.

In practical terms, the gamma affects the lightness or darkness of the midtones — especially the exact midtone, 50%. The way it works, in practical terms, is that gammas higher than 1.0 lighten the midtones. Gammas lower than 1.0 darken the midtones. Here are two small captures to show you the difference: 1.7 on the left and .5 on the right. As you can see, far more than the 50% point is affected. Everything moves except the endpoints.

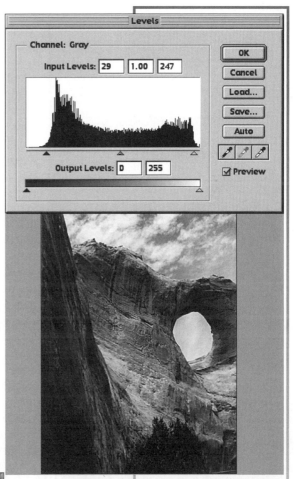

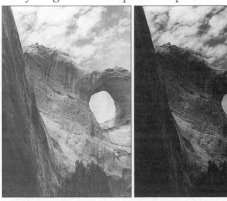

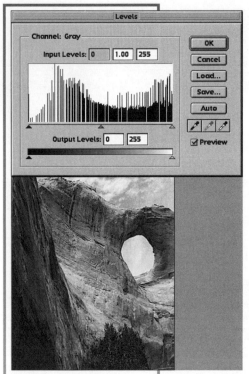

Gamma slider

It is important to remember that the gamma slider works backwards also. If you move the slider to the left, it may seem like you are compressing the shadows. Actually, the new point becomes the new center. The result is that all the levels to the left of the new point are stretched backl top the middle and the levels to the right of the new mid-point are squeezed into less space.

What happens is that moving the gray arrow to the left compresses the highlights and stretches the shadows. What you see to the left is a capture showing the effect to the histogram and the image of an auto adjust and a Gamma adjustment of 1.7 to lighten the midtones. The shadows (from 0 to 128 or 100% to 50%) have been stretched. This lightens them and increases the contrast. The levels from 128 to 255 (50% to 0%) have been compressed. They are also lightened but the contrast in the upper midtones and highlights is sharply flattened.

Both of these gamma adjustments in Levels are severe. They go far beyond recommended amounts so you can clearly see the differences. However, in the case you see to the left, the shadows are still too dark to print and the highlights are very posterized and flat. In addition, many of the highlights have gone to pure white. (Or they will after printing when all tones above about 220 or 10% will drop out to no dot.)

Here's where I have severe disagreements with the other two major books on the market. They clearly direct readers to love Levels, although they both definitely say that the Curves adjustment is more powerful. Their basic attitude is that you can't handle Curves. My experience is the opposite. With only a little practice and explanation, Curves becomes second nature and Levels is dropped as too clumsy to be very helpful. There is a good place for Levels and we will cover that in our practical production steps coming up at the end of this chapter. Normally, though, you will want to get into Curves as soon as possible. So, let's do that.

The Curves adjustments

Of the tonal controls, this is the dialog box with the power. Curves gives you complete control of any area of the image or the entire image. It shows a curve mapping every tonal level from 255 to 0 and from 0% to 100%. I can take any specific level and make it lighter or darker. I suspect that what concerns the authors of the other two books is the amount of power available. Obviously, if you can take the 10% level and change it to 85%, you are going to ruin the image. I think you can handle that.

The real reason this dialog box is so essential to learn, however, is that every image you work with in your entire career will be different. You will come to appreciate this more and more as you grow in skill in your career. Every photo and every scan will have different

tonal ranges, different contrasts, and different problems to solve. Although some professional black-and-white photography can be adjusted almost automatically in Levels, the truth of the matter is that you will need to go to Curves sooner or later in almost every instance. My point is: let's make it sooner and learn the power of the Curves dialog box right now.

As you can see to the right, the Curves dialog box looks innocuous enough. It really hasn't changed since version 3, at least. I think I remember it in version 2.5, but that is too far back in the mists of time. The only thing new is the Smooth button.

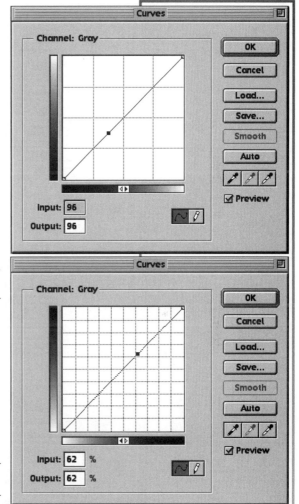

You do have two important decisions to make the first time you open the box (using the shortcut you might as well start memorizing now, Command/Control M). First, you need to realize that both of the captures show the same information. A PostScript level of 96 is the same as a percent tint of 62%.

To switch from the 0–255 PostScript levels to the 0% to 100% percentages, all I did was click on the double arrows in the center of the graduated bar at the bottom of the curve. If the whites are to the left, you are working in percentages. If the whites are to the right, you are using PostScript levels. That is your first major decision.

I highly advise that you choose the percentages option. One, that is the only option I show in this book. Two, you can already think in percentages. If I say 30% gray, you already have a fair idea of what that color looks like. If I say level 179, it is hard to realize that we are talking about the same color. Also, most of us can work with percentages in our heads. With PostScript levels you constantly need to calculate portions of 256. That is much harder. Think of percentages as the decimal version of this dialog box, if it helps.

The second choice has to do with the grid behind the curve. As you can see, the lower setup is marked off in tenths. What I did to switch to that view was Option-click in the curve box. On a PC you would Alt-click. This is a new thing I discovered while working on this book. I am trying it out.

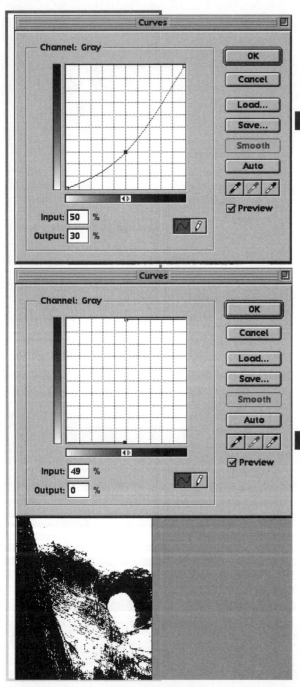

I effectively and easily used the 25% marks for ten years, like you see in the top box. The 10% grid looks like it might help accuracy a bit. It's entirely your choice. The Option/Alt-click changes a preference, so you can change back and forth at any time.

How Curves works

As you can see, every time you open the dialog box, you do not have a curve, you have a straight line proceeding from the 0% point to the 100% point in the upper right. That is because the Input levels and the Output levels are the same. If you click on that line you get a point, and the cursor changes to a four-sided arrow. Obviously, this means that you can move that point wherever you wish. As you do so, watch the Input/Output fields at the bottom of the box.

Here you see a curve where I have clicked on the 50% point of the line and dragged that point straight down to the 30% level. This has changed the 50% grays to 30% grays, in the entire image or selected area. Because it is a curve, this means that the 40% grays have changed to about 21%, the 30% grays to 14%, the 20% grays to 9%, the 80% grays to 69%, and so on. Cool!

Adjusting contrast

Contrast in Curves is shown by the steepness of the curve. The ultimate, which you see here in the bottom capture, is the curve applied when you convert from grayscale to bitmap with a 50% threshold. Here the curve is almost perfectly vertical, with 49% being at 0% and 50% being at 100%. On the curve top left, you can see that after dragging the 50% point down to 30%, the right side of the curve is steeper and the left side is flatter. This means that the shadows have more contrast and the highlights have less contrast – in this instance. You can use this technique to adjust the contrast to wherever you need it. It does what IMAGE>> ADJUST>> THRESHOLD does.

The problem with extreme contrast is clear on the bottom of the opposite page. There is no detail left anywhere, unless that detail was right at the 49–50 level change. This is what we would call maximum posterization – two levels of grey, white and black.

Posterization

You will always have problems with posterization if the contrast is too severe. Sometimes, like for fine art screenprints, you want obvious posterization with maybe 5 levels of gray. In Curves, you do that with the tool at the bottom that looks like a pencil. This enables you to draw straight-line stair steps for extreme posterizations with control.

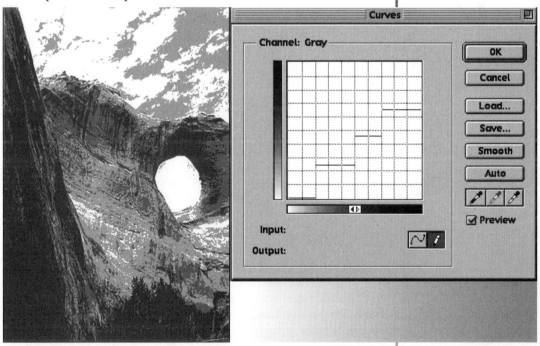

Here we see our shot of Window Rock posterized to four levels of grey: 0% or white; 25%; 46%; and 64%. As you can see, it is quite a dramatic effect. It also has the benefit of allowing an accurate four-color GIF, which is going to make it really small on the Web. All you have to do is select each color and fill it with whatever colors fit your fancy. I just did one in 7 minutes, producing a 4" x 5" GIF that is less than 16K.

However, posterization is normally a problem. If your model's facial skintones are all in the 45% to 52% range (which is common), contrast that is too strong can quickly reduce that face to one color with no detail at all.

Setting the endpoints

The main thing we have to do, as we get close to being able to actually produce professional halftones, is get the dot range into this equation. As you'll recall, I said that every technology has different limits and different dot gain. In a little bit, I will give you a revised list to use when setting the endpoints. For now let's just say that a 10–70 dot range has endpoints of 10% for the highlights and 70% for the shadows. To rephrase, this means that all dots less than 10% drop out to blank paper, and all dots larger than 70% print solid black.

In the case just mentioned, you want to make sure you do not have any dots that drop out (unless they are small specular highlights). The jump from blank paper to the 10% dot is very obvious. Even a jump from blank paper to a 6 or 7% job is usually visible. Also, you need to remember that jobs with this compressed dot range are usually also running relatively coarse linescreens: 65-line to 85-line range. These dots are visible to the naked eye for many people, even without this huge level jump.

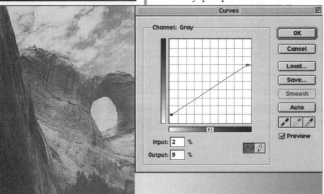

Here you can see a sample 10–70 adjustment. As you can see, I moved the 2% points up to 9% (hoping to extend the range as far as possible by telling the printer to please be careful). The darkest shadow point is the 95% point moved down to 70%. If you can compare this to the original image above it, you can see it is very flat.

The important thing to remember is what happens if you do not make these adjustments. With no adjustments, the final printed image would look a lot like you see below the 10-70 capture. It looks a lot like a "typical computer image," doesn't it? Assuming the normal dot gain from the printer of this book (we use 5–85), the capture of the top one is probably pretty contrasty also. It wouldn't surprise me if the "flat one" in the middle ends up the best looking of the three.

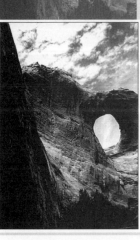

That is the main thing to remember – it is **NOT** that we are making these things look good on the monitor. What we are doing is making them look as good as possible **AFTER** they are printed. The point is simple. If you do not do this, the final printed image will be ruined. Obviously, we can help these flat images a little also. It will take some careful adjustments (usually dragging the 50% down a little farther). Beyond that, every image will vary. This is why you want to be using Curves instead of Levels.

Multiply adjusted curves

Now we start to see the real power of Curves. You can have more than a dozen adjustment points on that curve. Version 5 allows fourteen points. I just squeezed fifteen on a curve in version 6, but it is very tight. In practice you rarely need more than five or six.

It may not seem important until we mention some other attributes of the dialog box. First of all, when you move the cursor back over the image an open circle appears on the curve showing you what the color is under the cursor. So if you find a place that is too flat and important to your image, you can quickly determine what colors are in that area and make that portion of the curve steeper to add contrast.

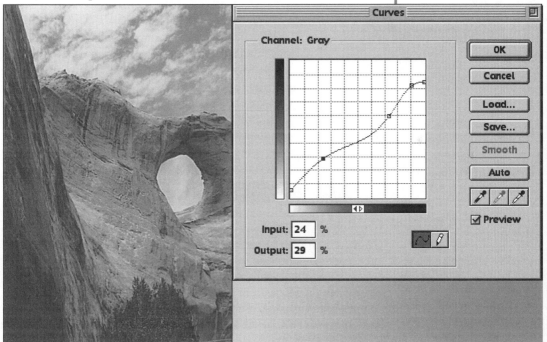

Here's a sample adjustment of the image we have been playing with. The trees on the bottom were almost solid. The sky seemed especially flat. So I moved the cursor around in the trees and discovered that the colors there were all from 74% to 90%. The sky ranged from 2% to 24%. As I mentioned, the printer for this book likes 5–85. So, I moved the zero point to 5%; moved the 100% point to 85%; dragged the 90% point to about 82%; dragged the 74% point to 68%; and finally added a point at 24% and dragged it up to 29% as shown above. As you can see, none of the changes is radical from a normally sloping curve, yet the changes to the image are very good.

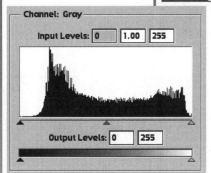

Image Cache

In Preferences, there is an option to use the image cache for histograms. You want to have this turned off. When it is on, the anti-aliased screen image is used to build the histogram. It is faster. However, if you are working on an enlarged view, the histogram may not even be of the entire image.

Adding specific locations to the curve

One of the other nice features of Curves is the ability to pick certain points in the image and add a point at that color onto the curve. All you have to do is Command/Control-click on the location in the image and a point representing that color will be added to the curve.

Setting endpoints in Levels

Yes, it is true that you can set endpoints in Levels also. If you look at the Levels dialog box to the left, you can see the Output levels gradient below. All you do is move in the end sliders to match the dot range. So, let's see — 5–85? So, I move the slider into 250? Nope! 5% of 255 is 12.75. So you would have to move it into 242. The other end would move into about 38, I think. You see the problem. Now, you can memorize the dot ranges you use all the time. But I still think that 5-85 makes more sense.

Beyond that, however, you are still going to have to make the subtle curve adjustments to fine-tune the image. However, when you open Curves you have a straight line angled at 45° up the dialog box. You have no idea what has happened to the endpoints, so you have to waste additional time figuring out what changed and why. It's far better, in my humble opinion, to simply open the Curves dialog to start with. It saves time and gives you more control. That's good, right?

Brightness/contrast — **NOT!**

Many people, when they start out in this business, use the IMAGE>> ADJUST>> BRIGHTNESS/CONTRAST... dialog box to try to fix their images. So what is the problem? Everything is global and there is no control at all. You cannot set endpoints. You cannot adjust the gamma. If you lighten or darken, everything goes light or dark. This just moves more of the highlights into the unprintable area or more of the shadows into the solid ink area. Contrast adjustments just tilt the overall flat-line curve toward vertical or horizontal with no controls at all for intermediate points. This dialog box is a total waste of time!

Sharpening the image

One of the things often forgotten is that all scanners blur the image to some degree. Images simply do not like being busted up into pixels. The result is that you always have to sharpen your images. Well, almost always. But we will cover that as we go through. As usual, we have to be careful what we use for professional results. As always, the easier the tool, the less powerful it is. This is almost always true.

Sharpen, Sharpen Edges, Sharpen more

Think BRIGHTNESS/CONTRAST... global, no control, bad idea, you should never do that. All of these options are like this. The only one that really works well is the one with the weird name. *"Figures,"* you say.

Unsharp Mask

This is the name of an old traditional photographic technique. It roughly involved taking a negative sandwiched with a blurred positive to isolate the edges of an image. That's close enough for our purposes. What was formerly true is only of historic interest now.

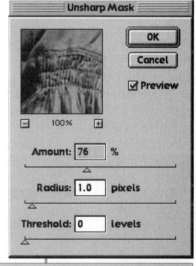

However, FILTERS>> SHARPEN>> UNSHARP MASK does do about the same thing as the old photographic technique did. We do not need to be concerned with the technical methods, either the old or the new. We'll leave the old for the historians and the new for the geeks. What you need to know is that the Unsharp Mask filter finds subtle changes in tone. The filter takes the light side of the tonal change and makes it unnaturally light. It makes the darker side unnaturally dark. Because these changes are small (we're usually talking about two or three pixels total on both sides of the edge), all it does is make the edges stand out more, which makes the viewer think the image is sharper or crisper.

As you see to the right, the Unsharp Mask dialog box has three settings: Amount, Radius, and Threshold. The drawing just below the dialog box gives you a better idea of what we are talking about. Please do not think this is scientifically accurate. Who cares about that? What I want is for you to clearly grasp the concept.

The Threshold setting determines which edges will be sharpened – that is, how much of a color shift has to occur before sharpening is applied. A threshold of zero means that everything is sharpened. A threshold of 10 means that things will not be sharpened unless the color difference is 10 PostScript levels (0 being black and 255 being white). Often you want to increase the Threshold to prevent skin textures from being accentuated into orange rind on the face of your model, for example. On the right, you would need a threshold of 2 or less to sharpen it.

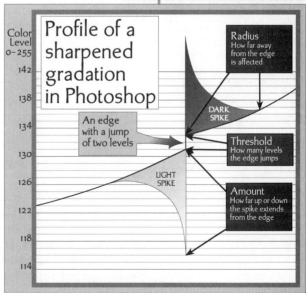

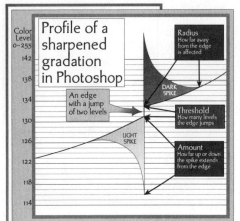

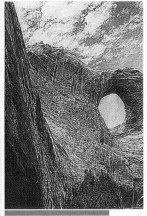

Over sharpening

As you can see, this one has been sharpened to death.

The Radius setting determines how far from the edge the sharpening is applied, measured in pixels. This varies with the resolution. For example, a radius of 3 on a 72 dpi image is going to add a light line that is 3 points wide on the light side and a dark line of 3 points on the dark side of the edge. This total of six points is a twelfth of an inch, in this case. On a 300 dpi image, that same radius of six total pixels is only a fiftieth of an inch or a little over a point. So on high-resolution images the radius can often be increased. You simply have to be careful that you do not add halos. You can easily get dark areas with white outlines and light areas with dark outlines. Check your high-res proof carefully.

The Amount can range from 0–500%. It determines how light or how dark the added outlines are, relative to the original. For example, an amount of 500% is often just what is needed to sharpen lineart, because the light edge goes white and the dark edge goes black at 500%. Normally I find that images take about half the resolution for the percentage. So 300 dpi would take 150%; 72 dpi would take 36%. But these will have to be modified by your expert eye.

My amount suggestions are a little lower than some suggest. However, my experience has been increasingly that small amounts applied two, three, or more times work better than a sharpening that does it all at once. I've gotten so I leave my filter set at **50%** for the amount. I then simply apply it and press Command/Control-F to reapply the filter until it looks good.

Unsharp masking can easily be overdone. When it is, "halos" appear at all the edges, or smooth skin can look very textured. Where the light side is lightened, there is a line that is unnaturally light. If you sharpen too much, this becomes visible. In small images, it tends to make the photo look like a copier image (though it does look extremely sharp!).

Also, sharpening is very dependent on the output resolution. The important thing to remember is that proper sharpening is essential to make your halftone look crisp and professional. You will be amazed at the quality difference. Again, **DO NOT APPLY SHARPENING BY HABIT AT A STANDARD SETTING**. Every photo is different. Carefully check your sharpened image at 100% (one pixel of the image to one pixel on your monitor). Undo, if necessary, and then redo until you get it right. Do small amounts and ease up on the final sharpening. This is a skill that will become second nature after you have done a hundred halftones or so. Carefully examine your finished printed product to see if you could have adjusted better — it may be too late for this project, but you can help the next one.

Tips for tonal adjustments

Here are some general procedures, concepts, and ideas to bear in mind as you begin to learn to fix your images on a professional level. Remember, there is no substitute for experience. You really need to produce a few hundred, have them professionally printed, and carefully examine the results.

1. **You are dependent upon good data.** Use the best photos you can find and the best scanners you can afford. Do not hesitate to go to a service bureau to use their drum scanner if the quality requirements merit the charges.

2. **Use adjustment layers whenever you have time.** It is true that the keyboard shortcuts for Levels and Curves really do save a lot of time. Many times when I have an image where I know what I need to do, and I am on a tight deadline, I just use the Command/Control L for Levels, and Command/Control M for Curves. Remember, the normal time allotted by the normal prices for halftones is about 10 minutes to scan, correct, adjust, clean up, sharpen, and save. Often that leaves no time for adjustment layers, even though they can save you if reediting is required.

3. **Keep your adjustments as small as possible.** Large adjustments cause posterization, loss of detail in highlights or shadows, and the emphasis of dirt and other artifacts. **BE GENTLE!**

4. **Try to do all adjustments in one step.** Multiple adjustments cause increasing damage. All adjustments lose data. You cannot get it back. Use adjustment layers if you must, as you learn your craft. You will find that my basic procedure, which follows, has you making at least three adjustments. You have to be careful. If you apply adjustments on top of adjustments, you are begging for trouble and compromised images.

5. **If necessary, make backups.** Normally I discourage multiple copies of images. This is probably a reaction to what I see students do, day in and day out. I've seen twenty-five or more versions of an image and the student is asking me to help figure out which one he or she really wanted to use. The solution is to make backups sparingly, with accurate naming. An image called WindowRockCurves30/60.psd is fairly easy to understand.

6. **Immediately save a PSD, and work on a copy.** In general, the advice is, *"Take it easy!"* If you are not careful, you can quickly destroy the best original image. Having a copy of the original scan will save you more often than you'll be willing to admit.

Practical production procedures

A seven-step process

There are seven necessary steps for every halftone, at the very least (step 6 is often a two-part procedure):

1. **Locate the best possible photo**

2. **Determine the size and resolution**

3. **Preadjust the scan**

4. **Crop to size**

5. **Clean up the image**

6. **Check levels and adjust curve for dot gain**

7. **Sharpen**

Let's take these steps one at a time. It is very important that you not only memorize the steps but also understand why you are doing them in this order. All of these steps are essential for a professional result.

#1—Photo location

There are several things going on here. Many of you probably do not realize the cost of a professional photo. There is usually a $1,000 minimum for a photo shoot. This is just for the photographer's time and equipment. The final prints or transparencies are an additional cost. This is why a professional-quality stock photo can easily cost you $300 (although stock-photo CDs have come down to $200–$300 or so for 50 images or so).

What you get for this money should be an exceptionally sharply focused, well-composed, high-contrast image that will reproduce beautifully. With a custom photo shoot, you should get a designed image that exactly meets your need. However, the days of that type of budget are long gone for most of us. Today we tend to shoot our own or deal with customer-supplied snapshots. If you are shooting your own, get a good camera!

The problem of digital cameras

One problem that has recently surfaced is the advent of the consumer-priced digital cameras. The vast majority have been low resolution, not very sharp, with major color shifts. Often they shoot extremely dark pictures. Even a 3-megapixel camera will barely do a 5" x 7" photo at 300 dpi. Professional digital cameras are still not cheap. Think in terms of a camera back for a Hasselblad. The back will be several thousand and the camera itself will too.

If you are just doing Web work, the new consumer cameras can do super work. For professional 300 dpi shots, you still need 6 megapixels, superb optics in the lens, excellent exposure control, and so on. Yes, there are many pros working entirely digital. However, when you start asking serious questions, they all have five figures or more invested in their cameras — not to mention lights, backdrops, cases, computers, and so on. Most of them have the fastest PowerBook just to take into the field to handle the shots straight off the camera. Also be very careful of the download speed. I have used some cameras that took 20 minutes or more to download the images after they were shot.

You are responsible for the quality of the images

As with most areas of desktop publishing, the responsibility for the quality of the photos has become yours. You need to examine all pictures for sharpness, dirt, bad composition, and so on. Sharpness is especially important. Scanning is going to soften your pix regardless. If they start soft, they will probably be unredeemable. Even Unsharp Mask has to have edges to sharpen. This is especially true if you have to rescreen.

 Rescreening: One of the things to be especially careful of is pre-printed images. Most people do not realize that printed images are broken into dots. To fix the photo, you will have to blur it until the dots disappear and then resharpen it. You can do a fairly good job, but it certainly compromises the image.

 WARNING! You must be extremely careful to watch out for inkjet prints submitted as photos (especially if they are black and white). They often look very good at first glance. However, these are worse than preprinted images. They are all printed stochastic (random dot) and the dot sizes are very large. You will have a very difficult time saving these abominations — if they can be saved at all.

Processing dirt

Increasingly, many of the photos you get will be unusable because of processing dirt — white spots (from the neg), black spots (dirt on the printed emulsion), hairs, scratches, and more. Some can be dirt on your scanner glass, but not usually. All professional processing was formerly done by specialized color labs that took great care (and charged a lot). Except for the larger cities, these have disappeared (at least partially because the price had gone through the roof). Even camera shops now simply send their film to processing mills where the film is loaded, without inspection, into machines that give you an average processing quality. However, there is no such thing as an average photo. Most of you will never know the control that was possible with hand processing — for all practical purposes, it is gone forever or has become prohibitively expensive.

So, what is the bottom line?

You do the best you can. Shooting your own photos solves all of the copyright problems. You will need at least a good 35mm camera with focus and f-stop adjustments. Many of the new, better-quality, auto-focus, auto-exposure cameras will do well. See if there is a local processor that cares about quality (even twice the price is well worth it).

Here are some general guidelines:

1. Bad color casts are not a horrible problem for grayscale halftones. They are terminal for color separations.

2. You are better off with a lesser quality photo that is sharp and crisp than with a super composition that is soft or blurred.

3. A sharp, crisp shot of a group can often provide that portrait of the person you need (tightly cropped and greatly enlarged, of course).

4. Many compositional problems — like that telephone pole growing out of her skull — can be easily fixed with the cloning tool.

5. Finally, make sure that the picture chosen is lined up square. You certainly do not want to be forced to rotate the image in Photoshop. Not only is it slow, but it also softens the image. If your image is crooked, use a drawing board and T-square or a parallel rule to trim the top edge square or mount the picture square on a heavy sheet of paper.

#2—Set the size and resolution

Of course, this isn't quite as simple as it looks either. It helps to know why you need to do this. Basically, you need to remember how bitmaps work and what printers require. Let's deal with the size first. You need to create your halftone to size. In other words, you do not want to resize your photo in page layout. You want to import it and leave it at 100%.

As you can see to the left, resizing a bitmap causes some real problems with the edges of your image. Even in the simple enlarged rectangle depicted, the side and corner pixels have large color shifts, which blur the edges of the image. If this were a red square in a blue background, all of the blurring would be purple. Now, it can be argued that this blurring is insignificant (normally a hundredth of an inch or less), and this is true. But the blurring does occur.

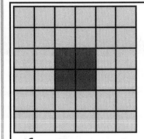 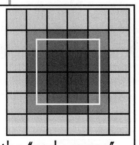

If we try to resize the "red square", on the left, to the square shown by the white line on the right, the pixels become a mixture of the colors by percentage, for a pixel can only be one color. This blurs the edges.

The larger problem is the way page layout software prepares your scanned image for printing. Basically, modifying the halftone in page layout increases the RAM requirements necessary to print it. So, the basic advice is don't do it. I'm not saying that you can't do it. I'm saying that it may cause problems — and you do not need more problems with your output.

This resizing of finished halftones can cause real agony. A couple of years ago, a student scanned in a colored pencil drawing he had created at 100%. For some reason (known only to his rather simple mind), he started resizing it on the screen to fit his layout, using the Image Size dialog box. After five of these adjustments, the image was a shapeless blur, all facial features were gone, all detail had disappeared. There was no way to fix it. He had to start over.

Thankfully, the solution is simple — preplan! Do not scan your halftones until you have a layout for your document, until you have determined where the image is going, and until you have decided how large it has to be. I highly recommend that you determine an exact size for your halftone *before* you scan. Then you can measure your photo and determine the scaling percentage needed to properly size your halftone. If your math is weak, purchase a proportional wheel from your local art supply store. It should be much less than $10. To clarify for the rest of this step of the procedure: 100% is same size; 50% is half size; and 200% is twice the size.

What resolution do I need to use when I scan my images?

The answer here depends on your final output. This is one of the reasons why you need to pick your printer before you start to design. If you are going to a high-resolution imagesetter, platesetter, or digital press, every linescreen dot should be an average of a little four-pixel square. Simply put, that is the way PostScript works when it calculates the appropriate size of a halftone dot.

If your final output is a cheap inkjet, a stochastic imagesetter, or stochastic plate, then you can use the resolution that most closely matches the apparent linescreen. This would be 85- to 100-line screen for the cheap inkjets, and 150- to 200-line screen for the high resolution output.

So, with normal linescreen halftones, the scanner resolution should be set with the spi at twice the final lpi when adjusted for sizing. This requires some simple math. If you are scanning at 100%, a 150-line halftone should be scanned and saved at 300 spi/ppi, a 100-line image at 200 spi, an 85-line image at 170 spi, and so on. If you have to enlarge or reduce the image, you

The original scan

Here is the scan we started with for this little talk. It is dark and almost useless as it was scanned.

need to apply that scaling percentage to the scanning resolution. The formula looks like this:

$$lpi \times 2 \times percent\ scaled = spi$$

So, if you are scanning a photo that you are enlarging 145% and printing at 85line screen, the figures are 85 x 2 x 1.45 = 246.5 spi. To be totally accurate, the resolution only has to be 1.5 to 2 times the linescreen. You can fudge a little, but using twice the resolution is much easier to calculate. Anything more than twice the linescreen is simply discarded by the computer. You certainly do not want to scan at a higher resolution than necessary. You will find that your file sizes are already larger than you want to deal with, anyway. In fact, the only time it is necessary to use less than twice the linescreen is to save storage space.

Scanner scaling

This is where a good plug-in saves you time. If you can change the scaling percentage in the plug-in easily, the scaling percentage is figured out for you when the image is scanned. I have had several scanners, though, where this was not easy at all. In fact, it was easier (and much faster) to calculate the scaling percentage with a wheel.

 What if you have to scan and return the photos, and you simply do not know the size, or the image will be used in several places and sizes? All you can do, in this case, is make sure you scan it at the largest size and highest resolution you think you might ever need. Yes, it will be a huge file, but there is no option.

Resolution limits in your scanner

This is where you will get burned if you bought a cheap (under $500) scanner. One of the things least often understood by digital artists is that interpolation is useless for scanning continuous tone artwork. To rephrase, if your scanner is rated at 600 x 1200 dpi, and it offers interpolation to 9600 dpi, the most you can scan your photos at is the native or optical resolution, or 600 dpi. This greatly compromises your enlargement abilities.

In practical terms, while working with 150-line images, the most you can enlarge them is 200% if you only have a 600 dpi scanner. An image scanned at 600 dpi and enlarged 200% ends up at 300 dpi, as you know. Now you can see why slide scanners commonly use 6000 dpi. A 300-dpi scanner is really only usable for Web work.

Uses of interpolation

Interpolation is guessing. If one pixel is 30% and the next is 50%, then it seems reasonable that a pixel put between them would be 40%. Sounds good unless that pixel between is a gray hair in the midst of a brown head and should read 15%. In practical terms, interpolation only works for lineart. Artwork that is scanned in black-and-white can be interpolated, and it will actually help image quality.

Lineart should be scanned at the resolution of the imagesetter

With lineart, the scanner already knows that the pixel has to be black or white. All it has to do is determine the location of the colors. Here, the higher the resolution, the smoother the image shapes are. However, super-high interpolations will not add detail. Remember, all the pixels between the original optical pixels are merely educated guesses.

A stupid computer will never guess that there really should be finer lines there, or that there is supposed to be crosshatching instead of a gray area. All you can do is the best you can. If you are outputting on a 1200 dpi laser printer, scan lineart at 1200 dpi. If your final output is a 600 dpi DocuTech, then anything more than 600 dpi is a waste of space.

#3—Adjust the scan

There are many ways to adjust the scan. All scanning software is different. Some are separate applications. The majority are plug-ins to Photoshop. On the PC side they all use TWAIN. On the Mac side, only ports from windows use TWAIN. I have no idea why, but all the TWAIN-compliant plug-ins have been limited (but then my exposure to them has been limited).

This section merely highlights features that are common to all professionally capable setups. When you get into consumer scanners, beware! When you purchase your scanner, one of the most important considerations is the Photoshop plug-in used. With a good plug-in, you will have a great deal of control over your scanning. This is why I made the brand name recommendations I made in chapter 1. This, for example, is why I recommend you avoid H–P scanners, which are excellent scanners but have a history of lousy software.

To illustrate the problem, let me share some of the problems with what I am using for this book. It is a cheap, consumer Epson, the 636U. It uses a plug-in with a TWAIN interface, which I blame for all of its ills (deservedly or

Lineart scans

This scan is at **2400** dpi. See if it is better than the other version found on page 144. It is at 1200 dpi. I doubt if you will see any real differences — unless my printer uses the 1200 dpi setting on its image-setter, which might blur this image a little.

Hand rescreening

After you scan your pre-printed image, open it and view it at 100% (double-click on the Zoom tool). Look carefully for moiré patterns. They will be found on any smooth area of the image. Choose Filter>> Gaussian Blur and adjust the Radius until the moiré disappears. Do it a minimal amount, but the moiré has to be completely gone. Otherwise it will reappear when you sharpen later. Often you have to do hand work with the Blur and Sharpen tools on these images.

not). I really like the scanner, but I have had to make several compromises to my working techniques, simply because the plug-in is missing many of the features I came to take for granted with my previous Umaxs and Linocolors. It does scan extremely fast, though, and that makes up for a multitude of sins. However, all I can use it for is raw scans. With earlier scanners (some admittedly made for professional use), I could freely set rotation angles, flip, rescreen, set highlight and shadow points, and most importantly, adjust the gamma to lighten the midtones as needed before scanning. With the cheap Epson TWAIN plug-in, those are all gone. I can see several controls that are grayed out. I assume they are available for their higher priced models.

A good plug-in will have the following controls

Good scanning software has a pair of tools that look like eyedroppers: one black, one white. These are used to pick out the highlight and shadow points, or the lightest and darkest portions of your image. In the case of the photo on page 174, many points in the rocks were the lightest tint. The darkest shadows, by far, were in the bushes in the upper right. (However, in my case, I was able to avoid this complication by clicking on the Auto-Adjust button in the Umax plug-in software.)

Next, this photo took a gamma adjustment of 1.2. *Gamma* describes the contrast of an image. In practical terms, in the scanning software, it is indicated by numbers like 1.2, .8, or 1.6. All you need to know is that numbers higher than 1.0 lighten the midtones. Lower numbers darken them. An average image will need a scanning gamma of around 1.5, but this is an individual setting for each scan. It also varies widely between scanners. Usually the cheaper the scanner, the darker it scans.

As mentioned, many images will have to be rescreened. If they are printed images, they are already broken up into dots. These dots cause moirés (which we will discuss in the color printing section) or horrendous graininess. Many plug-ins have rescreening options. I find that few of them work well, except on the higher-priced scanners

Be very careful not to go to extremes with any of these adjustments. You can easily posterize highlights, shadows, or the entire image. As with almost any tool, **IF YOU HAVE TO FORCE IT YOU ARE DOING IT WRONG**. We are talking about a series of gentle tweaks rather than strong global color shifts.

#4—Crop the scan to size

It is usually better to make sure that you scan enough area to totally cover the image you need. The scanner prescan previews are not accurate enough for tight scanning. It is far better to scan oversize and crop than it is to have to rescan because you cut off an edge.

As soon as possible, though, you should crop to size. This saves surprising amounts of disk space. In addition, cropping often solves image problems. Be careful here. The photographer is likely to insist that you place the image full frame. This is rarely done. Remember, we are talking about communication and graphic design, not fine art. You need to crop to focus on the message. Poor photos often have to be cropped severely.

Fixed-size crops

Here is one place where I often change the procedural order. Many times, I do not know exactly how I want to crop the photo before I get it into Photoshop. One of the nice things about Photoshop's cropping tool is that it can be set up to automatically resize, rotate, and set the resolution. Remember, we have mentioned many times the need for care in size/resolution adjustments. One adjustment is enough. More than that can start to cause visible damage. The Cropping tool, gives the option to select "fixed size." In PS6, just type the numbers in the fields.

By using the fixed-size option, I get a constrained proportional marquee that can be sized to the best appearance, and rotated to the best alignment. When I double-click inside the marquee, the scan is cropped, rotated, and resized in one step. This saves a great deal of image degradation via experimentation. If I don't like the first attempt, I simply undo and retry. This is also the perfect solution when many heads must be the same size.

#5—Clean up the image

You should have already cropped out as much damage as you possibly could. The two most common tools to use for actual repairs are the cloning tool (or Rubber Stamp) and the History brush. With the stamp, you need to randomly clone around the damage from all sides. You have to place your clone source as close to the damage as possible. **Avoid overlapping the clone source, as this will generate unnatural repeating patterns.**

Sometimes the Sharpen/Blur and the Burn/Dodge tools help. Occasionally you can even get in there with the airbrush or brush. You need to work transparently, a little at a time. It is extremely easy to add changes that are obvious. The human hand is very clumsy at recreating reality. Some of you will have a real gift for it. It's an important part of your résumé.

The History brush is a wonderfully quick method of cleaning up. Painting with a blurred snapshot, using the Lighten and Darken blending modes, will allow you to simply *paint away* dirt. You must be careful. Paint too much and you substitute the blurred snapshot for the actual image.

Increasingly, you must spend a good amount of time at this point cleaning up processing dirt. This is where those expensive, professionally processed photos will save you a great deal of time and money. You need to

> **In fact, a general rule of thumb is: "The worse the photo, the tighter the crop."**

double-click on the Magnification tool, to bring your image to 100% (which Photoshop defines as one pixel in the image to one pixel on the monitor). Then, hit the Home key to go to the upper left corner and use the Page Down key to clean up that vertical swath. Then click on the bottom scrolling bar to move over a full screen and Page Up. Tile over the entire image, cloning out all the dirt. On professional photos, this will take a few seconds. With cheap 35mm slides it can take well over an hour (or much more).

#6a—Check and adjust the levels

Level adjustment is a particular capability of Photoshop. Although a few other programs have similar controls on a rudimentary basis, only Photoshop makes it easy. Halftone creation depends on either level adjustment or curve adjustment. Some teachers emphasize the histogram (found in the Levels dialog box), but this is not very powerful.

Although many writers swear by the histogram, many others who work with halftones (like myself) swear at it. Much better is the Curves dialog box. This charts the gray levels as a continuous curve that shows what each grayscale level is before correction and what it will become when the changes are applied. In very little time, the Curves dialog box becomes an extension of your mind. You quickly learn to think in a grayscale curve.

Quick check with Levels

To the left are the histograms from the Levels dialog box of the adjusted scan on the top and the unadjusted scan on the bottom. As you can see, the scanner plug-in made a huge difference. The adjusted scan has already adjusted the levels to a nice spread from 0–255.

The unadjusted histogram, however, shows some things that you need to be looking for. If you look to the left side of the histogram, you can clearly see, in this case that many of the darker shadows have been clipped. In fact, if you look at the adjusted scan above it, you can see which levels have been clipped.

What this means, in practical terms, is that many of the darker grays are now completely black. If you have a scanner that does this to you a lot, you have a real problem. My newer Epson, for example, does not do this at all. It may scan very dark and red, but at least it does not clip off data that cannot be recovered.

However, a quick check with Levels can reveal problems like what you see above right. Here you can see at a glance that we have some real problems. The levels are all tightly compressed, with almost no shadows. In fact, the

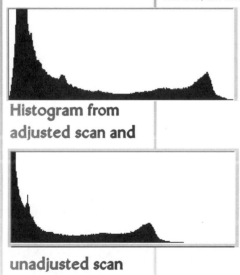

Histogram from adjusted scan and

unadjusted scan

dark shadows are a mere horizontal line, which suggests that there are very few of them. The same is true of the bright highlights.

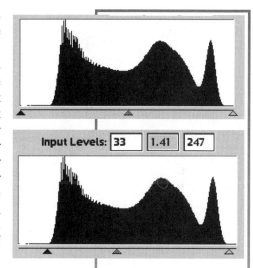

This type of problem is relatively easy to fix in Levels with simple adjustments to the three sliders. You can see what I used here. I tried clicking the Auto button but the left slider then clipped too many of the shadows and the right slider eliminated all the white areas in favor of the yellow areas of the image (yes, this is a histogram from a color scan). Bringing in the shadow and highlight sliders really lost detail in the midtones and made everything look far too dark. So, the final little adjustment was to move the gamma slider to the left a quarter-inch or so. As you can see, I ended up with a gamma of 1.41 — which lightened the midtones a lot and greatly improved the basic look of the image.

This is where the good plug-in is important. I had to really look for the example found above right. In general, my scanners have produced scans where the histogram looks like the one for the adjusted scan on the bottom of page 178. In those cases, there is simply nothing to be done in Levels. In fact, I confess, I rarely use levels at all.

6b—Adjust the curve

As I just mentioned, I usually skip the Levels substep. I can do this because I know what my scanner normally does. Also, Curves has become such a part of my adjustments that I can no longer stand the limitations of Levels. There is certainly nothing wrong with doing both. If there is any doubt, I simply hit Command/Control-L before opening Curves. If I see anything radically wrong in the histogram, I make a quick adjustment.

Normally though, even the quick look at the histogram is merely to give me a rough starting point for Curves where the control really is. A mere glance at a histogram will show me immediately what to fix in Curves. Adjusting the curve gives me so much more control that the crude global adjustments with Levels become relatively useless.

Let's look at the curve for the adjusted scan. We've already seen that we have a nicely preadjusted histogram. Therefore, we know the levels are nicely spread, at least. However, a quick look at the image shows some real problems. There is very little detail in the shadows, especially in the bushes. They are so dark that I know dot gain is going to make the bush a black blob. Also her shoulder is almost glaring in the strength of the high desert sun. Her face is almost posterized the left is so much darker than the right.

There are a lot of little tweaks we can do to fix these things. First, however, we have to revisit the basic dot gain adjustments, most importantly the endpoint settings. What Photoshop calls dot gain only affects the 50% level. The problem is that all the shadows go to a solid black if you are not careful.

So, where do you start? The most important thing is setting the endpoints – what I have been calling the dot range. I have given you a little table to get you started. However, this will need to be modified heavily by reality and experience.

Probably the most difficult thing for the new designer who is getting into the production planning process is to realize that all printshops and copy shops have different equipment, in differing states of maintenance and repair, and press operators that run the gamut from old, burnt-out alcoholics to highly competitive, wonderfully trained young people. As an aside, I would be looking for female press operators. They tend to have a better handle on the attention to detail needed.

On the chart

Believe it or not, these figures tend to be a little optimistic. You will probably find that you will have to cut these figures further, largely depending upon your budget. The cheaper you go the more the dot gain. I have seen down-and-dirty copy shops with DocuTechs that had a 10% dot gain and a 5-90 range. You have to work hard to abuse a machine that badly. A DocuTech in good shape should have a dot gain of 0%.

The chart, plus your communication with the printer, should make the adjustment for dot gain very simple. All you have to do is communicate with your output supplier (printshop, copy shop, or

Dot ranges (rough guide)

Sheet-Fed Duplicators:	Uncoated	Coated
Integrated	10-70	N/A
Segregated	10-80	7-85

Sheet-Fed Presses:		
Old, beat-up	10-85	7-90
Top quality	7-90	5-95

Web Presses:	Newsprint	Uncoated	Coated
Duplicators	12-65	10-75	N/A
Cold-set	12-75	10-85	5-85
Heat-set	N/A	7-85	5-90

These figures vary greatly according to machine quality, operator skill, and company attitude. In addition, the quality of the stock affects these numbers. Cheap paper has more dot gain. Text gains more than offset. Quality bond gains less than offset because of the heavy sizing. Companies that maintain their presses well have much less dot gain.

personal printer experience) to find out what the adjustments should be. As already mentioned, the ranges in the black-and-white sections of most books, printed on ordinary uncoated offset, are 5–85. That is what we need for our sample.

These adjustments are very simple to make. The midtones are a little more complicated, as we will see in a bit. To adjust the shadow so the darkest point is 85%, simply click on the 100% point horizontally and drag it down until the readout says 85%. To adjust the highlight to 5%, click on the 0% point and drag it up until the readout is 5%.

At this point, the photo is adjusted for dot gain according to the printer's specs: 5–85. Of course, it is rarely as simple as that. We have just begun to touch the power of the Curves box. When those adjustments were made, the shadows on the side of her face were way too dark and her face had too much contrast. The contrast of her entire head had to be softened, since this is the focal point of the photograph. The detail in her hair had to be increased and the values of the two sides of her face brought into balance.

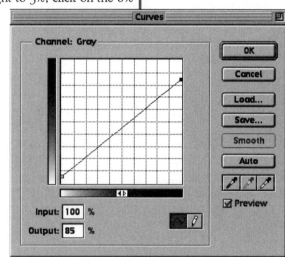

So, several little adjustments were made, very carefully. By moving the cursor over the scanned image, I get an eyedropper and a little circle that moves up and down the curve in the dialog box, showing me what the actual colors are at the point covered by the cursor. I can also read the numbers in the lower left corner, below the graphed curve (or on the Info palette). With that knowledge, any adjustment I need can be made. Often I have to select certain areas (I usually use a feathered selection to make the small area adjustments less obvious), to apply specific adjustments to smaller areas. This is where you will quickly become addicted to Curves.

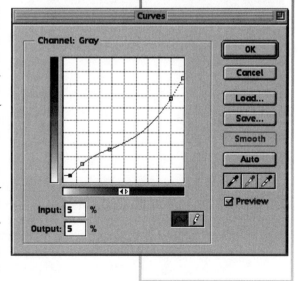

The steeper the slope of the curve, the more contrast there is. Total contrast (or black-and-white) is a vertical line wherever the break between white and black should be. In this case, more contrast is desired in the 80-100% range. The left side of her face was too dark; clicking on that area produced a little circle on the curve at the 82%

input location. By clicking on that point and dragging it down to 58%, a solution was found. The problem was that this gave a smooth curve that blew out all the highlights and lighter midtones.

To fix this, another point was needed. Clicking at the 40% input location and dragging it back up to 27% brought the highlights and the lighter midtones back. However, the curve was still too flat in the highlights on the rock she is seated on. So, I clicked on the 15% and dragged it up to 15% again. Finally, I dragged the zero point to the right until the 5% was 5% again. This gave a little more contrast to the highlights. Satisfied, I clicked OK and saved the image. Without those last points, the photo was an unusable mess.

#7—Sharpen with Unsharp Mask

As you can see above left, the current image is in pretty good shape. But there is still one final step. Scanning always blurs the image to some degree. Continuous tone does not submit easily to being crammed into those tiny squares. No matter how good your scanner, pixilated scans need sharpening.

The bottom image has Unsharp Mask applied at 75% Amount, 1.0 pixel Radius, and 0 Threshold. I applied it three times and then touched up areas with the Blur and Sharpen tools to get rid of artifacts in areas that were too sharp, and to blur back portions of the background that were competing. I added some extra sharpening to the jewelry. As you can see, it is a lot sharper. This is not a minor thing, but a major necessity.

Final comments

All these operations have to be done on almost every halftone. At the very least, they have to be checked thoroughly. At this point, heed a few final words of warning. If at all possible, create your halftone at the finished size. This is seldom mentioned by other writers, but it makes things flow much more smoothly. Most simply make the halftone oversize and then crop it in page layout. This is a makeshift approach, at best. Changing the size of imported halftones often softens them, at the very least. It can result in pixelation that ruins the halftone.

Halftone production is (and will remain) a craft, not a science. Be very careful of automated solutions to halftone production. There is no such thing as an "average" picture. Examine every photo carefully before scanning. Some pictures have textures that can never be sharpened. Some artwork is so light that everything has to be darkened. Others are so dark that the brightest highlight is 40%. Sometimes you can simply change that beast to a 7-85 like the others. Other times, lightening the highlights in that manner ruins the picture. Sorry, but you are going to have to think and decide for each scan. *That is why you are getting the big bucks.*

Special problems

Pencil drawings cause all kinds of problems. Here the highlights have to go to white, but extreme care has to be taken so the delicate light detail is not lost. Also, the darkest areas of a pencil drawing are 60% or so. This means that *after* dot gain, the darkest areas are 60%.

Some of the worst things to scan are old engravings. You almost always have to scan and rescan until you get the best you can. Scanning as lineart with very high resolution sometimes works (using an amount of 500% in Unsharp Mask). Other times you have to scan grayscale, use Gaussian blur to get rid of most of the fine crosshatching, and then sharpen very carefully.

You will have a lot of trouble with photos that have fabric with an obvious weave. You will not be able to sharpen the fabric at all. In fact, you will often have to blur the fabric until you cannot see the weave, just to make it look like "normal" fabric.

Even photos vary wildly. We will cover many of the finer correction decisions in chapter 11, on printing color. Basically, you need to remember that a steeper curve increases the contrast, and a flatter curve eliminates contrast. Often you have to select certain areas for an increase in contrast and others where detail must be eliminated. Just don't beat the poor photo to death. Remember, you are usually only getting $10–$20 for that halftone. Anything over a half hour should be charged for or you are losing money.

Where should you be by this time?

Working, working, working. If at all possible, you should be producing halftones and printing them on the widest variety of printers to begin understanding what technology does to the prints. You should be practicing, doing Miniskills and Skill Exams.

DISCUSSION

You should be discussing the problems with halftone production with each other. One of the best ways to improve your skills is to expand your horizons by brainstorming with other designers.

Talk among yourselves...

Knowledge Retention

1. What is the problem with Levels?

2. How do you add contrast with Curves?

3. How do you use a History brush to eliminate dirt?

4. How does Photoshop define dot gain?

5. What affects the dot range?

6. Why is a 600 dpi scanner a problem?

7. Why do you have to pick your printer before you start?

Chapter 10

Color

Concepts:

1. RBY

2. RGB

3. CMYK

4. Hi-fi color

5. Spot color

6. Standard color

7. PMS color

Definitions are found in the Glossary.

Understanding the color spaces we work with digitally

Chapter Objectives:

By giving students a clear understanding of how publishing uses color, this chapter will enable students to:

1. choose an appropriate color space to work in
2. explain spot color
3. describe hi-fi color
4. explain the current state of color printing.

Lab Work for Chapter:

1. Finish more of the theory exams and email for grading.
2. Finish more Miniskills.
3. Finish more Skill Exams.

These images can be seen
in color on pages 205—206

But the color doesn't match!

Beyond black and white

As you have seen, the production of black-and-white or grayscale work in Photoshop is complicated enough. Color increases the complication to an entirely new dimension. For this reason, it will be wise for you to work in black and white as much as possible to develop your skills. You should get grayscale solved first, before you tackle color. More than that, you will find that even your color pieces should be proofed in grayscale to see the structure of the design more clearly. Color usually lessens your contrast and confuses your eye. It makes your projects much more complicated, and your print projects much more expensive.

Color blindness is more common than you think

Also, very importantly, remember that there are sizable portions of your readership who are color blind. Statistics would suggest over 10% — almost entirely male. Your pieces have to work even if reduced to grayscale and even if only part of the colors are seen. Add color only when it is required by your client and/or circumstances. We'll just mention the cost increases created by more color: every additional color adds the same costs as the first color. That is, two-color is almost twice as expensive, three-color is three times as expensive, and so on. Of course on the Web, color is free — but very limited.

Having said that, we must acknowledge reality. One of the primary results of the digital revolution is a vast increase in color usage. Some studies suggest that full color printing is up to almost 25% of printing in some areas of the industry. This is up from industry-wide figures of less than 3% process color maximum in the late 1980s. It has become increasingly easy to work in color, proof in color, and print or publish in color. On the Web it is extremely unusual not to use color. The problem with this is the same one: many new desktop publishers do not have a clue.

Reality is not reproducible.

You need to thoroughly understand that the colors used in digital publishing come from several color sources and theories, none of which

are reproducible in the broader color arena. In other words, reality is not reproducible. Fine art cannot reproduce reality, and fine art cannot be reproduced (unless it is designed to be reproducible by a knowledgeable artist). Monitor color cannot be calibrated (as far as general Web use is concerned) and it normally cannot be reproduced by printing inks without substantial color shifts. Printing color cannot be viewed on the screen (unless you spend a lot of money for the software and hardware to calibrate your monitor, printer, scanner, and so on.). We'll cover the beginnings of readily available color management in chapter 14. For now, let's review general color theory beyond publishing.

WHICH COLORS ARE YOU USING

Color spaces or Color systems?

Color space is the term used to describe the colors available in a given color theory using primary colors. In a color space, all of the colors in that space are made from mixtures of the three primary colors. Beyond that, the color spaces we will be talking about are all full-spectrum color spaces. In other words, the color produced by mixing the primaries includes all areas of the visible spectrum, giving the possibility of producing the illusion of reality.

A *color system* is a standard set of colors; the classic example is the 64 standard colors found in the Crayola system (which are extremely useful in software that has them available). There is a color space for TV, a space and a system for the Web, a space and several systems for printing, a space and many systems for fine art, and so on. The problem is that the different colors existing in the various color spaces may not be available in other spaces or systems of color. In fact, the progression from reality to fine art to monitors to process printing to spot color continuously limits the colors available. More than that, printing has colors that are not available on a monitor and spot colors may be available neither on a monitor nor in process color print. Many people try to restrict the Web to a 216-color system. To work in publishing, it is necessary to be familiar with three-color spaces plus several color systems.

Fine art color

The first of these three spaces is the one you learned in elementary school. As you all know from early childhood, there are three primary colors: red, blue, and yellow. You were told that any color could be made with these three. As you found out (if you played with color at all), this is not so. I still remember the frustration, somewhere in the fourth or fifth grade, of trying to generate a strong vibrant purple by mixing red and blue.

The red, blue, yellow (RBY) color space was the first one you learned. It claims to be all-encompassing, but it is not. There are many colors outside the RBY color space. Unfortunately, color does not lend itself to neat, tidy analysis. Actual physical production of colors can be immensely frustrating. There are many colors in reality that cannot be reproduced by any known mixture of pigments or dyes. However, it is possible to produce a convincing representation of reality.

The problem with the RBY color space is simply that there are no true RBY primary pigments. Remember, the idea of primary colors is that they, and mixtures of them, must make up all the colors in the color space. The theory works well when trying to predict what colors will result when mixing cobalt yellow and ultramarine blue, for example. However, the practical use of the color space has nothing to do with mixing primaries. It simply becomes a way to anticipate how the various fine art pigments are going to interact.

The complexity of color vision

It's amazing that we can see at all. The eye sees in a different color space — red, green, blue (RGB) — but the RGB of the human eye goes far beyond the capabilities of any man-made reproduction system. What we see as specific colors are in fact the reactions of our optic nerves to mixtures of electromagnetic waves. How that really works is of mere scientific interest. What is important is the realization that a red rose is much more than that.

Most people are not aware that a red rose is a different color every time it is seen. The eye sends signals to the brain. The brain places that input in a category that says "red rose." The mind literally changes the perception to make it match past experiences of roses from that bush. Unless you train it differently, your brain sees what it expects to see. One of the most difficult skills for a fine artist or a graphic designer is training your eye to *see* reality instead of your mind's construction of reality.

It is important to note that there is a major difference in viewed color, even with an identical rose. We are not talking about the color of the petals fading in the bright sun. Color changes constantly. The rose in the yellow light of sunrise is very different from the same rose at noon. A rose at noon with a dark blue sky at 5,000 feet above sea level is very different from the same rose under a sky with lots of white clouds. The differences are especially noticeable if it is completely overcast. The light at sea level is that fuzzy, murky haze that coastal dwellers call clear sky, and the rose is yet a different color.

I noticed, for example, as I drove into school on a bright October morning (after a week of rain) that the cottonwoods along the Rio Grande fairly exploded with flaming yellow-oranges and yellows. The colors were

so bright that they almost didn't look real. The day before I had thought to myself that the trees weren't very pretty this year. I had forgotten how important sunlight and blue sky are to the viewing of fall color. That same year, in the late afternoon sun up in the mountains north of Albuquerque on a photo shoot, we passed through a flat-bottomed valley spotted with individual cottonwoods at peak fall color. I commented to my wife that they looked like miniature frozen thunderheads climbing out of the wash with an intense yellow that almost hurt the eyes. The brilliant yellow sunlight backlighting the leaves at 4:00 P.M. under the deep blue sky made the color contrast absolutely amazing.

Reflected light

Many other things affect the color we see. We must talk a little about reflected color. That rose will change color if a woman in a brilliant yellow dress stands next to it. It will look different next to a white wall, a cedar fence, or a red brick wall. We are not talking about how the brain perceives color differently when seen against different color backgrounds. That's another story.

What you need to realize here is that the light reflected off the yellow dress colors the rose yellow on that side. The same is true of the light reflected off the walls. If there is a green bush on one side and a brick wall on the other, our poor rose will have greenish tints on the bush side and reddish ones on the brick side, all colored by the bluish ones on the top from the blue sky and the intense white highlights from the direct reflections of the sun.

This is what the impressionist painters, such as Degas, Monet, Manet, and Cézanne, were after at the turn of the century. They tried to solve the color reproduction problem by adding dots of the reflected colors in the appropriate places. They could perceive color much better than most of us can. Even then, however, the accuracy of their color was affected by several other complexities.

Light color

The next major factor to consider is the color of the light. We have already alluded to this by mentioning that our rose looks different in the yellow of sunrise, the glare of noon, or the diffuse light of a hazy sky. Artificial light sources are even more problematic. Incandescent lighting (known as tungsten lighting after the material used to make the filaments in the light bulbs) is very yellow. Fluorescent lighting is normally very blue or green, though it is possible to find warm fluorescents that are tinted pink. The pink tint mixes with the blue light to make something that is less harsh. It's weird color, though, and simply doesn't look natural. The greenish tint of fluorescents is what makes people look dead (or very ill) in its light.

Printers try to deal with this by using a concept called *color temperature.* This concept uses a temperature scale that begins at absolute zero (that place where all molecular activity ceases). This is about 273°C below zero. If we place what is called a black-body radiator into a furnace and begin heating it, we can watch it go through color changes as it gets hotter. As the heat increases, the color changes, passing from red through orange, yellow, and white to blue-white.

All you need to know is that printers need lights with a color of 3000°K or higher (the yellow of tungsten lighting) for black-and-white film. The standard used by printers for viewing printed color pieces is fluorescent lighting at 5000°K. This is an average white light. It is very close to the white light from the sun at sea level, which is around 5400°K. The sun in Santa Fe, New Mexico, at 7,000 feet above sea level, is around 6400°K. The color of the light is why so many artists are captivated by Santa Fe. A light source of 7500°K is recommended for checking press output for color uniformity. The bluish tint to the light aids the human eye in the detection of minute color differences (even though it is lousy for color proofing accuracy). It also helps to detect color misregistration.

Any printing company that is serious about quality color reproduction will have a 5000°K color booth with the walls of the booth painted a specified neutral gray. Often, all of the lighting in the press room will be 5000°K. This is not because the color looks better under this lighting. It is because a standard is needed when jobs are printed in multiple facilities in different areas of the country. Designers also need a standard for color comparison. Color at 5000°K will look very different than it does on your monitor or in your studio where you use tungsten lights. However, it will always look the same in a 5000°K light booth, no matter where that booth is built.

This color temperature has a very strong influence on printing. For example, studies have found that an identical process color piece will tend to be printed very blue if printed in Ohio or New York. The same piece printed in Tucson, Las Vegas, Albuquerque, or San Diego will have a distinct reddish bent. More than that, there are differences between the day shift, evening shift, and night shift. The day shift prints warm, the evening shift prints most accurately (though it would certainly vary as the sun sets if there are windows), and the night shifts tends toward the blue.

Wise designers do the best they can to design so their work shows best under the light source their readers will be using. Needless to say, this is a guessing game at best. A fascinating test (that can be dangerous for the clumsy) is to take a printed process color piece and carry it through several different light colors. The teaching lab in my former, traditional commercial printing area at school, for example, had a section that was tungsten and

Monitor color

Monitor colors vary widely. One of the easiest things you can do to help you see color more accurately as you work is to adjust the white point. Usually you will have at least three choices: D50, 6500K, and 9300K. Macs tend to use 9300K by default which is a very bluish intense white. 6500K is recommended for Web design because that is the closest to the normal PC monitor. D50 is the 5000°K we have mentioned. It is very helpful to use D50 when we are working in CMYK and preparing for print production.

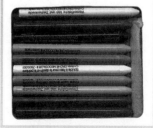

Value in landscapes

Most perspective problems that are caused by color are value problems. Distant objects of the same hue and intensity must have a much lower value to be seen in the proper place in the distance of your image. Of course, distant objects also become much bluer as they are covered by the haze of the air.

See this one in color on page 205.

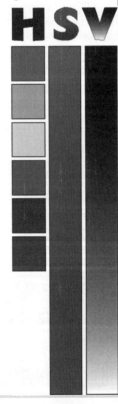

another that was fluorescent; the stripping or film assembly section was yellow, the darkroom was red, the press area was 5000°K, and outdoors at 5,000 feet the ambient color is around 6,000°K. Observing carefully, it was possible to see the colors change before your eyes as you walked through the different light colors. Some students could see the changes and some couldn't. Of course, some simply fell down.

Color terminology

Of course, the field of color (like all areas of design and publishing) uses terms that are unknown to the layperson. Some of these will be familiar to those of you with fine art training. Some are specific to printing. Again, *the goal is communication with our peers.* There is no room here for such nondefinable frivolities as blush, mauve, lime, peach, and so on. These names are simply fashion, mean different things to different people, and change definition yearly. For example, I could easily mix fifty or more colors that could be called apricot yet were very different from each other.

Fine artists are taught to break color down into three parts: hue, saturation, and value. Printers tend to substitute the word *brightness* for *value.* Software programmers (as usual) just do what they are told and have no idea how the words are used in the real world they affect.

Hue

Hue is the name of the color: blue, red, yellow-green, and so forth. There are only six hues plus white and black: red, orange, yellow, green, blue, and violet (or purple). Hues can be taken into what could be called the fourth level: like a yellow yellow-orange or a blue blue-violet, as opposed to a blue-violet or a violet blue-violet.

Saturation

Saturation is the intensity of a color, or how far it varies from neutral gray. For example, barn red is much less saturated than stop-sign red. Saturation should probably be used instead of terms like *dull* or *brilliant,* because these terms could include value variations. A saturation change could be referred to as dull green or intense green, for example.

Brightness or Value

Brightness or *value* refers to the lightness or darkness of a color. The same hue of green may be a dark green or a light green. A pink, red, and maroon could all have the same hue and saturation. The only difference in this case would be the value.

Two more terms that further define value may also be of interest when talking to fine artists. These terms are used by fine artists when mixing pigments. A fine art *tint* is a hue with white added, rather than the printers' *tint* made with the variable dots of linescreen. A *shade* is a hue with black

added. White and black cannot be added in a true full-spectrum color space like RGB or CMYK. This only works in RBY. A tint of red is pink. A shade of orange is brown. Pastels are tints. Jewel tones are shades.

HSB or HSV

Any color can be described in terms of hue, saturation, and brightness or value (HSB or HSV). A neon red, for example, could be described as an extremely saturated, extremely bright red. Barn red, however, could be referred to as an unsaturated, very dark red. The hue could be the same for both colors.

RED, YELLOW, BLUE

The artists' color wheel

The color wheel is a diagrammatic illustration of the color space that was taught to you in grade school. What you need to understand is the relationship of colors. It does not help very much to understand that each color is a certain wavelength on the electromagnetic spectrum. It may be of interest to a color scientist, but that has little or nothing to do with what designers use in color.

The wavelengths of visible light are measured in billionths of a meter and cover the range from 400 millimicrons to 750 millimicrons. The color change here is linear, starting from invisible ultraviolet through violet, blue, green, yellow, orange, red, and ending invisibly with infrared. This is the spectrum we see in a rainbow. In fact, the interesting thing about double rainbows (which we see frequently in the high desert) is that one of the rainbows has red inside and the other violet. The rarer triple rainbow has a band that goes from violet through red and back to violet again.

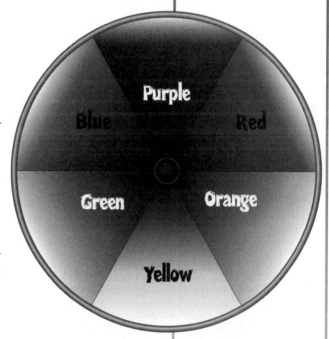

The fascinating thing about a color wheel is this: though the spectrum is linear, the color relationships are circular. In other words, red does not end things. Instead, it blends through red-violet, and violet-red, back to violet, and then continues. In addition to being continuous, some color relationships

Drawing rainbows

As an aside, when you are drawing a spectrum, a rainbow, or whatever, do not make all of the bands of equal width. To look proper, the yellow band must be much narrower. It is really not much more than a yellow line between the red and orange bands on the one side, and the green–blue–violet bands on the other. Actually, green and blue dominate, although this is not nearly as important as the narrow band of yellow.

This spectrum can be found in color on page 205

seen in the wheel work in a circular fashion. Of course, there are specialized terms to describe these relationships. You need a basic understanding of these relationships to enable you to plan a palette.

We have already mentioned one of these relationship terms: *primary colors*. The three primary colors here (of pigment) are yellow, blue, and red. With these three you can theoretically make any color. With ink or pigment, all three together make black. You can mix any two primaries and produce the color between them on the wheel. These are called *secondary colors*. This is true even though red is at one end and blue at the other end of the spectrum. If you mix them you get violet or purple (even though highly saturated purples cannot be mixed).

Complementary colors

A *complementary color pair* is a primary color and the secondary color on the opposite side of the color wheel: e.g., red/green, blue/orange, and yellow/violet. Again, all these colors have the same relationship with each other. Two complementary colors of equal saturation and value will produce a vibrating edge between them: harsh, garish, exciting, compelling, maximum color contrast.

More interesting is the fact that when you mix a primary with its complementary secondary you get neutral gray. This again boggles the mind, because the same neutral gray is produced no matter what the complementary pair is. Purple and yellow produce the same gray as red and green (assuming you have theoretically pure hues). Of course, the complement is made up of a mixture of the other two primary colors and all of the primary colors mixed together give you black — so it makes sense once you think about it.

 This graying of color from complements will take on real importance as we begin to deal with the color of separations. Muted colors (when not wanted) are almost always caused by contamination with the complement. In many cases, you make colors brighter and cleaner not by increasing the saturation but by eliminating the complement. You will find the Info palette to be of great use in this.

Available pigments

Theory works fine until reality smacks you in the face. The theoretical colors available can almost all be seen by the human eye. Finding pigments to reproduce these colors is another story. This is why artists' paints have so many color pigments. A pure red is rare; the closest would be one of the multitudinous cadmium reds. A pure yellow does not exist. They are all either orange-yellow or green-yellow to some degree. Cadmium yellow tends toward orange, strontium yellow toward green, cobalt yellow toward

green, and so on. Blues are a real problem. Those that seem pure blue are low in brightness and/or saturation.

Most pigments are muddied by their complements or a neighboring primary. As a result, most common pigments tend toward brown or muddy green. However, because of all the different pigments available, artists can reproduce almost every color in nature except for the most saturated.

Finally, the better, purer, more saturated colors are all extremely expensive. Common colors like barn red (which is iron oxide or rust) might cost $3.60 per artists' studio tube. It is very low in saturation and brightness, and the hue tends strongly to orange. The same tube filled with the best cadmium red could be more than $20. A pound of printers' ink runs $5 to $10. A pound of cad red medium could be as much as $300 or $400. Originally, ultramarine blue was ground lapis lazuli. Because lapis is a semiprecious gem, a tube of ultramarine blue would cost well over $1,000 a tube (if it hadn't been removed from the market several years ago). Obviously, printers had to find a better solution.

Printers' problems

When printing color, economics play a huge role. The cyan, magenta, and yellow toners took a long time to develop and virtually no other toner colors are available. Even with ink, usable pigments took a hard search. Plus, every separate pigment requires a separate plate, an additional printing cylinder, and so on. In practical terms, every additional plate costs about the same as the cost of the first color to produce (when paper costs are disregarded).

So, a fine art painting that used thirty different colors of paint would cost thirty times as much to print (plus the cost of the paper). Of course, this would assume unmixed colors printed on top of each other. Even if such a thing could be done (and it cannot, under normal circumstances), the economics would prevent it. The only place we find such a thing is in classical Japanese woodcut prints, for which dozens of plates were used.

The solution involved using a different color space: cyan, magenta, and yellow (CMY). This color space was developed in the later part of the nineteenth century. With the addition of black (for reasons we'll mention later) printers can produce a full-spectrum printed space that gives a convincing illusion of reality using only four-colors. These four-colors use cheap pigments that only cost about 60% more than black. Black is simply soot collected in a variety of ways from a variety of sources.

Permanence

Before we pass on to the other color spaces, there is one more consideration to be touched. Those who come from the world of fine art are

Toxicity

Additionally, fine art pigments are often very poisonous. I remember working on a gouache painting (opaque watercolor) several years ago. I absentmindedly shaped the tip of my brush with my tongue when using cobalt yellow and got extremely sick for several hours. In fact, all of the pigments mentioned by name earlier are poisonous, to one degree or another. In general, cobalts are the worst, followed by strontium, and cadmium.

Fine art prints

This is an area you should check out if you buy contemporary fine art prints. Most of them are simply printed with normal printing ink (and are therefore almost worthless as investments). If the artist went to the expense of museum-grade paper and permanent ink, a certificate will be provided certifying this fact. He or she will be very proud of the printing quality. Plus the price will be higher to cover the additional costs.

horrified to find out how impermanent (or fugitive) printing colors are. To fine artists, permanent colors are pigments that will last for several centuries or more. In fact, in fine art, permanent means 200 years with no visible fading, at barest minimum.

Except for black, no printer's ink is permanent by this definition. It is possible to specifically order permanent inks for printing and pay premium prices (see sidebar). However, this is rarely done. Printing inks are considered permanent if they retain their color (indoors) for a year. Outdoors, in the bright sun, they fade after a month. The yellows go first, followed by the reds. After a year, many process color pieces are reduced to cyan and black. After several years, even the cyan disappears.

This is really not so horrible. First of all, printers' inks fade very little if kept indoors away from bright light and/or ultraviolet light sources. Secondly, exactly how many printed materials are kept for more than a year? Most of our production is almost instantly disposable. Even critical color work, like a fashion catalog, is only good for a few months. Premium coffee-table books are another, very different story. Permanent-color ink is one of the reasons why they are so expensive.

There is an attribute of pigment that can cause severe problems. This is fugitive color. First of all, remember that all printing ink is considered fugitive, by definition, from a fine art standpoint. A fugitive color in printing is only good for about a month. In bright light, some colors fade severely in a week. Severely fugitive color like the neons (Day-Glo™ pigments) will fade in a matter of hours if not protected. If your client is concerned, suggest the use of permanent inks (warning about the expense, of course).

Fugitive color is of special concern with large format and grand format inkjet prints. Here they have developed pigmented inks and UV coatings to prolong the life of the prints. They are claiming 100 years. But then, these inks have only been available for less than five years, so they are guessing.

THE WORLD OF THE EYE AND THE MONITOR SCREEN

The colors of light

Humans see color through the rods and cones of the retina in the eye. The rods measure value and are really used only in low-light situations like dusk or pre-dawn hours when everything is seen in grayscale. The cones, however, are more complex. There are three different kinds of cones. Some are sensitive to red, some to blue, and some to green. That seems quite strange to those of us used to the color wheel mentioned earlier.

The rods and cones are amazingly sensitive. It has been calculated that a fully functioning human eye can see trillions of different colors. We can see things that no scanner, camera, or artist can reproduce. Sorry to keep harping on this, but what you see has little to do with what you get, as far as reality is concerned.

This second color space is the first that you will need to thoroughly understand for our industry. The color space our eyes use is called RGB by our industry, for the three primaries used: red, green, and blue. These are the primaries used by light and light sources. They are called *additive color.* They are additive because adding all three primary colors gives white light. White light contains all the colors.

In our industry, this is the color space used by monitors and scanners. This is where you live in the GUI, or graphic user interface, on the desktop of your computer. Everything seen in the environment on your computer screen is RGB. RGB is a full-spectrum color space like RBY or HSV. However, RGB is the first color space we have discussed that is severely limited. Many colors that are seen in reality are not available in RGB color. In fact, only a relatively small number of the colors seen in the real world can be duplicated by RGB. Of course, duplication is a mere theoretical concept when we consider the trillions of colors we see compared to the 16.7 million of the 24-bit monitor. So, we are actually talking about a millionth of the colors. More importantly, RGB is very limited in the yellows, browns, beiges, and so on.

This is normally not a problem. When in the color space, it seems as though every color is available. This is because it is a full-spectrum space – there is a good representative sampling of all six hues, most of the values, and quite of few of the saturations available in reality. However, if you bring a TV with a video of your garden into your garden, you'll see a vast difference – and not just brightness or saturation differences. Many of the hues will be different on your screen. You need to burn that into your consciousness, now. Things will get worse.

THE SPACE OF *FULL COLOR* **PRINTING**

The colors of ink

Now things get complicated. First of all, we are no longer dealing with light. So we are closer to our color wheel? Well, sort of. The problems of printing full-spectrum color were severe. Most of the problems originally involved the number of colors needed. Japanese woodcuts often used thirty to sixty colors and even they were not remotely realistic. After a full-spectrum space for printing inks was developed by Frederick Ives in 1893, the main

The TV test

If you visit your local electronics superstore, you'll quickly see that every TV reproduces the colors differently — not only in brightness and sharpness, either. Some TVs will show that shirt as blue, some as purple, some as teal. For the first time in our little discussion, we have run into the bane of our industry, accurate color reproduction. Accurate reproduction of color is virtually impossible, even on a theoretical level.

RGB/CMY star

In this little illustration, the white triangle is light and the black triangle is ink. Any two colors on the tips make the color between them when they are mixed in ink or light.

problem became *registration*. We will define this term in another chapter. For now, let's define it as the ability to place two or more colors in exact alignment with each other.

But how did we come up with a full-spectrum printing system? Around the middle of the nineteenth century, a Frenchman wrote about RBY theory. This was never developed into a usable printing system. In the last two decades of that century, Ives turned from printing to an intense study of photographic color reproduction. By using pigments that are the complements to RGB hues, a printing system was developed, with Fred showing the world in 1893. By the turn of the century, almost all printers knew the general theory. Publications like *National Geographic* were being printed in full color.

To understand how this works, we need to leave additive color and reenter the space of subtractive color. RBY is subtractive. Subtractive color uses primaries that, when added together, produce black. These primaries absorb light. When added together, they absorb all light, leaving black (if the primaries are pure).

This is the major full-spectrum color space you need to know for printing. It was discovered that reproductive camera shots of color originals using red, green, and blue filters created negatives that could be printed in the subtractive primaries to reproduce the original colors. These subtractive primaries are cyan, magenta, and yellow (CMY). This process is called *separation*. The following shows you how CMY colors are related to RGB when starting with white light and white paper:

- Magenta – The color seen when all green light is eliminated. The negative produced through a green filter.
- Cyan – The color seen when all red light is eliminated. The negative produced through a red filter.
- Yellow – The color seen when all blue light is eliminated. The negative produced through a blue filter.
- Black – The color seen when all RGB is eliminated. The negative produced through a neutral-density filter.

Process color

Process color uses the separation concept to print full-spectrum images. There are some real problems, however. Even though process color

covers the entire spectrum, it misses many colors. Remember, RGB only covers 60 to 70% of all colors, and CMY covers a little less than that. This is further confused by the fact that RGB cannot reproduce some CMY colors, and CMY cannot reproduce many RGB colors.

Again (due to the fact that process color is full-spectrum), if you restrict yourself to the color space, it seems real. However, we are in worse shape now. CMY cannot reproduce RGB. Neither of them can come close to the real world.

RGB is not CMY is not RBY, and none are reality

For our purposes, we are discussing three totally separate color spaces. This is true on a practical level, even though reality contains all RBY, and RBY contains all RGB and CMY color. This explains why fine art reproduction is such a frustrating exercise, and why it is so difficult to print the newest fashion colors, and why a photograph of the Grand Canyon can never capture the magnificent reality of the place.

Four-color process?

So, why is it four-color process? We have been discussing three-color primaries – CMY. Again, reality strikes! The problem is the pigments. CMY inks are really not very close to theoretical CMY. Some of this is due to economics. The CMY pigments available are not economically feasible, or they are not quite the right color, or they are not strong enough, or they are poisonous, or some combination. The compromises we presently use are reasonable and economically viable. They are all a little more expensive than black, but in the acceptable range.

However, they are inaccurate. The three primaries added together do not make black – they make an ugly, muddy brown. This is primarily because the cyan used is weak (and slightly off-hue). In addition, all three pigments have impurities. As a result, a fourth color of ink is used: black.

In this introductory analysis, that's all you need to know. Otherwise, this would quickly begin to read like a physics text. All we have to know is what color space we are working in and why.

BUT THERE'S MORE

Spot color

*Spot colo*r is really not a printer's term. It is a term made popular by software applications. However, it is useful even though it means many

RGB and CMYK color limitations

As you begin to learn the differences, it helps to view them simplistically. Basically, RGB has trouble with yellows. CMYK has trouble with blues. It goes much further than that, to be sure, but this is a good starting place. If you doubt it, take a look at the limited yellows available in the Web-safe color system.

Few yellows for RGB means troubles with beiges, tans, browns, oranges, greens, and so on. The weak blue in CMYK causes trouble with purples, blues, and even greens and reds.

Tints are essential to CMYK

Before we go on, we have to remember the printer's definition of a term used earlier — tint. A *tint* for our industry is a screen of a color. We have no way to add white other than letting white paper show though. In other words, a tint is a solid color broken up into dots that are described as a percentage of area covered.

different things to different people. In the context of what we have been talking about, spot colors are specific RBY colors. They can be custom-mixed or bought by the can. They can fit into a system of color or not. The main thing is that they are printed separately, on a separate plate.

PROCESS COLOR IS CREATED BY PRINTING TINTS OF THE FOUR PROCESS COLORS ON TOP OF EACH OTHER. A typical color might be described as 100c 50m 0y 10K. K is used for black to avoid confusion with blue, which is written c because it is really cyan (go figure). Anyway, 100c 50m 0y 10K stands for the tints involved. In this case, there is solid cyan, overprinted with 50 percent magenta, no yellow, and 10 percent black. This produces a very rich shade of royal blue.

Spot color, however, is mixed pigment, blended not by overprinting tints, but with a paint knife on a mixing table. Brilliant red, warm red, Van Dyke brown, and so on have no specified relationship to CMYK. In fact, many of these colors cannot be produced with process color. These colors are referred to as *standard colors*. This is sort of funny because they are not standards. They are really colors manufactured by a specific ink company. They are only standards for that particular company. One company's warm red might be very different from another's warm red.

Standard color systems

Standard colors became a real problem. In the 1950s, there were more than a thousand ink companies in the United States alone, each with its own set of standard colors. In the mid-1960s, a company named Pantone gave our industry in the United States the first standard color system that was accepted industry-wide. It is called the Pantone Matching System or PMS. PMS color is available at almost every printer in the United States. Although there are some others around the world, PMS is the only universal standard color system that you normally need to be familiar with, in the United States.

The first thing you must understand is this: PMS color is not a full-spectrum system. It covers many colors outside the RGB or CMYK color spaces, but it is not based on primary colors. PMS colors have to be described by RBY or HSV; **35% of PMS colors cannot be reproduced with the tint overprints of process color.** Many of them cannot be reproduced with RGB. They are formulas for more than 1,000 custom-mixed inks.

PMS is a completely separate system

At present, PMS uses 15 standard colors that can be mixed into 1,000 standard mixes. The mixes can be seen in swatch books, which have a swatch of the actual color printed next to a formula. This formula tells the printer

which of the standard colors to use and what weight percentages to mix to create the specified standard mix. Printing companies using the system have very accurate scales. They are usually digital and accurate to a hundredth of a gram or better. These are used to get the proportions right. The inks are placed on a steel-surfaced table and mixed with ink knives.

With a swatch and a PMS number, anyone can match any PMS color in any facility that puts offset lithographic ink on paper. PMS inks are also available for some other printing methods. However, you must be careful: unless your printing method can use Pantone inks, PMS colors cannot be matched. Pantone sends color engineers to work in the various licensed ink manufacturing plants to ensure color accuracy. All Pantone-approved color has the word PANTONE in the name on the label.

High-fidelity (hi-fi) color

Recently, there has been a flurry of activity trying to solve the problem of the different color systems and their color reproductive inadequacies. Pantone has released a six-color system called Hexachrome which seems to have won, at this point. The goal is to produce a process color system that can reproduce almost all the colors of the standard color systems plus all the colors of CMYK. The common term, at this point, is *hi-fi color*. Pantone claims that Hexachrome reproduces all but 5% of the PMS spot colors. Remember, process color (CMYK) can only reproduce 65%.

The ink manufacturers are assuming that some hi-fi system will become the standard. They are also assuming that hi-fi color is perceived to be of high value by the printing industry. The overriding issue, however, is, *"Will customers pay the extra costs?"* It will obviously cost more money, simply because more color heads are needed. In fact, it goes beyond that. Hi-fi color requires stochastic color, imagesetters that can handle a seven-micron spot size, and presses that can also handle those tiny dots. Hi-fi color can cost double or more to print.

Hi-fi color will help a lot in such relatively small niches as fine art reproduction, fashion color catalogs, and the like. Companies like Spiegel, for example, can save a great deal of money with more accurate color. The most common reason for clothing returns is that it doesn't *"look like it does in the catalog."* Hi-fi could cut the return rate substantially, saving millions of dollars per year for much less than that in additional printing costs. For normal process printing customers, the color accuracy possible with hi-fi color is not yet enough of a difference to justify the increased cost.

The push may come through the six-color, large format inkjets. However, calibrated color requires an expensive RIP. The people using them are usually involved with top-quality color reproduction. Accurate color still

The standard base PMS ink colors

PANTONE Yellow
PANTONE Yellow 012
PANTONE Orange 021
PANTONE Warm Red
PANTONE Red 032
PANTONE Rubine Red
PANTONE Rhodamine Red
PANTONE Purple
PANTONE Violet
PANTONE Blue 072
PANTONE Reflex Blue
PANTONE Process Blue
PANTONE Green
PANTONE Black
PANTONE Transparent White

With the standard mixes, this gives you 1,001 custom colors. The swatch books are broken into identical Coated and Uncoated sections. Here the ink is the same, but the colors look different because they absorb so deeply into the uncoated paper. Pantone also produces a metallic swatch book with about 200 mixes of the standard colors mixed with seven silver, copper, and gold metallic inks. Pantone also produces a DayGlo™ swatch book with the standard colors mixed with seven standard DayGlo™ or neon colors.

Spot color

My students have more trouble with spot color than anything else in the color arena. The thing to remember is that spot color requires a separate plate for each custom-mixed ink. Also, there are no spot color toners.

The only place you run into digital spot color is with RISOgraph digital mimeographs. These marvelous machines have 14 standard spot colors available. None of them are PMS. However, RISOs can print for a penny a copy or less, per color, at 7200 copies an hour.

If you try to print spot color on a digital printer, you will get the closest color possible with CMYK. Often that is not very close.

costs a lot of money to print, and will for the foreseeable future. Accurate color on the Web will probably never happen, because surfers don't care. All they want is lots of color. Who cares if it is the same color on their neighbor's set?

Keeping spot and process separate

CMYK, or process printing, offers 16.7 million colors with four-color plates: cyan, magenta, yellow, and black. Each spot color is a separate plate. So black and PMS285 (a warm red), would be a two-color job with two plates. It would probably cost 40% of process printing or much less. However, a process job with full-color CMYK separations costs more if you add spot color. CMYK plus PMS285, a dull varnish, and a gloss varnish would require seven plates. This means three extra plates at $25 to $200 each. Plus three extra makereadies (or setup charges) at $25 to $100 per color. Plus mixing charges for the PMS colors. Plus you would need a press with seven color heads. Or, you have to run the job through a four- to six-color press twice.

This is why six-color presses are so common. These types of high-end commercial printing jobs are relatively common, or were until digital color came along. Remember, in general, **DIGITAL COLOR CANNOT DO SPOT COLOR — ONLY CMYK.**

Commodity color

This is the bottom line with digital color: *Most people don't care.* As an industry, printers have spent trillions of dollars developing the capability to produce relatively accurate color and no one cares except printers and designers. **When is the last time you tossed a brochure in the trash because the color was not accurate?** All most consumers demand is what the industry calls "acceptable color."

Acceptable color means simply that the reds are red and the greens are green. That skies are blue and skin tones look healthy. This will satisfy 90% of printing customers — and it is absolute heresy to the printing industry. However, reasonably well-calibrated, process color, digital presses are becoming ubiquitous. The corner copy shop has the capability to toss off a cheap color print that makes the customer ecstatic (even though they still tend to think it is too expensive).

The spectacular growth of color

The traditional portions of our industry are hoping that hi-fi color will keep their traditional presses running. What will probably develop is an additional niche in the printing industry. Our industry is likely to develop along the same lines as many others in the late twentieth century — like

cable TV. We will become increasingly diversified. Each niche will have its own preferred printing method. The mass-media color space will be process color, CMYK. With all of its deficiencies, it works well and it is universally available. The problem is that process color is surprisingly difficult to do well. Each of you will have to develop years of experience before you can handle process color fluently, without problems.

With tabloid CMYK laser printers becoming cheaper than 300 dpi black-and-white LaserWriters were in the late 1980s, we will see phenomenal amounts of color printing. Full-bleed, tabloid, duplex-color digital presses now cost less than $20,000. Full-bleed, tabloid, color laser printers are less than $4,000. Acceptable production speed only boosts the cost to a little over $50,000. This is phenomenal in an industry that as recently as 1990 assumed that a multimillion-dollar press was required to print process – plus hundreds of thousands of dollars for prepress equipment. Now process color can be easily printed directly from $1,500 computers to $2,000 color laser printers, at normal letter sizes.

Hi-fi color may never become common enough to appear in copiers and hi-fi color laser printers, although the technology is certainly possible. Several six-color inkjets have been released with Hexachrome support from Pantone. Hi-fi large format and grand format are readily available. The governing factor is likely to be economic. As mentioned several times already, modern technology is not primarily concerned with increasing quality. Its main concern is the increase of perceived quality at the same price or cheaper than is currently available. Quantity instead of quality is the normal goal in a economically based, marketing society.

All we have to do is remember that top-quality fine art originals now cost from many thousand dollars to close to a million dollars. The days of printing with hand-ground pigments on hand-made 100% rag paper are almost gone forever. Many of the best pigments have gone the way of the hairy mammoth. However, color printing for the masses has gone far up in quality and quantity. Mass-produced process color printing of outstanding quality is now sitting on many people's desktops. It's an exciting time to be alive. Our industry is growing like crazy and will continue to grow for the foreseeable future.

Where should you be by this time?

By now you should have finished at least a half dozen Miniskills and Skill Exams. You should be comfortable enough with Photoshop so we can go on to color correction and adjustment.

DISCUSSION

You should be discussing the different color spaces with each other. One of the best ways is to print some projects and hold them up next to the monitor to see the differences. You will be appalled, at first!

Talk among yourselves...

Knowledge retention

1. Compare the RGB of the human eye with 24-bit digital RGB.

2. Why is the K necessary in process color?

3. Why is grayscale structure so important?

4. Define a full-spectrum color space.

5. What is the purpose of 5000°K light booths?

6. What is the significance of full-spectrum color spaces and the differences between RGB and CMY?

7. What is holding back hi-fi color?

The Electromagnetic Spectrum

As you can see, the yellow band is very narrow and most of the spectrum is green and blue.

H S V

Notice that saturation goes from color to gray, whereas value goes from black to white

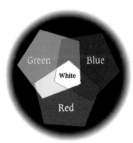

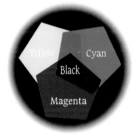

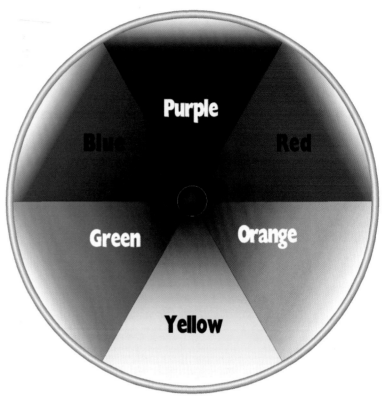

The color wheel

This is what most of us base our color mixing experience on. What we have to remember is that this roughly applies to CMYK, but it has no relationship, at all, to RGB.

Chapter 11

Printing Color Well

Dealing with CMYK

Concepts:

1.	Separations
2.	Specular highlights
3.	Neutral grays
4.	Duotone
5.	Tritone
6.	Quadritone
7.	Varnishes

Definitions are found in the Glossary.

Learning to control color when you print it

Chapter Objectives:

By giving students a clear understanding of publishing in print with color, this chapter will enable students to:

1. adjust neutral grays
2. produce printable separations
3. deal with spot color
4. produce duotones, tritones, and quadritones.

Lab Work for Chapter:

1. Finish more of the theory exams and email for grading.
2. Finish more Miniskills.
3. Finish more Skill Exams.

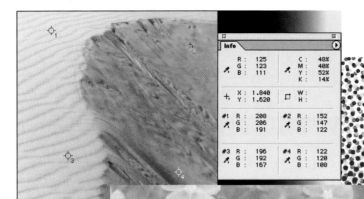

How lines fit bitmaps

Color printing concepts and skills

I'm not very enthusiastic about this chapter because process color is a skill that can be developed only by experience. I will share with you much of what I have learned over the past thirty-plus years, but you will still have to develop your own set of personal experiences. This is one of the places where understanding printing is essential.

The majority of desktop designers do not have a clue about traditional printing techniques. Since the monitor is in color and color can be added at will, many assume that color is no big deal. All you have to do is apply the color, send it to your printer, and get it printed.

THIS IS NOT EVEN REMOTELY CLOSE TO THE TRUTH. Before you can even start, you need to have a good handle on color theory, which we covered in chapter 10. I highly suggest that you go back and review that now before you start here. This is not something you can pass over. You must understand that monitors are in RGB color and that process color uses different primary colors and a completely different color theory.

Color reading list

This area requires not only experience but also study. Therefore, I want to give you a minimum suggested reading list. Learning type is a necessity before you can even start professional-level desktop publishing. Process color is an area that is optional. Many of you will rarely design full color work. This is changing rapidly with the onrush of commodity color, but the majority of work is still one- or two-color. This situation is likely to exist until the second decade of the new millennium.

So, here is my suggested minimum reading list: *Color in the 21st Century* by Helene Eckstein (Watson-Guptill, 1991). This is basically a 150-page customer handout from the vice-president of one of the best top-end color separating houses in America for the past couple decades. *The Color Mac, 2nd Edition* by Marc Miller and Randy Zaucha (Hayden Books, 1995): an excellent guide to top-end process color.

Both of these excellent books are out of print (which should give you some idea of the poverty-stricken level of the knowledge of most designers), but the bookstore on my Web site will lead you to an area where you can authorize a search for out-of-print books, http://kumo.swcp.com/graphics/bookstores. Of course, there are others.

However, most are such technical bores that I won't mention them. In fact, the main reason I mention them at all is to point out the poverty of choices.

Of course, being a teacher and writer, I'll start you with a brief review. Let me give you a few general guidelines on using color with both PostScript illustration and bitmapped imagery. I know this is a Photoshop book. However, if you are not using FreeHand and/or Illustrator as part of your illustration tools, you are a fool. You will be using color — trained or not, capable or not. I wish to give a few warnings and tips.

Photoshop

As you know, with few exceptions, Photoshop paints a picture dot by dot, pixel by pixel. The problem here is that you will be drawing in RGB (on the monitor) and printing in CMYK. The dilemma is that many of the colors on the screen cannot be printed. As a result, you will have to use printed swatch books to judge final printed color. Your results will become more predictable with experience. My warning is this, however: the first printed pieces you design are going to be horrible shocks. The color will be muted, dull, and in many cases a different hue.

The only way around that is a color-calibrated monitor. Until very recently this would have cost you $10,000. However, Apple now has its ColorSync monitors out. These work remarkably well (when compared to what was commonly available in the mid-1990s). The only other options are Radius and Barco, which have calibrated monitors out in the $3,000–$10,000 range. This is one of many areas where the majority of PC owners are simply using inadequate software. Color calibration did not exist for PCs until Windows 98. Windows 2000 (NT5) is the first Microsoft operating system to fully support color management. As a result, accurate, calibrated monitors in the wild, wonderful world of Wintel are very rare.

PostScript Illustration

PostScript illustration is a completely different animal. Here we are not looking at dots or pixels, but shapes. These programs (FreeHand, Illustrator, and CorelDraw 10 or better) can create any kind of shape and apply any color to it. This is what you need for two- and three-color work. These programs make full-color process work a dream. Colors can be added at will to the shapes. But this is the only professional-quality illustration software that can draw with spot colors.

For process work you will have the added difficulty that FreeHand and Illustrator render process color on the screen differently than Photoshop or Painter. Adobe is working hard to get its entire line consistent, but it hasn't happened yet. Again, you will be forced to use printed swatch books to have any idea of the final output. Again, a calibrated monitor will help, but

remember that spot color cannot be rendered by RGB or CMYK. In addition, there are no proofing options for spot color. Swatches are essential.

Swatch books

I keep mentioning swatches. These are most commonly the ones produced by Pantone and (in the United States, at least) a set is essential for designers. One of the common sets is shown to the right: the formula guide to PANTONE PMS colors; the process color system swatches; and the PMS to process comparison guide. The comparison guide is really handy because it will show you what will happen to your nice bright spot colors when they are printed in process.

PANTONE has many other swatch books also. They have a DayGlo™, or neon, color mixer formula set. They have a metallic formula set. One of the handiest is the two-color mixing book which gives you a reasonable idea of what is going to happen when you mix two spot colors with each other, for duotones and such.

Without a swatchbook, professionally calibrated proofs are required

It may be true that, after several years of experience and persistent calibration of your hardware and software, soft proofs are sufficient. However, they will always be confusing, at best, to clients with no visual training. Swatches will remain necessary for most of us (and remember that was just written by an art director with more than twenty years' experience working for commercial printers who specialized in process color).

WYSIWYG?

Not in color. All I am going to say here is that in digital graphics you will constantly be fighting the three-color schemes used. These color systems are not compatible with or comparable to each other. Worse yet, publishing to places like the Web sets you squarely in the middle of monitor hardware chaos. Accurate color takes a lot of work.

Reality (RBY) cannot be reproduced

Gouache

This can easily be the result of a scan of opaque watercolors. In the original, the colors were smooth and the detail was very subtle. Here all of the detail has been replaced by the variations in fluorescence in the pigment itself.

In original art, you are dealing with full-spectrum RBY color: red, blue and yellow, the colors you were taught in grade school. Here you have almost unlimited pigments. The mixtures result in trillions of colors. Many of these colors cannot be duplicated by the other two, more limited, systems. The color is subtractive, meaning that all the colors added together subtract out all the color and produce black.

A particularly difficult situation is gouache (opaque watercolors). Most gouache pigments fluoresce. This means that they convert ultraviolet to visible light and as a result they glow (like blacklight posters). This fluorescing capability cannot be picked up by a scanner. That is why scanned gouache paintings look very different when printed — and there is nothing you can do about it.

RGB color only works on monitors

Once you have your images in the computer and on the screen, it doesn't matter if they are computer-generated or scanned. You are in an entirely different color world — RGB. Red, green, blue is a world of light limited by the phosphors available in the tube. Here we are talking about additive color. This means that all the colors added together make white light. More importantly, light sources glow.

It is a full-spectrum color scheme (gives the illusion of reality), but the colors are limited. RGB can only describe about 60% of the colors available in the real world. In addition, it describes them quite differently from what you see in physical reality. When you look at a rose, for example, you do not see red only. The light reflected from the sun is primarily red, but there are small portions of all the colors. On a computer monitor, all you will have is RGB percentages that describe the overall average that you saw as red outdoors. This is why our reproductions usually seem so flat when compared to reality.

In addition, RGB has some definite hue limitations. Yellows are very compromised. As a result, RGB has trouble with browns, beiges, creams, Naples yellow, and so on.

Printed color (CMY[K]) — called process

When we get to printed materials, we have lost even more color possibilities. Reproduction color is very limited in pigment choice. Here we go back to the original RBY with a real limitation.

This is an entirely new color world — CMY(K). Cyan, magenta, and yellow are the subtractive primaries (they are a direct complement to RGB). Because of economics, CMY is not even purely subtractive. In other words,

CMY does not produce black but muddy brown. This is primarily due to the weakness and spectral inaccuracy of the cyan. As a result, K or black has to be added to correct the darker colors. Plus, the blues, greens, and purples are very compromised. You can see that in the little watercolor on the opposite page. It's hard to believe that this is rich ultramarines, isn't it?

CMYK is a limited version of RGB in pigment form. Maybe 85% of RGB colors can be attempted in CMYK. The reds are very weak and dull, leaning strongly toward orange. There are no rich, vibrant purples. The blues are horrible, tending toward lavenders and violets. However, it is a full-spectrum color scheme, so the mind is fooled.

When we look at process color, it looks complete. However, do not expect it to match either reality or monitor color. When seen separately it works. However, it is not even theoretically possible to match the original. Use it wisely, with no false expectations.

Process color cannot match either reality or monitor color

All full color printing is process. Sometimes a fifth color is added to pump up the reds and purples. Hallmark has been making money using this trick for years. As far as I know, it is still their tightly held trade secret. I have heard from countless sources, though, that they use fifth and sixth colors to boost the reds and purples.

Spot color

Spot color is RBY like original art. The most common spot color scheme in the United States is PMS color (the Pantone Matching System). However, instead of having unlimited pigment choices, there are fifteen pigments to choose from. This means that this is not a full-spectrum color space – that is, the illusion of reality is not available. If we add DayGlo™ pigments and metallic color, we have a total of a couple dozen pigments. Instead of millions of colors, there are 2,000 or so custom-mixed ink formulas.

We can reproduce maybe 60% of the total spot colors available with process. Obviously the neons and metallics are completely impossible. There are many spot colors that cannot be viewed on the screen. There are many monitor colors that cannot be duplicated with spot color. RGB has more high-intensity color, especially in the reds and purples. The advantage with spot colors is that they are standardized custom-mixed colors used anywhere in the United States. In fact, PMS color is almost universal in American printshops. It has become dominant here.

Color handling tips

 Do not mix spot and process color unless you have a large budget. Process plus two spot colors is a six-color print job. This costs almost 50% more to print than process alone. Sometimes you have no choice, but you can usually design around the problem. Remember that every color adds another color plate or head to the press or printer. This means that every printing cost is added again except for the paper.

 Make sure your spot color naming systems are consistent from program to program. If your illustration program calls Christmas Green PMS 348 and your page layout application uses the name Pantone PMS 348C for the same color, you will end up with two separate negatives for the two separate colors.

 Mixing screen tints of spot colors is forbidden. It works really well, in theory. I have done a lot of it, but then I have an unlimited supply of student drones who have to do what I ask them. However, the computer programs did not allow it until FreeHand 7 and Illustrator 7. Even now, you cannot make a color that is 45% PMS 348 and 15% PMS 254 except in Quark. Commercial printers will usually not print them unless you sign a release. This is because there is no way to proof mixed spot tints. All proofing materials are either opaque or CMYK.

You will be creating color based on your theoretical understanding of what the resulting mix will be. With experience, you can control these color mixes very well, but all the proofing is in your head. You have to be able to imagine what a turquoise like PMS 326 is going to look like as a 55% screen mixed with a 35% screen of PMS 200, which is a bright wine red. It will result in a grayed-out blue-violet tint of some kind. It will probably be pretty — but you will not know until it is printed.

The question is, *"Can you get the client to trust your taste enough to authorize it?"* Based on my experience, this is not likely. Clients and printshops usually want guaranteed color based on either a color proof or a printed swatch. These are simply not available for mixed spot color unless you pay a lot. Even then the proofing methods are often limited in color choice. Most customers get very queasy when you say, *"The color is great! Trust me!"*

 Limit your color palette. First of all, this is a sign of good taste and style. You might even try (horror of horrors) a coordinated color scheme. This would be specially true if you were trying to recapture the look of the fifties and early sixties. If you are doing two-color, black and a spot color, use the color sparingly and dramatically.

The worst thing you can do is simply make all the heads and subheads in color. Remember, color always gives less contrast than black and white. Dingbats and small emphatic graphics work well in spot color, as do hand-drawn boxes used for underlines. Color also works extremely well for tinted boxes used as sidebars, mastheads, graphics, and so forth. However, the contrast in color is usually against the background of solid grayscale layout.

 Approach color with fear and trepidation. Color is ridiculously easy to add on the monitor screen. However, it greatly increases printing costs. It is often not worth the money. Having said that, your clients will certainly demand it. Remember that discretion is a sure sign of refined taste. BE DISCREET! Do color with style and flair, not sprayed all over like some graffiti vandal.

MOIRÉ PROBLEMS

Let's get into process printing

Of course, you have guessed by now that the complexities haven't ended. Process color involves four-colors printed transparently on top of each other. This creates several problems.

Regular patterns have a major problem. If you print two of them on top of each other, you create an incidental interference pattern called a *moiré*. They are named after the Frenchman who studied them. These moirés can easily create plaid patterns in your carefully produced screened photographs, for linescreens are certainly a regular pattern. Remember, process color requires four screens to be printed on top of each other, so moirés can be a real problem.

One of the more common sources of moirés is demonstrated in the figures to the right. The name is *rescreening*, and it is caused by screening an already screened piece. In this case, a graduated screen was printed and put back in the scanner. The bottom image is the rescanned gradient.

The more common source is photographs that have already been printed. In projects like photo directories for clubs or classes, you will find that a quarter to a half of all the submitted pictures have already been printed — meaning they are already screened. The dots are usually too small to copydot (unless you have access to very expensive hardware), so they have to be rescreened.

The moiré that most of you have probably noticed happens on television when a talk show guest shows up with a pin-striped shirt. Often the stripes are so small that they are not noticeable, but the shirt shimmers with what looks like a glowing, moving oil

slick. That's a moiré caused by the stripes on the shirt combining with the horizontal lines of the TV image.

Rescreening is simple in concept, but often horrible in execution. The basic process is to blur the scan to the point where the moiré disappears. Obviously this messes up the photo or scan. However, by carefully using the Gaussian Blur filter to blur "just enough," the effects are usually almost unnoticeable (the photos are usually so bad that a little blurring can't hurt too much, anyway). Many scanner plug-ins have rescreening options. As usual, these automatic options only work for the average scan — which, as we know well, does not exist in reality. You are better off playing with Gaussian blur, although it is often slow and tedious at best.

Content moirés

One of the other places where moirés are common is the production of images that have content with a regular pattern. We've already mentioned striped shirts. However, there are window screens, corduroy cloth, burlap, herringbone tweed, chain link fences, net stockings, denim jeans, and on and on. Normally, the only way to fix them is with the Blur tool.

Angled screens

We need to see why angling screens is such a problem, digitally. The difficulty is that darn bitmap again. Lines are no problem if they remain horizontal or vertical. Even if they are at 45° they remain straight and even. Any other angle requires contortions.

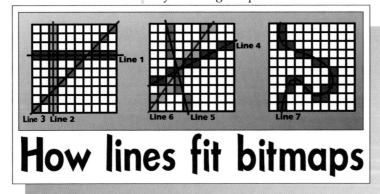

How lines fit bitmaps

As you can see, bitmaps chew up lines. In the same way, they really mess up screen angles. What you need to understand is that screens have to be angled for process printing. Angling screens causes many problems with the digital bitmaps. They do not fit well. This causes several problems, of which moirés are the major difficulty.

To avoid moirés, screens have to be at 30- or 45-degree angles to each other. This does not sound like a big deal. After all, we have 360 degrees to play with. But you are not thinking clearly. A screen covers four angles. This is because a screen has two sets of parallel lines at right angles to each other. In other words, a horizontal/vertical screen uses up the 0°, 90°, 180°, and 270°

angles). A 45°/angled screen covers 45°, 135°, 225°, and 315°. This greatly complicates our problems with moirés.

Screen visibility

The next difficulty revolves around the human brain. It would really be a great deal simpler if the brain were not such an incredibly good design. Our minds are indescribably powerful computers. One of the mind's capabilities is pattern recognition. It is especially good at recognizing horizontals and verticals (and even better with horizontal/vertical repetitive grid patterns).

As a result, screens at 0/90° can be seen at 75-line or smaller. However, 45° screens are hard to see at 65-line. In practical terms, this means that our halftones are shot at 45° if possible. This helps to fool our brains so that our eyes think they are seeing continuous tone. The 45° angle makes the halftones appear to be smoother. The two samples to the right have a 45° angle on the top and a 0° angle on the bottom.

The standard process angles

Now we have to put it all together. The process colors require four screens to be placed on top of each other. This causes horrendous moiré patterns, so a standard procedure was developed, many years ago. Other solutions are possible, but no one uses them.

Because the most visible color is black, it is set at 45°. There are two more angle sets available that are 30° from each other: 75° and 105°. These were given to cyan and magenta. That covers all the angles that are 30° apart. But what to do with yellow? The next smallest moiré is the 15° angle. So, yellow is set between the cyan and magenta, 45° from the black, at 90°. This does create a small moiré. However, it is a yellow moiré. Yellow is almost invisible anyway, so the small yellow moiré is easily tolerable.

The rosette

There is a small pattern, that is a very complicated moiré, called a *rosette*. It is the result of properly registered process screens overlapping. The rosette can be seen only with a loupe. With 133-line process, the rosette is around 110-line. In other words, it is certainly an acceptable pattern.

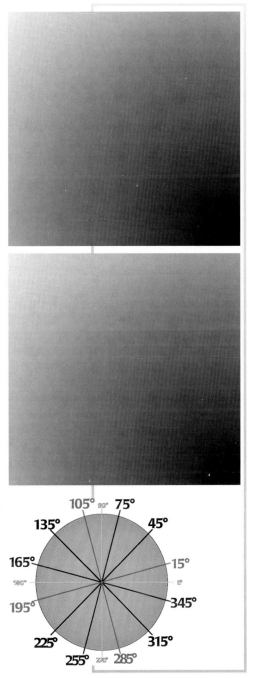

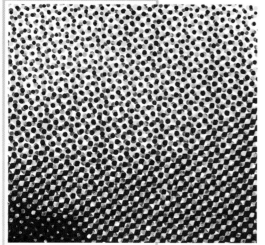

It is, however, one of the reasons why 150-line process looks a lot better. The rosette in 133-line tends to make the image look a little grainy.

This is one reason why quickprinters cannot do process color. Being restricted to 100-line screen, the rosette is easily visible. This, of course, is assuming that they can hold the registration necessary to print process color in the first place.

As you can see, the rosette patterns are pretty horrendous if they get too large. However, all printed pieces are broken up into dots. The key is simply to make them too small to see. This is, nevertheless, one of the reasons why stochastic separations tend to look brighter and cleaner. There are no moirés to deal with and the rosette is gone.

Yet another problem: Angled cells

The final problem with angled screens has to do with the halftone cell itself. At this point, you may consider this rather straightforward. Of course, it is not. The halftone cell is easy to understand, as long as it is 0° or 45°. At any other commonly used angle, it gets ridiculous.

As you recall, the halftone cell takes a group of dots (usually a square) and treats it as a single unit. This cell allows the creation of halftone dots that vary in size. We've mentioned before how messed up the shapes are compared to the old standard of dots that gradually varied in size. The cells are calculated by simple division. The resolution in dpi is divided by the linescreen desired to give you the horizontal dimension of the halftone cell. As just mentioned, this works fine as long as the cell is 0° or 45°.

At other angles, it gets very complicated because of the limitations of a bitmap. When you rotate a halftone cell, the outside corners of the corner dots have to fit the grid exactly. Bitmaps make no provision for partial dots. A dot is either on or off. This means that the cells have to be squeezed into strange sizes to fit the grid. For traditional printers, these sizes are exceedingly strange. As you can see by the example at the bottom of the opposite page, the

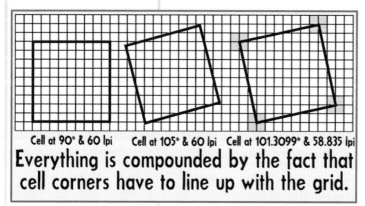

Cell at 90° & 60 lpi Cell at 105° & 60 lpi Cell at 101.3099° & 58.835 lpi

Everything is compounded by the fact that cell corners have to line up with the grid.

resulting cell has little to do with standard linescreen or standard angles — 101.3099° indeed! In fact, early digital screens did not match the traditional angles at all. As far as printing establishments were concerned, digital process color was a horrifying mess of weird angles and moiré patterns. In the following example you can get a much better feel for how far off the angles were.

Basically this has become a nonproblem. RIPs using PostScript Level 2 and PostScript 3 no longer have that problem. However, before this was solved you could generate a process sep and specify a resolution of 2540 and a screen of 150. The screen sets actually generated were: black at 45° and 149.7 lpi, cyan

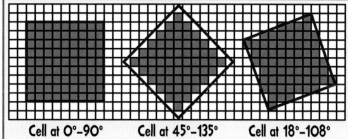

Cell at 0°-90° Cell at 45°-135° Cell at 18°-108°

at 108.4° and 133.9 lpi, magenta at 71.6° and 133.9 lpi, and yellow at 90° and 141.1 lpi. As you can see, the traditional camera angles of 45°, 75°, 90°, and 105° were severely modified. The 30° ideal was lost.

In this situation, moiré is still a problem. As you can see, 71.6° to 108.4° is substantially more than 30°. It is 36.8°, to be exact. This causes a moiré. The 45° to 71.6° (or 26.6°) difference between black and magenta causes another moiré. It drove traditional prepress personnel nuts.

Supercell technology

A better solution, used by professional imagesetter and platesetter RIPs, is to use large groups of cells (300 to 3,000 cells) treated as an overall unit. One of these technologies incorporates a technique called Supercell to structure halftone cells. The Supercell technique calculates the placement of pixels for large groups of halftone cells rather than for a single cell at a time. Every single dot is a different shape. The Supercell method increases the accuracy of screen angles and frequencies so that it is possible to generate virtually moiré-free screen sets for different output devices. Needless to say, it takes a powerful CPU. In fact, it really takes a hardware RIP.

Stochastic

These problems have been a large portion of the impetus behind stochastic screening. I'm defining *stochastic* as any technology that places dots that do not vary in size in a pattern that appears random. This would include handmade stochastics created with the diffusion dither option of the bitmap mode in Photoshop. It also includes the cheap inkjets. Stochastic screening totally eliminates angling and moiré problems. In fact, it has been the enabling technology for hi-fi color.

In addition, traditional process is very dependent on tight registration. Any color out of register by more than half a dot causes color shifts. Stochastic solves that also. This would make stochastic the enabling technology for process on duplicators and digital presses. However, this has not been implemented so far (as far as I know – it changes daily).

Hi-fi color

High-fidelity color attempts to solve many of printing's color problems by using a system of six process colors. As in the 1960s, there were several competing technologies, but at this point Pantone's Hexachrome seems to have won out. The additional colors of green and orange enable presses to output process color that includes 95% of the colors of the PMS system plus all the process colors. The problems are obvious. With traditional screens, there were no more angles available to eliminate moiré patterns. Stochastic screening solves that.

WITH THAT REVIEW

Let's print in color!

A quick review of color theory is probably in order for those of you who bought this chapter by itself. RGB and CMY color seem to be two totally different systems. In many ways they are. But as we have seen, they are really reverse images of each other. They are simply the additive and subtractive complements of the same color system. The complements of one system make up the primaries of the other.

The two are never seen in the same place. On this page CMY wins. If it were a Website or monitor-viewed PDF, RGB would rule. It is highly recommended that you learn to work in CMYK on the screen. Now that Apple has released reasonably well-calibrated ColorSync monitors at reasonable prices, you should have a calibrated monitor. It is the closest approximation to what will be printed, though it is still only approximate. You need to keep a printed swatch book next to the keyboard. That is the only way you can keep track of how the images will change when printed. Even then, you will find that experience is the only sufficient teacher. In the same way, you should always build your colors by the CMYK numbers. After a while, you will learn to think in process color, but you need to train your mind. You will have to print a lot of projects in CMYK.

Working in RGB

If you have read any of the popular Photoshop books, like the *Wow!* book, you have been exposed to the idea that you really should work in RGB as long as possible. There is an argument that many of the filters only

work in RGB. There is an equal counterargument that you will not have any time for filters in production work.

The main thing is that working in RGB keeps you continually frustrated with process color. It also tends to skew your color toward the blue-violets. It will be very hard for you to get very far as a process color print designer if you keep working in RGB.

Calibration

Most of the industry is focused on calibration. Apple's ColorSync is winning out, but unless you work for a company large enough to afford the time, equipment, and software, it is a waste to spend too much. Windows couldn't really do this at all until Windows 2000 with the Microsoft ICM. For years, all graphic designers worked in black and white. They simply specced (specified) the colors they wanted, and the prepress wizards produced it.

If you have a calibrated system, great! Do not trust it, without a great deal of experience with actual printed projects using the system. No matter how well calibrated, it is still RGB trying to render CMYK. With experience, you will learn to automatically compensate in your head — assuming you can work on the same system long enough!

Consistent color tips

Here are a few more things to keep in mind as you begin to produce color images:

In all cases, monitor color looks brighter than printed color. It is a light source, after all. This is going to be true no matter how well you have your monitor calibrated. You may learn how to compensate in your mind, but the colors will still glow.

Most of the RGB gamuts provided by Photoshop are quite a bit larger than the CMYK color gamut. This is one of the reasons why many of the colors will not be available. The main change is still the lack of yellows going to the weak blues.

One of the real advantages to CMYK is that almost any RGB color can be produced several ways. With four-colors used to make three-color blends, your options are greatly increased. Starting with CMYK, you can lose subtlety going to RGB.

It is very important to remember the effect upon color of paper, press, operator, and technology. Colored paper is obvious, but the affect of harder and smoother paper is often garish and slick. Softer paper with more natural whites can really kick up the appearance of quality, making the product more accessible.

ADDING PRINTED COLOR

Duotones, tritones, quadritones, and separations

All these are multilayered halftones. By printing several halftones on top of each other, many things can be done. Separations are the core of process color. They have four halftones on top of each other – cyan, magenta, yellow, and black. They have to be angled, as discussed before, to avoid moiré patterns. Separation procedures are discussed later in this chapter.

Duotones

First let's talk about duotones, for they require an entirely different conceptual understanding. Duotones, tritones, and quadritones are halftones that are built in two, three, or four layers. For years, low-quality printers have spread the lie that duotones are a cheap way to add color images to a brochure. This is true in the hands of the monetarily greedy. In fact, they are an expensive way to make your black-and-white photographs richer and more beautiful.

Density range

Before we can start, we need to add to our store of halftone theory (haven't had enough yet, right?). Photographs are very different from printed halftones. One of the major differences is the tonal range that can be captured. Remember, density is measured in a logarithmic scale from 0 to 4 (pure white to absolute black). Therefore, a density of 3 is ten times more dense than a density of 2. Photographs have a much greater density range than single-color halftones can possibly produce.

Ink on paper (except for anomalies like the opaque ink of screen printing) has a maximum density of about 1.1 or 1.2. A single color of ink usually has a density range that is closer to .9 from the lightest white to the darkest black. Normal color snapshots have a density range of close to 2 points. Professional photographs have a range of close to 3 points. Outstanding photography like that produced by Ansel Adams, Charles Weston, or Richard Avalon can have a density range from 0.1 to 3.6 or 3.7. It should be obvious that printed halftones fall far short of this. Compared

to a professional-quality photo, printed shadows are a pale gray — never a true black.

Simply explained, a duotone makes a second halftone from the identical image. This second 'tone contains only shadow dot information. When it is printed on top of the first 'tone, the resulting duotone has shadow densities that run from 1.5 to 2.0. A tritone uses a light color for the highlights with the shadows being hit at least twice with darker colors. A quadritone can use two grays and two blacks for the closest approximation of quality photographic prints.

Duotone production

All multitones (my invented word) start with a grayscale image. It can be a layered image with masks or whatever, but it has to be grayscale.

Step 1: Convert to Duotone mode

After you have created the grayscale image, you convert it to a monotone, duotone, tritone, or quadritone. When you select Duotone..., the Duotone Options box opens. As you can see, the Type: popup gives you the choice of a Monotone, Duotone, Tritone, or Quadritone.

A monotone is a halftone of any ink other than black. Duotone uses two inks. Tritone uses three. Quadritone uses four.

As you can see to the right, the tritone choice gives you three fields in which to enter colors. To the left of the color field are two squares. The left square is the familiar Curves dialog box. The square next to the curve is the custom color box. Double-click on this to open the Custom Colors dialog box. As you can see, you have a choice of thirteen color systems.

It would be a waste of space to describe these here. In the States, we use the PANTONE systems. For these systems, all you have to do is type the number of the color from the swatch and it will be selected. Click OK and it becomes the custom color used for that ink. I wouldn't worry about any of the others unless your printer says they use that system.

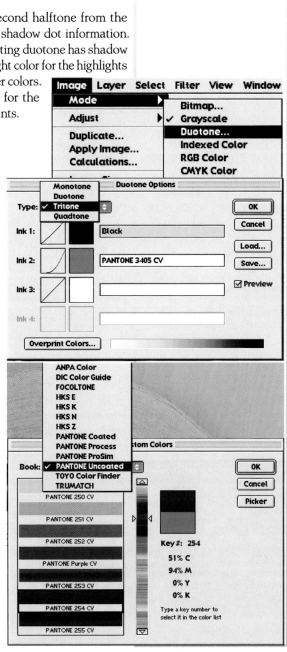

 The entire concept of multitones is an area fraught with problems. Traditionally, they were created by hand, adjusted by experience, and set up by personal taste. Digital duotones are becoming more and more commonplace as RIPs improve, but they are still always experimental.. You should always talk to your printer first to find out how they want to handle them — *IF* they can handle them at all. Do not just assume it will be OK. Also, make sure that a multitone will really help your project communicate to your readers. You are adding a level of complexity that may well not be necessary. It will require hairline registration for sure (which eliminates most quickprinters unless they have a T-head).

Photoshop presets

The best way to learn multitones is to use the presets that come with Photoshop. In PS6, they are found in the PHOTOSHOP folder, in the PRESETS folder, in the DUOTONES folder. In earlier versions, they are found in the GOODIES folder. These will give you a starting point to learn how the curves fit together to give you greater shadow density and shadow detail control. You can easily modify the presets after you load one of them. Remember that you are dealing with spot color duotones. There is no proof until it is printed.

What you see on the screen is spot color rendered in RGB!

Why bother?

For this to be justifiable, you need good photographs. They must be sharp and clear, with detail in both the highlights and the shadows. Because every color adds almost as much cost as the first color, this is a quality choice, not a bottom-line option to save money.

It is true that if you are already using two-colors, duotones are a cheap way to make your halftones look better. However, unless you understand the density range concept, you will be disappointed with the results. Many pushing this technique do not understand the density range concept.

Because the CMYK of this book will not accurately reproduce spot color, I am going to present you with some CMYK samples. Yes, you can certainly use multitones within a process document for special effects. The photo is marginal, but it will serve our purposes.

Our original

Duotone

This is a typical duotone with the color plate converted to a 0–50 range. What this means is that the second printer (a blue rough resembling cyan) has been adjusted to 0–50, leaving only shadow dot information.

Type: Duotone

Ink 1: Black

Ink 2: Cyan

Tritone

Here's the same photo in a black, magenta, yellow tritone. As you can see the mix of curves is much different. The result is a darker brown version of a sepia tone. Remember, these simple samples are merely meant to trigger your imagination. Hopefully, you can see there are huge possibilities. Imagine this one with three spot colors: deep purple, warm red, and beige.

Type: Tritone

Ink 1: Black

Ink 2: Magenta

Ink 3: Yellow

Here's the magenta and yellow as a duotone to further intrigue your creativity. The options are truly endless.

The question is, though, how does this differ from a two- or three-color separation? We are using the same inks.

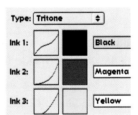
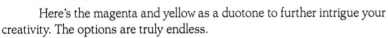

Two-color separation

This is the same scan separated as a CMYK. Then the magenta and yellow were tossed. The result is basically a duotone with completely different color balance. No one would ever know that the shirt was originally purple. But two-color seps always look a little strange.

If it is still not clear in your head, here are the halftone, duotone, and tritone side by side. As you can see, the multitones look much richer. They really are an excellent solution for two- or three-spot color jobs. It is easy to use this effect to make sepia tones for historical pieces.

Multitone problems

Most duotones are made with black and a spot color. There are some good reasons to use a dark brown and a spot color, especially if you need the look of the old sepia tones of the late nineteenth century. The dominant halftone should always be the black one (or the darkest color). There is a tendency to make the colored (or weaker) one stronger, but this tints the highlights as well as the shadows.

As you can see, a reversed duotone is a very different effect. If your second color is green or blue, tinted highlights tend to make people in the photos look very ill. In the second halftone, all the highlights and upper midtones should be eliminated. Then all the richness is added to the shadows without darkening or coloring the highlights.

Spot color proofing is almost nonexistent. This is why we have not discussed multitones done with multiple spot color. Although students do

Duotone Reversed

these as experiments, only on very rare occasions can clients be successfully sold on the idea of multitones done with multiple spot colors. They can be extremely beautiful and dramatic. They are very hard to sell.

Fake duotones

Fake duotones are not duotones at all. They are a technique sold by relatively incompetent printers as a cheap way to add color to a photo. A tint block of color is simply printed under a halftone. There is no registration to deal with, but all the highlights are ruined with the tint of color. As you can see, this is an ugly mess. It is a halftone with a solid block of 20 percent cyan behind it. There is no real use for such an image, but they are sold by unscrupulous printers.

True duotone techniques are a powerful tool when you are working on two- or three-color jobs. There are a couple of things to remember. First, it is often easier to get the exact effect you need by manipulating CMYK separations and then printing the seps in the spot colors you need.

Second, you won't have any way to proof the spot color duotone. Photoshop does offer a preview in RGB. The best color indicator so far is Pantone's two-color specifier book. It contains mixed tints for several hundred spot color combinations. There is rarely the exact one you need, but you can at least get an idea of how the spot color tint blends might look. There is no accurate proof, though.

 There is one place where quadritones are required — when you have a black-and-white photograph in the midst of four-color separations. If you do not make the grayscale image a CMYK quadritone, it will look very faded and weak next to the separations.

PRODUCTION TECHNIQUES

Making separations

Four-color separations are the primary reason why printing was formerly an arcane craft — and today's tools provide too much power for the process novice. However, the procedure is still basically the same, except for steps five and seven (the complexity shows here).

Your real problem will be in learning how the image is going to change from the monitor screen to the calibrated printed proof. It will take you a while to get that under control. Also, color corrections are fraught with trouble. You can very easily make your photos look very different from the original. Normally, this is not what your client is paying you to do.

Here are the same basic steps we used for halftone production. There are some ambiguities here, though. When do you change to CMYK? There is no one pat answer. For normal separation production, you will do that conversion at the end of step four, as I have indicated.

1. **Locate the best possible photo**
2. **Determine the size and resolution**
3. **Pre-adjust the scan**
4. **Crop to size** (convert to CMYK?)
5. **Clean up the image and correct color**
6. **Check levels and adjust curve for dot gain**
7. **Sharpen**

Because our goal is to place ink on paper, we need to get to ink colors as soon as we can. You really need to build skill in manipulating ink color (CMYK). Once you have created your masterpiece, all of the image assembly and presswork will be concerned exclusively with CMYK. Therefore, you need to learn to speak their language. You need to learn to think in CMYK. The problem is that several of the filters only work in RGB. In addition, the GCR settings now required by Photoshop really mess up the dot range of the color channels in CMYK. *Do it as soon as you can.*

Let's start with a basic scan from a photo of a close friend and my basset. As you can see, there is no *punch*. The photo is cute, but the *snap* needed to grab your eyes is missing.

Here's the way it started — it's a little flat. There is extraneous detail that does not help the image. Obviously, I have violated the first general rule — finding an excellent photo. However, there are some definite advantages to this photo. First is the price. Because I shot it myself, it cost me less than a dollar. Second, and probably most important, is that there are definitely no copy-

right worries. Copyright hassles are something you must decide about very early in a project. Copyrighted materials greatly increase the cost, plus they often require specific photo captions and many other things. This is the real reason why modern illustrations have turned more and more to self-done work (if you have the skills).

Size and resolution

For my purposes, I decided on 4 inches wide and 300 dpi.

Crop to size and clean up

Actually this photo went much easier than many. It turned out that very little cleaning up was necessary. On many pictures this will not be the case. This one was not very dirty (just one bad glaring specular highlight in her eye).

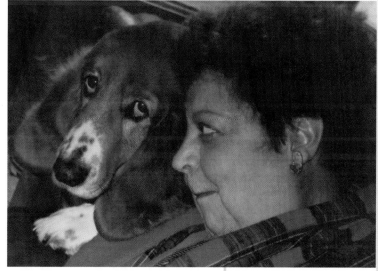

I need to tell you how to deal with specular highlights. Remember, a specular highlight is a reflection off a shiny surface. These specular highlights have to remain pure white — no dot at all. They are usually very tiny anyway. The main thing you have to remember is that you cannot use your specular highlights to set the highlight of your dot range. Your highlight is the brightest area in the picture that is not specular.

In this picture, there are specular highlights, from the flash, in both the basset's eyes, in her eye, and on her earring. They are so small that I can ignore them as I make my adjustments. However, I have to remember to punch them back to white before I finish.

Clean up and adjust color

Here I strongly felt that I needed to make some adjustments to the background, plus I hoped to lessen a decidedly yellow cast from the incandescent lighting. I didn't want to be too radical, however. The goal is to make changes that enhance without leaving any evidence of human adjustments to reality. Also, part of the pleasure from the shot is the warmth of the lighting, so the background might stay. You really must examine each scan closely to determine what makes it work and what hurts the image.

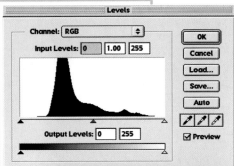

Levels adjusted

Our task is to emphasize the good and eliminate the negative as much as possible. Here I started by opening Levels. It is a very compressed histogram, as you can see. I clicked the Auto button to supposedly improve the color range and, as you can see to the left, it ruined the image. The skin tones became very red and everything darkened to the point where most detail was gone.

Obviously, Levels isn't going to help much here. I held down the Option/Alt key which changed the Cancel button to Reset. I played around for a couple of seconds and finally settled on a small highlight adjustment (234) and a gamma of .68. This darkened the midtones nicely without blackening the shadows and brightened up the highlights without posterization.

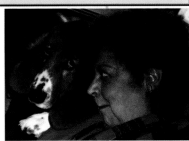

History brush

Increasingly, I find myself using the History brush to access the changes I need. It has the advantage of being very fast, unlike many of the fancier masking techniques. Here I tried adjusting the background, but it was obviously going to take too long. I tried lightening the hair to increase detail – nope. Finally, with the History brush using the cropped, cleaned-up original as a source, I simply added a couple of very light, 400-pixel sweeps in Screen mode over the face to lighten the skin tones.

Adjusting CURVES

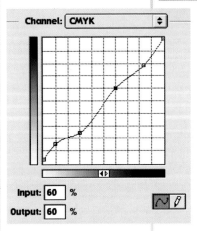

As usual, the complex adjustments are made most easily with Curves. I tweaked the black plate a little to add contrast in the hair by making the curve more vertical, from 60% to 100%. Finally, I added the rather complex curve you see to the left. I used the 60%/60% point to anchor the midtones; lightened everything from 20% to 60% (increasing the contrast a little in the 30%–60% range); increased the overall contrast a little more in the 75%–100% range; and increased the contrast from 0%–10%.

Remember, making the curve more vertical increases the contrast by causing more separation in tone between the lower and higher numbers. To rephrase the midtone change, this curve changed the 30%–60% to a 23%–60% – among the other adjustments. By now the photo is starting to come into shape. The warmth of the look toward the woeful basset is accentuated without losing reality.

During the curve adjustments, her face became really red. I solved that with a Hue/Saturation adjustment layer where I lowered the saturation in the reds only. We're finally getting pretty close to what I wanted.

The sharpening process

Now we come to the reason why I wanted to use this photo. This woman is always impeccably made up, and coiffed. We have caught her "unpainted" – as one of my friends would say.

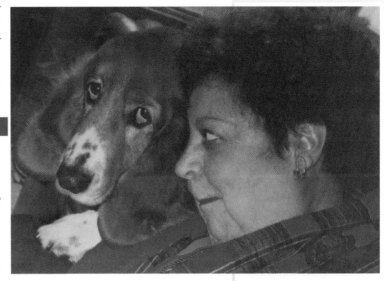

What this means, on a practical level, is that we have to be very careful when we sharpen. If we are not careful, we can make her face look like the skin of a basketball. Not only is that ugly, it would be nasty.

A far better approach, for a shot like this, is careful sharpening and blurring with the Sharpen and Blur tools. So, I went about doing that. About a minute into the process, I said to myself, "**SELF!** What the heck are you doing? She's never looked this bad."

I went back to an earlier stage I had saved, and discovered that I had already ruined what skin texture I had had in the beginning. So I reopened the earlier stage and did some selective sharpening of the basset's face, touched up the earring, got rid of some of the shine in her ear, and cloned in some of the texture to her hair that I had done fairly well in my Level and Curve changes.

So, what's the point? You have to be really careful. You cannot simply do steps by rote

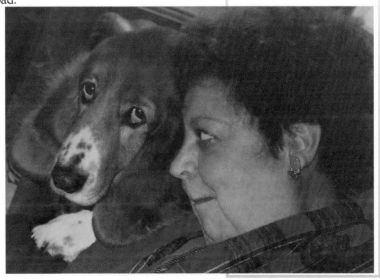

because that's the procedure David taught you. Often the procedure is really solid. You'll see that in several of the Skill Exams. Often, the results are really spectacular. For my original book, *Printing in a Digital World*, I found this shot of the Grand Canyon to play with. As you can see, it came magically alive. It actually conveys the feel of the morning we were there – after the adjustments.

WHAT'S THE POINT?

Why is this necessary?

The entire process for each of these examples took about fifteen minutes. The cañon printed beautifully in *Printing in a Digital World* on coated stock. In fact, it looks much better than the original photo, as printed in that book. Our local newspaper, here in Albuquerque, allows seven minutes for a halftone and fifteen to twenty minutes for a separation. This is typical of production situations around the world. This includes the scanning time. You need to be thinking about getting the work done at a professional speed. For top-end printing you might get an hour for this sep, but that would be the most you would get without special instructions and additional charges.

Normal time frames

Let's rephrase: a normal work procedure to add a color photo to your document includes scanning, saving, cropping, cleaning, adjusting, sharpening, saving, and placing into page layout in fifteen to twenty minutes. Some would argue and say that you have a half hour.

Anything more than that and we are now discussing illustration. Many clients will have to be convinced that the expense of illustration will help their bottom line. This is the reason we do things, remember? We are helping our clients communicate with their clients – every time, every document.

The real advantage of Photoshop 6

Images like this (which is the final result of Miniskill #10) now easily fit within the half-hour production time frame. Special effects that formerly took years of collection as specially constructed Actions are now available at a click of the mouse — and they are completely editable.

You always have to consider how much time your fancy and complicated ideas are going to take from your budget for the project. Almost all design projects are priced on time plus materials. If you have three hours in your quote, a two-and-a-half-hour filter effect is probably out of the question. Most of us cannot afford that much pro bono work.

Eliminating color casts

This is an area we need to talk about. However, you must bear in mind that many color casts cannot be fixed. Eliminating that green cast from shooting indoors under fluorescent lighting is particularly rough. It will be rare to find a photo that is so important that it will be worth the time.

However, all consumer scanners have color casts. Sometimes it can be a little confusing. My little Epson 636U, for example, has a color cast that usually makes flesh tones look better. I often leave its warm color cast alone. It rarely bothers me (though I always check).

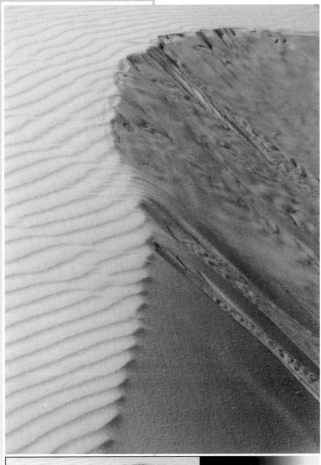

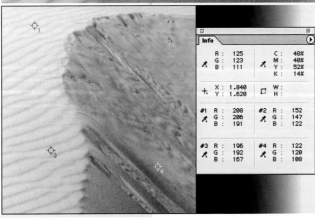

Balancing neutral grays

A very common task, however, is bringing grays back to neutral. The photo to the left is some of the famous white sand from White Sands National Monument. It is brilliant, pure white. It is gypsum — the center rock in sheet rock for your walls.

Obviously, we have a problem here. This is not white sand. It is not even close to white. What we need to do is bring it back to where it was when I shot it.

This is one place where RGB is an essential help. One of the nice things about RGB is that we always know if a color is a neutral gray. If the colors are all the same, it's neutral gray. 105r 105g 105b is a neutral gray. If that is true, how do we find out what is off to the left? The answer is the Info palette.

COLOR SAMPLER TOOL

Down at the bottom left you see the four sample points I picked with the Color Sampler. I don't use this tool much but I can show you four samples at a time with it. I normally just use the Eyedropper and move it around the image, sampling a couple of dozen locations.

If you look at the four samples, you can see that in all cases the numbers for the blue channel are about 30 less. Because these are PostScript numbers, 30 less is about 10–12% darker. What we obviously need to do is move the blue numbers up into neutral balance. The green is 2 or 3 less, and we can adjust that in the same way. Why do I want to adjust things up? Because I know that the White Sands are so bright you can hardly look at them. These really look dark and dingy. We make the adjustments in Curves.

#1	C :	16%	#2	C :	46%
🖋	M :	11%	🖋	M :	42%
	Y :	9%		Y :	27%
	K :	0%		K :	4%

#3	C :	20%	#4	C :	53%
🖋	M :	17%	🖋	M :	45%
	Y :	15%		Y :	31%
	K :	1%		K :	6%

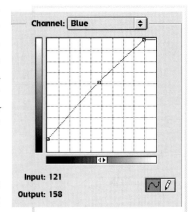

If you want a little persuasion about why you really do not want to use CMYK for these adjustments, take a quick look to the left. This is what happened to the RGB numbers after I converted modes to CMYK.

As you can see, things have gotten very complicated — virtually incomprehensible. The problem is the weakness of the cyan. You can adjust the colors by eye, but that is awfully dependent upon the accuracy of your monitor.

Channel: Blue

Input: 121
Output: 158

Regaining neutrality

As you can see, all I did was open Curves and pick the Blue Channel from the popup above the curve window. I raised the Zero point to 30 and then the 225 point to 255. That raised the curve 30 along its entire length. By moving the cursor around the image, I could see that the midtones needed a bit more, so I tweaked the curve up a little around the 50% point.

On many scans you will not have a neutral gray to work with. In that case, you will need a neutral gray ramp or step gauge you can place alongside your image as you scan. Then you can adjust the neutrality of the ramp and the photo will be fine.

Also, you will quickly come to recognize the color cast in your scanner. It is reasonably consistent. The cast will be very different from scanner to scanner, however, even within the same model from the same manufacturer. The solution, of course, is to buy a decent scanner in the first place. Like most of us, you will probably have to develop enough business to justify that purchase.

Summing up color

It is easy to sum this up: **COLOR IS A LOT OF WORK**. You cannot just dive into color and expect reproducible results. You may be able to get away with it on the Web. It'll never happen in print.

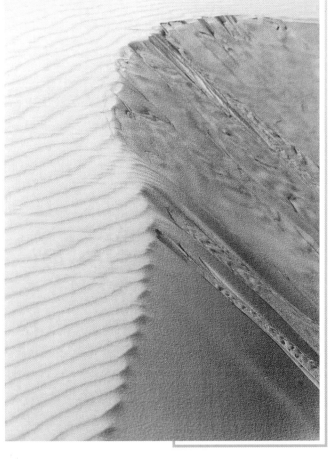

Where should you be by this time?

You should be feeling fairly comfortable with Photoshop. You should have done several Miniskills and Skill Exams. At this point, you should be working on real projects to apply the knowledge you have gained.

DISCUSSION

You should be discussing printing problems of all kinds with each other. I know that many of you will want to do all of these things on your own. I've been there. However, now is a perfect time to find out what others are doing. It will help your skill level immensely.

Talk among yourselves...

However, it goes farther than that. The production of excellent color will take you several years of practice and dozens of color jobs in RGB, spot, and CMYK. You really need to work with your printers and publishers to learn how their equipment works. All machinery has individual foibles. This includes computers. However, if you work at it, color will become one of your most valuable tools.

The production of excellent color will take you several years

Knowledge Retention:

1. Why must you distrust monitor color?

2. Why is spot color always at a 45° screen angle?

3. What is a rosette pattern?

4. How do you proof spot color?

5. What is the advantage of a duotone?

6. How many colors can be overprinted with no moiré?

7. How does adding PMS 253 and PMS 200 affect the cost of printing a job with process color separations?

A quick rough sample of spot color separations (see page 244)

Chapter 12

Miscellaneous Techniques

Concepts:

1. Posterization

2. Diffusion dither

3. Handmade stochastic

4. Spot color separations

5. Ghosting

Definitions are found in the Glossary.

Several important techniques that do not fit tidily into other chapters

Chapter Objectives:

By giving students a clear understanding of how publishing uses color, this chapter will enable students to:

1. ghost an image
2. produce images that print well on low-resolution printers using handmade stochastic screening
3. posterize images on purpose and under control
4. produce multicolor effects with two- and three-spot color low-resolution projects

Lab Work for Chapter:

1. Finish more of the theory exams and email for grading.
2. Finish more Miniskills.
3. Finish more Skill Exams.

Miscellaneous techniques

I hope the shock wasn't too bad, slipping back into grayscale. Here we have a few things to cover. There are several techniques that will not fit tidily in any specific category or chapter. The first two methods help with low-resolution digital printers. Any printer with less than 600 dpi produces unacceptably coarse screens. A 300 dpi printer outputs 53-line and 400 dpi outputs 71-line screens. Many of the new digital printers and presses fall into this resolution range. Something is needed to make these more useful (like a screening technique).

Poor printing is almost always the designer's fault

One of the traps many designers fall into is the idea that they are restricted by poor equipment. **You better get rid of that idea right now!** It may be a challenge, but poor equipment is no excuse for poor design. This is why they are paying you the big bucks. You must be able to make excellent designs even if your equipment is an old mimeograph using hand-typed stencils. That's your job.

Graphic design is a difficult job

It may be sandbagging to let you get this far, but here goes. Many people get into desktop publishing because they "like to draw." This is not sufficient. This will give you an enjoyable hobby, but it will not sustain you in this very difficult career. Design as a profession is impossible without constant study, undying curiosity, and an insatiable drive for excellence.

Basically, graphic design is problem solving. Every project is a series of problems that you are charged to solve with style and grace. You do not get to complain about tight deadlines and equipment limitations because they are a part of the normal job description.

All equipment and technologies bring limitations

I don't know why designers complain so much when they have to work in grayscale or with low-resolution printers. It is certainly expected when you work with screen printing, for example. What about making sure that logo will work on an embroidered patch?

Teach us
that wealth
is not elegance,
that profusion is
not magnificence,
that splendor
is not beauty.

— Benjamin Disraeli

So the proper course of action is not to rail against the limitations but to design within them. We have all seen incredibly masterful work done with woodcuts. How much more limitation is there than that? The technological limitations just become one of a long list of problems to be solved as you design a communication solution for your clients.

Design responsibilities

As a graphic designer, you are responsible for every mark on the paper. You need to have a reason for everything. That reason can rarely be whimsical, and it has to increase accurate communication. All of this has to be done in an environment run by people who rarely understand creative necessities. In fact, that last statement is not only true, it is also a good thing. When designers gather together and pat each other on the back, design quickly degenerates into the pit called "art for art's sake."

There is no room for the egomaniac in graphic design. This is a service industry. Properly viewed, we are hired guns who provide the creativity others lack for a fee. Our services are as valuable and at least as complex as the services offered by doctors and lawyers. It has been accurately said that the only equipment a doctor or lawyer needs is a phenomenal memory. Designers, in contrast, have to tread where others fear to go.

More than that, designs are such an integral part of our personal character that critiques can be taken personally far too easily. We have to become persons who use our skills professionally. It helps a great deal to remember that you are offering your creativity for the client's use to serve that client. In most cases, she couldn't care less what you want. What she wants is for you to express her ideas and concepts — clearly, accurately, and beautifully — the way she would if she could. *Rant concluded.*

Dealing with reality

Having said this, let me remind you that you will always be dealing with reality. Your job is to make it look good when published. That can be very difficult within the restraints of the Web, for example, if you care enough about your client's customers to minimize download times. Often you will be using low-resolution printers, for a variety of reasons. The most common one is money, of course.

One of the machines we use in my program, for example, is a Riso-Graph. It's a 400 dpi digital mimeograph. No real benefit except it produces 7,200 copies per minute, in up to 14 spot colors, for about a half cent per copy. This makes it extremely valuable for many applications. The problem, as mentioned, is the 71-line halftones which are mottled and indistinct on top of that. A solution is needed. This solution also works well with 600 dpi laser printers, DocuTechs, cheap inkjets, screen printing, and so on.

Handmade stochastic

The technique we developed to solve this problem can be called *handmade stochastic screening*. This method uses Photoshop's diffusion dither option. Halftones are created normally. When satisfied, change the mode to Bitmap. One of the Bitmap conversion choices is Diffusion Dither. Common resolutions are 130 dpi to 300 dpi conversions, depending on the individual printer.

This technique converts the halftones to what looks like stippling. At higher resolutions, the photos take on a fine mezzotint look. It is certainly not traditional halftoning, but it is good-looking. The biggest problem is the necessity of lightening the midtones severely to adjust for dot gain. This adjustment will simply have to be made experimentally with the digital press or printer you are using. Every printer will be a little different.

The solution for our RISO is 200 dpi diffusion dither. Yes, the dots are big. Yes, that is objectionable. Yes, they look far better than the halftones that can be produced with the machine. The same thing would apply to a screenprinted T-shirt.

It is also true that this technique looks intentional and artistic. The look of the random dots is quite pretty, if done well. The technique fits especially well in booklets and brochures that use hand-drawn graphics. In that case, a slick halftone can look very out of place.

In this little example, I am trying to show you the potential. We have done portraits this way and product shots. It takes some work, but it can look really good. All it takes is a willingness to work within the technology instead of fighting it. It saves on ulcer pain and things like that, too.

Spot color separations

I wish there were some way to show you what can be done with handmade stochastic images when you layer them in spot colors. One of the real advantages of the 1-bit TIFFs is that you can color them anything you like. I have already mentioned that two-color mixed tints are very hard to use because of the inability to proof. However, overlapping random dots providing a colored background can be very impressive, even in top-quality projects. The problem, of course, is proofing.

1-bit TIFFs are transparent

One reason this works so well is that the white background on 1-bit TIFFs is transparent. This means that you can get some visual reference about the color mixing before you print. You can't get accurate color on the screen, but you can at least locate the various pieces accurately. **It is very important that you make the colors in the TIFFs overprint**, so they won't knock holes in the patterns underneath.

This is a very different paradigm

Spot color, in general, is very different to work with. You never know exactly what the project is going to look like until it is printed. Because there are no mixed tints, you have to treat each color as a separate image. All you can show the client is the preprinted swatches. All you can say is, *"Trust me, it will look great."* Many clients cannot handle that.

You seduce them with price. Your design charges are no less — sometimes they are even a little more. But, you can reduce the printing costs by a third, even for three-color jobs. For two-color projects using duplicators, you can cut the printing costs by 75% or more. If you can find a printer with a RisoGraph, you may be able to do even better than that. The final result will still look great!

It will take a little imagination. However, if you had a two-color job of deep, rich Hunter Green (PMS 350, for the type) and a subtle, rich red (PMS1797, for the accents), the two gradients to the left would have deep maroon balls with the top one emerging into a bright, light red. The type could be either color, but green would probably be more dramatic. You can see a rough, CMYK approximation of this on page 236.

If you print it on a rich, fiber-added, cream-colored 70# text (or heavier), the results will be very rich and elegant. Of course, that depends a great deal upon your abilities as a designer. With the right fonts, the perfect layout, and careful assembly, you can make your client very happy. Always remember, that is the name of this game. You are here to serve your clients. Your task is to make them look good (and make them money).

Mezzotint filter

I know that some of you are wondering why I do not show you some of the wonderful filters that come with Photoshop. Here's a little sample. It took me more than a half hour, and I still do not have any image that is nearly as good as the simple 1-bit diffusion dither.

This gets to a point I will make several times in this chapter. Filters are often not cost-effective. You can waste an amazing amount of time playing with them. I am not saying to avoid filters — I use many of them. I am saying that you need to practice using time you can afford. Buy a *video game* book like the *Photoshop WOW! Book*. (I call them video game books because I see students practicing with some of the effects in books like this shouting, *"Cool!" "Incredible!"*, and so on. They act and sound like the kids seen in the local video arcade.)

Ghosting

The technique of ghosting has many uses. It also has two definitions. The first is to select an area of an image and make it light enough to drop type or another image into it (that can still be read). This kind is very common, and commonly very poorly done. Ghosting an area of the image gives you a relatively flat area where placed type still ties into the overall image. If you look carefully at the lighter area behind the letters, you will find that you can still see the photo.

The
beauty
of the
Navajo
Nation

This can be accomplished in a couple of ways. The first, and easiest, is a simple marquee and an application of Curves. After opening Curves (or adding an adjustment layer), you simply drag the 100% point down to about 25% to 30%. Observe carefully to see if there is any difficulty in reading the type. Readability is what matters.

For more complicated effects, you will need to make a selection with your tool of choice in a new layer. Then you should fill it with the color or colors needed to produce the look you want. You can apply layer effects to your heart's content. The type is on top of this. However, remember that the effectiveness of this technique lies in its simplicity and elegance. The ghosting in this case is done with the opacity slider. An opacity of 70% to 80% usually works well. The key, as always, is to remember that you have a couple of minutes to apply this technique before you begin to lose money. This is an excellent technique for catalogs that place prices on products.

Ghosted backgrounds

The second basic ghosting effect is to make a large graphic to place in back of your type. This is often done with a logo or graphic created in FreeHand or Illustrator. Placing type over a photo is usually a real problem. The detail of the photo often makes the type illegible. It is yet another technique done with Curves.

The technique is simple and easy. Open the image to be ghosted. Open the Curves dialog box, drag the 100% point down to 20 or 30%, and apply the change. Simply change the 0–100 scan to a 5–20 halftone. You may have to go lighter than that. You must end up with a very light photo that is still recognizable, but does not get in the way when other images and/or type are placed on top.

One of the problems, as you can see here, goes beyond the readability issue. This is hard to read, as I'm sure you can tell. The real problem, though, is that you can no longer see the content of the image. What you discover, with these ghosted graphics, is that the outline of the shapes is the only real clue you get as to what image is so beautifully arranged behind the type. Without that shape outline, you cannot even tell what is so carefully placed behind the type. Of course, if you can tell easily what is behind the copy, then the copy is usually illegible.

What we eventually get to is that dropping a photo, graphic, or logo behind body copy is a **DUMB** thing to do. It serves no real purpose, even though you may be convinced that it is gorgeous. Often a client will ask you to do something like this. The key is to remember that you will need a very recognizable shape. Often you will need a small, full-color version on the same page to give the reader a reference. Complex shapes make the type crossing the edges very hard to read. Basically, the only time this technique works is when you have flat colors and simple shapes that you can lighten to a 10% tint. Often you will be asked to do this for letterheads — keep it very light and simple. Other than that, avoid it.

Posterizations

Sometimes graphic designers intentionally posterize images. This is common in screen printing. It normally falls into the category of image distortion and/or destruction, and we have enough trouble with that already. Posterizations are created by drawing steps with the Pencil tool in the Curves dialog box. The flat steps are a level of gray and the verticals are the jump to the next level. To be effective, you need to keep the levels to fewer than a dozen or so. Just make sure that the technique really helps communicate with your clients' readers. This technique would be appropriate for a theater poster, for example.

Posterization usually works best with three or four levels. Screen printers, because they cannot do halftone screens unless the dots are huge, often posterize to a few levels and print every level in a different color. As you can see in Curves below, the

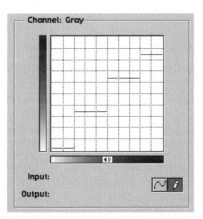

image to the right has been broken into four layers. It would be very easy to take this grayscale posterization into CMYK and select each individual color with the Magic Wand having CONTIGUOUS unchecked. You then fill each selection with the color of your choice. Make each color a separate channel.

A few filters

Warning!

I will almost certainly offend many of you in the next few pages. I do not care. I am sick of having my eyes assaulted by filter play at the hands of the tasteless.

Actually, as you know, there is no such thing as a *few* filters in Photoshop. Version 6 comes with more than 100 filters right out of the box, and that does not include all of the variations in many of them. As I warned I would hammer home, this is a real problem. You can waste hours with experimentations that are finally tossed in favor of a more *normal* approach (or they should be tossed).

That being said, you need to keep these filters in mind as you create your images. The problem with filters is not that they are not powerful enough. The problem is that they are far *too* capable. They can do so much that you have to develop procedures that you like for your personal style. This takes time — free time, to experiment.

As you can see, our friends at Adobe have tried to make some sense out of this huge collection of filters. To the left, you see the default filter collection for Photoshop 6. Their setup is not up for grabs. In other words, you cannot customize the arrangement to help find filters you like. You have to memorize where they are.

The best you can do, to get things under control, is to drag filters you are certain you will never use into a new folder. I suggest a folder called Unused Filters in your Photoshop folder. However, the nature of these filters suggests that you will probably use all of them — at one time or another. I would leave them alone. You have more important things to deal with.

Third-party filters

There is a large market in specialized filters for Photoshop. Over the years I have had dozens. Your selection of these is entirely up to you, and I am not going to get into that can of worms at all. The only one I will even mention is a filter for helping mask backgrounds of very complicated images. To get that model's head with the hair gently blowing in the wind, you will need help or a lot of time. If you do this type of thing regularly, you may well want to purchase a specialized filter. At this point, the offering from Corel (believe it or not) is the one most recommended. It's called KnockOut.

Basic filter categories

Let's quickly run through the basic categories, as set up by Adobe.

Artistic filters

The filters provide effects that vaguely resemble fine art techniques. In general, they distort the images to which they are applied. Please take a close look at the real definition of the word *distort* — in the sidebar.

Distort: (Webster's definition)

1. To twist in shape. 2. To twist aside mentally or morally. 3. To wrest from true meaning. To pervert

No wonder they are called distortion filters. It is certainly an accurate description of what many of them do to the poor images that fall into their clutches.

Blur filters

These filters are commonly used. Most often, Gaussian Blur is needed to soften mask edges and for rescreening. We will get to that in a minute. A very common distortion effect is supplied by **Motion Blur** and **Radial Blur**. As you can see below, the Motion Blur does add the appearance of movement (assuming that you have a photographer with inadequate camera technique). As you can certainly tell, I do not like this type of effect, at all — personally. Please do not let my opinion stop you. These filters are fashionable.

Blur and **Blur More**: These two filters are really a waste of time. You will do far better to use **Gaussian Blur**, which gives you quite a bit of control over how much you need to blur. You have already used Gaussian Blur in several of the Skill Exams. It will become one of your most relied-upon tools. We will use it later in the chapter as we discuss rescreening.

Brush Strokes

Here you find more of those *artistic* distortion filters. I've never found a real use for them. If I want something to look like a painting, I paint it. Their primary use is to add effects to layers of what John McWade called *grunge collage.* Neither he nor I can deny that this look is very popular and fashionable.

One of the main things you need to keep track of as you add filter effects is simple communication. I certainly am not saying there is no place for artistic distortion filters. What concerns me is the lack of attention paid to communication with the reader. In most cases, these immensely complex, multi-layered Photoshop image collages have **ALMOST NO APPEAL EXCEPT TO OTHER PHOTOSHOP USERS.** Be careful that you do not lose sight of the fact that you have been hired to communicate.

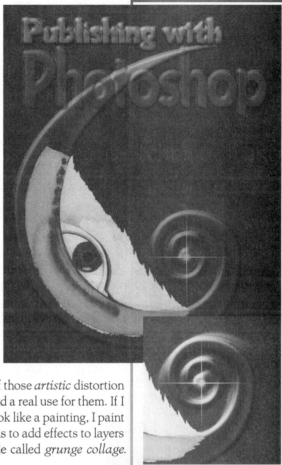

The beauty of the Navajo Nation

Distort filters

These are the classic distortion filters that sort of started the whole thing back in Photoshop 2. They will provide you hours of entertainment. Their function for communication is less clear, as I just mentioned. This is the most common playground of my students. I've seen countless iterations of the effects. The *Wow!* book is full of examples. I can't remember the last one I saw where the adjectives *elegant, classy, beautiful,* or *functional* came to mind. They usually give effects to amaze other Photoshop video game players.

Noise filters

These are very useful. They are used to clean up scanning messes, eliminate banding, and smooth over remnants of the touch of human hands. They also make excellent backgrounds. I can hear some of you saying, "Why does he like these and not some of those other cool filters?" The answer is personal taste, I imagine.

Pixelate filters

I do find myself using these upon occasion, for showing obvious pixelization. To quote Adobe, these filters "sharply define a selection by clumping pixels of similar color values in cells." Now you know as much as I do. Basically, they severely pixelate an image. As you can see to the left, severely is a major understatement. As with most distortion filters, a light touch and a specific need are called for. If you are curious, the one to the left is **Crystallize**. The one above right is **Mosaic**. As I mentioned, I can see uses, but these are also focused on communicating with computer geeks. As tools to talk to the general public, they are not very helpful.

Render filters

They make pretty clouds, nice simple 3D shapes, and realistic lighting (in RGB only). The clouds are not realistic. The shapes can be done far better in other programs or with simple selections and gradient fills. The lighting effects are very nice but very memory-intensive. As you can guess, they're not on my A list.

Sharpen filters

We have already covered this a great deal. **Unsharp Mask** is one of your major tools in halftone and separation production. **Sharpen** and **Sharpen More** are global with no control. **Sharpen Edges** sounds very good, but it's also global with no controls. Stay with Unsharp Mask and learn to use it very well.

Sketch filters

Here are some more of those *artistic* filters. I've tried many of these many times. As you can see below, it is difficult to make an effect that does not make the image unreadable. On the right is my best solution: using the original as a transparent copy over the top of the artsy effect.

The bas relief in the sidebar is very nice. You can see you have to be careful of the image. Simpler is better. As a very subtle background image, this might work well. Nevertheless, the challenge to readability is always a severe problem.

 The key to understanding filter use is to look at professional use in large market media. You will not find much of it in *People*, *Time*, *Newsweek*, *Smithsonian*, *Popular Mechanics*, *The Enquirer*, or your daily newspaper. That should certainly tell you something. Most of these wonderful filters have little use in the real world — and never will.

Stylize filters

These are more of the same. Deke McClelland use to claim that Find Edges was one of his favorite tools for masking out complicated images. My guess is that he is now using one of the dedicated masking plug-ins. A good example would be the Solarize filter. Solarizing has been around for a long time. I've never seen one sold to a client. The solarized image with glowing edges to the right is hardly even recognizable. How could it sell product?

Texture filters

These are the same filters we have seen before. Texturizer, for example, has the same choices as Conté Crayon minus the art strokes. Mosaic Tiles is very similar to Crystallize or Mosaic. Stained Glass is almost identical to Crystallize except it adds gray lines around the shapes. The only one with any "real" use is probably Grain, which does give some wonderful textures for backgrounds of images. Everyone has seen Craquelure used with the cosmetic ad on TV.

Video filters

These are necessary if you are working with video.

Other filters

Extremely powerful mathematical filters for those who love programming and mathematical control over images.

Digimarc

This embeds a digital signature into your image to help catch thieves who would steal your work without payment.

An apology

I am really sorry for all of the negativity. I have seen wonderfully beautiful images created using these filters. They are as rare as the people who are talented enough to create them. Most filter play is merely visually offensive to the average reader, viewer, or surfer. I have found, over the years, that I cannot be negative enough to stop the horrendous overuse of these filters. Do whatever you are going to do – knowing that it is counter-productive in most cases. Make sure your client's customers can handle it.

Rescreening

Now we come to a real use of filters. We mentioned rescreening in chapter 9. We need to spend a little time giving you a technique. You may remember this little hill outside Santa Fe from chapter 2. I'm going to use that for an example of one of your most common problems (though you may not have discovered that yet).

You will normally run into this difficulty when you are doing newsletters, programs, or directories. In any project where you have to place several (if not dozens of) photos of people, you will receive preprinted pictures. Almost no one realizes that printed photos have been broken

up into dots in a regular grid. My experience suggests that if you do a membership directory with photos of all the members, about 25% of the photos submitted will be already-printed images.

"So what?" you say. "Look right!" I say. This image is the one you see at the bottom of the opposite page placed back in the scanner and rescanned after it was printed in a proof. As you can see, the moiré problems are not minor.

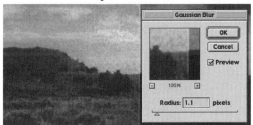

Here is the solution. A simple minimal Gaussian Blur almost magically eliminates the moiré. Of course, it blurs the image a little. However, that can be covered reasonably well with a Curves adjustment and a little sharpening.

 Be careful though. If you have not completely eliminated the moiré, it will return with the sharpening. Often, it is better not to give an overall sharpening to the image with Unsharp Mask. Careful use of the Sharpening Tool will commonly work better. It is often much quicker in addition to providing better control.

Content moirés

A similar problem, with a similar solution, is fixing moirés in photos of regular patterns. Items like corduroy pants, denim jeans, striped shirts, chain-link fences, and so on can all cause moirés when scanned. The good news is that the solution is often very easy.

If you look to the right, you can see what happened to the moiré when I simply painted over it with the blur tool. It almost magically disappeared. In the same way, you can fix those images with bad content moirés with judicious use of the Blur and Sharpen tools. The thing to remember is that quite often the effect of excellent sharpening can be accomplished with quick clicks of the Sharpen tool (over the eyes of a model, for example).

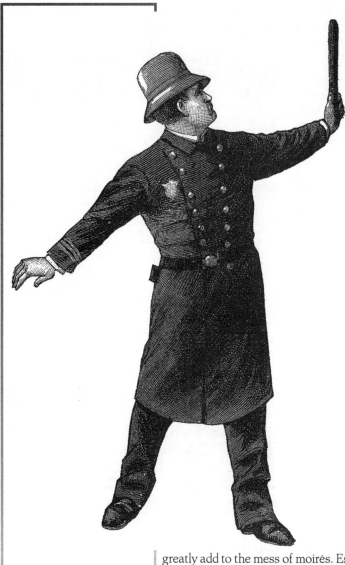

Old engravings and lineart

Another problem appears when you scan something like this old engraving. The parallel lines carved by the graver's burin can also cause content moirés.

If you look here at the hat and the area under his arm, you will see some pretty gnarly engraving. In this particular case, we do not want to blur. That would erase entirely the basic character of the engraving.

Now we need to understand another of the problems you will have in dealing with moirés in your scans. The horizontal lines of your monitor greatly add to the mess of moirés. Especially with artwork like an engraving, with all of its tiny parallel lines, you need to enlarge the view enough to make sure that the mess isn't being caused by the monitor. In this case, the mess was really there, but rescanning at 600 dpi solved the problem. As you can see, at the top of the next page, the higher-resolution scan (which looked just as bad or worse at 100%, looks better when enlarged to 400%. Even the area under the badge is relatively clean at higher enlargements. So,

higher-resolution scanning solved many of our problems. In fact, here I only scanned at 600 dpi to solve the problem. As we mentioned before, I probably should have scanned at 1200 dpi or 2400 dpi – because that is the output resolution of the imagesetter being used for this book.

However, all is not roses. First of all, the image is still in grayscale. Not only does this make the file size eight times larger than necessary, it also makes the background gray and the detail within the image cloudy. The solution is Unsharp Mask again.

The first step was elimination of the background. A quick selection

with the Magic Wand solved that by deleting to a white background. The problem remained within the image. This was solved by using an Amount of 500% in the Unsharp Mask dialog box. 500% lightens the light side to white and darkens the dark side to black. In this case, that solved almost everything. However, I couldn't move the radius beyond 1.4 pixels without messing with the neighboring black lines. As you can see, the collar, the cheek, and the highlights on the hat are still pretty messy. Four quick click-deletes using the magic wand solved those areas also.

Unsharp Mask at 500% cleans up lineart.

Finally, I converted to Bitmap mode at 600 dpi, using the 50% Threshold option, and the rest of the gray was gone. For a finer-lined engraving, I would have gone to 1200 dpi or higher.

Eliminating banding

Here we run into the same mathematical limitations discussed with maximum levels of gray for a given linescreen and printer resolution combination. Near the end of chapter 8 we mentioned that banding is caused by inadequate levels of gray. To a certain extent, banding problems can be solved by lowering the linescreen, which gives a larger halftone cell with the same resolution printer. However, the lpi dots quickly become large enough to see. We can also solve some banding by going to higher resolution for the output. Some imagesetters allow you to increase from 1200 dpi to 2400 dpi.

256 levels of gray

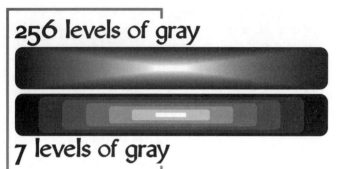

7 levels of gray

Some even have the capability of going to three or four thousand dots per inch. In most cases, however, neither of these options is a real solution. What we have to do is deal with the edges of the bands.

You will not find nearly so many banding problems in Photoshop images as you do in purely PostScript illustration programs like FreeHand and Illustrator. Part of this is because Photoshop cannot do blends. Photoshop's gradients are pixelized calculations instead of stacks of individual shapes.

Another reason is that the nature of bitmapped illustration doesn't often produce long, uninterrupted, smooth gradations. Nevertheless, you will run into banding problems on a regular basis, especially with vector EPSs. The solution is discrete amounts of noise.

The best banding solution is random dots.

By now, if you are using Adobe's Photoshop Annex (which they call Illustrator 9) you are probably a little confused. But we won't go there. Suffice to say that Photoshop's noise filters are the solution, whether you find them in Photoshop, Illustrator, or InDesign (it's a safe assumption that they will be in InDesign 2 along with the transparency). Our companion book, *Publishing with FreeHand and Illustrator,* will explain why banding is a larger issue in those applications.

We have already discussed the most radical solution: hand-made stochastic. Photoshop's diffusion dither option completely eliminates banding because it does not use PostScript's paradigm of blended shapes to produce the illusion of gradation.

The sample I am using here is extreme, I know. If your banding is this severe, you really need to redesign the graphic. The point is that even with banding this bad, you can eliminate it with a simple application of the Add Noise filter. Normally, your banding will not be nearly this obvious or intentional.

Your choices for Noise are: **Uniform, Gaussian,** and **Monochrome**. If you want Adobe's normal mathematical explanation, go to the Help files. In general, Uniform adds much smaller and smoother noise. It's meant to mimic film grain. Gaussian, more accurately stated, texturizes the selected area. I commonly use

Beautiful Bands

Gaussian noise to add a nice grainy background to images. In RGB and CMYK images, Gaussian noise adds wonderful multicolored smoothness. Monochrome makes the noise so it only affects the value without changing the color at all.

I normally just adjust the slider and click the three options on and off until I like the result. They do seem to have a cumulative effect. So, if I switch from Uniform, to Gaussian, to Monochrome, and back to Uniform, the second Uniform state is different even though the filter has not been applied yet.

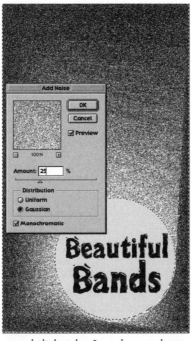

In this case, the banding was so severe that I made several clicks plus I used a very large Amount to eliminate the bands. By that time, I felt that the original concept had been lost. The texture was too blotchy.

So, I went to the Dust & Scratches... filter to blur back the noise. Then I added some more noise, then I blurred again. I did this several times in small doses, and then added another large Gaussian Noise. The final result does not look like a smooth gradient, but it looks intentional and the banding is gone. Normally, your adjustments will not have to be nearly this radical.

As you have seen, banding can be eliminated with this filter. You should use feathered selections and go gently. It can also be used to gently smooth heavily reworked areas of edited scans and photos.

Building backgrounds

In addition, as mentioned, noise can make wonderful multicolored speckled backgrounds. Here we find one of the best uses for these filters. Building gorgeous textured backgrounds is very easy with Photoshop. The only problem, of course, is the usual one. You can waste hours. More than any other software, the temptation to waste time playing with the program is a major concern.

Tips for filter use

1. When using edge effects, you may need to feather the edge before you apply the filter to keep it under control.

2. Filters are applied to individual layers. Often you have to filter several layers successively to build up an effect.

3. The most effective use of filters often comes when you apply them to individual channels. Eliminating banding from color images, for example, usually is better done with a little noise in each channel separately.

4. Sharpening is especially sensitive to individual channels. Often you will find that sharpening only a single channel does wonders. This is especially true if you temporarily switch to LAB mode, where all of the value (and therefore most of the detail) is found in the Lightness channel.

5. The creation of backgrounds often starts with a simple gradient or solid color. Noise, Chalk, Charcoal, Craquelure, Clouds, Mezzotint, Rough Pastels, Glass, Conté Crayon, Sponge, and many others work beautifully on a smooth colored beginning.

6. Using the History brush, you can transparently paint in filter effects exactly where they are needed.

7. Apply your filters to feathered selections for greater control.

8. If you have several photos that look very different, you can increase consistency by applying the same filter effects to each.

Dealing with speed issues

Many filters are euphemistically called memory-intensive. The simple translation is that you cannot ever have enough RAM – especially for print with the high resolutions necessary. You will regularly need to use some simple techniques to speed things up.

1. The simplest is often to purge. The EDIT>> PURGE command allows you to clean up History states, the Clipboard, the Undo, or all of them. In older versions, you will have to do this by using the Options menu of the History palette, copying a couple of pixels to the Clipboard twice, and then Undoing the last copy. These simple steps can eliminate hundreds of megabytes from memory, depending upon what you are doing, of course.

2. On the Mac, you can assign more RAM to Photoshop. Even though I have been warned not to do this, I use huge amounts of virtual memory on my Macs with no problems. I only have 320

MB RAM on this machine, for example, but I am running 777 MB virtual memory (set in the Memory control panel). Windows 2000 and Mac OSX supposedly solve this automatically, but I have not tried these options yet.

3. Applying the filter to individual channels reduces the memory required by a third or a quarter, depending on whether you are in RGB or CMYK.

4. If you are going to be printing in grayscale, convert the mode to grayscale. However, the filter effect might be different in grayscale.

5. Save and Save As to work on new copies if you are concerned that purging might eliminate History states you may need again.

The Fade command

One of the best controls for filters is the FADE command. This is found under the Edit menu. It allows you to adjust the Opacity and apply the filter effect using any of the blending modes. Most of you have already learned the shortcut to reapply a filter (Command/Control F). All you have to do is add the Shift key to get the Fade command.

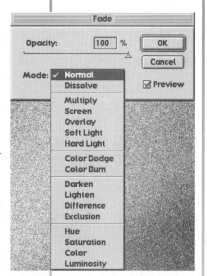

 Remember that many times you will get better results by applying a filter repeatedly in small doses. The fade command is a wonderful addition to this. Simply hold down the Command or Control key (depending on your OS) and type F. Then immediately add the Shift key and type F again to Fade it, if that meets your need. I often apply a filter in a very small dose. Then I hold down the Command key and type F repeatedly until I get the effect I desire.

Extracting a portion

As mentioned in many places throughout this book, one of the major challenges of using Photoshop is making accurate selections of complicated shapes. Skill Exam #5 uses the Magnetic Lasso to select a photo of a boy to eliminate the background. Several of the Skill Exams use the magic wand in various ways. Skill Exam #6 uses the Pen tool to draw a path to select a portion of an image. It uses that path as a clipping path to drop out the background (or keep it from printing).

We have also talked a little about the fact that if you do these complicated selections on a daily basis, and especially if you do them several times a day, you probably need to buy a specialized plug-in. Corel Knockout currently has the best reputation, but I have never used it. It can really be necessary if you do a lot of tight selections and clipping paths.

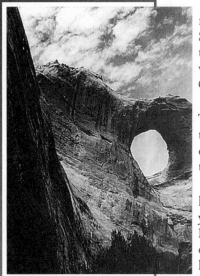

One of Photoshop's best options is the EXTRACT command near the bottom of the Image menu. Let's look at a simple example. Say we want to eliminate the sky from the shot of Window Rock to the left. Choose IMAGE>> EXTRACT. This opens the image in a separate window with specialized painting controls. These work sort of like Quick Mask, but there are much better controls.

The top tool in EXTRACT's little toolbar is the Highlight tool. The icon looks like a highlighting marker and that is what you do to the edge that you want extracted. You simply paint around the edge. Yes, this is very much like the quick mask option. However, the preview is much better.

The Eraser allows you to erase the edges of the highlighted line surrounding the area you want to extract. The Fill tool allows you to select everything inside the highlight line for extraction. The Preview button shows you exactly what you will extract. The two edge cleanup tools allow you to subtly adjust the edge or paint in a hand-feathered edge with the opacity.

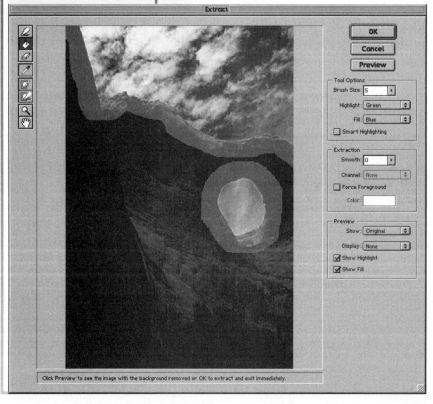

Does this ability duplicate several of the other selection tools and techniques? Of course it does. However, it feels very different. Some use this tool all the time. I use it occasionally. The choice is always yours. The results are what matter, not the method. It is much faster than the Magnetic Lasso for edges that are indistinct.

One of the really nice things about the EXTRACT interface is that the result goes beyond a selection. It produces a transparency mask directly. This saves

several steps as you build images. In this case, let's just say I wanted to drop a sunset in back of the window. Too bad you can't see it, but you get the idea, I'm sure.

Sometimes, however, the edges are too complicated. If you do not have a plug-in, the next best thing is the ability to find edges. There are filters for this.

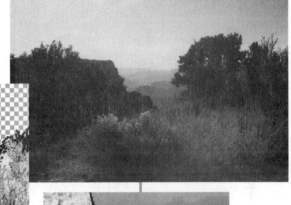

The edges filters

Here's another simple example, done very quickly (about five minutes). We'll start with our canyon shot. I want to drop out the distant mesas, canyon edges, and sky. So I duplicated the image into a new layer to apply the Find Edges filter (FILTERS>> STYLIZE>> FIND EDGES). Here is the result after I started cleaning and painting.

As you can see, the filter did an excellent job of outlining the bushes and edges of the foreground. I started by painting in with black. I selected the sky with the wand and quickly deleted as much as possible to transparent. Turning on the background layer with the original image shows how easy it is to see opaque pixels left in the sky and distance.

It didn't take more than two or three minutes to clean up the sky and the edges. Then all that was necessary was to Command/Control=click on the new layer to activate the transparency mask. I filled the selection with black. Then I made another duplicate layer of the original and clicked on the New Layer Mask icon to load the selection into the new layer as a layer mask. I deleted the original background, made a new layer, and added the gradient. You can see the results on the top of the next page. For different purposes I would have worked the edges better, but it was really quick.

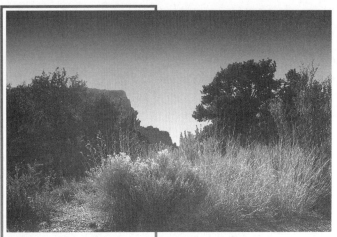

As you can see, the new edge is very clean and very complete. All of the options and filters in this chapter provide some interesting possibilities. Again, they are used a lot more now that special effects are so easy in Photoshop. Until the digital era, special effects such as posterizations, duotones, all the fancy backgrounds, and many others used to be quite difficult. In most cases, some poor camera operator had to experiment until the artist was happy. Then the designer had to convince the client to use it. As a result, not much of it was done. Now they can be produced and proofed quite easily by the designer. The only problem still prevalent is proofing spot colors. That will not change, but spot colors will fade in importance as more work goes to digital production and as digital CMYK comes down in price. A recent DRUPA report suggests that by 2005 digital CMYK prints will be the same price as grayscale is now... we'll see.

Where should you be by this time?

Working, working, working. By now you should be comfortable with using Photoshop to produce printable images (assuming you have been following the curriculum). Remember, you should not be printing them out of Photoshop. You should save a copy as an EPS (if you have a clipping path) or a TIFF and place the image into Pagemaker, Quark, InDesign, or FreeHand for printing.

DISCUSSION

You should be discussing production with each other.

Talk among yourselves...

Knowledge Retention

1. What are the advantages of 1-bit dithered TIFFs?

2. How do you use the FADE command?

3. What is a content moiré?

4. What is the basic procedure for rescreening?

5. Why are ghosted images in the background usually stupid?

6. What is the major problem with spot color separations?

7. How does homemade stochastic solve the problems of low-resolution printers?

Chapter 13

Web Graphics

Concepts:

1. GIF

2. JPEG

3. PNG

4. PDF

5. Slicing

6. Matte

Definitions are found in the Glossary.

Creating Web graphics that read well and download fast

Chapter Objectives:

By giving students a clear understanding of how publishing uses color, this chapter will enable students to:

1. optimize a GIF
2. optimize a JPEG photo
3. pick an appropriate file format
4. design a functional Web page.

Lab Work for Chapter:

1. Finish more of the theory exams and email for grading.
2. Finish more Miniskills.
3. Finish more Skill Exams.

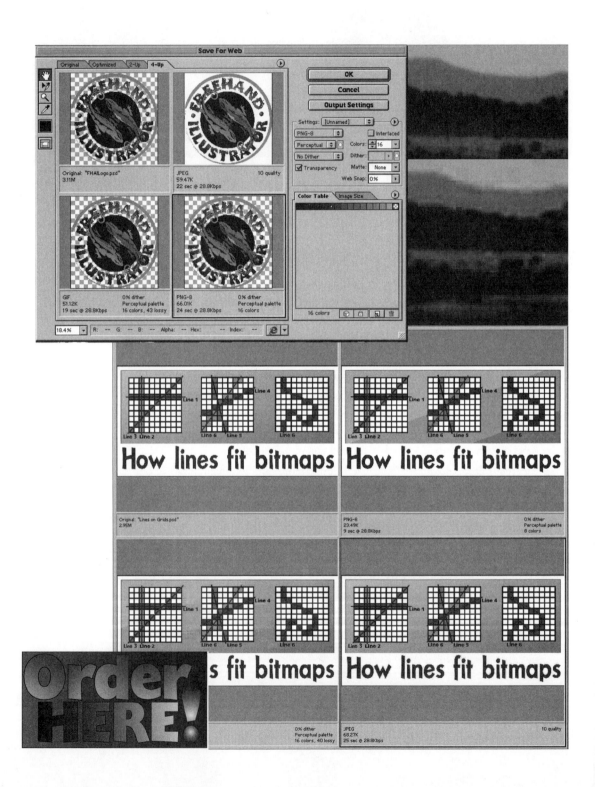

A different world

This is the place where all the excitement has been for a few years. This is the place where many designers with a print history will begin having a rough time. On the Web, we are entering a world of coarse, crude graphics, with little layout control, no color calibration, and no output control. However, like all design problems, this is just another problem to be dealt with. There is hope. Some of the new software, like Dreamweaver and GoLive, promise layout control, but it is still dependent on the defaults of the individual browser doing the reading of the site. Flash and LiveMotion give us vector graphics that print at high resolution, but most practitioners are still generating huge page sizes that can take well over a minute to download.

Web hype has been over the top

There are some signs that sanity is slowly coming to the Web. The big brick-and-mortar operations are entering the fray. The dotcoms have clearly shown us how to go bankrupt quickly. The Web has been victimized by its own hype. The hype has been so far over the top that rational analysis has been extremely rare.

It has been interesting to watch sites eliminate their graphics in favor of functionality. The push for technologies like Flash has obscured the fact that no flashed sites are making money except for Macromedia and Disney. OK, that's a little exaggeration. I know vector imaging may well be the future of the Web (if we can find enough illustrators). But then this is a book of practical day-to-day techniques. In most cases, this still means HTML, GIFs, and JPEGs. There is quite a distance to go before bandwidth allows much more than we have now. It's hard to see any real solution less than cheap, small, satellite transceivers.

Regardless, the statistics I see in *TrendWatch*, *Electronic Publishing*, *Publish*, and the like all agree. No matter what you want to do in graphic design in the first decade of the twenty-first century, almost all of us will be spending about half of our time on Web design and half in print design. Multimedia is still a very small percentage of the overall business.

What is often forgotten is that the printing industry is huge. It may have redistributed a little into offices. However, as recently as 1996, printing was the third largest manufacturing industry in the States, right after cars and appliances. The Web is a marvelous marketing tool. It will continue to grow (as will print) as long as we are an economy ruled by marketing. However, expect the hype to end in favor of practicality — soon.

> **However, like all design problems, this is just another problem to be dealt with.**

The software only changes a little

The primary software for Web graphic creation is FreeHand, Illustrator, Photoshop, and CorelDraw. Fireworks and ImageReady are making a good run, but they rarely create images. The new software with the best reputation is ImageReady, but then what would you expect from the creators of Photoshop? There are literally dozens of other secondary programs, but surely you can see by now that we are still talking about bitmap and PostScript Illustration programs.

This is the primary reason why Website design and creation are still dominated by desktop publishers. It is basically the same skill set. The drawing and creative skills are almost identical, only compromised by the limitations of the formats used. The layout and design techniques are still largely the same, except for the fact that many normal options are no longer available.

PRINT AND WEB DO HAVE DIFFERENT REQUIREMENTS

Limited by the environment

Basically, this chapter revolves around a discussion of internet and graphic format capabilities. Then we can talk about methods to cope with those limitations. First of all, the Web is severely limited by its output devices – the monitor. While it is true that the Web looks better on high resolution-monitors, most people do not have them. Even if high-res monitors are available, the graphics are limited to 72 dpi.

Color depth

Beyond the low resolution is the problem of color depth. By now you should understand that concept clearly. As of late 1998, the average monitor around the country was still 8-bit, at best. Average means that many are less and many are more. By now you can probably assume 16-bit, or thousands of colors. 16-bit makes JPEGs an iffy option, though.

If your client's customers are mostly graphic designers, then you can almost count on resolutions of at least 1024 x 768 with 24-bit depth. If those customers are small business owners, you better design for 640 x 480 and 8-bit. If you are marketing to ancient bureaucracies or dated agencies, you better plan for 4-bit or less.

Platform differences with monitors

This is one place where you have to be cognizant of the vast differences between PC and Mac. It sounds like a simple difference. PC monitors use a gamma of 2.2, and Macs use a gamma of 1.8. If you remember from the halftone production section, *gamma* is a measurement of contrast. In

practical terms, gamma makes your monitor look lighter or darker. So, to reword the results of the gammas just mentioned, Mac monitors are much brighter (and usually much higher resolution). Images created on a high-res Mac, that look great, often look very dark and dingy on a PC – not to mention that they look huge. Images created on a PC, that look fine there, are often far too light, with all the highlights blown out. Often they are also much too small.

This is even true of type. On my high-res monitors, I usually use 14-point type or larger to make it legible on the screen. The type looks absolutely huge on a PC. This is also the reason why many Websites that were created on a PC are completely unreadable on a Mac, because the type is too small to be read.

It should be remembered that because the Web is so graphic, Macs are used by a much higher proportion of the participants than in the general audience. Accurate stats seem very hard to find (probably because the statistic manipulators are mainly on PCs). Every guess I see is in the 25% to 33% range though. I have seen guesses about the proportion of Mac-generated Web pages as high as 50% or more.

Rarely is reality even discussed

I saw a stat on CNN suggesting that 60% of the pages on the Web are porn. I guess they definitely need the graphics, but people will probably put up with slow downloads there. In general, people surf the Web for data. They come to your site (and your client's site) for information and easy contact. This is probably not the place to mention all those who surf with the graphics turned off. However, in 1998, that same Web survey stated that nearly a quarter of all surfers fly through cyberspace with the graphics turned off for faster access speed.

Pretty depressing, huh? Actually, it's not that bad.

This is an environment where color has no penalty – you can always work in color, if you want to, at no extra cost. We are not talking about the impact of four-color process on cast-coated stock with the photos popping off the page, highlit by gloss varnish in front of a dull varnish background, but the color available is good enough to get the reader's attention: 256 colors are definitely better than black and a spot color.

Oops, we forgot about bandwidth!

This problem is actually worse than the limited palette. As I write, the average surfer has a 28.8 to 56K modem at best. Even the 56 kilobit standard is glacially slow, when we consider that normal color separations are dozens of megabytes in size. At 28.8 (which is well under 4K per second), a 10 MB graphic would take forty-two and a half minutes minimum to download (if

File size

The important factor in Web graphics is not the physical size of the image but the file size in bytes. If you are careful, you can make graphics in relatively large physical dimensions that are very small in data size.

there is not a break in communication that requires you to start over). In general, modem connections over phone lines work at far less than 56, no matter what hype sold you your particular modem.

It is commonly stated on Web design Websites that the average surfer cancels out and moves on if the entire page takes more than 30 seconds to appear. An informal study of my students would suggest that this figure is closer to 15 seconds. I tend to believe (and I have seen people state the same thing) that anything over five seconds starts compromising readership. This means that the entire page must be well under 45K – closer to 20K. Even at the community college where I teach (where we have a T1 line), I consider myself fortunate if I can see a page in five seconds or less.

Of course, there are always the storied cable modems and even satellite modems. They are slow compared to my T1 line, and surfing is not fast on a T1. I know something of that ilk will probably come in the next decade, but we don't know what it is yet. So the sum of the limitations is that your Web graphics have to be 72 dpi, usually 8-bit, and always under 30K (3K is obviously far superior). Fortunately, we have been given three file formats that deal with these limitations fairly well, plus a format that circumvents the limitations entirely, if necessary.

WHAT WE HAVE TO WORK WITH

The four formats are GIF, JPEG, PNG, and PDF

Almost all graphics you see on the Web are in these formats. In fact, as I write in 2001, the only two formats seen are GIF and JPEG (with some Flash for entertainment, games, and the like). PNG is still very rare, and PDFs must be downloaded and then read with Acrobat Reader. Until things change a little more, I would stick with GIF, JPEG, and PDF. PNG has received some hype, but there is no overwhelming advantage other than the software writers do not have to pay a royalty to CompuServe to use the standard.

You will hear a lot about Flash and SVG – and I'm sure there are and will be many more formats bandied about (XML comes to mind). The key to remember is that many of your client's customers are interested in getting in touch with their clients who are using AOL. AOL's built-in browser is still limited, and using a normal browser through AOL is still much slower than direct access.

Flash can be read by almost everyone now, but that first download is still a killer. I'm sure we are all willing to stare at a "Loading" animation while waiting for some real content. (I hope you don't believe that.)

I am not going to give you a technical analysis of these formats. What you need to know is their capabilities: color depth, compression, and transparency. This is easily shown here:

GIF: 8-bit or less, LZW compression, transparency, and animation.

JPEG: 24-bit, lossy compression — no transparency or animation.

PNG: 8-bit and 24-bit, zlib compression, partial transparency (alpha channel or soft mask).

PDF: Anything you can do in print, plus links, movies, and sound with embedded fonts, print control, PostScript.

As you can see, it is pretty straight forward. You determine what type of graphic you are producing, and use the format that meets your needs best. The biggest problem is still the byte size you must attain. On the Web, a graphic of more than 10K is large. An image over 30K is unusably large. This is certainly a massive change from the 30–40 MB files we have become accustomed to when dealing with process printing. Even 300K grayscale halftones are absurdly large.

The good news is that here the Web's limitations work in our favor. Because we are forced to use 72 dpi, our pictures are much smaller to start with. Remember, if you cut the resolution in half the file size is 25% smaller, because the resolution is cut in half both vertically and horizontally. So, instead of working at 300 dpi, we are now working at less than an eighth of that. However, that still means a 32 MB file would now be 4 MB.

Web compression

The key to the solution of these problems is the built-in compression schemes used by the various formats. Basically, there are two type of compression: lossy and lossless. The names make obvious the capabilities. Remember, the purpose of compression is to save on file size – compression makes files smaller. The question that distinguishes lossy from lossless is: *"What happens when you decompress something?"*

If you have lossless compression, nothing happens. The decompressed file is exactly the same as the original file. You lose nothing. However, if you have lossy compression, you lose data with every compression. In other words, if you compress and decompress, compress and decompress, and compress and decompress, you end up with obvious compression "artifacts." Details disappear and things appear in your images that were not there when you started.

So, the obvious question is, *"Why would you ever want to use lossy compression?"* The equally obvious answer is, **"WHEN IT IS THE ONLY SOLUTION TO YOUR PROBLEM."** Lossy compression must be approached with care and handled correctly, but given that, lossy compression

can make your files 5% of their original size. Beyond that, we need to discuss how the different compression schemes work. Understanding this can allow you to plan for better compression.

LZW compression (or run-length encoding in general)

LZW is the compression scheme built into GIFs. It is also an option when used with TIFFs, so you should remember how it works. Basically, it is a type of run-length encoding. In other words, LZW reads all of your pixels left to right, top to bottom, row by row, looking for patterns. The basic concept can be expressed this way. Pixels are located by row comma column, so the first pixel in the first row is 1,1; followed by 1,2; followed by 1,3; etcetera. An uncompressed image has to define every pixel by location and color. The color is indicated by a number representing the PostScript level from 0 to 255 (0 being black and 255 being white).

If we have an image that is two inches square at 300 dpi with a white background and a one inch black box in the center of the two inch document, we then have an image that has 600 rows and 600 columns. Uncompressed, this would be written: 1,1 255; 1,2 255; 1,3 255; 1,4 255; and on and on for the 600 pixels in the first row; the 600 pixels in the second row, etcetera. With LZW the document would be described something like this: the first 150 rows are all 255; the next 300 rows are 150 pixels of 255, followed by 300 pixels of 0, followed by 150 pixels of 255; the final 150 rows are all white. The LZW description is completely accurate, yet describes the entire document in a couple of hundred bytes of data (.2K!) Uncompressed, the file needs from 8–12 bytes per pixel (minimum). Since there are 360,000 pixels, we are talking well over 2 MB to describe the file.

However, there is an obvious problem. In the example I just gave, we have a very simple image that can easily be described in sentence form. What happens with multicolored vertical stripes? Or worse, yet, what happens if you are dealing with a photo where every single pixel is different? The simple answer is that LZW will not save you anything in these cases. In fact, it will make the file size larger.

The basic rule with a GIF is this: GIF is the superior format with relatively large areas of flat color, preferably in horizontal patterns. It also does well with regular patterns, by substituting a marker for each pattern. In other words, GIFs work best with what we have come to know as PostScript illustration with few gradient fills.

JPEG compression

This is a completely different type of compression. With JPEG you lose data and detail. JPEG compresses by taking areas of pixels – 3 x 3, 5 x 5, and so on. This sample is then averaged, and the average color is applied to

each pixel in the sample. It would seem that 5 x 5 averaged would give you 25 to 1 compression ratios, and that is nearly true!

JPEG is the only solution to getting photos on the Web, at this point. PNG will probably be used more in the future, but there is not enough support for PNG yet. Also, PNGs do not compress nearly as well as JPEGs. Of course, without 24-bit monitors the advantages disappear.

The problem with JPEG in the printing world is that the little averaged squares are visible in top-end process printing at 150-line screen. As a result, the huge compressions available cannot be used. On the Web, this is not a problem. Web graphics are so crude that the JPEG artifacts are usually too small to be seen, even with the most extreme compression options offered by the format.

For print, you often cannot get away with even the medium compression option. For the Web, you will find that the lowest quality option will do nothing more than make your files small enough to use. You obviously still have to be careful of the pixel dimensions of your image, but it is not at all unusual to have an RGB photo of 5 or 6 MB, that reduces to 700K when converted to 72 dpi, that further reduces to 30K when saved as a lowest quality JPEG. It will still look remarkably good on the screen (as long as the monitor is 24-bit color).

A reality check

Please remember that outside our community of designers the average monitor is still 8-bit or less. As recently as 1996, the average monitor in my department at school was 4-bit. All of those gorgeous, too-large, Web graphics were crammed into the sixteen colors available. It was a sorry sight.

Those of us in the design community tend to forget how bad the average business PC is. Remember, the Mac is designed by graphic designers for graphic designers and the PC is designed to be cheap. Always check out your designs on both platforms with every browser you can find. Then make the best compromises you can.

System color variances

The final platform difference we need to discuss is commonly seen when using GIFs. Remember that GIFs use indexed color (8-bit or less). Both PC and Mac have a standard set of 256 system colors. Of course they are different sets. Actually, it's not as bad as it sounds, as 216 colors are common to the two different systems.

Much has been made of using the "Web-safe palette." In my humble opinion, it is simply more of that anal-retentive nit-picking commonly found

Here's the problem

If you can read the tiny type, you can see that in this case PNG-8 wins in file size, with less than 25K, even though we started with nearly 3 MB in the PSD. Here GIF comes in with just under 45K and JPEG can only do a little less than 70K. However, please notice that there is bad banding in the PNG and the GIF has obvious "dirt" in the background. In this case, the JPEG is far better in quality. If you cannot see it in this grayscale version, trust me. What I am telling you is true. However, the obvious fact is that none of these images can be used on the Web. They are all too large. Dealing with Web graphics requires a different way of thinking.

in designers who think that the "perfect color/design/layout" really matters. Basically, "Web-safe" is an oxymoronic concept. At this point, it is not even possible to have a calibrated PC monitor, so you have no idea what the colors are going to look like anyway. The real solution is not a Web-"safe" color palette, but clean, crisp design that looks good no matter how the colors are modified. The much-talked-about concern for dithering is also more irrelevant blithering. Simply design your graphics so dithering doesn't matter.

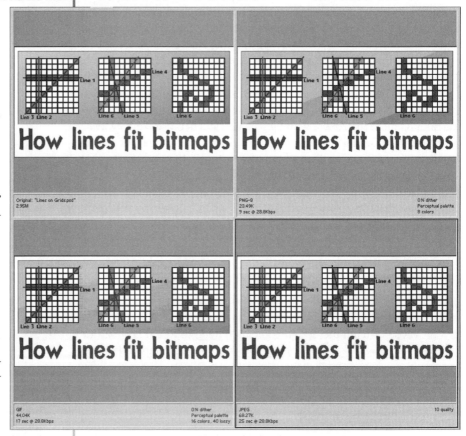

Some suggested general production procedures

First of all, my suggestion for graphic creation on the Web is to work from FreeHand, Illustrator, or CorelDraw. I know that most things are done in Photoshop, and that this is a Photoshop book— but please hear me out; we'll get there in a minute.

The key to small, easy-to-read, functional graphics is that they be small, clear, and communicate clearly. One of the major tests of your design

is that your pages download in less than ten seconds on a 28.8 modem over a regular phone line, so it is imperative that you use no graphics without a very good reason. When you decide to use a graphic for a good reason, it has to be SMALL.

The result of this is that many, or most, of your graphics will be words or will contain words. Photoshop has gotten much better with type. But even with Photoshop 6, and its much vaunted type layers, type is clumsy at best. In print, everyone knows that PostScript illustration is the only real solution for powerful type manipulations. Personally, I recommend FreeHand (since it handles type much more fluidly than Illustrator). I have many students who claim the same power with CorelDraw (this is one place where Corel's problem with clean code makes no difference).

You have ImageReady and probably Flash and Fireworks. However, for most of us, Web design is an addendum to our skills, not the focus of our life. You already have FreeHand or Illustrator and Photoshop as part of your skill set. They are actually more powerful, in many ways, than the specialized Web tools, which are totally incapable of being used for anything other than the Web.

Reality suggests that almost all Web graphics can be done with Photoshop's SAVE FOR WEB...command

We will get to that more in a bit. First we need to talk about those fabulous slicing tools in Photoshop 6 (and ImageReady and Fireworks). It is assumed by all Web software producers that this is what you really need, because this is what you are asking for. In reality, if you slice up your images you probably made a big mistake.

Sliced image maps

There are a couple of ideas about image maps that you need to understand. First, cutting an image into smaller pieces does not reduce its file size. In fact, it increases it a tiny bit because of the extra code. Second, the image does not download much faster, if any; it just looks like it because there is something to see.

So, if the much-touted advantages are illusory, what about disadvantages? Most important, while you are waiting for an image to download, you can do nothing. Most surfers are not going to sit there and do nothing. Yesterday, I went to the Website of one of the best suppliers of clip art, stock photos, and so on. I made the mistake of clicking the Flashed version. I

was dazzled with fancy graphics for well over a minute, getting increasingly irritated because I could never find the link that would tell me what they sold, what it cost, and how to subscribe. I finally gave up in disgust and left for easier-to-access data.

My wife is a pastor. Her denomination's international headquarters has for years had a Website where the first page is a 348K image map. It is gorgeous, but on our modem at home it regularly takes more than three minutes before you see anything you can click on to get where you need to go. There is a direct link to their site map we have bookmarked, but it has several slightly smaller image maps that still take more than a minute to download.

 One of the most common things forgotten in all of this is the factor played by the individual servers. Much of it depends upon the skill of the programmers who wrote the scripts in the CGI bin to interact with the database. Much of the slowness can be attributed to that. As a practical example, consider the following:

I have a T1 line at my school. From Macromedia and Apple I can download at up to 500K per second. From Adobe's site, I have never managed a download of more than 25K per second. When I click a link, it takes twice as long at Adobe as it does with the other two. These are server/programming problems.

Showing links

The largest problem with sliced image maps is that they do not show visited links. You cannot tell which links you have clicked before. As you are searching through a site, it quickly becomes confusing. It only takes a couple of times of returning to the same page for a surfer to bail on you. This not just an problem with large image maps. It is also a problem with the number one use of slices — rollovers.

Rollover buttons

Although these are commonly sliced out of a single image, they can also be separate graphics. Like any sliced-and-diced image, they give no reference to visited links. To complicate the issue, each button is actually three graphics, at least. I'll grant you that you can get those images pretty small. Even so, a completed button is between 1.5K and 3K or more. Ten buttons total 15K to 30K, and you have a real problem.

The first rule of graphic design is that it must not be noticed by your readers.

If the readers (surfers, whatever) of your graphic designs notice the wonderful design, you have utterly failed. The idea, bubba or bubbette, is that they notice the product and decide that this is something they can really use. The reaction must be that the product is valuable – whether that product is Web access to the company, a service, inspiration, or a physical product sold.

If they notice your graphics, you have failed.

It is easy to make similar arguments against frames – they cannot be bookmarked and they're slower. Flashed sites suffer from horrendous waiting times while things are loading. Plus, no bookmarks and there are normally no visual references to where you have been. All of these things can be gorgeous. Normally, they are simply hindrances to actual contact with the customer and to meeting the needs of the customer.

Save for Web...

Let's step down from this soapbox and get practical for a minute. Photoshop's SAVE FOR WEB... controls are fabulous. As much as I am convinced that PostScript illustration (FreeHand, Illustrator, and CorelDraw) is the best place to start your Web graphics, I cannot deny Photoshop's part. Nothing comes close to the speed and control offered by its SAVE FOR WEB... command. Using anything else sacrifices a competitive advantage.

Yes, I know that Image-Ready has the same dialog box – so why go there? The same dialog box is also in Illustrator, but then I am sure you have heard of the problems of AI9 by now (largely due to the fact that they crammed most of Photoshop into a PostScript illustration program). The point is, however, that this dialog box is essential for controlling your Web graphics. Nothing else comes close to giving you the controls you need for file sizes, color depths, formats, and all the rest.

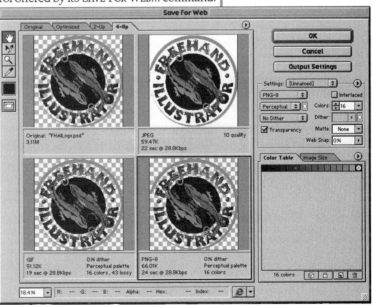

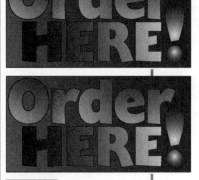

The dialog box, as powerful as it is, is not much help unless you understand how each file format compresses. We'll start with simple GIFs.

Keeping images small

We need to spend some time showing some design tips to make your images as small as possible without compromising quality. I have drawn a small ordering button. In reality, it would have to be much smaller than this. Also, it would look a lot better. However, it works well to show us what we need to know. I have kept it very simple so you can clearly see what is going on with the LZW compression in a GIF. Because these are done in grayscale, you need to imagine them in full living color. It is very easy to make these very colorful without increasing the file size at all. Remember, GIFs use indexed color. In other words, they convert the image to a very limited palette of a certain number of colors. The maximum number of colors is 256; the minimum is 8. By radically reducing the colors like this, the file size can be made much smaller.

Multiple vertical gradients

The original on top was 238 colors and 93K. Just below that, going to 128 colors and 9% lossy dropped it to 32K. Below, all I did was go to 64 colors and 9% lossy — the file size dropped to 27K.

There are a couple of important things to keep in mind. First is dithering — that process of giving the illusion of intermediate colors by randomizing the dots. Don't use this, because it greatly restricts the compression abilities. The procedure is to use Perceptual and the fewest number of colors without banding. Then add lossy compression until artifacts show up and back off a little until they are gone again.

For the first version of this little image at the top, there are hairline rules and multiple, varied fills. The background and the word "HERE" have vertical gradients (from left to right). At 300 dpi (to give good size comparisons) and 2 inches wide, the original was 238 colors and 93K. Simply cutting it to 128 colors and 9% lossy, gave me 32K. That is still a very large file, in Web terms — even though I cut the file size in thirds. By converting it to 64 colors and 9% lossy, it went to 27K. As you can see, there was virtually no change in the image.

Horizontal gradients compress better

For the next version of the image, at the top of the next page, the gradients were radically simplified. The words were made into one horizontal gradient top to bottom (with the exception of the exclamation mark). The background was also changed to a horizontal gradient. When this was rasterized at 2 inches wide by one inch tall like the first one and converted to a GIF, there were 239 colors. The file size was 33K.

However, an interesting thing happened. Because the gradients were longer in length, it proved to be impossible to get the file much smaller. Finally, by turning on diffusion dither, adding lossy compression to 25%, and

reducing the colors to 64 I was able to get the file size down to 22K. Notice, please, that because all the gradients were horizontal, and fit into the paradigm of LZW compression, it compressed nicely. Even though there was exactly as much data as the original image that ended up at 93K, this image started at 33K. This clearly shows how much it helps to have the gradients in horizontal bands that compress well. The problem here is that the gradients are busted up by the letters of the words.

The final version drops the background. The exact-color GIF had 230 colors with a transparent background. But, because it used horizontal gradients, it saved at 22K on the first try. By taking it down to 40 colors and 25% lossy, the size dropped to 14K. On a monitor, this image looks sharp, crisp, and colorful.

This is especially true if it had been rasterized at the actual size used (one inch wide) and at the real resolution (72 dpi). At that size, we can go down to 16 colors, 18% lossy, and a final image of only 1,080 bytes, which is tolerable. At 1K, this is a button that could be used a lot on several pages. Once this image is downloaded, it can be used wherever needed with no additional memory penalty, as long as the image is still in the image cache of the browser.

There was one more interesting phenomenon. When produced at the final size of one inch wide, this image was only marginally smaller than the first one with the randomized gradients. The original, one inch, 72 dpi can be taken down to 2K.

This points out the most important factor in the byte size of images: physical pixel dimensions. Make the images as small as you can. Remember that on PCs, most people are still working at 640 x 480 pixels. This means that the tiny little image on your high-resolution screen will look much larger on the low-resolution monitor.

The problems with JPEG

As mentioned earlier, there are two basic problems with JPEG graphics. The first is also one of its major benefits: 24-bit color. The argument has always been that continuous tone illustrations require 24-bit color to look good. This would include virtually all Photoshop output, especially photographs. The obvious problem is the relatively small percentage of computer users who have 24-bit color on their monitors.

I'll grant you that these people get the most press. We're talking about the gamesters and graphic designers, mainly. For these people, we can go all-out. If you are designing a gaming Website, by all means, assume 24-bit color and the fastest CPUs. To get their attention you will probably

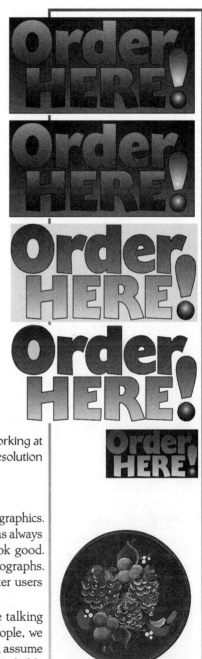

need Maya, or at least Flash. There is a sizable market here, and it is Web-driven. However, surely you will grant that sites for video gaming are very specialized and tightly focused (think: relatively small). The same is true of sites that cater to graphic professionals, in general or for specific areas of the industry.

The rarity of creatives

The thing to remember is that there are not many of us. You do not find our software or hardware sitting on the shelves in your local CompUSA, Best Buy, Circuit City, or WallyWorld. Our market is not large enough to merit shelf space. It would be foolish for the large retailers to have sections devoted to FreeHand, Illustrator, Maya, Director, QuarkXPress, plug-ins, Xtensions, and the like. I assume there are specialty shops in the large megalopolises that are filled with them. Most areas do not have that luxury. This is the main reason why we have always been served by mail order. We are not a mass market.

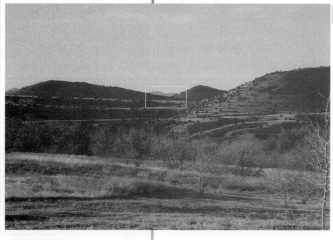

JPEG compression artifacts

The major problem with JPEGs is that they are lossy and produce very ugly changes to your images, if you are not really careful. Let's take a close look at one of the photos from the Skill Exams on the CD. I have enlarged part of what you see contained in the white outline in the center of the photo.

At the bottom, the original photo is to the left. The JPEG artifacts are to the right. I have to confess, I am very disappointed with the grayscale view. In RGB, when I captured them, the differences were horribly blatant, because the averaging used by JPEG does not just affect the value, it also affects the hues and saturation. As you can see, it is most visible at the better defined edges of color shapes.

This is mainly a problem in faces, for example, where smooth cheeks are stopped by the eruption of a nose or the cavity of an eye. I couldn't use that as an example here because those changes

are almost entirely in the colors. They make the skin very blotchy, often making the poor model look like she has a bad case of rosacea. In your SAVE FOR WEB... dialog box, you must watch carefully as you increase the compression. It is true, in the Web, that you can often go for very extreme compressions without great problems. You do have to watch carefully, though – and now you know why JPEGs are such a disaster in the printing world.

Using PNGs

Though no one is sure what the average browser is at this point, we can assume that at least half of the people online cannot read PNGs. The reason we cannot know better is that every computer now ships with browsers. All Macs, for example, come with Netscape Communicator 4.6 or 4.7 (I'm not sure which because I always toss the new one to access one of the sites that used to sell my fonts, which requires 4.5). And they have Explorer 5 installed also. No stats I have ever seen can tell me which of those browsers is the most used. Explorer 5 will handles PNGs. Communicator (in these older versions) is iffy. Many with older computers never bother to upgrade. So PNGs are not ready for prime time, except to the graphic set.

Photoshop's lossy option added to GIF still usually does a better job than PNG-8. There are certainly many more controls with a GIF. PNG-24 has no control at all. You get what you get.

JPEG 2000

This great new compression scheme hasn't arrived yet. It is no longer 2000. Who knows what they will call it when it finally arrives?

Controlling optimization in ImageReady

The optimization options in ImageReady are much more powerful. You can control your optimizing with channels. You can mask your JPEG compression, the lossiness in a GIF, and the amount of dithering in a GIF or PNG-8. Those options are esoteric enough that I won't cover them in this book, but they are available if you want to get into that. My suspicion is that if you need these options, your graphic is too large to start with.

Always preview your site

I clearly remember my shock the first time I saw my original site, back in the mid-1990s, on a computer in one of the PC labs upstairs. It was huge, very dark, and in Times New Roman. That original home page didn't even vaguely resemble the clean, bright page set in Palatino that I had designed on my screen. I ended up redesigning quite a bit of the page, making the logos and the type smaller. More than that, I had to completely revamp my color palette. Dark and subtle was obviously not going to work. This is a

Space hogs

What is often forgotten in the heated cross-platform arguments is the wasted space used up by Windows toolbars. I remember an officially presented demo of Front Page a couple of years ago: by the time they had demoed all the options there was less than a three-inch square left in the center of the screen. On Window machines, they often cannot use 800×600 because the space between the double toolbars on top and the task bar on the bottom is much less than 600 pixels. Explorer even has a side bar that takes up nearly a hundred pixels on the left side.

much larger problem than you might think. Platform differences and the huge quality differences between what we have and what "normal" people have are still a major design concern.

We have already mentioned that the Microsoft and Mac system palettes are different, with only 216 common colors. A much more important difference is the monitors used, as we have also talked about. As is true of most things PC, the operative word is cheap. Whenever you have a product and an entire industry that is governed primarily by price concerns, you have a problem. PC purchasers complain if a computer costs more than $1,000; in fact, many now expect them to cost less than $500. This is absurd for our purposes!

Now that comparable PCs are more expensive than Macs, to get a computer that will do what we need it to do for graphic design will cost $3,000 or more. You cannot even seriously run a PC before you buy several cards and peripherals that do not come with the machine as standard equipment. No matter which platform you use, you need scanners and other equipment. The real problem here, as far as viewing your marvelously designed site on the Web is concerned, is that any monitor costing more than $500 is considered ridiculously expensive. Most systems purchased in Wintel have $100 to $250 monitors. Needless to say, crude and ugly are the operative words.

Effects of cheap monitors

First of all, the resolution is usually very low and very crude: 640 x 480 pixels is still very common (hanging around 25% to 35%). The Mac designer average of 1,024 x 768 pixels on the 15" monitors to 1,600 x 1,200 pixels for the 21" screens is virtually unimaginable to most surfers. Some assert that the current average on the Web is 800 x 600 pixels, but that is still debated. Read the sidebar to the upper left on space-hogging software. Mac surfers do all right because it is almost impossible to buy a monitor lower than 1,024 x 768. In practical terms, this means that pieces designed on a Mac often look nearly twice as large or larger when seen on a PC monitor.

Secondly, monitor calibration is only a very recent arrival to Wintel machines. In fact, it really wasn't even possible until Windows NT and Windows 98, because the operating system did not support it. (The dirty secret is that professional, calibrated PostScript graphics are only arriving very slowly with Windows 2000.) A calibrated monitor costs well over $1,000 for a PC, and is a real rarity.

Third — and this is a fundamental difference — Mac and PC use different gamma settings for their monitors. Mac's standard gamma is 1.8, whereas the PC standard gamma is 2.2. In other words, a PC monitor is normally much darker than a Mac monitor. I've changed the gamma on my

Mac to 2.2, but the PC monitors are still quite a bit darker than that. I am even using my monitor set on D50 because most of my work is CMYK print as opposed to RGB Web, and PC monitors are still darker than that.

Finally, we have the differences in browsers. We assume that there are only two: Explorer or Communicator. But already you can see the problem. Many do not have Communicator; they are still stuck back in Navigator. In fact, AOL still uses a limited browser and it is the largest source of surfers. More than that, we have the different version numbers. All of the latest bells and whistles assume that you are using a version 5 browser or better. The average is still version 4. Both browsers and all of the different versions of those two browsers show pages differently; check out as many as you can when proofing your Websites.

Here are the steps I use

THIS IS OFFERED MERELY FOR YOUR TITILLATION. The most common reaction I get from my sites is, "It's so clear and colorful!" I put it to you that this is not a bad response. I don't expect you to use my methods (though I find they work very well for me). I offer them in hopes that they will solve some of your production bottlenecks. In addition, I hope they will allow you to stand back and look objectively at the tools you have on your computer.

1. I draw my graphic in FreeHand. I do this so I will always have a high-resolution printable version available. I have a Web graphic template with my custom RGB color palette that I created using the Crayola color palette. By starting with a common color palette, I achieve a consistency that is often lacking in other sites. I draw it to size (the size I expect it to be on the Web page). Because the fluidity of change is so powerful in FreeHand, I have the total design freedom allowed by PostScript illustration.

 TIP! I am very careful with my stroke widths. I know that a line will not be a predictable color on a monitor unless I make it at least **2** points wide (even then you might have to go to a **3**-point stroke). Remember that the tiniest thing you can do on a monitor is one pixel, which is one point. Anything less than that is going to give subtle, colored edges when the anti-aliasing appears in the resulting GIF. For example, a one-point, vertical black line will look like you planned, if it hits the pixel grid exactly. However, if the line is half on one column of pixels and half on the next one over, you will get a **50%** gray line two pixels wide. If it falls **30%** on one column and **70%** on the other, you end up with a **30%** one-pixel line next to a **70%** one-pixel line. I use hairline strokes to aid in overall visual sharpness with no regard for stroke color.

The need for FreeHand for the Web

I counsel my students always to start in FreeHand, and you need to know why. First of all, the design freedom in PostScript illustration is much greater than in Photoshop. But that would also include Illustrator and Corel-Draw. Second, FreeHand has master pages and the Page tool to use for visualizing or laying out an entire Website. Third, anything done in Free-Hand can be brought directly into Photoshop, Flash, or Fire-works as necessary. Fourth, **and most important,** everything created in FreeHand prints at high resolution when required, making the almost inevitable conversion to print much easier. Fifth, FreeHand's ability to directly export multipage PDF proofs for client conferences and visualization is unexcelled. Sixth, FreeHand exports to far more formats than any of its competition. Try it, you'll like it.

2. I save the original and then export it as a Photoshop PSD if the background is solid. If I need a transparent background, I export as an EPS to be rasterized by Photoshop. I can drag'n'drop the paths across to Photoshop, but I find the extra step of exportation gives me saved stages of graphic development that help. This gives me a very accurately rendered RGB image in Photoshop.

3. Sometimes a little cleanup is necessary in Photoshop, sometimes not, and sometimes I have to go back to FreeHand and make changes. Increasingly I bring my FreeHand layers into Photoshop to add layer effects. Simple type I occasionally generate in Photoshop, but too many of the type editing controls I rely upon are simply not available in Photoshop (even in version 6).

4. I open the graphic in Photoshop's SAVE FOR WEB... dialog box and adjust it until it is as small as possible in file size. Remember that in almost all cases, your Web graphics should be well under 10K.

5. Occasionally there is some minor final cleanup. I usually save it out of Photoshop as a GIF with a transparent background. I usually end up with very pretty graphics that are less than 10K (often 2K or 3K).

 TIP! Don't go by the size listed in your window on a Mac. Use the Get Info box under the file menu. It will give you accurate byte figures. The conversion to UNIX on your server strips out a lot of data, like thumbnails and so on.

Animation, cascading style sheets and DHTML

Now you are going to get very upset with me. No one wants to hear this part. Many, if not most, of you have been patiently waiting for me to get to the fun parts — Java scripting, Flash, ShockWave, animated GIFs, CGI/Perl, and all of that. You will have a long wait. You don't want to do any of that!

HERESY! I can see the crossed fingers fending me off around the world. You will probably need CGI, and your applications will probably be written in Perl. Much of your site will be Java-scripted. However, if you are a typical designer, the entire process of programming is slightly less exciting than watching Sesame Street reruns.

At this point, designers increasingly do the graphics to give to the programmers and database mangers. We are still governed by phone lines. In most cases, we are hemmed in by AOL. We have to design for our customers. The fancy stuff mentioned above is increasingly handled by the programming and scripting staff, usually in Dreamweaver. Designer sites are rapidly being replaced by targeted database management.

The best quote I have ever read was on one of the Web design sites and it went something like this:

People do not come to your site to see the killer Website — they come for easily accessible data.

Your customers (or your clients' customers) are not looking for amazing digital dances to amuse and pass the time. They want to know what you are offering, why they need it, and how to get it. The fancy stuff does not help. **IT IRRITATES!** It's the same reason why most of your printed projects are still (and will remain) black and white. In printing, process color is the fancy stuff – and it is much easier to justify than that incredible animation with the imbedded row of changing interactive buttons where you have to wait seconds (or minutes) for each new image.

At school, I am running a fast G4, with 256 MB RAM, on a 100BaseT WAN, to a T1 line – and I still find the fancy stuff merely mildly irritating (entertainment at best). Imagine how I would feel on a Quadra or 486, with 16 MB RAM, using a 28.8 modem through AOL. Heck, maybe your customers even live in rural areas where good phone lines are a luxury that hasn't arrived yet – and DSL, ISDN, or cable modems will never arrive.

A final word on friendliness

Websites are unique bits of graphic communication. On the one hand, they are very cold, noninvolved, impersonal assemblages of digital data. For pixel pushers like us, they are great fun and global on top of that. On the other hand, our Websites reach our customers on a very personal level in a quiet time, where they are isolated within their computer environments. Successful Websites are mainly extremely well-written, comfortable places to communicate. They are not entertaining visual wonders.

Using HTML for presentations

One of the places where all of these fancy bells, whistles, slicing, and dicing work very well is in HTML for presentations. No matter where your client goes to speak, he or she will be given a computer that has a browser and probably a hot Internet connection. I agree there is an excellent argument for Flash here, but simple HTML presentations can be created very quickly. They can have great impact and allow presentations to demonstrate with images and content located anywhere on the Web. Their flexibility and potential graphic quality far outshine the graphic choice of the masses, the

Where should you be by this time?

You should be feeling fairly comfortable with Photoshop. You should have done several Miniskills and Skill Exams. At this point, you should be working on real projects to apply the knowledge you have gained.

DISCUSSION

You should be discussing Web problems of all kinds with each other. I know that many of you will want to do all of these things on your own. I've been there. However, now is a perfect time to find out what others are doing. It will help your skill level immensely.

Talk among yourselves...

ubiquitous PowerPoint. All you have to do is put together an easy-to-navigate "Website" and burn it onto a cross-platform CD-R. Imagine navigating through a presentation with those wonderful button bars you always wanted to put on your Website (but they were too large).

Knowledge Retention:

1. Why must you distrust monitor color?

2. Why are GIFs usually the best solution?

3. What are the problems with sliced image maps?

4. What percentage of your surfing audience has high-resolution, 24-bit monitors?

5. What difference results from the direction of a gradient?

6. What is the maximum recommended size of an entire Web page with graphics in bytes?

7. What is the danger of creating Web graphics in Photoshop?

Chapter 14

Proofing

Concepts:

1. Matchprint

2. Contract proof

3. Profile

4. Laser proof

5. Press proof

6. Film proof

Definitions are found in the Glossary.

CYA on a professional level

Producing proofs that enable clear customer communcation and accurate production

Chapter Objectives:

By giving students a clear understanding of how publishing uses color, this chapter will enable students to:

1. generate an art proof
2. order a contract proof
3. explain to a client the purpose of proofing
4. explain when a press proof might be necessary.

Lab Work for Chapter:

1. Finish more of the theory exams and email for grading.
2. Finish more Miniskills.
3. Finish more Skill Exams.

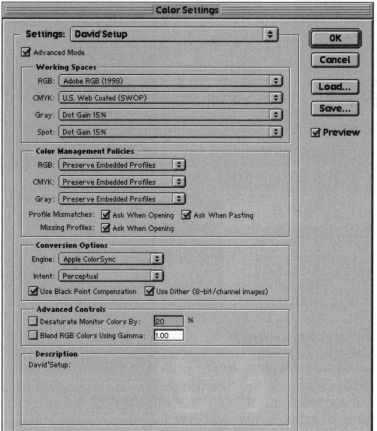

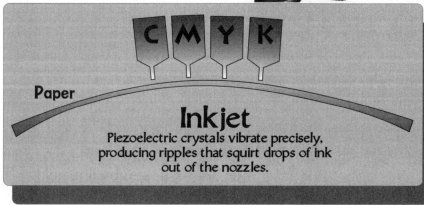

Paper

Inkjet
Piezoelectric crystals vibrate precisely,
producing ripples that squirt drops of ink
out of the nozzles.

Keeping it under control

There's a story about a quality control inspector who was so tense that he sucked himself inside out. His nickname was SphincterMan. He lived to find minor variations from the established parameters and squash them before they had a chance to spread. Quality control (QC) can get like that. It ranks right up there with the most boring jobs you may ever hold.

The sad thing is that QC is necessary. The problem is us. Most created or natural things are self-regulating, but humankind does not seem capable of that. As a result, our only hope for excellence lies in quality control. Our monk here is attempting that (with limited success) by using a model.

The basic thing to remember is that there are no absolutes in quality. Quality, bottom line, is a subjective judgment. This frustrates the heck out of QC managers. One manager, for whom I worked many years, had a horrible time with color proofing, for example. The separators that he liked produced separations that the clients despised. There was no way to tell him that he simply saw color differently than most of his clients. As a result, he was constantly switching separation houses. The problem was never completely resolved until the clients began bringing in their own proofs and he lost the prepress business.

The same standard

The first basic is to get everyone on the same standard. It really does not matter what that standard is. As long as it can be related to the jobs produced and everyone is involved, it will work. There was a client who was always upset that we could not match the colors he wanted. That problem was finally solved when we realized that he was using an old, beat-up PMS swatch book that was at least 10 years old. It had faded and changed color substantially. We bought him a new PMS book and the problem was fixed.

The difficulty is in achieving objectivity in an endeavor that is almost entirely subjective. This is complicated by the common assumption that

printing is a science that can easily produce thousands of identical copies. This simply is not so. If you go to your printing company while they are printing your job, you will see many variations as the run proceeds. Some of these variations are major.

There are many color standards. We've already discussed the use of swatch books. In many parts of the United States, Pantone is absolute, both for spot color and for process. However, even here there are still problems. Clients regularly specify a PMS color and then get horribly upset at the results. It usually turns out that they were looking at the C (coated) section and printing on uncoated stock. The U (uncoated) section of the swatch book has the same colors on uncoated paper. They are much more subdued because uncoated stock does not have the ink holdout required for saturation and brilliance. Even more ignorant is the assumption that a spot color will look as expected on a colored sheet of paper.

The problem of trust

The problem with standards goes far beyond trust. A trusted standard is assumed. However, we are always at the mercy of individuals who use that standard to adjust our printed project. More than that, we are at the mercy of the experience of those people. Here is another of those dirty little secrets: it's all based on experience. The only proof you can trust is the press proof at the beginning of the run, and even that is compromised by the ability and experience of the press operator. Even digital equipment gets battered by power surges, temperature, toner levels, and humidity.

Calibrated monitors

Calibrated monitors are still rare. If you have one, that is a good thing. The best most of us have is the semi-calibrated monitors from Apple. These Studio Displays are really not calibrated. What they do is have a lookup table showing how the phosphors decay over time. They adjust the monitors' color by what they *think* will happen according to the time you have had the monitor turned on. This is not calibration.

A calibrated monitor comes with a standardized target, a densitometer or a photospectrometer, and software that allows you to adjust the colors of your monitor to match the standardized target. These monitors start at more than $1,000, and I doubt you have one.

Dealing with reality

So what does this mean? You need to learn to use swatch books and printer-supplied color proofs. The standard for the United States is Pantone swatch books: Process, PMS, and Process conversion of PMS. You need to

learn to spec colors by the book. As a result, you will be able to function with or without calibrated hardware. The problem will be the printer, imagesetter, or platesetter used by your service bureau or printing company. All that need be done is to calibrate the imagesetter output to find out what it is doing today. The good places calibrate four times a day or more. If it is pretty consistent, you'll do fine.

Notice that we did not say *accurate*, we said *consistent*. Consistency is much more important than accuracy. It is a total waste of time to try to make a machine line up with your ideas of accuracy. A machine is as accurate as it is. Calibration starts with reality. Your standard becomes your machine's capabilities. The goal is to make the equipment as accurate as it can possibly be consistently. It does no good if the dot variance is 0% today, +2% tomorrow and -3% next Wednesday. You would be much happier with +1% every day. Then you know what the output will look like, and you can compensate for the variance. Consistent compensation is far preferable to total accuracy part of the time. You need to be able to rely on your setup.

Color management

Color management takes calibration to the next level. Calibration involves setting a machine to the manufacturer's specs. Color management tries to make the final output match the original art. This is done by making color profiles of all the input and output equipment. These profiles are made by using standardized targets that are scanned and compared to the actual output of the individual peripheral.

Herein lies the key: individual machine. Photoshop 6 forced us to use some kind of color management. It is really a pain in the... neck. The few people in the country who do enough critical color to really need color management have dictated to the rest of us what we *need* to do. The truth is: *most of us do not need it*. What we need is predictability and Photoshop 6 comes close to taking that away from us.

To make an accurate profile of an individual scanner, monitor, printer, proofer, platesetter, and press, we need to spend a lot of money. If you get a job working for a large firm, you will have this. Software and hardware to make accurate color profiles can be purchased for around $1,000. Of course, to be able to use this software, you need a pretty good scanner: another $1,000 to $100,000. To be able to see the scan you need a monitor that can be calibrated: another $1,000 to $10,000. To make quick in-house color proofs, you need a printer that can be calibrated: another $3,000 to $20,000. To make accurate prepress color proofs, you need an imagesetter that can be calibrated and equipment to make accurate film-based proofs, like a Matchprint, or you need an Iris inkjet or digital proofer. Now we are talking real money — six figures: $100,000 to $500,000. A good, solid managed

color printing workflow cannot really be done for less than several hundred thousand dollars (or access to equipment that costs that much). This is why we still have service bureaus.

Most color is not that critical!

Soft proofing

There are many reports, especially among those on the Photoshop beta teams, that this type of workflow is commonplace. These people report that they can accurately proof their projects from their monitors. This is called a *soft proof.* This is true for a very small minority of designers and is needed for a very small proportion of printing projects. The day this will be readily available to the average designer is quite a ways in the future — maybe 2005 or 2010.

The reality of color management

Color management is usually a waste of money. The extreme is fine art reproduction. Most printers hate this type of work, many of them with good reason. Artists can be difficult clients. Unfortunately, the reality is that their paintings cannot be reproduced accurately — not even theoretically (as we mentioned in the color theory chapter).

The problem is the same for all jobs. Fine art reproduction just magnifies everything. To reproduce an original piece of art, you must make an accurate RBY to RGB to CMYK conversion. We already know that RBY is not RGB is not CMYK. The best we can hope for is approximate color accuracy. Every step loses colors and compresses the gamut. Try telling that to an artist who has spent the better part of a year creating a masterpiece.

You will run into many similar problems: the restaurant owner who wants you to match her color scheme, the clothes designer who expects you to match his fabric colors, the designer who is trying to match a two-color PMS logo with CMYK color. The solutions take more tact and people skills than anything else. Even when it is imperative that the colors match, either your equipment can do it or it cannot. Lying will not help anyone.

Color management tries to bridge those gaps. Many management schemes are available. There are hardware solutions and software solutions. Apple has released ColorSync that gives everyone on Macs a common ground to work from. Adobe is pushing its own system. Heidelberg has a system. Microsoft even has one now in Windows 2000 (gasp!).

The point is that whatever your company uses is fine. Learn its system, with its strengths and weaknesses, and find out what you have to do to compensate. Once you adjust to the system, any system will do. The trick

is to train your mind to see what the colors will actually look like when they are printed. Of course, this assumes that you use the same printers for color all the time. If you are in a system where you have to put your color out on bid, you have a real problem. We won't go there.

Most management procedures include gamut alarms and output simulation. A gamut alarm will let you know if the color you see on your screen is not reproducible in CMYK, for example. Output simulation will attempt to modify colors to come as close as possible to the final product.

The point is to do it as your service bureau or printer requests. They have to supply you with the final output profiles, or at least tell you which ones they use. They have to calibrate their equipment for consistency. You have to go with what they use. At this point in the exercise, they all use something different.

Adobe gamma

Be careful! This control panel often produces corrupt or inaccurate monitor profiles that can ruin your color management by changing colors in ways you do not intend.

Photoshop 6: color settings

Here we have the new Photoshop dialog box to set up your color management. It is no longer an option, It is no longer possible simply to use the defaults. You are going to have to deal with this dialog box.

 VERY IMPORTANT! Do not change profiles to make things look *better* on the screen. Set things up before you start. Try to stick with your choices. Use the setup suggested by the company that will be printing your project or producing your color proof. Changing profiles does just as much data damage as applying Levels or Curves. This is not something to play with! Trying to figure things out by simply changing profiles can ruin your images and force a restart.

Color Settings

Settings: David'Setup

☑ Advanced Mode

Working Spaces
RGB: Adobe RGB (1998)
CMYK: U.S. Web Coated (SWOP)
Gray: Dot Gain 15%
Spot: Dot Gain 15%

Color Management Policies
RGB: Preserve Embedded Profiles
CMYK: Preserve Embedded Profiles
Gray: Preserve Embedded Profiles
Profile Mismatches: ☑ Ask When Opening ☑ Ask When Pasting
Missing Profiles: ☑ Ask When Opening

Conversion Options
Engine: Apple ColorSync
Intent: Perceptual
☑ Use Black Point Compensation ☑ Use Dither (8-bit/channel images)

Advanced Controls
☐ Desaturate Monitor Colors By: 20 %
☐ Blend RGB Colors Using Gamma: 1.00

Description
David'Setup:

OK
Cancel
Load...
Save...
☑ Preview

Custom RGB...
Load RGB...
Save RGB...
Other
Monitor RGB – Apple Studio Display
ColorSync RGB – Generic RGB Profile
● Adobe RGB (1998)
Apple RGB
ColorMatch RGB
sRGB IEC61966-2.1
Apple 12" RGB Standard
Apple 13" RGB Standard
Apple 16" RGB Page-White
Apple 16" RGB Standard
Apple 21" RGB Page-White
Apple 21" RGB Standard
Apple Multiple Scan 14
Apple Multiple Scan 15
Apple Multiple Scan 17 – 9300
Apple Multiple Scan 17 – D50
Apple Multiple Scan 17 – D65
Apple Multiple Scan 1705
Apple Multiple Scan 20 – 9300
Apple Multiple Scan 20 – D50
Apple Multiple Scan 20 – D65
Apple Performa Display
Apple Performa Plus Display
Apple Studio Display
CIE RGB
Color SW 1500 Pattern
Color SW 1500 Scatter
Color SW 2500 Pattern
Color SW 2500 Pattern Best 1
Color SW 2500 Pattern Best 2
Color SW 2500 PhotoGrade
Color SW 2500 Scatter
Color SW 2500 Scatter Best 1
Color SW 2500 Scatter Best 2
Color SW Automatic
CSW 6500 Coated
CSW 6500 Plain
CSW 6500 Specialty
David's Studio display
Generic RGB Profile
HP 800 Series DeskJet
Mac Color Display Standard
NTSC (1953)
PAL/SECAM
PowerBook 2400 Standard
PowerBook 3400
PowerBook G3 Series
SMPTE-C
sRGB Profile
Studio Display 17 – 9300
Studio Display 21 – 9300
Studio Display AMLCD
Twentieth Anniversary Macintosh
Wide Gamut RGB

What profiles to use?

This is a subject of hot debate with no real *right* answer. Much of it depends on your equipment. I don't have any way to attach a scanner profile to my scans, for example. The company printing this book does not use color management, other than the old-fashioned, *"Let's make a Matchprint and see what we have"* routine. They *think* that SWOP will work best, but they are sheetfed. (SWOP stands for Standard Web Offset Printing.) This is pretty much state of the art for now.

There are certainly workflows that use color management to save hundreds of thousands of dollars. The key to color management is really very simple: ask them what they want you to do. If the company you are using to print your project uses color management, they will be able to tell you exactly how to set up your software. They will have a custom profile to send you for their presses.

The key to color management is very simple: ask them what they want you to do.

If you do not have anyone to ask (or if you are doing a general setup to get started), I would use Adobe RGB (1998) for my RGB working space, U.S. Web coated (SWOP) for my CMYK working space, and 15% Dot Gain for both Grayscale and Spot Color. With that start you should be all right unless someone (or experience) tells you differently. Remember, this is one area where there is no substitute for experience.

THE ESSENTIAL TOOL

The color proof

One of the simple facts to keep on the conscious level of your printing life is that you cannot remember colors. In other words, when you are looking at the printed product, there is no way to compare it to the proof or the original unless they are there. Side-by-side comparisons are absolutely necessary. Even in a 5,000°K standard color booth, you need side-by-side viewing to determine whether the piece matches the proof.

A *proof* is a print of the job at any step of the way, used to check for accuracy and completion. There are laser proofs, rough color comps, overlay proofs, laminated proofs, soft proofs, digital color proofs, and press

proofs. Printing is extremely complicated, as you have figured out by now. There are literally thousands of things that can and do go wrong during every step of production. You must check for needed corrections every chance you get.

$5 in design, $50 in image assembly, $500 on the press, $5,000 in the bindery

The goal is to avoid higher costs. The appropriate response when someone catches your error is, "Thanks, good catch!" The earlier you find a problem, the cheaper it is to fix. With digital production, if you catch it in design, there is no cost except the five minutes it sets you back.

If the typo or error makes it through the imagesetter, it not only takes the time, but it also costs the materials expended: $50. Actually, with the current cost of negatives and film proofs, that figure is now probably closer to $150 or more, depending upon how many colors you are using.

If the plate is hung and you have started the makereadies, you have some major expenses. With large presses charging at $250 to $750 an hour, errors caught in a press proof are expensive: $500. Again, those are old figures. When you figure that you need new film and new plates, if you are printing process color on a 40" press, this cost could easily be $1,000.

However, if you do not catch it until finishing, you have spent the entire materials and labor cost already. With most larger shops running under 10% profit, you've spent 90% of the billable receipts: $5,000. Obviously, this varies also. Many print jobs are closer to $50,000. A $45,000 loss is enough to make most production managers and CEOs livid.

No matter what, the best thing is to catch errors – period. The worst scenario is the enraged client's phone call after he finds that his phone number is wrong! Catching an error and losing money is far superior to missing it and losing the customer (which happens regularly). This can cost well over $1 million per year for a good customer.

Better in bindery than on the client's desk

Here we run into one of the major problems with digital production. Traditional proofing used the actual film negatives to produce a proof. The dots were the same on the proof as they were on press (even including simulated dot gain). Digital proofs are often not like that.

Digital proofing problems

Because all of the traditional proofing methods use assembled negs, they only work with imagesetter output. This basically means that CTP

(computer-to-plate) production has a severe proofing problem. Many shops simply run out film on their imagesetters to make a proof and then output plates for the final run.

The problems with that are twofold. First, it is an expensive and time-consuming way to proof an otherwise streamlined process. Imagesetter output is not cheap. Just the film can cost from $1 a square foot for traditional film to $4 a square foot for some of the newer thermal films. The time involved is also substantial. It is not uncommon to take close to an hour to output film.

Secondly, the platesetter is a different device with a different RIP. Therefore, the image produced is different. The calibration problems are formidable. The best solution, now used by many, is to have a workflow that uses the same RIP for the proofer as is used to make the plates.

The crux of the matter

Traditional printers often do not trust the digital process. Now we have gotten to the heart of the matter. They are used to doing it the "*normal way.*" We run headlong into the paradigm shift again. In reality, the old proofs were not so good. We were always telling new customers that "these proofs are brighter and sharper than the press can produce." Clients did not like that.

In fact, the old proofs really did not look anything like the final product. All that was different was that we knew how to compensate internally. We did not notice that the proofs were shiny plastic laminated onto white plastic sheets. It did not bother us that the color key overlays were tinted sheets that gave our image a dull, gray look when all four colors were taped into position. We knew what to look for.

Know what to look for

In many ways, digital proofing is far superior to traditional methods. It is simply very different. The new digital-press employees consider digital proofs to be the norm. To soft proof jobs accurately, you must know your system well enough to predict what the final product will look like by examining the image on your monitor.

This requires two things and one attitude. The things are a loupe and time. The attitude is that it is really important that I teach myself to see how the colors are going to change in the final print. You really need a loupe. This is a little 6X or better magnifying lens that you can carry in your pocket – always. The most common is what art supply shops call 1x1 linen tester. Buy one. They are about $15 to $20. Test it before you buy it to make sure you can see the dots in printed materials clearly. It will become one of your most trusted and commonly used tools of your trade.

Close examination

With traditional proofs, inspections revolved around experience and what one could see with a loupe. With digital proofs, inspections revolve around experience and what one can see with a loupe. With soft proofs, inspections rely on well set-up color management, screen magnifications, and the numbers used to create the colors. You won't have any problem trusting the machinery if you know what it will do. This is all that is necessary.

Internal proofs

The most important proofs from a quality standpoint are the internal ones. These are proofs you make so that you can see what is happening. You don't care what anyone else thinks. You are proofing for your own information and that of your comrades on the printing team.

Most internal proofs are generated during the design phase. It is not uncommon to go through several dozen grayscale laser proofs as you hammer out the details of the design. Most of these can be small, cheap 300 dpi laser prints. It is extremely handy to have a full-bleed tabloid printer available – especially if it is 1200 dpi or more – but this is a luxury rather than a necessity. You can clearly see the importance of purchasing a PostScript laser printer. With an inkjet, these quick design proofs usually cost between $1 and $3 each. With a laser printer, they cost from 2¢ to 6¢ each.

It is particularly important to proof all the halftones and separations. You need to make sure that you are happy with them before the client sees them. Multitones and separations should be proofed in color. We'll talk about that in a little bit.

Customer proofs — art proofs and contract proofs

The most important proofs, from a legal and public relations stand-point, are the customer proofs. These are sample prints marked up with notes to explain problem areas. Three proofs are usually necessary. First is a laser proof of the artwork, or *art proof*. Increasingly this is a color print. Second is a contract color proof from the service bureau or printing company. Third is a blueline and/or press proof. A *blueline* is a very cheap proof that simply shows the final imposed layout (or signatures) that will be printed

Many times the press proof is not needed. With on-demand, digital presses, the press that prints the run can also produce the proof. In this situation, the color proof and the press proof are identical. This will begin happening more and more.

A laser proof is always needed. It must be signed off before image assembly begins. Increasingly this is a color laser print or a calibrated inkjet print. You must make sure that it is a PostScript proof, however. Anything

else will be too different from the final results to be useful. You need an art proof that will give your client a good idea what the project will look like without the expense of a contract color proof. This contract color proof is where you start paying the big bucks.

There is no substitute for experience

The contract color proof is the ambiguous part. At this time there are many options. The biggest problem is that people are unfamiliar with the compensations necessary. The mental adjustments to digital output have to be developed exactly the way they were for Cromalins, color keys, or Matchprints. There is no substitute for experience – experience with the specific company doing your printing..

Film proofs (overlay)

These have become very rare with modern four-color or more presses. The standard term for overlays is like *aspirin* or *thermos*. In other words, it is a trade name that has passed into common usage. The Color Key™ was developed by 3M. It uses four sheets of film that are coated with a pigmented emulsion. The emulsion is exposed in a vacuum frame and developed with a strong alcohol solution. The nonexposed areas simply wash off in the developer, leaving an image on a clear sheet.

In addition to the process colors, a fair selection of PMS colors formerly were available. Most of these seem to have been discontinued, though. There are now several competitors. Some of them use aqueous developer, which helps a little in the environmental arena.

Advantages and problems. Overlay proofs scratch easily and the film is slightly tinted. As a result, the resulting proof is easily damaged and quite dark. The biggest problem is that overlay proofs require assembled negs with a normal dot. They are necessary for printing process color on one- or two-color presses.

Film proofs (laminated)

Laminated proofs use the same concept as overlays. The difference is that the film is much thinner and clearer. The films are laminated to a substrate that is usually a sheet of white plastic. Some use a powder that adheres to a polymer sheet that gets tacky when exposed. Some use pigmented emulsions. There are many brand names. They all produce very accurate proofs, but they can be too good. In other words, they can be so clean, bright, and saturated that presses cannot duplicate them. That problem is largely solved, however, by the experience of the people using them.

Advantages and problems. Laminated proofs are very durable and bright. The main requirement for overlay proofs of any type is assembled negs with a normal dot. This means that neither CTP nor stochastic methods can use overlay proofs. There is a tendency toward overly bright proofs. Plus, there is usually no way to laminate to the stock being printed on. Even if you can do that, the paper is covered with a heavy layer of shiny plastic. In addition, laminated proofs come only in process color (CMYK). They are no help with spot color proofs.

 Overlay proofs are required for single-color and two-color presses. There you must have a method for adjusting each color separately. Laminated proofs became dominant for process work as the industry turned almost exclusively to four-color presses or much more than that. When you have four or more plate cylinders at your disposal, the print comes off in completed form. It therefore needs a laminated proof that shows the finished product well.

Film-based proofs are still the norm in shops using traditional presses. They are designed to proof for those presses and will continue in use as long as there are shops using these methods. They are an excellent product, but their life expectancy is relatively short, mainly because of CTP and those directly imaged plates. Digital proofs are taking over.

DEALING WITH THE PARADIGM
Digital color proofs

We mentioned briefly that film-based proofs do not work at all well for CTP, stochastic, DI (direct imaging), or digital presses. To use them, you are forced to stop the process to output film (that is not needed for printing) to produce a proof. In the case of stochastic, the spot sizes are so small that film-based proofing simply cannot hold the dots. Even for large-spot stochastic, film-based proofs are not usually the best choice. For Web delivery of proofs, film-based models will not work at all.

Calibrated color printers

At this point, there are many printers to choose from. Some are very cheap and give a rough indication. Others produce extremely accurate color prints. Traditionalists have problems with all of them; digitalists use them just fine. There are basically four types in use:

- Inkjet and solid inkjets
- Thermal wax
- Dye sublimation
- Xerographic

All of these have their appropriate uses, advantages, and disadvantages. Let's review them a little, and talk about how they are being used as the new millennium starts. Obviously, anything stated about printers will change monthly. However, I can give you a general idea.

Inkjet printers run the entire range of usefulness

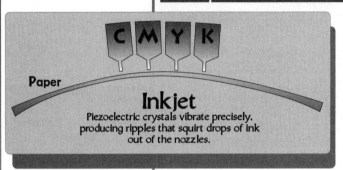

Inkjet
Piezoelectric crystals vibrate precisely, producing ripples that squirt drops of ink out of the nozzles.

Low end. Entry-level inkjets start at the low end for under $100. These machines are slow and not very accurate. However, they are certainly good enough for rough internal proofing. They are not PostScript printers, so they require a software RIP like StyleScript to output PostScript illustrations (but it is not calibrated). We did have a very good solution with Adobe's PressReady. However, Adobe has stopped development of that and we have seen no replacement. The cheapest calibrated proofer is a cheap inkjet supported by PressReady. They may still be available, depending on where you look.

Because the sprayed ink is very liquid, it soaks and bleeds into the paper. The best results come with special coated inkjet papers. As a result, they are not the best choice for proofing on the actual stock. In addition, inkjets are very expensive in consumables, both paper and ink.

Calibrated proofers. Epson makes several of these. They are in the $3,000 to $10,000 range. They work very well.

Large-format. These work for large-format proofing. They have most of the same advantages and disadvantages. However, they are PostScript. Most will only output 100-line screens, so you can only use them for artwork proofs on large, high-res printing. They are still relatively inexpensive, running from less than $20,000 on up.

Advantages and problems:

* Inexpensive, but consumables are a major expense
* Bright colors require special coated paper
* PostScript, but the RIPs are often software and therefore slow
* Many are very slow, with low-res, coarse screens

High end. Here we are discussing Iris inkjets. These are some of the best digital proofers available. They come in larger sizes. They can be calibrated and fit into color management systems. This results in almost perfectly accurate color proofs. The problem is that there is no discernible dot structure and they are expensive ($20,000 to $120,000 or more).

Printing expenses

Remember that the consumable expense of an inkjet is high. They are very cheap printers, but the costs for the special paper and ink cartridges can mean they cost $3 to $10 per print. Of course, this is cheaper than dye sublimation printers and laminated proofs. The main reason for this sidebar is to remind you to budget in your proofing costs. Someone has to pay for these things, and it better be your clients. It is a normal expense that often does not have to be itemized.

Advantages and problems:

- Very accurate proofs
- Expensive to purchase and to operate
- No dot structure

Solid-ink wax printers

These are inkjets with a difference. They can print on almost anything (MacUser claimed that one printed on a tortilla). The ink comes in crayons or wax sticks that must be melted before use. This can take quite a while (15 to 20 minutes) and usually has to reoccur every time the machine is restarted or shut off for any reason. Because the ink hardens instantly on contact, these machines work well for art proofs on the actual stock being used. One manufacturer offers black ink sticks free for the life of the printer as an inducement.

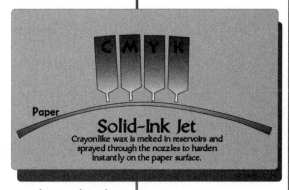

The color is superior to laser printers and to most inkjets unless those inkjets are printing on the most expensive photo paper. They now come with PostScript 3. In many ways, they are the answer to in-studio art proofs. The cost per print is low when compared to the rest of the digital printers

Advantages and problems:

- Can print on almost any stock
- Consumable costs are low
- Slow ink melt times
- Proofs can melt if left in a hot car on a sunny day

Thermal wax printers

These are commonly used for final art proofs. They have a relative low consumables cost as long as you are using full-page color. The problem is that they use the same amount of consumables even if you have only a small area of color on the page. They produce bright, clean color, though it has a slightly oversaturated look. Thermal wax printers are quite fast, but the low resolution uses very coarse screens. They are really useful only for art proofs

Thermal wax/dye sub hybrids. A couple of machines output both thermal wax and dye sublimation. In both

cases, a thermal head transfers ink from a roll. There is a major difference, however. Thermal wax printers need tightly spaced thermal pins at a constant temperature to melt and transfer the wax. Dye-sublimation printers need thermal heads that have precise temperature controls, but the thermal pins do not have to be as close together. The combination machines require compromises in both directions. Their only advantage is that they are cheap. The cheapest are not even PostScript. They are incredibly slow.

Advantages and problems:

- Fairly fast and not too expensive
- Low consumables cost for full-sheet coverage
- Coarse screens
- Need special paper
- Work well for large-dot stochastic

Dye-sublimation printers

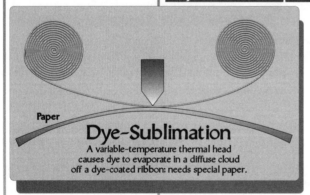

Paper

Dye-Sublimation
A variable-temperature thermal head causes dye to evaporate in a diffuse cloud off a dye-coated ribbon; needs special paper.

This technology was formerly considered the best quality of any color printer except for the Iris inkjet. At this point the images they produce are not as good as the high-resolution inkjets from Epson and HP. However, they are used quite a bit by professional photographers for proofing their images.

They produce photographic quality with continuous tone. The color hits the paper as a diffuse cloud of dye. The thermal head has precise temperature control, so the dot size varies, unlike thermal wax printers. Because the dots bleed into each other, there is no discernible dot pattern. These printers are very expensive and very slow. The prints are gorgeous. The cost of consumables is very high.

Advantages and problems:

- Beautiful proofs
- Photographic quality
- No dot structure
- Needs special paper
- Expensive, very slow, with high consumables cost

Color laser printers

These have become the art proofer of choice. They are fast, PostScript, 600–1200 dpi, and relatively accurate. Many of them even use the same

trick as digital presses by having dots that can vary in color; 6-bit and 8-bit dots are not too uncommon. The consumables cost is the lowest of the professional-level printers — well under 50¢ a print for solid coverage. Even the hardware costs are getting much lower, running from less than $2,000 for letter-size to about $5,000 for tabloid extra (12" x 18").

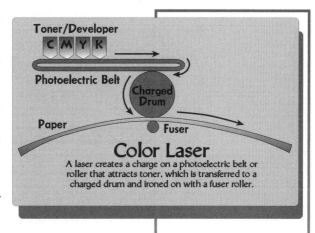

Color Laser

A laser creates a charge on a photoelectric belt or roller that attracts toner, which is transferred to a charged drum and ironed on with a fuser roller.

Because most of them are incapable of "normal" high-res linescreens, they have limited use as color proofers for traditional presses, but they are accurate enough for color art proofs. The color depth of the pixels can cause strange things to happen with custom linescreen and/or screen angles, for example. They do work well for color proofs for most of the digital presses like the DocuColors. Plus, for very short-run process printing (less than 500 or so), they can work fairly well as production printers.

Advantages and problems:

- Fast (up to 12 pages per minute)
- Plain paper, inexpensive consumables
- 600–1200 dpi PostScript
- Specialized screening can cause proofing problems
- Can be used for very short-run color printing

THERE ARE STILL PROBLEMS

Proofing summary

Digital printers work fine for art proofs. The problem lies in accurate color proofing for contract proofs. On-demand digital presses themselves can be used as color proofers for their own production. In general, digital proofs work well for digital printers. They give a reasonably accurate indication of what the final product is going to look like. It takes some getting used to, but color keys and laminated proofs require experience also.

Increasingly, contract proofs are being done with calibrated inkjet proofers. Epson has come out with several models in the $5,000 to $10,000 range that do an excellent job. The key is letting the printing company provide the color proof they are comfortable with, whether digital or film-based.

Problems arise when you are printing on a traditional press with digital plates. For these situations, the Iris inkjet is becoming very common. For top-end, high-production environments, there are dedicated digital proofers

that are excellent. (They better be as they cost up to half a million dollars.) In general, top-end commercial printing firms have, by far, the most stringent requirements for color management. Their customers are willing to pay the extra charges necessary to cover the strict quality controls. For the vast majority of printing establishments, digital prints work fine for proofs. For top-end printing, they are not good enough. Top-end digital proofing costs a lot of money, but then, it always has.

Using the same RIP for proofs and plates

One of the problems with color accuracy has been the use of one RIP for the proofs and then a different RIP for the film or plate. Increasingly you will see solutions that use the same RIP for both. It is the best solution for DI and CTP production. These processes never produce film, so the solution is to use the same RIP for proofing and plating.

Press proofs

The only real way to guarantee color accuracy (or acceptability) on a press is to request and pay for a press proof. This means you will be on call so you can be there when they actually print your project. This causes all sorts of problems with finances and schedule.

First of all, commercial printers need to have a constant backlog of printing jobs so they can keep their presses running. When you are paying several million dollars for a press, you cannot afford to let it sit around doing nothing. If there is a problem with a given job, it is kicked back to prepress to fix it and they put the next job on the press.

This means two things. First, tight scheduling is impossible. The printing company can probably tell you which day they will print your project, and maybe which part of the day. However, because of the cost of equipment many printing companies run twenty-four hours a day, six days a week. Some are even 24/7, though rarely 365. Thus, you are required to be available when they are ready for you.

Second, because of the need to keep the presses running, you have to be on call so you can be at the shop within a half hour whenever they are ready to start. With press time running nearly $500 per hour, you do not want them waiting for you, running up charges. One local company, that prints millions of catalogs a year uses a printer more than 1,000 miles away, in Lincoln, Nebraska, to print its catalogs. The printing company flies the designers to Lincoln and puts them up in a hotel for the duration of the printing for every catalog.

The third problem is that press proofing is very expensive, because all the negatives and plates have already been completed and billed. If you make any changes while the job is on the press, it is kicked back to prepress

and a new set of negs and plates have to be made. This can cost you $1,000 or more. Plus it has to be rescheduled — maybe in a couple of days.

Because of all these factors, press proofs normally cost around $1,000. If you cause a redo, it is another $1,000. If you are late showing up, they bill you at the going press rate ($300–$500 or more). However, for the most color control, press proofs are often necessary. You should brace yourself and try to design so a press proof is never necessary.

The basic problem with proofing

The basic conflict is that the printing company wants an absolutely accurate proof to lock the client in. They want a guarantee that **IF** they match the proof the client will pay for the job. This is why they are called *contract proofs*. They are a contract between you, your client, and the customer, stating that the job will be paid for if the proof is matched.

However, this capability does not truly exist except in the on-demand arena. Here, for the first time, it is possible to print one copy to see what it will look like before the production run. After that, the production is identical to the run of one. Traditionally, contract proofs could only be judged by experienced professionals. As you can imagine, this led to many problems. For one small example, many clients could not understand that their gorgeously brilliant, shiny MatchPrint would not be nearly that bright or glossy on cheap paper.

The entire attitude of trying to guarantee client approval with a signed proof causes customer relation problems. Proofing is a frustrating necessity in the digital world. This is primarily because every digital print is new and separate from all others. Unlike traditional printing, there is no negative to fall back on. With stochastic screening, even imagesetter negs are all originals. Again, we are required to adapt — no big deal. The modern world requires constant adaptation to reality.

Accurate color will never be cheap or easy. It will always require experienced professionals.

Some look on color management as a simple solution to solve the color problem. They really believe that they will be able to quickly send a digital image to their client over the Web and that they can use that as a legal proof. Then there are those that believe swimsuit models are real humans and the photos are undoctored. Some even believe in Santa Claus or are members of the Flat Earth Society.

You must prepare yourself to gain the experience that will enable you to help your clients get a proof that will allow them to decide whether to proceed and pay for the project. That's the bottom line.

Where should you be by this time?

Working, working, working. By now you should be thinking about employment and writing your business plan. This, of course, is only true if you are a student who has not worked in the industry and one who has studied the rest of my books: *Intro to Digital Publishing*, *Publishing with FreeHand and Illustrator*, and *Publishing with InDesign* (among others). Of course, Intro to Digital Publishing will not be available until the spring of 2002. You will have to use *Printing in a Digital World* until then.

DISCUSSION

You should be discussing design, production, and your place in the industry with each other.

Talk among yourselves...

Knowledge retention:

1. What is the biggest problem with color management?

2. Why is calibration not sufficient?

3. Can a monitor simulate process color accurately?

4. What is the problem with film proofs in CTP production?

5. Why are traditional printers so upset with digital proofs?

6. How do on-demand presses solve the proofing problem?

7. What is the biggest requirement for using a proof well?

Chapter 15

Output Problems

Concepts:

1. Proper attitude

2. Deadlines

3. Business ethics

Dealing with clients and the rest of the industry

Chapter Objectives:

By giving students a clear understanding of how publishing uses color, this chapter will enable students to:

1. choose appropriate print formats
2. choose appropriate Web formats
3. live with deadlines
4. serve a client.

Lab Work for Chapter:

1. Finish more of the theory exams and email for grading.
2. Finish more Miniskills.
3. Finish more Skill Exams.

You've got to treat him right!
It matters not whether he is or not...

Sending it elsewhere

Sooner or later you will run into a problem with Photoshop that is unsolvable. You are going to have to print your image or send it up on the Web. Photoshop does not do that. Even though many foolish folks attempt page layout in Photoshop, Photoshop does not do that.

I cannot emphasize that enough. Photoshop is not designed for output. It is an incredibly powerful graphics creation application designed to produce images to be used in a vast array of projects. Isn't that enough?

One of the constant ongoing problems I have with my students revolves around this issue. Because Photoshop is so much *fun*, many students learn nothing else. Then when they print a proof, they output the image directly from Photoshop. If that works (and it rarely does), they complain for the rest of the project that the colors have changed. "It doesn't look like it does in Photoshop" is the constant lament.

Of course, my response is often less than helpful. What I always want to say is, "Hey, idiot, what were you doing trying to print from Photoshop in the first place?" I usually try to show them that they can save a copy as a TIFF and import it into page layout and print it from there faster than they can print it from Photoshop. This really misses the point, however.

Photoshop does not really have any output capabilities. It cannot do multiple pages, margins, high-resolution copy, or many of the other things necessary for a finished printed project. It cannot do links, multiple pages, HTML, or many of the things necessary to make a small, quick-downloading Website.

Outputting for print

Here the choices are four — although I would argue that figure should be two. In general, you want to save your image as a flattened TIFF. The SAVE A COPY... option usually does an excellent job of this. Yes, Photoshop 6 can save TIFFs with layers. No, no one else can use those layers — yet. TIFFs are your only good option if you are going to a non-PostScript printer, for example.

There are a couple of places where TIFFs cannot do the job really well, however. The first is with clipping paths. Yes, TIFFs can include clipping paths. No, many applications cannot handle that data. Even if they can, like InDesign, clipping paths in TIFFs are not handled nearly as well as they are in EPSs.

EPSs are your best choice if you are using clipping paths. They are your only choice if you want to include specific linescreens, screen angles,

Stop! Thief!

The fact that everyone else is doing it does not excuse your behavior. If you have not got enough time to contact the creator, you'll have to create the image you need yourself, from scratch.

or dot shapes. I have been told that EPSs also print faster because they are pre-rasterized. I have never seen that difference in action, however. In my experience, TIFFs usually print faster.

Increasingly, page layout applications can use PDF as a graphic format. This one is coming on fast, and I have seen no problems – except, of course, with old RIPS. These machines often cannot print PDFs at all.

InDesign can import PSD files directly. This is a dangerous practice. It goes back to understanding that the best basic procedure is to have a graphic original from which you export graphics for various uses. Use PSDs directly, if you like. Sooner or later, it will bite you.

Outputting to the Web

We covered this thoroughly in chapter 13. GIF is usually still best, closely followed by JPEG. PNG is coming, but not here yet.

What I want to address, one more time, is the foolishness involved in using Photoshop for layout of Web pages. As mentioned, around 60% of graphic designers claim to do this (according to *TrendWatch* and several magazines). No wonder so many Web pages are graphically overloaded. Quit it! Websites are much more appropriately laid out in a program, like FreeHand, that is designed for the task.

You will need master pages (for the navigation bars and fixed elements), multiple pages (for the reality of Websites), and ability to visually structure the arrangement to show the links between pages.

Now it can be argued that Front Page does this best. The problem here is its requirement of an NT Web server. Believe me, you do not want an NT server. The constant crashes and month-old backups are a nightmare. But then many of those arguments can be made about Windows products in general, and that hasn't stopped many of you. The only way I can really handle that, as a teacher, is to encourage my Mac students to be grateful for the competitive advantage offered by those who use it.

Copyrights and theft

One of the major problems with the new digital technology revolves around scanners. All of a sudden, it is amazingly easy to "borrow" an actual drawing or photograph to use as the basis for your original artwork. The problem with that, of course, is that it is no longer original if it is based on someone else's talents and skills.

One of the most outstanding examples of this phenomenon in the last decade was the scandal involving the winner of the yearly Corel design competition. The winning illustration was discovered to be a very beautiful,

hand-done color rendering of a grayscale stock photo. No credit was given to the photographer. A huge uproar erupted, with massive lawsuits, and so on. The $25,000 prize was forfeited and a fairly severe punitive judgment was awarded against both Corel and the artist.

Even though there are a couple of very small legal loopholes, the basic rule is this: Anything that has been drawn, painted, or photographed by someone else cannot be used. The only exception is work that is over 75 years old. Even then, the estate may have renewed the copyright so the work is still not available.

Getting permission

The only way around this is to get written permission from the copyright holder. Current law reads that copyrights are automatic. The artist does not have to file or register the work to be protected until 75 years after death.

If you have any doubt about legalities, get written permission

You should expect that with the permission will come an invoice. The only way writers and illustrators have to make a living is to get paid. This means that they can and should charge for each of their work. The same thing applies to writers. Do not be surprised if you are asked to pay several hundred dollars for image use. Many illustrations take 100 hours or more to produce. Most illustrators spent years virtually starving. When they can get paid, the going rate is reasonable. Image use without payment is simply theft.

A large source of images

The only major exception is work produced by governmental agencies. Since you paid to have it produced (with your taxes), you have the right to use it. This includes such outstanding resources as NASA, the Smithsonian Institution, and so forth. You will have to spend some research time, but many of these images can be downloaded from the Internet.

Clip art, stock art, stock photography

This is a huge source of images. The problem here is to make sure you read the licensing agreement that came with the clip art or stock photos. Just because you bought a CD of photos does not mean that you can use them anywhere you want. The sample art that comes with Photoshop, for example, cannot normally be used for commercial purposes.

Often there are restrictions on use. A typical example is the large and inexpensive library of Dover books. These printed books of clip art usually cost less than $10. The can be used freely – anywhere you want, for any purpose you desire. But there is a limitation. The license printed in the book states that you can only use a maximum of six images from any one book in any one project. To use more than six, you have to get written permission. These kinds of usage restrictions are very common. Before you buy, if possible, read the license. If you can't legally live with the restrictions, don't buy or use the work. This society has a big enough problem with thievery. Do not add to it.

Layouts

Although layouts are usually not protected, you have to be careful here also. For example, there was a suit not long ago by Time, Inc. Someone used the folded page corner, fonts, and color scheme of the *Time* magazine front cover. They paid dearly for the theft. The same problem has existed with the yellow border of *National Geographic*. The basic rule is this:

When in doubt, don't!

NOW I HAVE A JOB,

How do I get started?

Design is incredibly difficult. The possibilities are endless and there are no rules. In fact, whole schools of design are based on breaking all the rules; the current crop of "professionally ugly" design is but the latest variation on a recurring theme. It's usually told as a joke, but we really are expected to read our clients' (and readers') minds. On top of everything else, the deadline pressures are often unreal. Because of all these things and much more, creative block is a real fact of life for the designer.

Fortunately, there is a simple methodology that makes design blockage highly unlikely. Though there are no laws, it is certainly true that norms rule. I cover these norms in my other books. Regardless, you have been encouraged to train your eye to see and recognize both norms and current fashion. Our cultural history and marketing economy have made it certain that almost all our readers will react habitually. Because we are all exposed to most of the same general influences, we have predictable reactions.

Design, in general, is like that. Though lockstep procedures virtually eliminate creativity, many things can be done to enhance the creative process. Even though we do not understand where creativity comes from, we can set up an environment in which it is more likely. There is much discussion

concerning creativity as a learned technique or an innate gift, but it is clear that we can develop rudimentary talent into strong, competent skills. The technique is simple: Ask questions and get moving.

Ask questions and get moving

Simplistic balderdash? No, a basic technique. First, you have to understand how ideas are generated by the creative personality. Basically, you toss all the data you can find into the hopper. After an undefined time period, ideas begin dropping out the other end. Or add huge amounts of data to a large pot and wait for the dumplings to pop to the surface. How this works we are not sure. The most common word used by the geniuses of our civilization is *inspiration*. However, it is clear that new concepts and structures are an intuitive outgrowth of an educated (though not necessarily formally educated) mind. Creativity generally builds on a basic curiosity and hunger for facts. It then assembles those facts uniquely.

In our field, that hunger revolves around printed materials, graphics, signs, paintings, Websites, and visual stimuli in general. Graphic designers normally have an almost compulsive desire to feed their mind with images. You should read every book you run across on design, go to every gallery within reach, read magazines and look at the ads. Tear everything apart in your mind and try to improve the designs. Designers do this continuously.

If you don't do this, it's quite possible you need to focus on production instead of design. As mentioned, creativity cannot be faked. However, many clients really do not want astounding creativity. What they truly need is reliable production of projects within budget and on time. This does not take creativity. Nonetheless, the most creative designers are subject to the same production pressures.

The basic technique for creative output

You start by asking questions — as many as you are allowed. When you have asked the persons involved all that you can think of, begin meditating on the questions and the answers. It helps to run through a personal list of questions that you ask yourself. At this point, try to avoid solutions. You are merely assembling data. Conclusions reached before the data is in are usually simplistic, at best.

As the data reaches overload, begin the physical process by organizing your work area. Look over the supplied materials; read the copy; clean the area while focusing on the project. Do any busy work you need to do to give your mind time to percolate ideas. If you focus on the ideas, you will often stunt their growth. Focus on the project and just let the ideas come.

Before long the ideas will begin to surface. Jot them down in note form. Just keep organizing. By the time the cleanup process is complete, you will normally have plenty of ideas to flesh out.

The next step involves finalizing your ideas; creating the resultant graphics; choosing the type, color palette, and document size; and settling on a style. Once you reach this stage, composition becomes a simple exercise in production. You are enabled to produce the documents with minimal hitches, glitches, and redoes. You simply build on your decisions and assemble the project.

Remember, there are no rules carved in stone. The structure is necessary merely to channel your rampant creative urges toward the specific project you were hired to design. Just remember one simple fact: Graphic design is about communication and little else. Everything is subordinate to the message. The most important thing about the message is this: can and will it be read?

This is not all about pretty pictures

The writer is the graphic designer's co-creator. With luck, you will get a chance to work with him or her on the content of the project. Just remember that your task, in most cases, is to present the copy in a way that can be easily comprehended and quickly absorbed. Nobody really cares about the conceptual basis of your art. If you need to do that, find a gallery and put on a show.

A warning of experience

Illustrators and photographers are the bane of the publishing industry. They are the source of most of the beauty and much of the ugliness. They are often difficult to work with because their priorities are so different. Most illustrators (graphic or photo) are highly opinionated and headstrong. They have to be, in most cases, for emotional survival. Art creation exposes very personal matters to public scrutiny. However, this is no excuse for rude behavior. Arrogance is usually a poor attempt to cover inadequacy.

Normally, only the best, most creative graphic designers can use illustrators well. Unless the graphic designer knows clearly what has to be done for a given project, the artists can easily sway design focus with their graphics. Often the message gets lost. This can be a problem with stock art also. Make sure that you know what you need for the design, and do not accept or use anything that changes the direction or focus of the message. Remember who hired you and why.

Remember, the message takes priority!

Talk with the crew

As soon as you have your ideas and plans finalized, communicate your decision to those producing the pieces of the project: artists, writers, and photographers. The more they know about what you need (and the sooner they know it), the better the results will be. With creatives, holding too tight a rein causes stilted and contrived artwork. Allowing too much freedom gives license that can produce beautiful art that has no bearing on your content or style.

Perfection is the norm

We cannot emphasize enough how important it is to proof the document thoroughly. Sloppy proofing is one of the surest signs of non-professionalism. It is the cause of countless problems with client relationships. Everything should be proofed by three people at a minimum. You can be one of the three, but you cannot be the only proofer. One thing is certain: if you made the mistake in the first place, you will probably miss it when you proof it. If at all possible, turn it over to a professional proofreader (some call this person a copyeditor, but copyeditors also have authority to change the style of the copy).

The customer is always right?

Of course not! What we have to keep foremost in our minds is that it doesn't matter whether the customer is right or wrong. Our job is to serve the client. Our task is to convince them that we are professional and that we really care about their business. It does not matter if they are wrong: if we treat them like they are, they are gone. That may solve the problem (as they are no longer our client), but it is a poor way of doing business.

A service industry

Publishing has been referred to as a service industry throughout this book. As we draw to a close, it is imperative that we review this most important fact. **OUR JOB IS TO PLEASE THE CLIENT.** We are manufacturers of custom products. We normally cannot just make millions of copies and throw them around, hoping to sell a high enough percentage to stay in business. The best Website has to attract hits and keep them, or its design costs are a total waste of time and money.

We sell custom products for individuals. Even though you may be dealing almost exclusively with large corporations, it is the individuals in the corporation that matter. If we do not make the individual who ordered our services happy, that person will find a designer who will. It is that simple.

Two out of three isn't bad

There has been an adage in the printing industry for many years. You can have any two of the following three qualities: fast, excellent, and inexpensive. In other words, you can have fast and excellent, but it won't be inexpensive. You can have fast and inexpensive, but it won't be excellent. You can have excellent and inexpensive, but it won't be fast.

But it's not good enough

The problem is that this adage is commonly untrue. Our industry is extremely competitive. Many publishers now meet all three of those parameters. It used to be considered cute to have a large sign over the door saying, *"If you wanted it yesterday, you should have brought it in tomorrow."* You cannot blow customers off with cute sayings anymore. They do have options — your competition. Rush jobs are a major portion of our income. Ridiculously fast deadlines are one of our major opportunities to win customers who remain loyal because of our service.

There was a very common cartoon in the 1980s, printed in various poster sizes, showing a printer collapsing on the ground in gales of laughter, choking out, **"YOU WANT IT WHEN?"** In this age, those attitudes will send your customers down the street faster than you can imagine. They have serious problems. Your task is to help them solve their problems.

Sometimes it's impossible

However, sometimes you can't. Most clients are smart enough to realize that 30,000 copies of a 200-page, process color, perfect-bound book will not be done tomorrow. They may even realize that sleek, easy access to their database will not be tossed on the Web in a week. What you have to realize, though, is that there are companies that will give it a real good shot. In an age of digital production, many things are possible that were not possible ten years ago.

THE REALITIES OF PRESSURE

Deadlines

Our industry is run on deadlines. Many of these time limits are ridiculous. We know it. The customer knows it. It does not change the fact that the deadlines are real. If you are producing an event program, complaining about the deadline will not move the event back a day. If the SEC has a March 1 deadline for receipt of that annual report, March 2 is not good enough.

It is common to blame the client for delays. It is common for designers to lose work because they blame their clients for deadlines. Instead, they

should figure out what can be done as soon as the job is brought in. This is one of the main reasons for the questioning process. One of the things you are looking for is possible production problems. You can do a great deal to help customer relations by simply explaining reality to your clients whenever possible.

Sales staff and CSRs

Reality checks are primarily the task of the sales personnel. As they locate and close deals with clients, they must be aware of the deadlines involved. However, more and more, we are all involved with the customers – face-to-face, by phone, or by email. In modern digital publishing, all of us deal with the clients on a daily basis. That art department hidden in the back has been exposed to the light.

If you are employed, you know that normally only the owner or the production manager has the authority to turn away business. You must accept the fact that they will do so only if absolutely necessary. In most cases, they are driven by the need to get more business. Being able to refuse a paying customer is not a normal attitude of a successful publishing manager. Their goal is usually to get so much business that they need additional help.

An excellent employee is prepared to do what it takes

That's a scary thought. What if you are asked to work on the weekend? What if you have to come in a little early or leave late? Are you willing to be reliable help to your employer? This goes way beyond the normal requirements of showing up every day, on time, ready to work. Of course, if you are working as a freelancer, or if you have started your own design business, you already know about 72-hour work weeks.

The proper attitude

We cannot continue until we cover what you should expect to offer an employer. They do not owe you anything beyond honesty and integrity (even these are sometimes in short supply). When you are hired, you will be given a list of company expectations — sometimes written, sometimes verbally, sometimes through the grapevine.

Your job is to meet those expectations. If you cannot, do everyone a favor and find a place where you fit. Every position has pluses and minuses. You want to find work where the positives meet your needs and the negatives are inconsequential. It is not the employer's job to change the company to satisfy your desires. Their concern is financial survival.

Owners and managers make the big bucks because they have the big headaches. If you want the money, you get the pressure. It is a decision you have to make. You will never be a welcome employee if you are always complaining about reality. Your task is to meet your employer's needs by satisfying the company's customers.

You need to be prepared to work extra hours and to put the company's needs on a high priority. You will discover, as your career develops, that many people do not do these simple things. As a result, they make everyone's life miserable – always complaining, always the bottleneck in production. If you are like that, do us all a favor and find another career quickly.

Publishing is a team sport. All of us need to work together. Many students are almost horrified to learn that they cannot take anything all the way through production. Sooner or later, you have to hand off your baby to someone else. The likelihood is that you will be working on something started by someone else anyway.

The key is communication

How many times has this been said over the past 300+ pages? Experience shows that it cannot be repeated often enough. There must be good communication between the sales staff and the client; the sales staff and the designers; the designers and the client; the image assembly staff and the pressroom; image assembly, the client, and the press room; the client, designer, and ISP; designer, programmer, and ISP; and so on.

The job ticket

The first major communication tool is the job ticket. This is the way the sales staff communicates with the rest of the shop. It is extremely important that these forms be filled out accurately and completely. Not only are the complete job specs required, but also the complete client name and address, former job numbers, and the appropriate contact person(s) with both phone and email.

Just as important as filling out the job ticket is reading it. Most jobs that have to be redone were messed up because someone did not read the job ticket. Do not take anyone else's word for what you need to do – read the job ticket! This even covers the bosses' instructions. You make them look good if you discover that what they told you does not match what is on the job ticket.

You can save the company thousands of dollars. Remember that with a 10% profit margin (better than most), you will have to locate $9,000 in new business to cover the costs of reprinting that little $10,000 print project.

Customer proofs

The next most important communication tool is the proof. We've mentioned them throughout. However, we need to examine them from the customer relations viewpoint. The most important proofs from a legal and public relations standpoint are the customer proofs. These are sample prints or a Web page that explains what the client might not know.

Yes, we covered this in the last chapter. Yes, the repetition is necessary. Three proofs are usually necessary. This differs a little from print to Web. In print, the first is a laser proof of the artwork. This art or copy proof must be signed off by the client before you proceed to the expense of a color contract proof. In some cases, it is better to have an artwork proof that has FPO graphics. You might not want to spend the time color-correcting separations if the customer has not even approved the photos yet.

Often, what we are calling the art proof takes the place of what used to be called the *comprehensive* or *comp*. The comprehensive was accurate enough to enable the client to approve the artwork (without spending any more time or money than necessary). In many cases, all the budget will allow is a digital color print of the final artwork and the hope that the client doesn't make too many changes.

It is important to make sure the customer realizes that signing the art proof means that he or she approves of the graphics and the copy on it, including all wording, spelling, and grammar. If you do not have that, you will find it very difficult later to charge for customer alterations. Supposedly, if the client changes her mind about copy or layout, she should be charged for the time and materials it takes to make those changes. Without a signed art proof, you have no evidence that she ever liked the artwork in the first place. You will find the client making changes without recourse.

 This is one reason why you need such thorough proofing before the customer sees them. Clients are rarely professional proofers. They will not see typos or obvious printing errors. It is very bad form to use their lack of expertise to point the accusing finger when something goes wrong. "But you signed the proof..."

Web proofing

On the Web, proofs go in stages. One of the real advantages is that Websites can be updated at any time. In fact, they should be redesigned, updated, or simply changed about once a month or so. Therefore, Web proofs tend to be ongoing emails with a link to the page, saying something like, "I changed [x], what do you think?" Web graphics should just be attached to an email for proofing. Of course, this is one of the ongoing expenses of Web design, also. Make sure you are set up to bill for these changes.

Getting customer approval

The signed proofs become legal contracts. You promise to produce the work as proofed. The client promises to accept and pay for the work as proofed. There are ways to ease the approval process. The primary method is by doing thorough proofing yourself. **As a general guideline, you are in trouble if you have more than one correction per four pages.** Any more problems or typos than that and you will be considered less than professional. Proof it before they see it.

The basic problem is that clients are used to Madison Avenue, just like the rest of us. Their baseline assumption is perfection, because that is what they are used to. Typos are still very rare in the national slick magazines. A sizable percentage of clients feel the same about artwork charges as they do about dental bills — and it does not make them happy. Many of them are looking for an excuse to prove that they know as much as you do. You will find, in not a few cases, that customers will use your mistakes to try to leverage a reduction in the charges. What is the simple solution? Do not give them anything to pick on. Give them a technically perfect proof.

The customer is always right!

The old saying, *"The customer is always right,"* is not a joke. It is a truism. In other words, it is so obviously true that it seems stupid to mention it. This is where we started this chapter, but we have not covered it yet. By definition, the customer is right because our job is to serve the client. Our task is to bring their requests into reality.

There will be many times when you are asked to do something very difficult. Remember that you chose this career to avoid boredom. To develop skill, you have to be stretched. If everything is easy, you get bored, relax into bad attitudes, and begin to dislike your profession. Some of your clients' most ridiculous requests are your best opportunity for growth. Learn to relish the challenges. The boring sameness of jobs can really get you down. For example, when you have something as tightly controlled as a Coca-Cola billboard, they all begin to look the same. They may be difficult, but they are boring.

You do not have to like your clients. You do have to respect them. In a very real way, the success of your business depends on the success of their business. Often clients are headstrong or arrogant or egotistical. Some of this is necessary; some of it is simply obnoxious. It is not your job to tell them that their arrogance is simply a projection of their insecurity (even though this is often true). They are in business to make a profit and your job is to help them. They need help, not hassles.

Business relationships are not social relationships

Even if you do like your clients (and that is always pleasant), you should not expect a social relationship to develop. Friends that you hang around with tend to make poor clients. There is a tendency to give them favors, put their jobs on a higher priority, and do many other things that jeopardize your relationships with the rest of your clients. The friend who allows you to keep business on a businesslike basis is a rare friend. I hope you have many.

CODIFYING THE PROCESS

Business ethics

There are many lists and several books concerning business ethics and trade practices. For example, there is the excellent *Graphic Artists Guild Handbook: Pricing and Ethical Guidelines*. They put out a new edition regularly. Edition 10 came out in 2001. We find their prices extremely high for our locality, but it is easy to make a percentage adjustment. Another reference is *Electronic Design and Publishing Business Practices* by Allworth Press (1996). Don't restrict yourself to this list. Ask your employers for a copy of the list they use. In general, these books are concerned with legislating morality, which is always tricky at best. The basic tenets are always the same: honesty, integrity, keeping your word, and fulfilling written agreements. In this day of constant litigation and adversarial relationships, it is extremely wise to have written contracts.

This is a major pain. However, it is really not optional. Contracts are not about limiting people and keeping them in line. The purpose of a contract is clear communication and mutual agreement. Little is more disheartening than to do exactly what you think you were asked to do and get screamed at for your incompetence. People simply hear wrong, believe it or not.

Your word may be good, but that does not help if clients think you promised something else. This does not count those who are looking to

pick a fight to avoid payment. Those people exist also, and contracts help keep them in line. The best thing is a standard printed contract. The *Graphic Artists Guild Handbook: Pricing and Ethical Guidelines* has many of these, of almost every possible variety. That way personal friends and disliked clients get the same treatment. It is all in the interest of fairness and communication.

When in doubt, write it out!

Another reason this book cannot be a complete guide to industry practices is the flux things are in. This chapter closes with a series of areas to think about concerning your business and/or your employer. Chances are things are still changing rapidly.

- How are roles defined?
- When will quotes and proposals be ready and what will they contain?
- What proofs will be provided?
- Who pays for which alterations?
- What are all the deadlines and delivery charges?
- Who stores the materials?
- Who owns the materials: the output and the digital files?
- What is the payment schedule?
- What kinds of rights are being purchased (copyright questions)?
- How will disputes be settled?
- Who is paying for production?
- Who is responsible for production?
- Who handles outside services and how are they billed and paid for?

As you can see, it gets very complicated. The likelihood is that your new employer already has a working set of guidelines in use. If the company doesn't, the two books recommended are excellent resources. They are part of your necessary knowledge.

Knowledge Retention:

1. What good is a series of questions going to do at this point? If you are still confused, practice for a month or so and reread this entire book. I hope it has been edifying.

Curriculum glossary

This glossary is a first for this series of books. It combines the much more limited glossaries from *Digital Drawing* and *Publishing With InDesign* with the materials presented in this book. It should be much more helpful to students of any area of digital publishing.

This glossary contains many terms that are specific to Photoshop. However, it is recognized that no software application used by digital publishers stands alone. All graphic designers have to work with a huge variety of software, hardware, and publishing services.

The alphabetical listing

A

Additive color — A full-spectrum color space in which all three primaries add together to make white.

Aliased — unmodified bitmap edges that are jagged.

Anti-aliased — bitmapped edges that are visually smoothed by adding partial colors to mooth the jagged pixel blocks

Application defaults — The defaults for an entire application (program). Photoshop does not use them.

Ascender — The strokes of lowercase letters that project above the x-height: in bdfhklt, for example.

B

Banding — The bands of color that appear in gradients or blends when the resolution is too low, the linescreen is too high, the length of the transition is too long, or the color differential is too small.

Baseline — The imaginary line that the letters of type sit on.

Basis size —The sheet size used to determine the basis weight (used to define the weight of paper in pounds).

Basis weight — A ream (500 pages) of the basis size: that is, 500 sheets of a 20# bond paper weighs 20 pounds. This is the paper weight written on the packaging.

Bézier curves — The mathematical equations used to describe PostScript paths.

Bitmap — The grid to which pixels are mapped.

Bitmap image — A graphic in which every pixel is separately defined

Bleed — Printing ink one-eighth inch beyond the trim size to give the illusion that the ink goes exactly to the edge of the sheet of paper.

Blend — The transformation of one path to another. Not available in Photoshop.

Blending mode — the method Photoshop uses to combine or overlay layers in a document.

Body copy — The basic reading paragraph of a document. This is outside the paradigm of Photoshop.

Bond — The most common name of office paper

Bounding box — The invisible box defined by the vertical and horizontal lines that touch the extreme left, right, top, and bottom edges of a shape or group. The manipulation handles for an image are located by the corners and centers of the sides of the bounding box.

Bridging — When two halftone dots barely touch and bleed together, creating a dot that is larger than the one specified.

Burst — A splashy graphic used to pull the reader's eye to a compelling idea or command (such as "free," or "buy now").

C

Calendaring — Using a stacked series of large milled steel rollers to polish and compress paper as it comes off the papermaking machine.

Calibration — Adjustment of equipment to manufacturer's specifications to provide the most predictable results.

Caliper — The thickness of cover stock measured in thousandths of an inch.

Callout — A paragraph style of enlarged or emphasized body copy used as a graphic device to recapture a reader's wandering attention. Only possible in a page layout program (that is, not in Illustrator or Photoshop).

Camera ready — Artwork that is black and white, ready to be shot in a copy camera to make a negative or a plate.

CMY(K) — The full-spectrum color space of process printing. Cyan (C), magenta (M), and yellow (Y) are the primary colors, with black added because of the weak cyan.

Color depth — The number of bits assigned to a pixel. This determines the number of colors available to the monitor, scanner, printer, or digital press.

Color management — Establishment of relationships between calibrated machines, using color profiles, to accurately predict the final product's appearance.

Color proof — A proof of the final color output; formerly called a *stripping* or *prepress proof.*

Color reproduction — The ability to reproduce original color in multiple copies; this is theoretically impossible.

Color space — A system of colors defined by a set of three primary colors; which are mixed to produce all the other colors in the color space.

Color system — A color environment that is not full-spectrum.

Color temperature — Color defined by its temperature in degrees Kelvin.

Color wheel — The RBY color space represented in circular fashion.

Commercial printing — Custom manufacturing of printed materials of almost any type.

Commodity color — Color that is so common that pricing is based entirely on market value and return on investment (copier color, digital color).

Complementary color — Color pairs of color wheel opposites.

Composite paths — Two or more closed paths that are converted into one path with a common even/odd fill. One of the major things missing in Photoshop's vector tools.

Compression — Replacing patterns in digital code with placeholders, or averaging areas of pixels.

Continuous tone — Images that continuously vary in color or tone, like photographs and scans of fine art paintings, pastels, charcoal drawings, and pencil drawings.

Contract proof — A proof used as a contract for the client who promises to pay, and for the printer who promises to duplicate the proof.

Contrast — The distance between the two extremes of dot range.

Copydot — Scanning or photographing a printed (screened) piece of artwork as lineart at a high enough resolution to copy the dots.

Creep — The movement of the copy toward the outside of a saddle-stitched booklet, due to the increasing thickness of the paper at the stitched edge.

Cropping — The elimination of extraneous data from an image.

Cross-platform — A workflow accomplished with some of the people working on Windows machines and some on Macintoshes or UNIX machines.

Curves — A line graph used to indicate all of the pixels in an image, which can be modified by click-dragging on the curve.

Customer proof — Used to give the client something to approve before continuing with production.

Customizable shortcuts — The ability to specify personalized keyboard shortcuts for almost all commands. This is a major lack in Photoshop.

D

Defaults — What the software and hardware do when the designer has made no specific choices.

Density — A measurement of the lightness or darkness of a scanned or printed area measured from 0 (pure white) to 4.0 (absolute black).

Density range — The difference between the highlight and the darkest shadow, as measured by a densitometer using a logarithmic scale from 0–4.

Descender — The portions of lowercase letters that hang below the baseline: in gjpqy, for example.

Diffusion dithering — Giving the illusion of continuous tone with seemingly random dots; the natural output of low-resolution color inkjet printers.

Dithering — A coarse arrangement of relatively small dots that gives the illusion of continuous tone, whether grayscale or color — used with low-resolution printers

Document defaults — Defaults that apply only to a specific document. The document setup that opens when you hit the New Document command under the File menu. They are not changeable in Photoshop.

Dot — The smallest unit of printing. A dot can vary in size or location but not in color.

Dot gain — The normal phenomenon of dots increasing in size

as they are printed. All printers have dot gain except for calibrated electrostatic printers.

Dot range — More appropriately called the *tint range*. The range from the lightest highlight to the darkest shadow in tint percentages.

Duotone — A technique used to give more shadow density by overprinting two halftones.

E

Electromagnetic spectrum — The visible light spectrum.

Electrostatic — A printing method that uses an electrically charged image. This image attracts charged toner that is melted onto the paper. The basic technology of laser printers.

Emulsification — The mixing of oil or grease and water. This is the purpose of soap (except that in printing, emulsification is a mechanical process).

Enamel — Another name for coated offset printing paper.

EPS (Encapsulated PostScript) — A graphic format written in the PostScript page description language. Files in this format can only be printed on PostScript printers.

Export — Writing digital code in a format that can be read by other software.

Extrema — Points placed on a PostScript path at the extreme left, right, top, and bottom of the path.

F

Fill — The interior content of a PostScript shape. The attributes applied to the area enclosed by a path.

Filler — A chemical added to paper for bulk and opacity.

Fine art reproduction — One of the most difficult printing projects, because of the critical nature of the color and detail reproduction necessary. Many fine art colors cannot be duplicated and many details are too fine or subtle.

Flag — The name of a newsletter or newspaper expressed in a banner-style design on the front page.

Flexography — A method of letterpress using relatively soft, flexible plates; dominant in packaging

Font — A complete set of characters for a given typestyle.

Font family — A group of typestyles of different weights from light or thin to bold, heavy, or black.

Format, graphic — Code exported from a digital document in a form that can be read by other programs.

Formatting — Arranging copy for readability and comprehension by applying specific paragraph styles.

Frame — A containing shape in PostScript, or an additional window open on a Web page.

Front matter — Pieces of a book or magazine that come before the real content such as table of contents, foreward, preface, and the like.

Fugitive color — Color that fades quickly to white.

Full-spectrum — A color space that contains colors from all areas of the visible spectrum.

G

Gamma — The slope of the curve indicating contrast.

Gamut alarm — A dialog box that warns when the color on the screen is unprintable.

Generation — A copy of an original.

Ghosting — making an image, or a portion of an image, light enough in value that type can be overprinted.

GIF (Graphic Interchange Format) — A graphic format with limited colors and good compression, used for low-resolution Web graphics. CompuServe's Web graphic format uses indexed color (8-bit or less) and LZW compression (like TIFFs).

Graphic design — Design in any area of digital publishing production. What was formerly called commercial art; the arrangement of copy and graphics for the purpose of clear communication.

Gravure — The modern printing technology using intaglio.

Gray levels — A number of available tint percentages.

Gripper — Blank space left at the edge of a sheet of paper to allow the press to grab it and pull it through the duplicator or press.

Group — Constraining two or more objects into permanent relationship. Photoshop cannot do this.

GUI (graphic user interface) — A computer interface, like MacOS or Windows, that uses graphic analogies to relate to the data in the computer: mouse, icons, popup menus, and so forth.

Gutter — The vertical white space left between columns; also used to describe the center margins of a book or booklet.

H

Halftone — A method for converting continuous tone art to lineart using screens that convert the continuous color to patterns

of dots. Breaking up continuous tone artwork into variable size dots to enable the printing of the illusion of continuous tone.

Halftone cell — A group of dpi dots used to generate a variable sized lpi (or linescreen) dot. A group of printer dots producing a halftone dot.

Handles — The manipulation levers attached to a point, used to manipulate the tangents of the incoming and outgoing segments.

Handmade stochastic — a random-dot halftoning technique using the Bitmap mode's diffusion dithering option.

Hanging indent — A paragraph style with a left indent, that has a negative first-line indent and a tab on top of the left indent to line up the rest of the first line with the indent; used for bulleted or numbered lists.

Hard cover — Perfect-bound or smythe-sewn books covered with hard cardboard covers.

Hard dots — Dots with hard edges, even density, and a specific size.

Head — A paragraph style, normally sans serif, used to capture the reader's attention with a real benefit.

Heat-set web — A printing press that prints on a roll of paper and has infrared dryers to dry the ink, enabling high-speed four-color printing.

Hi-fi (high-fidelity) color — Process color schemes to assist the colors available in more closely reproducing reality. A process color system using more than four colors to produce a much larger color space; Hexachrome, by Pantone, seems to be the standard.

Highlights — The tints in an image from 0 percent to 25 percent. The lightest areas in continuous tone artwork.

Histogram — The least intuitive method of interactively indicating gray levels.

HSB or HSV — Hue, saturation, and brightness or value; a color description language that allows accurate communication of color.

Hue — The name of a color.

I

Imposition — Arranging multiple pages on the front and back of a single sheet of paper so they are in proper page sequence after folding and trimming.

How do you keep up when the meanings change weekly?

Anonymous student

Incandescent or tungsten — An ordinary light bulb uses a tungsten filament and glows with a very yellow light (or low-temperature) light.

Index — A cheap, low-quality, calendared, lightweight cover stock (90# and 110#).

Ink holdout —The ability of a paper to keep ink on the surface with no absorption; produces much brighter and more saturated colors and gives much more control of ink densities.

Intaglio (now called gravure) — A printing technology that engraves or etches the image below the surface of the plate. The image is filled with ink and the background is cleaned and polished, then the ink is pulled out by squeezing slightly dampened paper into the recessed image. In gravure the background is squeegeed clean with doctor blades.

Interface — What you see on the monitor screeen that allows you to interact with your software application.

Internal proofs — Used during and within the production flow to locate problems and errors.

Interpolate — What image manipulation software does when it attempts to guess what color pixels to add when enlarging or which to remove when reducing.

ISP (Internet Service Provider) — A company that lets you use its Web server for a fee.

J

Jaggies — The pixelated edge of shapes or lines that appears when the pixels or dots are large enough to see with the naked eye.

Join — The three manners of rendering the appearance of the bends in a stroke at corner points.

JPEG — The lossy compression scheme used for contiuous tone art on the Web. It works for high-res printing, but compressing too far leaves "plaid" artifacts. Compresses by averaging pixel areas.

K

Knockout — A PostScript property whereby the top shape knocks a hole in its exact shape in the colors underneath it.

L

Laser proof — A generic term for a black-and-white art proof.

Layer (PostScript) — a collection of shapes that can be manipulated separately from the rest fo the image.

Layer (Photoshop) — another bitmapped image added to the Photoshop document that can interact with other layers — or not, according to the choice of the designer.

Layer mask — A selection in a layer that can be soft-edged, that blocks all the pixels outside the mask.

Leader — Filling the space between the end of the type and the new tab with repeating characters; used for attaching prices to items in menus and so forth.

Leading — Typographers' term for line spacing.

Letterhead — The stationery used by a company for writing official documents and letters.

Letterpress — The modern term for relief printing as developed by Gutenberg; currently used almost exclusively for die cuts, foil stamping, scoring, embossing, and the like.

Levels — A bar chgart that shows how many pixels are set to each of the 256 colors available in a channel.

Line — A design element that is distinguished primarily by length and direction.

Lineart — Originally, black-and-white artwork, also called camera ready; currently, the output of PostScript illustration programs. Photoshop's equivalent is Bitmap mode.

Linescreen — The number of elements per inch on a printed image. The measurement system for dot patterns necessary to print continuous tone artwork on a 1-bit press. Used to describe the size of the dots in halftones; measured in lines per inch.

Link —The digital pointer that causes the PostScript printer or Distiller to use the high-resolution original instead of the low-res preview that is actually in the document.

Linotype — The first mechanical typesetting machine in letterpress; the technology that enabled the daily newspaper.

Lithography — A printing technology that uses a water-receptive background and a grease-receptive image; the plate is covered with water and then inked with a roller containing greasy ink.

Local formatting — Making changes to paragraph or character specifications without using the Styles palettes.

Logo — A graphic device used to distinguish and market a company.

Lossless — A compression scheme that loses no data.

Lossy — A compression scheme that loses data.

Loupe — A magnifying lens used for examining halftone dot

structures, color fit, and trapping. The common name of a magnifying lens used by prepress personnel to examine screens, angles, fit, and rosettes.

LZW — The lossless compression scheme used by TIFFs and GIFs.

M

Marked up — Written on by the designer to indicate color breaks and instructions. Proofs are marked up by the client to indicate problems and errors.

Mask — A path used to cover, hide, or otherwise block out portions of a drawing or image. Photoshop uses selections (which are a type of path).

Master page — A page containing background images that are automatically placed onto pages of a document.

Masthead — The official, legal column listing publication personnel and publishing data required by law.

Matchprint — A color proof made from the negatives of the page made by laminating thin mylar images for each color of the separation: cyan, magenta, yellow, and black.

Matte — The color of the background when a transparent layer is flattened. Matting is supported by GIF, JPEG, and PNG. Its major use is to provide a background matte with a matte color that matches the background of the Web page (giving the illusion of transparency). Layer edges often blend more smoothly into a matte background.

MB (Megabyte) — A digital data size measurement for approximately 1 million bytes (8 million bits) of data.

Menu commands — Capabilities and dialog boxes accessed by clicking on the drop-down menu at the top of the monitor screen.

Mezzotint — A fine art intaglio technique that involves polishing highlights out of a solidly scratched, deep black, copper plate; for our purposes, the look of a mezzotint is a random arrangement of very short lines that produces a very arty halftone appearance.

Mezzotint filter —A very poor approximation of the look of a true mezzotint.

Mill order — Paper not commonly available that must be ordered in multiple-carton quantities from the paper mill.

Miter — The extended point, beyond the corner point, of a stroke that changes direction. The length of this point is controlled by the miter limit option. Not available in Photoshop.

Moiré — Interference patterns that appear whenever two or more regular patterns are printed on top of each other; a major problem when rescanning.

Morgue — A designer's storage and filing system used to keep samples and references for design ideas.

Multimedia — Graphic productions that use video, animation, sound, music, and/or interactive linkages.

N

Nested graphic — An image imported into an illustration and then exported along with the finished illustration; a separate digital file, or an image, within an image.

Neutral grays — Colors that show no hue cast.

Newsprint — An extremely cheap, low-quality, acidic wood pulp paper used for newspaper production.

Nouveau riche design — Conspicuous display of the powerful capabilities of publishing and design software, "just because you can."

O

Offset — Lithography presses that print the image first onto a rubber blanket and then transfer the image to the paper; allows right-reading plates.

On-demand — Storing documents digitally, then printing only what is needed when it is requested, often with variable data so each printed piece is different.

Opaque — A common name of high-quality, offset printing papers (#1 Premium sheets).

OPI (image substitution) — A process developed by Aldus to enable top-end scanners to supply low-res images to the designer for easy manipulation and then automatic substitution of the high-res images at the service bureau or printing firm, applying all the changes made by the designer to the low-res image.

Output simulation — Adjustment of the monitor and proof colors to mimic the final output of the production printer or press, using machine color profiles.

P

Page layout — The assembly of prepared pieces, graphics, and copy into a finished document. Contrary to popular opinion, Illustrator or Photoshop cannot do this — period.

The worst thing about desktop publishing is learning the languages...

Anonymous student

Panels or palettes — An arrangement of commonly used dialog boxes into floating boxes for easy mousing access.

Pantone Matching System (PMS) — The dominant standardized spot color system in the United States.

Paragraph rule — A rule attached to a paragraph, either above or below, applied with the Return/Enter key. Not available in Illustrator or Photoshop.

Parent size — The sheet sizes of paper purchased from a paper distributor, commonly 23" x 35" or 26" x 40" in United States.

Path — The name of the mathematical description used to define lines and shapes in PostScript illustration.

PDF (Portable Document Format) — A file format of simplified, streamlined PostScript that can be read on any platform with a free Reader. It contains all the fonts and all the graphics, so it is truly portable and can be used as the preferred format to send to your printing firm or service bureau.

Perfect bound — As opposed to saddle-stitched, these books and booklets are trimmed on four sides and have a square binding edge with a cover wrapped around.

Permanent color — In printing, color that lasts a year; in fine art, color that lasts a minimum of 200 years.

Pixel — A contraction of the two words *picture element*. A pixel is the smallest unit of a digital image. It can vary in color but not in location.

Pixelated — An image in which the pixels are large enough to be seen as tiny squares with the naked eye. This can be caused by enlarging or resizing a bitmapped image.

Place (import) — Putting a picture preview in a document with a link to the high-resolution version for printing; what is done with exported graphics.

PMS (Pantone Matching System) — A standardized spot color ink system that is dominant in the United States. It has 1,001 standard colors mixed out of 14 basic inks according to standard formulas listed on swatch books (you need to buy a swatch book).

PNG — A new Web format designed to eliminate the royalties for the LZW compression used in CompuServe GIFs. Supposedly it has superior compression, but it rarely does as well as Photoshop's new lossy GIF capabilities. It also supports partial transparency (alpha channels). Spotty support.

Point (paper) — Cover stock measured in thousandths of an inch with a micrometer.

Point (PostScript) — A reference location on a Bézier curve.

Posterize — The reduction of an image to only a few gray levels.

Posterizing — Converting continuous tone art to art with severely limited tonal values.

PostScript — A page description language at the core of high-resolution printing; the standard for the printing industry and the basis for PDF.

PostScript Illustration — Images drawn with PostScript shapes produced ini FreeHand and Illustrator (plus QuarkXPress and InDesign).

PPD (Printer Description File) — A small piece of software supplied with a PostScript printer that defines the capabilities of that printer to the software being used to print, such as resolution, linescreens available, paper sizes, and so forth.

Preferences — Settings for some basic application defaults.

Preflight — Opening up submitted digital documents to see if they are complete, correct, and will work; a checkout to see if it will "fly".

Press proof — A proof created using press output; used as the final proof on a job.

Primary colors — The three colors from which all other colors in a color space are made through mixtures.

Process color — A full-spectrum color space using primaries: RGB for Web and multimedia; CMY for color printing (plus K [black] because cyan is weak).

Proof — A one-off print of the final product used for checking accuracy of copy and layout, color, imposition, and traps. They come with huge differences in accuracy depending on need and price.

Pull quote — See *callout*; using body copy quotes as a graphic device to recapture readers' attention.

Q

Quadritone — A four-color separation using spot colors to give much greater shadow detail and midtone control.

Quality control — The means of taking control of the production process, using proofs, calibration, and color management along with customer and employee feedback.

Quickprint — Short-run, quick-turnaround printing using paper, plastic or digital plates and limited paper choices, Normally,

low-resolution, coarse-registration printing done on cheap plates with limited paper and ink choices using duplicators instead of presses. This portion of the industry was the first to adopt digital technology, so there are now wide variations in quality and capabilities.

R

RAM (random access memory) — The ultra-fast memory used by your computer to work in as it creates files and documents. It is wiped out any time power is cut.

RBY (Red Blue Yellow) — The fine-art, full-spectrum color space of artists' pigments.

Registration — The ability of a press to feed paper consistently. The normal standard is a half dot.

Rescreening — Screening artwork that has already been halftoned.

Resolution Independence — One of the basic attributes of PostScript: PostScript vector drawings and type have no resolution attached to the file, so they print out at the highest resolution possible on a specific printer with a custom bitmap created to best utilize that printer.

RGB (Red Green Blue) — The full-spectrum color space of a monitor. The additive color space of light.

RIP (raster image processor) — The computer in a PostScript printer that generates the custom bitmap of PostScript information to exactly fit the resolution of that printer, imagesetter, or platesetter.

Rollovers — A Java-scripted action where graphic buttons change as a mouse moves over them.

Roughs — A hand-drawn rendering of an idea to establish layout and proportion. Quick proportional sketches used to show possible layouts to your clients.

S

Saddle-stitched —Booklets made by folding paper, stapling through the fold, and trimming the three outside edges.

Sample — The smallest image unit of a scan.

Saturation — The intensity of a color.

Scanning resolution — Twice the linescreen.

Screen — Another name of a tint using linescreen dots.

Screen angles — The angles of the dot grid in the four halftones used for CMYK color (45°, 75°, 105°, and 90°); used to avoid moiré patterns.

Screen preview — What you see on the monitor when you place a graphic into a document.

Script fonts — Fonts that mimic handwriting (specifically modern handwriting).

Secondary colors — Colors made from mixing two primary colors.

Segment — The path portion between two points as defined by the handles.

Self-extracting archive — A compressed archive that will open with a simple double-click of the icon.

Separation — Converting a scan of a color image into CMYK.

Serif — A flare, bump, line, or foot added to the beginning or end of a stroke in a letter.

Service bureau — Companies with color expertise, high-end color scanners, and top-quality imagesetters who prepare designers' documents for printing.

Shade — A fine-art term to describe hues plus black.

Shadows — The dark areas of a halftone or separation; the tints in an image from 70 percent to 100 percent.

Shape — A two-dimensional piece of a graphic.

Sheet-fed — Presses that feed one sheet at a time.

Short-run — Printing 2,000 impressions or less.

Sidebar — Information placed to the side of a layout that is interesting but not essential.

Sign off — A way in which printing establishments attempt to place output responsibility on the client.

Signature — A sheet of paper with multiple pages arranged on it so that, after folding and collating, the pages are in the proper order.

Sizing — A coating that controls absorption.

Slicing — The cutting of oversized Web images into smaller pieces. Each piece can have its own links and disjointed rollovers.

Smooth — The surface of uncoated, calendared, offset paper.

Smythe-sewn — The highest-quality process for making a book, in which the signatures are hand-sewn together and case-bound, usually with a leather cover.

Soft proofing — Using the monitor for proofing. It is very dangerous without some kind of hard-copy proof to go with it, and requires much experience.

Specular highlights —Reflections of a light source off a shiny surface like chrome or water.

Spiral-bound — The binding of a book or booklet with spiral wire into prepunched holes.

Spot color — Color printed on its own plate or printhead.

Spot color separations — Outputting a spot color document so that each color is on a separate print, plate, or negative.

Standard color — A standard pigment mix of an ink company.

Stationery package — Business cards, letterhead, and envelopes.

Stochastic — A recent development in halftone technology that uses irregular dot patterns, precisely placed. The dots remain the same size. Tints are created by the number of dots in a given area.

Stochastic screen — A new digital halftone technique using precisely placed, very tiny dots with frequency modulation. A hand-generated stochastic effect can be created by using Photoshop's Bitmap Mode >> Diffusion Dither, which is a random dithering technique.

Stroke — The color and width applied to a PostScript path or the outline of a PostScript shape.

Stroke and fill — All PostScript shapes give you almost unlimited options to color the outlining path (the stroke), and the area enclosed by the path (the fill).

Style — A recorded format of a paragraph, character, graphic, or applied layer effects available on a palette.

Subhead — A lesser headline.

Subtractive color — A full-spectrum color space in which the primaries add together to produce black.

Swatch book — Standard sets of printed colors that show designers what the color will look like when printed.

Symbols — A shape with attached meaning.

T

Tabs — An soft return with a leading of zero to implement a new indent and alignment setting on the same line of type.

Tag — A very cheap, very thick card stock used for tags.

Tangent — A straight line touching a curve at a single point.

Templates — Saved documents with customized defaults.

Text — What software programmers tend to call copy.

Text fonts — Fonts that mimic medieval handwriting.

Texture — The visual "feel" of a shape's surface.

Thumbnails — A fast sketch (a few seconds) done to note down an idea in a personal shorthand that enables the designer

to retain the idea.

TIFF (Tagged Information File Format) — The most reliable format for printing bitmapped images.

Tint (fine art) — A hue plus white.

Tint (printed screens) — A partial color expressed in the percentage of area covered by the linescreen dots.

Tools — Software routines that change the abilities (and usually the look) of the cursor; buttons to click that change the capabilities of the mouse.

Transformation center — A target that appears with a transformation tool (in Adobe software).

Transparency — pixels that print or partially print or output.

Transparency mask — a mask or selection where the pixels outside the mask do not print or output.

Trapping — Building small overlaps into touching color shapes to cover for bad registration.

Tritone — Three halftones printed on top of each other for greater shadow detail and density plus better midtone control.

Tungsten or incandescent — An ordinary light bulb uses a tungsten filament and glows with a very yellow light (or low temperature) light.

Typesetting — The craft of setting type.

Typography — The art of setting and designing professional quality type and fonts.

u

Ugly — The current fashion in illustration, accurately presenting the frustrations of the younger generations.

Unsharp mask — A filter that heightens the contrast of edges to make them more apparent.

v

Value or brightness — The lightness or darkness of a color.

Varnishes — Transparent or translucent inks printed to protect or provide texture to underprinted inks.

Vector Image — Graphics drawn with outlines in which the curves are rendered with countless short straight lines (vectors). FreeHand and Illustrator (plus InDesign and QuarkXPress) produce vector images. Photoshop has a few vector tools.

Vellum — A surface description of relatively uncalendared offset paper.

Vellum bristol — An extremely cheap, wood-pulp cover stock.

Volume — The illusion of three-dimensional space.

W

Waterless printing — A new high-tech printing technology that uses plates covered with an ink-receptive coating covered with an ink-repelling coating. A laser is used to burn holes in the repellent coating.

Watermark — A slightly translucent image in office papers.

Web printing — Printing onto a roll of paper that is sheeted after printing is completed.

White space— The empty, open, or blank areas of a design; are one of the most important factors to control in graphic design. These areas should be planned shapes to increase readability.

Writing — The name of better-quality bond or office papers.

X

X-height — The height of the lowercase X.

Xtras — FreeHand's name for its plug-ins.

Y

Yak — An extremely smelly, ugly animal with a horrible disposition.

Z

Zorro — A hero of Spanish Southern California.

CD-ROM Content and Exam Summary

Discovering the treasures on the CD-ROM

A complete listing of all the Miniskills and Skill Exams

The last twenty pages in this appendix give you an overview of all the skill exams with the reasons for their existence and what you should hope to learn by completing that particular exam.

Complete Website
with all course materials necessary

All instructions and the pieces needed to produce the Miniskills and Skill Exams
Reading assignments; links to Adobe and Pneumatika; grading policies; and more

Everything is available for
Windows or Mac

Macromedia demo

FreeHand 10

This latest version of FreeHand is Carbonized for Mac OSX (the first major graphic application to do so).

Many Adobe demos

InDesign 1.5.2; Illustrator 9; Photoshop 6; GoLive 5; Reader 5

These are trial versions of the most recent editions as of June 2001.

The only demo we couldn't get is QuarkXPress. They don't make one. However, in the author's opinion, Quark is in serious trouble now that InDesign can do so many things Quark cannot. Plus, the head programmer of the software has retired. QuarkXPress 5 is vaporware of the first order.

Free fonts designed by the author

8 fonts that I have used on a regular basis that normally sell for $24.95 each.

AeroScript
1234567890_QWERTYUIOP[\ASDFGH
JKL;'ZXCVBNM,./qwertyuiop[]asdfghjkl;'z
xcvbnm,./!@#$%^&*()_+¡ ™£¢∞□¶•ªº—≠œ'' ®†¥åœ©
▲°¬…——‒

Bilbo
**1234567890_QWERTYUIOP[]\AS
DFGHJKL;'ZXCVBNM,./qwertyui
op[]asdfghjkl;'zxcvbnm,./!@#$%^
&*()_+¡™↘¢⇧□⌘•⬚º– œ´'®†¥ ß©**
°¬…—‒

Diaconia
1234567890_QWERTYUIOP[]\ASDFGHJ
KL;'ZXCVBNM,./qwertyuiop[]asdfghjkl;'zx
cvbnm,./!@#$%^&*()_+¡™£¢ §¶•ªº– œ´'
®†¥åß© °¬…——

Diaconia Italic
*1234567890_QWERTYUIOP[]\ASDFGHJ
KL;'ZXCVBNM,./qwertyuiop[]asdfghjkl;'zxc
vbnm,./!@#$%^&*()_+¡ ™↘¢⇧ □⌘•ªº– œ
´'®†¥åß© °¬…——*

Diaconia Heavy
1234567890_QWERTYUIOP[]\ASDF
GHJKL;'ZXCVBNM,./qwertyuiop[]asd
fghjkl;'zxcvbnm,./!@#$%^&*()_+¡™ ⊷¢
⇧□⌘•⊞º- œ´`® †¥åß© ˙ ˚¬ …–‒

Nördström
1234567890_QWERTYUIOP[]\ASDFGHJ
KL;'ZXCVBNM,./qwertyuiop[]asdfghjkl;
'zxcvbnm,./!@#$%^&*()_+¡™ ⊷¢⇧□ ⌘•ª
º- œ´`®†¥åß© ˙▲˚¬ …—–

Nördström Italic
1234567890_QWERTYUIOP[]\ASDFGHJ
KL;'ZXCVBNM,./qwertyuiop[]asdfghjkl
;'zxcvbnm,./!@#$%^&()_+¡™⊷¢⇧§⌘•*
ªº- œ´`®†¥åß©˙▲˚¬ …—–

Nördström Black
1234567890_QWERTYUIOP[]\ASDFG
HJKL;'ZXCVBNM,./qwertyuiop[]asd
fghjkl;'zxcvbnm,./!@ #$%^&*()_+¡™
⊷¢⇧□⌘•ªº- œ´`®†¥åß© ˙▲˚¬ …—–

These were some of the standard fonts for the style palettes used on my first three books. Newer, updated versions are available for sale at MyFonts.com plus many other fonts I have designed.

Free fonts designed by a student of David's, Seamus Mills, for the use of his students

11 more experimental grunge fonts Seamus designed and gave to my students

Ameridistort

1234567890_QWERTYUIOP[]\ASDF
GHJKL;'ZXCVBNM,./qwertyuiop[]a
sdfghjkl;'zxcvbnm,./!@#$%^&*()_+¡
™£¢ §¶•ªº— œ´´®†¥åß©˙ °¬...——

Beatz

1234567890_QWERTYUIOP[]\ASDFGHJK
L;'ZXCVBNM,./qwertyuiop[]asdfghjkl;'zxcv
bnm,./!@#$%^&*()_+¡™£¢ §¶•ªº– œ´´®†
¥åß©˙ °¬...—-

Celtic dusk

1234567890_QWERTYUIOP[]\ASDFGHJKL
;'ZXCVBNM,./qwertyuiop[]asdfghjkl;'zxcvb
nm,./!@#$%^&*()_+¡™£¢ ¶•– ´´®† ©˙ °¬
...—--

Century Cruel Book

1234567890_QWERTYUIOP[]\ASDFGHJ
KL;'ZXCVBNM,./qwertyuiop[]asdfghjkl;'zx
cvbnm,./!@#$%^&*()_+¡™£¢ §¶•ªº– œ´´
®†¥åß©˙ °¬...—-

Fiesty Spur
1234567890_QWERTYUIOP[]\ASDFGH
JKL;'ZXCVBNM,./qwertyuiop[]asdfghjkl;'z
xcvbnm,./!@#$%^&*()_+¡™£¢ §¶•ªº– œ''®
†¥åß©˙ °¬…——

Free Roman Black
1234567890_QWERTYUIOP[]\ASDFGHJ
KL;'ZXCVBNM,./qwertyuiop[]asdfghjkl;'zxc
vbnm,./!@#$%^&*()_+¡™£¢ §¶•ªº– œ''®†¥
åß©˙ °¬…——

GothCut Bold
1234567890_QWERTYUIOP[]\ASDFGHJK
L;'ZXCVBNM,./qwertyuiop[]asdfghjkl;'zxc
vbnm,./!@#$%^&*()_+¡™&¢ §¶•ªº– œ''
®†¥åß©˙ °¬…—

MIRTH
1234567890_QWERTYUIOP[
]\ASDFGHJKL;'ZXCVBNM,./Q
WERTYUIOP[]ASDFGHJKL;'Z
XCVBNM,./!@#$%^&*()_+¡™ ¢ •
- ''® © ˙ °…——

PudgiSal
1234567890_QWERTYUIOP[]\ASDFGHJK
L;'ZXCVBNM,./qwertyuiop[]asdfghjkl;'zxc
vbnm,./!@#$%^&*()_+¡™£¢ §¶ •ªº– œ´´®
†¥åß©˙ ˚¬…—--

SansForm
1234567890_QWERTYUIOP[]\ASDFGHJKL;'ZXCVB
NM,./qwertyuiop[]asdfghjkl;'zxcvbnm,./!@#$%
^&*()_+¡™£¢∞§¶ •ªº-≠œ´´®†¥åß©˙∆˚¬…—
-

SansStyle Abnormal
1234567890_QWERTYUIOP[]\ASDFGHJKL
;'ZXCVBNM,./qwertyuiop[]asdfghjkl;'zxcvbn
m,./!@#$%^&*()_+¡™£¢∞§¶ •ªº-≠œ´´®†
¥åß©˙∆˚¬…—-

Seamus' fonts were done as a lark, although he spent a lot of time on them. They are surprisingly useful for work done by a young man who was brand new to typography. Seamus has remarkable talent.

Seamus moved to Albuquerque from the East coast just to take my classes. He couldn't find anyone else in the country teaching what I teach. He moved back to the Washington, D.C. area after he finished my classes. About a year later he emailed me a dingbat font of fishing flies. He said he had decided to fly fish full-time and that he was doing illustrations for an angler's magazine. I've often wondered where he is now.

He sent me these fonts for my students to use.

Browser installers

Communicator 4.7

This browser which formerly was the industry standard has fallen on hard times since being bought out by AOL. We include a copy, but you need to be aware that it has developed a lot of downloading problems – both from downloading sites and in email.

The built-in email interface, Messenger, is hampered by being included within Communicator. So it is slow, plus the downloading problems mentioned.

Explorer 5

I hate to admit it, but Microsoft has done this one right. It is the best browser for a Mac and Outlook Express is the best email software for the Mac (plus it is not susceptible to all of the virus problems that plague Outlook in Windows).

The twenty following pages contain brief overviews of the ten Miniskills, and ten Skill exams

Each miniskill or exam has been written for a purpose and these overviews will help prepare you for what you need to learn.

They also work very well as skill development exercises for people with prior skill. Simply do not do those that are too simple for your skill level.

The complete instructions are found on the Website contained on the CD-ROM. You need to go there to actually work the tests.

MINISKILL #1

Compositing two photos

The goal of this skill exam is to select the rose and paste it into the brick wall, forming a composite grayscale photo.

Skills to be learned

There are several things you need to become comfortable with:

1. Mode conversions: the wall has to be converted to grayscale.
2. Copying and pasting an RGB rose into a grayscale image makes the rose grayscale.
3. The rose will have remnants of the background when it arrives in its new layer, which must be removed by the LAYER>> MATTING>> DEFRINGE command. This command will not work unless the rose is a floating selection or on a new layer with a transparent background.
4. Moving the rose off the edge crops it when it is saved.
5. Saving a file as a GIF and sending it as an email attachment.

The result

MINISKILL #2

Colorizing lineart GIF

Skills to be learned

There are several things you need
to become comfortable with:

1. Converting modes to add color.
2. Using of the magic wand.
3. Having anti-aliasing mess up the selection edge, and fixing the mess.
4. Filling an area. Before you fill an area, the area has to be completely enclosed (the mane is not).
5. Using gradient and radial fills.

The result — in glorious color

MINISKILL #3

Cleaning a filthy photo

© Patrician Stock: http://kumo.swcp.com/graphics

Skills to be learned

There are several things you need to become comfortable with:
1. Using the History brush.
2. Making a new snapshot for the History brush source.
3. Eliminating dirt without compromising the image
 (by using tiny brushes when necessary).

MINISKILL #4

Eliminating a bad scratch

Skills to be learned

There are several things you need to become comfortable with:

1. Using the Rubber Stamp to clone out damage.
2. Realizing the perfection necessary when cleaning up.
3. Eliminating dirt without compromising the image
 (by using tiny brushes when necessary).

We shouldn't be able to tell you touched the image!

MINISKILL #5

Generating a transparent GIF

Quërcül Troubadour

Skills to be learned

There are several things you need to become comfortable with:
1. Setting browser download preferences.
2. Rasterizing EPSs.
3. Changing canvas size.
4. Adding type in Photoshop.
5. Adding layer effect to type.

The final result should be something like this (in color, of course)

ANCIENT LORE FROM THE CONQUISTADORS

MINISKILL #6

Balancing a photo with too much contrast

This is a very difficult task!

Skills to be learned

There are several things you need to become comfortable with:

1. For some photos, the light and dark areas must be treated separately.
2. Using the History brush to lighten and darken specific areas.
3. The problems of posterizing with extreme adjustments.
4. Fixing distortions with Free Distort.
5. Learning what is possible and what is not.

The final result should be something like this

MINISKILL #7

Compositing to fix depth-of-field problems

This is a much more difficult version of Miniskill #1

Skills to be learned

There are several things you need to become comfortable with:
1. Selecting using the Pen tool.
2. Cleaning up fringed or matted edges.
3. Changing canvas size.
4. Smoothing out edges of overlapping images.

The final result should be something like this (in color, of course)

© Patrician Stock: http://kumo.swcp.com/graphics

MINISKILL #8

Building a four-color slick magazine ad

© Patrician Stock: http://kumo.swcp.com/graphics

Skills to be learned

There are several things you need to become comfortable with:
1. Thinking creatively.
2. Working without specific guidance.
3. Working within size limitations.
4. Dealing with bitmapped type.

The final result should be something like this (in color, of course)

Feel trapped inside while looking out at the budding trees?
The Park Service can save you!
More importantly, we need you.
Escape your office and send us a resume!
EMAIL RESUMES ONLY: SEND TO freedom@parkservice.org

MINISKILL #9

Fixing color balance

© Patrician Stock: http://kumo.swcp.com/graphics

Skills to be learned

There are several things you need to become comfortable with:

1. Seeing color accurately.
2. Adjusting to neutrality in RGB.
3. Seeing how color changes with distance.
4. Learning what is possible on a reasonable schedule.

Because it is a color correction, nothing can be shown here as the final result

MINISKILL #10

Using type as a clipping group

© Patrician Stock: http://kumo.swcp.com/graphics

This will keep you entertained.

Skills to be learned

There are several things you need to become comfortable with:

1. Type as a clipping group.
2. Layer effects.

The final result should be something like this (in color, of course)

SKILL EXAM #1

CMYK cover design for rose breeder

© Patrician Stock: http://kumo.swcp.com/graphics

This uses the roses you cleaned up for Miniskill #3

Skills to be learned

There are several things you need to become comfortable with:

1. Setting bleeds.
2. Using a photo that doesn't fit.
3. Setting type that is readable in Photoshop.
4. Being responsible for a saleable professional design.

The final result is your solution

SKILL EXAM #2

Cleaned-up CMYK tritone

Skills to be learned

There are several things you need to become comfortable with:

1. Difficult cleanup with Rubber Stamp and History brush.
2. The value of tight cropping.
3. Creation of well-balanced tritones.

The final result

SKILL EXAM #3

Distorted photo, damaged product

© Myrrh enterprises. Ltd., Co.
http://www.spikenard.com

Skills to be learned

There are several things you need to become comfortable with:

1. Repair of product image with Rubber Stamp and History brush.
2. Very difficult cleanup of reflection in type on bottle.
3. Difficult adjustment with Free Distort.
4. Addition of type.

The final result

Sorry about the 72 dpi image — the high-res version is up to you.

SKILL EXAM #4

Building a sunset

© Patrician Stock: http://kumo.swcp.com/graphics

Skills to be learned

There are several things you need to become comfortable with:

1. Accurate selection.
2. Color adjustments.
3. Careful curves and sharpening adjustments.

The final result (in color, of course)

Sorry about the low-res image — the high-res version is up to you.

SKILL EXAM #5

Tight-clipped quadritone

© Patrician Stock: http://kumo.swcp.com/graphics

Skills to be learned

There are several things you need to become comfortable with:

1. Difficult selection of ill-defined edges.
2. Quadritone creation.
3. Careful curves and sharpening adjustments.
4. Elimination of bad texture from photograph.
5. Export of a clipping path.
6. Import of an image into page layout.

You are responsible for the final result

SKILL EXAM #6

Using the Pen tool to clip a chile

Skills to be learned

There are several things you need to become comfortable with:

1. Selecting accurately with the Pen tool.
2. Building image areas that are hidden in the original.
3. Making transparent GIFs.

The final result (in color, of course)

Sorry about the low-res image — it's for the Web.

SKILL EXAM #7

Wedding program cover design

© Patrician Stock: http://kumo.swcp.com/graphics

© Patrician Stock: http://kumo.swcp.com/graphics

Skills to be learned

There are several things you need to become comfortable with:
1. Thinking creatively.
2. Working with very few limits.

The final result (in color, of course)

Sorry about the low-res image — it's just for ideas.

Welcome to
the wedding of
George P. Darthwaite
&
Helene Maria Mendoza
June 23, 2002

SKILL EXAM #8

Building a postcard with a very difficult to execute, rough layout

© Patrician Stock: http://kumo.swcp.com/graphics

© Patrician Stock: http://kumo.swcp.com/graphics

Skills to be learned

There are several things you need to become comfortable with:

1. Working within tight restrictions.
2. Working with very few limits.
3. Setting a lot of type in a small area and keeping it readable.

The final result (in color, of course)

A once-in-a lifetime opportunity!
There will be strictly controlled entrance and severely limited seating. You must be preregistered to attend!

All registrations will be taken on our Website:
http://santuario.org/healing/regis.htm

Healing seminars:
March 8, March 15, March 22, March 29 of 2003
$200 US for entire series (limited to 500); each session individually
$90 US (each session has 72 single-session seats available)

FIRST COME — FIRST SERVED!
All payments must be made by credit card online, at the Website.
Clergy training sessions: Requests must come in writing from your bishop.
Deadline January 12, 2003
Healing services: attendees will be let into the area through the North gate, just south of Chimayo village. 1200 per service will be allowed — preference will be given to those in wheelchairs with a doctor's letter.

SKILL EXAM #9

Making a label for Quёrcül Troubadour's Violeta Healing Balm

© Patrician Stock: http://kumo.swcp.com/graphics

Skills to be learned

There are several things you need to become comfortable with:

1. Working with very few limits.
2. Working in a historical context.
3. Developing a printable product.

The final result (in color, of course)

I sure hope you can do better than this sample.

Ambrosia los Violeta del Amante

One Liter
Aged 15 years in a hand-coopered Quercul cask

SKILL EXAM #10

Scanning and tracing a tiny CMYK logo

Plus it is printed in poorly registered CMYK!
Tracing logos like this will be one of your more common tasks.
This exam does require FreeHand or Illustrator and Streamline

Skills to be learned

There are several things you need to become comfortable with:
1. Clean up of scans for tracing.
2. Accurate reproduction of what the logo must have looked like when it was created so many years ago.
3. The normal time allowed for a tracing like this is about 20 minutes (or less).

The final result (you're converting to grayscale, remember?)

This is a very outdated version of Best Western's logo that we actually received in an advertisement from a client here in one of our class projects last year. To see their current version, check out their Website at:
http://www.bestwestern.com

Index

You made it!

Hope it was a fun ride.